U.S.A. $75.00
Canada $99.00

FACE TO FACE is a stunning collection of behind-the-scenes photographs of famous writers, poets, artists, architects, actors, directors, musicians, and social figures taken in Europe, New York, and Los Angeles. Camilla Pecci-Blunt, a nonprofessional photographer who grew up between Italy and New York, was well placed to forge the path she did. Her mother was passionate about the arts, took photographs, painted, and collected artists around her, and had galleries in Rome and New York. The more than six hundred photographs in this book from the 1950s to the early 1990s capture our cultural icons in casual, playful moments.

After she married Earl McGrath in 1963, their homes—first in New York and then in Los Angeles—became gathering places for a wholly unexpected mix of people that Camilla documented in these surprising, in-the-moment photographs: Jackie Kennedy, Jerome Robbins, Calvin and Kelly Klein, Nancy Pelosi, Dianne Feinstein, Bruce Chatwin, Andy Warhol, Larry Rivers, Jean Tinguely, Frank O'Hara, Jasper Johns, Allen Ginsberg, the Rolling Stones, Bryan Ferry, Bette Midler, Jerry Hall, Keith Haring, Linda Ronstadt, Jerry Brown, Sharon Tate, Roman Polanski, John Waters, Joan Didion, Anjelica Huston, Robert Graham, David Hockney, Michael Crichton, and Barbra Streisand, among many others.

Andrea di Robilant's essay, along with memories from Griffin Dunne, Vincent Fremont, Harrison Ford, Fran Lebowitz, and Jann Wenner, reveal the backstory of this irresistible look at the larger-than-life cultural figures of our time as you have never seen them.

FACE
to
FACE

FACE to FACE

The Photographs of

CAMILLA McGRATH

Andrea di Robilant

with Griffin Dunne, Vincent Fremont,
Harrison Ford, Fran Lebowitz, and Jann Wenner

Alfred A. Knopf · New York · 2020

THIS IS A BORZOI BOOK
PUBLISHED BY ALFRED A. KNOPF

Copyright © 2020 by the Camilla and Earl McGrath Foundation
Essay copyright © 2020 by Andrea di Robilant

www.aaknopf.com

Knopf, Borzoi Books, and the colophon are registered trademarks
of Penguin Random House LLC.

Library of Congress Cataloging-in-Publication Data
Names: McGrath, Camilla, 1925–2007, author. | Di Robilant, Andrea,
 [date] editor, writer of introduction.
Title: Face to face : the photographs of Camilla McGrath /
 by Camilla McGrath ; introduction by Andrea di Robliant.
Description: First edition. | New York : Alfred A. Knopf, 2020. |
Identifiers: LCCN 2019048192 | ISBN 9780525656463 (hardcover)
Subjects: LCSH: Celebrities—Pictorial works. | Vernacular photography. |
 McGrath, Camilla, 1925–2007.
Classification: LCC TR681.F3 M425 2020 | DDC 779/.2—dc23
LC record available at https://lccn.loc.gov/2019048192

Jacket photographs by Camilla McGrath
Jacket design by John Gall

Manufactured in China
First Edition

COLAZIONE A CASA
16 GENNALO

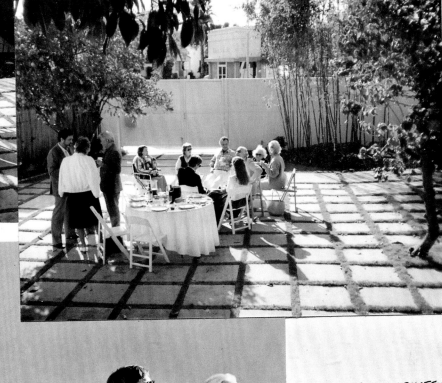

JOSEPHINE LOEWENSTEIN
MICK JAGGER
DIANTHA LEVANZON
HARRISON FORD
CONNIE WALD

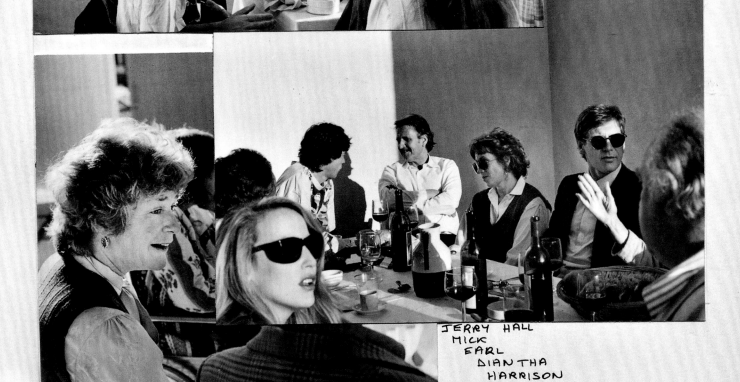

JERRY HALL
MICK
EARL
DIANTHA
HARRISON

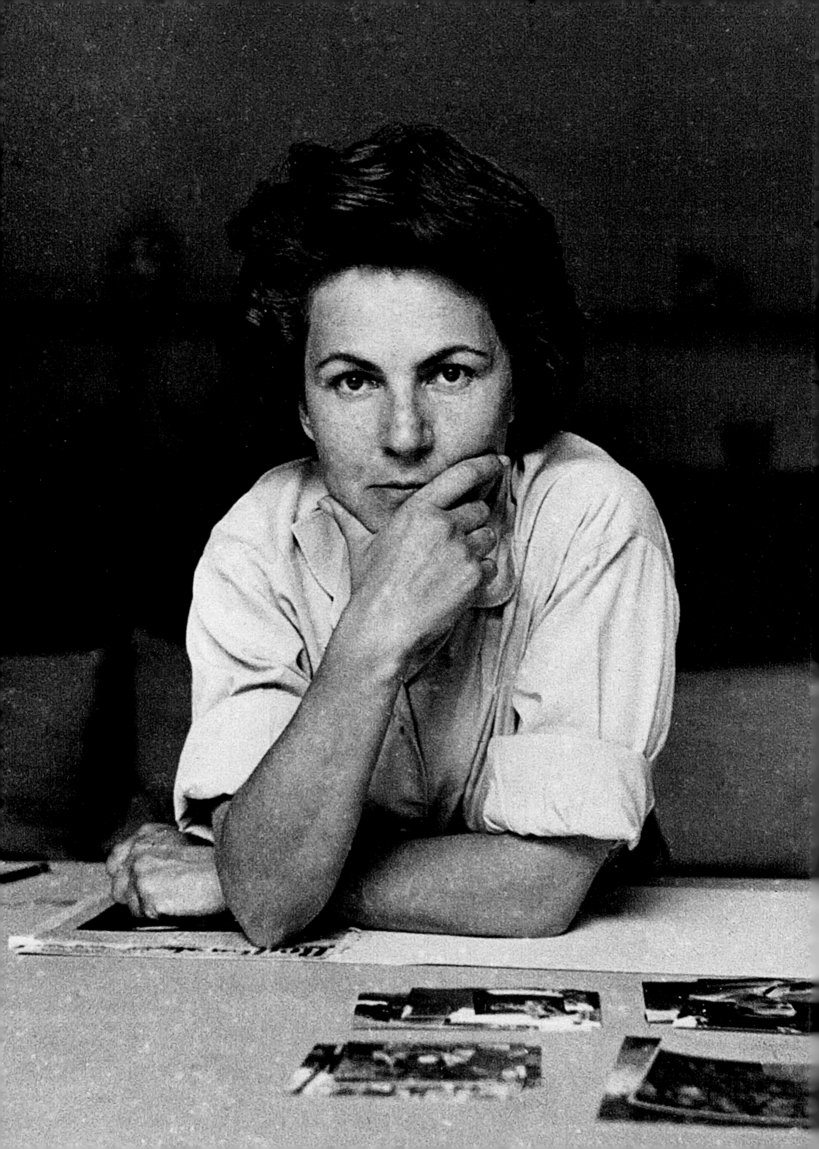

Contents

FACE
to
FACE

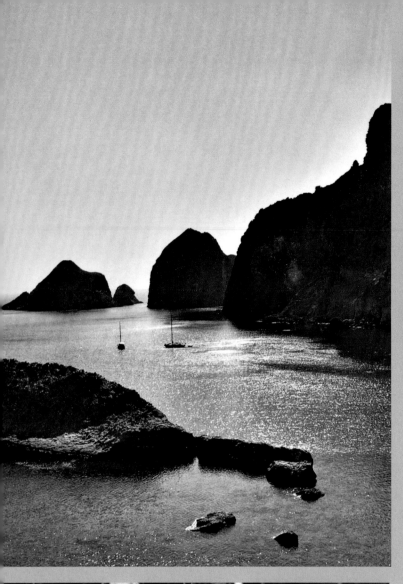

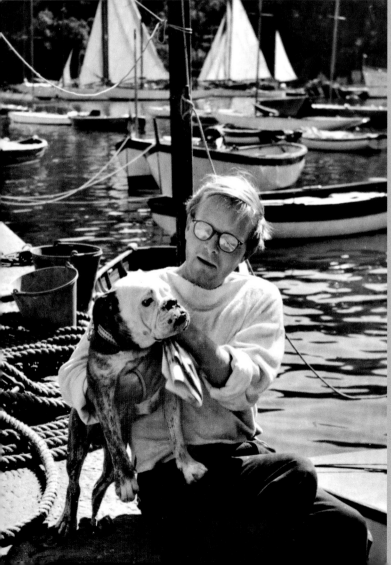

A Cool Place to Hang Out

Andrea di Robilant

I n the late seventies I was a student at Columbia University and lived on New York's Upper West Side. Midweek the phone used to ring at the apartment I shared at 420 Riverside Drive, and Camilla would be on the other end of the line inviting me to Sunday lunch. "Come early," she always said, meaning "Don't be late."

Camilla was an old friend of my father, Alvise. They went way back, to children's parties in Paris in the late twenties and early thirties, and she was also the godmother of my brother Filippo. When I moved to New York, she took me under her wing and made sure I was properly fed at least once a week.

On Sunday mornings I took the downtown local with Pietro Cicognani, who was studying architecture at Columbia and was like a son to Camilla; his mother, Helen Volkonsky, was one of Camilla's oldest friends in Rome. We got off at Columbus Circle and walked over to 171 West Fifty-Seventh Street. Pietro and I often *did* arrive early at the apart-

ment, to find Camilla still shuffling in the kitchen and Earl lighting up a joint over by the music nook, tapping his foot to a new demo by Max Romeo or Jim Carroll.

At that time of day, between noon and one o'clock, the apartment, which faced the main entrance of Carnegie Hall, was filled with light; it was the best time to look at the paintings and drawings that covered every wall of the living room and the adjoining dining room. Earl and Camilla were not "art collectors," but they collected art from their friends, so that the two rooms looked both striking and familiar.

I remember the Larry Rivers portrait of Earl and Camilla; Bruce Nauman's silk print over the mantelpiece: "This is the silver grotto / You can't hear me / This is the yellow grotto / You can't hurt me / I can suck you dry"; the two early Twomblys that Camilla had bought in Rome in the sixties and the later, large "chalk" canvas on the right wall as you entered; the little abstract painting by the Iranian-American artist Manoucher Yektai, full of thick yellow and orange dabs of oil paint. Robert Graham's sculptures scattered about. Wynn Chamberlain's double green paintings of the four poets sitting dressed in one and sitting naked in the other. And here and there were drawings by Brice Marden and Jasper Johns. But Earl and Camilla moved the art around constantly to make space for new works, even as they sold others to pay the bills.

I liked the lull before the other guests arrived—the warm, informal atmo-

sphere and the delicious smells coming from the kitchen. There was always a good chance of stumbling onto an unexpected scene: Governor Jerry Brown (who had just announced he was running for the presidency) coming out of the bedroom in his boxers looking for Linda Ronstadt; Keith Richards standing alone at the big Twombly painting, picking at an invisible acoustic guitar; Jasper Johns and Richard Diebenkorn sitting on the low couch in the dining room, silently sketching each other's portrait.

The room soon filled with lunch guests. Larry and Clarice Rivers, Brice and Helen Marden, Alex and Ada Katz, were among the artists who came regularly. There were always musicians, from Mick Jagger to Jessye Norman, from Patti Smith to the retired piano duo Arthur Gold and Robert Fizdale. Other regulars were Jann and Jane Wenner, Ahmet and Mica Ertegun, Reinaldo and Carolina Herrera, Freddy and Isabel Eberstadt, Prince Michael and Princess Marina of Greece.

The British contingent often included the art critics John Richardson and Ian Dunlop, Lord Brooke, or "Brookie," flush with cash after selling Castle Warwick, the family home, to Madame Tussaud, and Lord Hesketh, who had started a Formula One racing team named after himself and once came to lunch with the team's pilot, James Hunt. The two Guinness sisters, Sabrina and Miranda, were my age, so I was always glad to see them. Camilla was the one who brought Cy Twombly

previous page:
clockwise from top left: A view of the island of Palmarola in the Tyrrhenian Sea; Truman Capote and Rex Harrison; Camilla on a boat near Palmarola; Truman in the harbor at Portofino

into their life. She had known him since he moved to Rome in 1957 and, in 1959, he had married Tatia Franchetti, one of her oldest friends.

There was also a smaller group Earl referred to with mock disdain as "the Italians"—these were specifically Camilla's friends, anyone from Marella Agnelli to Michelangelo Antonioni, Isabella Rossellini, Bernardo Bertolucci, and Ugo "Misha" Stille, *Corriere della Sera*'s New York Bureau Chief. When the Italians became too loud or too numerous, Earl would get impatient. "I don't speak Italian, and I don't like people who do," he proclaimed, sailing across the living room, as if he were telling the world that he didn't like broccoli.

Lunch was served buffet-style and was very casual—you had to grab a seat on the couch in a hurry or you'd be left standing with your plate and your wineglass. Camilla usually prepared a simple, practical meal: a bowl of spaghetti or a pasta *al forno*, a salad, and a wheel of Brie sprinkled with almonds and roasted in the oven. It might not seem like much today, but in the age of Ronzoni and American Parmesan it was a feast. The wine was strictly Antinori, and there was plenty of it. Camilla's niece Francesca married Piero Antinori; by the time the

food appeared, the room was already loud with lively chatter and Clarice Rivers's piercing laughter. I don't remember great political discussions or philosophical debates. The atmosphere was convivial, lighthearted, unpretentious—it was just a cool place to hang out on a Sunday afternoon.

Long after coffee was served, Camilla started gently herding the unruly band of guests to one side of the living room for a group picture. "Chins up," she always cried out, as Earl made faces to attract attention to himself and grumbled aloud about "the Nazi of the Nikon." This was not a perfunctory ritual for Camilla: it was her chance to record, in her serious, professional way, one more day in the life that she and Earl had built together, against so many odds.

The party could then disassemble. As the early-evening shadows fell on Fifty-Seventh Street, clusters of boozy revelers spilled out of apartment 4B and onto the sidewalk while, on the other side of the street, a crowd was quietly lined up in front of Carnegie Hall. Invariably, Earl scrambled out of the elevator with Jiminy, the beloved old mutt Harrison Ford had given him some years before, and headed for a walk around the block.

Camilla's group photos and portraits, neatly dated and catalogued and now housed at the New York Public Library, form an extraordinary collection documenting behind-the-scene moments in the lives of well-known artists, writers, and musicians: over one hundred albums, covering the years from 1948 to 1999, for a total of some sixty thousand photographs. From a historical point of

view, the albums covering the sixties, the seventies, and the eighties are the most valuable: Earl and Camilla lived at the center of the social and artistic scene in New York and Los Angeles at a time when American culture was at its most dominant. On a more intimate level, the pictures provide a fascinating portrait of their unusual yet strong and enduring marriage.

Anyone familiar with Camilla's background knows that her albums are, in a way, the continuation of the legendary albums assembled by her mother, the imperious Anna Laetitia Pecci-Blunt, known to her friends as Mimì. From the early 1920s onward, Mimì was the photographer in the family, the chronicler and creator of the Pecci-Blunt saga. It took Camilla's steely determination—and the vastness of an ocean—to emerge from her mother's shadow.

So it is with Mimì that we must begin.

———

The only daughter of Camillo Pecci, an impoverished count, and Silvia Bueno y Garzón, an eccentric Spanish noblewoman, Mimì grew up in a moldering little castle in the village of Ramazzano, near Perugia. The family's cachet had improved notably when Camillo's uncle Vincenzo Cardinal Pecci became Pope Leo XIII. Still, Mimì, a big girl with dark eyes and a broad smile, had no dowry to speak of; suitors fell by the wayside—a whopping seventeen "fiascos" by her own count.

Determined to make something of her life, she left Ramazzano in 1919 at the relatively old age of thirty-four and headed to Paris. Using her guile and her Vatican connections, she snatched a rich American husband. The catch was Cecil Blunt, formerly Blumenthal, vice president of F. Blumenthal & Co. and an heir to the fortune his family had built in the leather business. Mimì added her name to form the hyphenated Pecci-Blunt, then persuaded Pope Benedict XV, a successor to Leo XIII, to bestow on Cecil the title of papal count. "He's either a phony count or a phony Jew," an American diplomat famously quipped. But invitations addressed to Count and Countess Pecci-Blunt arrived soon enough, and Cecil got used to his new title.

As a gift for his bride, Cecil bought a grand eighteenth-century *hôtel particulier* built in the style of Louis XVI, at 32, rue de Babylone. He installed central heating and American-style bathrooms. Mimì hired Jean-Michel Frank to decorate the interiors and Jacques Gréber, the landscape architect, to redesign the one-acre garden. The house became a showcase for the art collection Cecil had inherited from his father: Corot, Millet, and other artists of the Barbizon school. Soon the Pecci-Blunts were adding contemporary works of their own.

Cecil and Mimì quickly made their mark in Paris society, giving lavish eight-course dinners served by waiters in livery and throwing extravagant fancy-dress balls where the so-called

gratin, the upper crust, mingled with artists like Man Ray, Picasso, and Cocteau. One ball in 1924 featured Diaghilev's Ballets Russes. Marie Laurencin drew the cover design for the program and *Vogue* published an enthusiastic report. In only five years, the former spinster from Ramazzano had come a long way!

The family, meanwhile, was growing. Cecil preferred the company of men, but Mimì managed to produce five children in rapid succession: Laetitia, Ferdinando (known as Dino), Viviana, and finally the twins, Graziella and Camilla, born in 1925.

Looking to enlarge her domain, Mimì persuaded Cecil to buy a majestic but run-down seventeenth-century estate at Marlia, a village near Lucca. Villa Reale di Marlia, a three-story country palace, had belonged to Elisa Bonaparte Baciocchi, Napoleon's sister, when she was, briefly, Princess of Lucca and Piombino. Elisa had the Italianate façade and the interiors redesigned in the neoclassical style of the period. Cecil and Mimì painstakingly refurbished the villa in the same style, and restored the adjacent seventeenth-century Bishop's House and the elegant Clock Tower. They commissioned Gréber, who had done an exquisite job at the rue de Babylone, to revive the grounds, including the open-air topiary theater, the Teatro di Verdura, where Niccolò Paganini played the violin for Elisa; the majestic waterworks, the Teatro d'Acqua; the Alhambra-inspired Spanish Garden; and the nymphaeum

with Pan's Grotto. The main addition was a dazzling art deco swimming-pool area that became the center of outdoor activities. The panels with Mimì's photo collages of guests in swimsuits, which hung on the walls of the pool house, were a favorite attraction.

Fully operative by 1926, the Villa Reale di Marlia became the setting of colorful summer house parties, eccentric balls, soirées of tableaux vivants and elaborate parlor games. Mimì was indefatigable, and there was seldom a moment's rest for the guests.

By the end of the decade, however, Mimì grew tired of the Paris–Marlia commute. She longed for her papal roots in Rome. Cecil obliged by purchasing a five-story Renaissance palazzo at the foot of the Capitoline Hill, with a grand ballroom, a loggia, and frescoes by Taddeo and Federico Zuccari.

Cecil and Mimì took leave of Parisian society with one last extravaganza: the legendary 1930 Bal Blanc, with an all-white décor by Jean-Michel Frank and lighting by Man Ray, who projected movie clips directly onto the guests, who were also in white. Ray's assistant on the project was Lee Miller, the model and photographer who became his lover. The French aristocracy *au grand complet* mixed with the likes of Jean Cocteau, Violet Trefusis, and Arthur Rubinstein. The ever-present Elsa Maxwell went to the ball as a porcelain Buddha.

After Paris, conquering Rome was a cinch for Mimì, and good relations with Mussolini's regime helped. Her literary salon at Palazzo Pecci-Blunt took

off, with young Alberto Moravia as her favorite protégé. She also opened an influential gallery, La Cometa, in via Tor de' Specchi, around the corner from the palazzo. The gallery, managed by the poet Libero De Libero, showed Mafai, Cagli, Carrà, de Chirico, Savinio, De Pisis, and Severini, among others. In 1937 Mimì took her stable of artists to New York and opened an American branch, the Cometa Art Gallery, at 10 East Fifty-Second Street. In one of her albums there is a funny photograph of de Chirico wearing a head scarf in the manner of a peasant woman; Mimì took it on the deck of the *Rex*, the legendary liner of Fascist Italy, during the crossing. Inspired by her artists, she started to paint and began to take her photography more seriously.

In the thirties, the children led a sheltered life at Palazzo Pecci-Blunt, removed from the busy world of their parents. Dino was sent to boarding school in Switzerland. Camilla, her twin sister, Graziella, and her older sister Viviana attended classes at L'Assunzione, a Catholic school for upper-class girls run by nuns. Beatrice Monti, who was a boarder at the school and later became a close friend of Camilla's, remembers the three Pecci-Blunt sisters arriving every morning in their chauffeur-driven car wearing enormous blue satin bows. "We thought they looked very funny," she recalls. "The girls used to whisper that Camilla and her sisters were Jewish and had a lot of money."

Cecil never felt particularly at home in Rome and withdrew into his own world. On a trip to London, he fell in love with Cecil Everley, a former footman who worked at Lillywhites, the sporting-goods store at Piccadilly Circus; he began to divide his time between his family and his new lover. But it wasn't easy for Everley to feel accepted in high society. Trying to be polite, he once asked Daisy Fellowes, the American heiress, if she missed her yacht, the *Sister Anne*. "And do you miss your tray?" she snapped, for everyone to hear. But Cecil stuck with Cecil, eventually leaving him half his fortune; and Mimì became, as one of her friends put it, "la Reine des Deux Cécils."

Actually, there was soon another man in Mimì's life: Pietro De Francisci, a legal scholar who had joined the Fascist Party early on and was now the minister of justice in Mussolini's government. "Cisco" became the man-about-the-house at Palazzo Pecci-Blunt in Rome and at the Villa Reale di Marlia. He often accompanied Mimì and the children on their summer vacations at the seaside or in the Dolomites while the two Cecils spent their time on the French Riviera.

Despite Mimì's connections to the Fascist regime—Mussolini's daughter Edda and her husband, Count Ciano, were personal friends—her glamorous world came abruptly to an end on November 17, 1938, when the so-called Racial Laws were promulgated to appease Adolf Hitler. Mimì believed they could tough it out—she once crudely remarked that her strong Aryan blood

had watered down Cecil's "and none of [our] children are Semites." But that was not the view of Mussolini's hacks, who started attacking Mimì and the writers and artists of her entourage in the press, forcing her to close the gallery. Count Ciano himself called to suggest the family keep a low profile and cancel Laetitia's coming-out ball.

By the spring of 1940, with Italy about to enter the war on the side of the Germans, Cecil decided it was high time to get out. In extremis he arranged passage for himself and the two youngest children, Graziella and Camilla, aboard the *George Washington*, the last ocean liner to make the crossing from Italy to America before the war. Mimì stayed on in Italy, determined to find a husband for Laetitia. Viviana also remained with her mother. Dino was already in the United States, finishing his studies at St. Paul's, an elite boarding school in Concord, New Hampshire.

Camilla's first crossing to America turned into a harrowing journey. In the Bay of Biscayne a German U-boat targeted the *Washington* and spared it only when it became apparent that it was packed with American refugees. A blurred black-and-white photo taken on board that day shows a crowd of frightened children suited up in their life jackets. In one corner, Camilla is huddling close to Graziella.

Once safely across, Cecil took the twins to California. Dino joined his father and his two young sisters before going on to Harvard. Back in Rome, in the full gloom of war, Laetitia married a young Roman prince named Alberico Boncompagni Ludovisi in a quiet ceremony at Palazzo Pecci-Blunt. It was June of 1941. Two months later Mimì and Viviana escaped by car to neutral Portugal, then flew to New York and continued by train to California to reunite with the rest of the family.

———

To her friends Camilla was always the Italian half of the McGrath couple, yet she spent most of her formative years in America. She was fourteen when she arrived in New York aboard the *Washington;* she was twenty-one when the family returned to Rome six years later. And the time she spent in America during the war went a long way in shaping her multilayered identity.

The Pecci-Blunts lived in grand style even by American standards. Cecil purchased a sprawling villa in Santa Barbara when he first arrived with the twins. A year later the family relocated to New York in an elegant town house at 9 East Eighty-Fourth Street. The ever-busy Mimì gathered around her a lively mix of artists and socialites, just as she had done in Paris and Rome. After the fall of Mussolini in 1943, she threw herself into organizing the relief effort for her war-ravaged homeland.

Camilla was enrolled at Spence, the all-girls school only seven blocks from their house. She was not a brilliant student, but she enjoyed her time there—a far cry from the dreary nuns in Rome.

Her career as a "Spence girl," however, was nearly derailed when she was caught cheating on an exam and threatened with expulsion. Mimì rushed over to plead with the headmistress and saved the day. Once home, she let loose on her daughter. "Not for cheating!" Camilla used to exclaim, feigning outrage, every time she told the story. "She scolded me for getting caught!"

The Pecci-Blunts spent their vacations at the house in Santa Barbara, but every year Mimì also organized month-long educational trips to the South, the Southwest, and the Midwest of the United States, later filling scrapbooks with snapshots and ephemera of those journeys. When Camilla and Graziella were old enough, they were allowed to travel on their own to Mexico, Central America, Peru, Bolivia, and Argentina.

At the end of the war, Dino graduated from Harvard, entered the army, and was sent to Rome as an intelligence officer. The rest of the family set sail for Europe aboard the *Queen Elizabeth* on December 14, 1946. No sooner were they at Palazzo Pecci-Blunt—the trunks not even unpacked—when Mimì whipped up an elegant Christmas dinner to serve notice that she was back. Two months later her legendary *Bal en tête* brought a fresh crop of Rome's young smart set to the palace.

She then returned to the business of marrying off her son and her daughters—with very mixed results. In 1948, Dino married Joan Russell—her sister Aimée had married Cino Corsini, one of many postwar marriages between New York so-ciety girls and young Italian aristocrats—at the Church of Saint Vincent Ferrer on Lexington Avenue and Sixty-Fifth Street. The marriage was over within days and eventually annulled on the grounds of nonconsummation. Mimì claimed it was a bigger fiasco than all of her own seventeen fiascos put together.

She had better luck with Viviana, who married Count Luciano della Porta at Marlia. During the war, the Nazis and, later, the Allied forces had taken over the villa and had left it in ruins. After three years of restoration, the estate was now back to its former splendor; Viviana and Luciano's lavish wedding marked the beginning of a new season.

Camilla and Graziella were next in line, and Mimì had a plan. She and Count Étienne de Beaumont, a close friend from her Paris days, had decided that Étienne's nephew Henri should marry one of the twins. The hapless Henri first proposed to Camilla, who turned him down—an act of independence that stunned Mimì. Henri was forced to turn to the spirited, slightly eccentric Graziella, who reluctantly agreed to marry him, only to balk at the altar in front of hundreds of guests. She fled from Marlia in her tiny Fiat Topolino and drove off into the Tuscan countryside. It took days for Mimì to find her and bring her back to the church. By then all the guests had gone and the atmosphere was glum. In the wedding photographs the few who attended the repeat ceremony look as if they were at a funeral, bride and groom included.

It was a good thing Camilla didn't marry Henri (for one, they became close friends). Rome in the late forties and early fifties was a wonderful place to be single and free. The first picture of Camilla with her Rolleiflex dangling from her neck is from 1948. She switched to a Nikon in the sixties and remained loyal to Nikon the rest of her life. She came into her own, zipping around town in *her* Fiat Topolino, taking pictures of her new young friends at lazy lunches in Roman trattorias or at picnics among the ruins in the glorious landscape of the Campagna Romana.

Camilla was not as beautiful as some of the glam girls of those years—Domietta del Drago, Marella Caracciolo, Lorian Franchetti—but she was gregarious and very *simpatica*. Her thoughtfulness and natural reserve made her popular with both women and men. She had occasional crushes—the most lasting one for the dashing Guido Brandolini. And she had one persistent suitor: George Ortiz, a small, very rich Bolivian who collected antiquities and was devoted to her. Years later, whenever she and Earl went through a rough patch, she would grumble, "I should have married Ortiz!" But she showed no real inclination to find a husband. As her friends married, she began to collect godchildren. By the late 1950s she was well into her thirties, and with no husband in sight even the indomitable Mimì was resigned.

No one expected Earl to show up.

It was Gian Carlo Menotti, the Italian-American composer, who introduced Camilla to Earl. Menotti, who lived in New York, had come up with the idea of an arts festival in the town of Spoleto, in Umbria, that would bring American musicians, actors, and dancers to Italy. Looking for patrons, he gravitated into Mimì's orbit. There is a picture of Menotti in a skimpy swimsuit sunbathing by the pool at Marlia in Mimì's photo album for 1956.

Over that summer Menotti and Camilla became friends, and they paired up at Mimì's end-of-season fancy-dress party. The theme was "Famous Children." Menotti went as a little Marcel Proust in short trousers, Camilla as a girlish Gilberte Swann.

Two years later, in 1958, the Festival of Two Worlds opened with Verdi's *Macbeth*, conducted by Thomas Schippers and directed by Luchino Visconti. Franco Zeffirelli also made his Spoleto début that year, and producer Leland Hayward presented *N.Y. Export: Op. Jazz*, the first ballet of Jerome Robbins's own company, with sets designed by Saul Steinberg. It was an impressive beginning by any standard. The little Umbrian town known for its black truffles was suddenly packed with talented artists and glamorous guests. Swept up in the excitement, Camilla clicked away with her Nikon, chronicling the two-week-long event with a reporter's eye. She had a proper job as well: director of the student program, responsible for

the dozen or so young American interns who worked on sets and costumes.

Earl, too, was in Spoleto: a handsome, clean-shaven twenty-seven-year-old in a suit and tie who had come over as Menotti's general assistant. Not entirely at ease in the cosmopolitan Old World crowd at Spoleto, Earl tended to draw attention to himself with outrageous antics. Camilla, who was six years older, saw through the histrionics and was taken by his mischievous charm. "He makes me laugh like no one else," she told her friends.

But his background could not have been more different from hers.

Earl grew up in Superior, a small town in Wisconsin, and survived a rough childhood. His father was hard on him; his mother was an alcoholic ("a wicked, wicked, wicked woman," Earl said). Later in life, he discovered that his father was not his biological father: his mother had had an affair with his uncle—which he felt went a long way in explaining why he was treated as a stranger in his own home. He left his family when he was still a teenager and never went back. He lived at the local YMCA for a while and took menial jobs while finishing school at Superior Central High. Later he enrolled at San Francisco State. To pay his way, he worked as a male model in art classes but got fired, he claimed, because he kept getting erections. In any case, he never got his degree.

Earl wanted to be a poet—he wrote verse and read widely. For a while he drifted up and down the California coast, visited Aldous Huxley in Los Angeles and Henry Miller at Big Sur. In the summers he worked on merchant ships on the Great Lakes. All his life Earl kept a faded picture of himself with a band of bare-chested fellow seamen taking a break from work. "I was so good-looking that everyone wanted to fuck me," he used to brag, looking back. That was the thing with Earl: he often alluded to his sexuality in shocking terms, but he never revealed much. As Chayt Holzer, one of Earl's godchildren, says, "He remained a very private man in his own way."

Still in his early twenties, Earl wrote a fan letter to W. H. Auden, who used to winter in New York and summer in Ischia. Big-hearted Wystan answered the call, and Earl migrated to Manhattan. They formed a close friendship. Earl met other writers and poets— W. Somerset Maugham, Jack Kerouac, and E. E. Cummings, among others— and he became a close friend of Frank O'Hara's. After a few odd jobs, he found employment as an accountant and moved into a tenement house run by a German couple on the Lower West Side. Earl's employer was old and ill and was of a mind to leave the business to him. But accounting was not for him, after all; and looking for a way out, he joined the merchant marine.

At the Seafarers International Union Hall in Brooklyn he met Richard Baker, a Harvard undergrad who went on to become a Zen master and a lifelong friend. They sailed to the Persian Gulf aboard the *Steel Voyager;* the following

year they were in South Africa, Madagascar, and Mozambique.

When Earl was not at sea he was back in New York hanging out with poets and artists in Greenwich Village. In the late fifties, he found his way into Menotti's world of dazzling musicians; he became close to Samuel Barber, Menotti's companion. Other close friends of that period were Giovanni Ricordi, of the great Italian music-

publishing house, and his young wife, Marisa; their son, Camillo, was the first of the long line of Earl's godchildren.

It was the time when everyone in Menotti's circle was getting excited about the upcoming festival in Umbria, and Earl was quick to join the effort as the United States manager in charge of fundraising and organization. And in the spring of 1958 he was off to Europe with the rest of the Spoleto crowd.

————

"Camilla wanted to get away from Roman society, so superficial and snobbish, and be herself and not Mimì's daughter," remembers Nadia Stancioff, who was in Spoleto that year as an aspiring actress. "But I never thought they would get together. They came from such different worlds." That was precisely the point, according to Gaia de Beaumont, Camilla's niece: "Earl was fun, *simpatico*, full of beans, and most importantly, he had no connection with the Pecci-Blunts." The fact that Earl spent a lot of his time with men left her unfazed: "She had a great deal of familiarity with gay and bisexual men even in her own family!" Still, according to Earl, Camilla demanded full disclosure of his sexual past before allowing him into her bedroom.

A transatlantic relationship blossomed during the next few years. Earl traveled to Spoleto in the summer, Camilla went to New York in the winter. "She felt alive with Earl," remembers Maria Teresa Train, one of Camilla's oldest New York friends. "I don't think

she was very interested in sex. But life with him was fun and exciting and she didn't want to give it up." She kept her family largely in the dark; but when rumors of her romance reached her parents, Cecil fired off a warning: he would cut off all funds if she married Earl.

Camilla went ahead anyway and on January 5, 1963, she and Earl were married at the courthouse in downtown Manhattan. She was thirty-seven, Earl was thirty-one. The witnesses were Menotti and their friend Priscilla Morgan, longtime companion of Isamu Noguchi, the artist and landscape architect. Priscilla was also working for the Spoleto Festival at the time.

Camilla sent a cable informing her parents of the *fait accompli*. The gossip sheets in Rome ran with what they called a *notizia bomba*—a bombshell. CAMILLA MARRIES AND SENDS CABLE, said one headline, which she cut out and pasted in her 1963 album. Mimì was "understandably astonished," the newspaper wrote, "since she assumed,

like most everyone else, that her only unwed daughter, coiffed as she was *à la Sainte Catherine*, was headed for spinsterhood." But then again, the newspaper noted, Camilla "had always given her mother a hard time."

Was Mimì herself the unnamed source?

Later that year Camilla and Earl traveled to Rome. Mimì had them over for a reconciliatory lunch. She asked her friend Milton Gendel, a photographer and *ARTnews* correspondent, to join them. As Milton later told it, the atmosphere was frosty and lunch was soon over. Camilla and Earl left without even broaching the subject of their marriage.

To Camilla's disappointment, the rest of the family was not much nicer. Who was this Earl McGrath from Superior, Wisconsin? This penniless jokester with no real job and uncertain prospects? "Earl didn't fit in at all in the Pecci-Blunt world," Gaia remembers. "He wasn't loved and he knew it."

Indeed, Earl felt humiliated. "He always wanted to be the favorite," Freddy Eberstadt, a photographer and friend of the McGraths, says. "So he never forgot or forgave a snub, and he certainly never forgave the Pecci-Blunt clan." Even after Mimì's death, in 1971, when Camilla's sisters wanted to be friends, "it was no dice, as far as Earl was concerned."

It pained Camilla to see her family look down on her husband; it pained her that Earl disliked her family. But she was determined to make the marriage work.

Earl was her ticket to a more unconventional life than she would otherwise have had. Although she was reserved and well-mannered, there always was a part of her that was attracted to the slightly wilder side of life, and she knew that through Earl she could have that. Earl was just as determined to see things through. In Camilla he had found a loyal partner who understood his foibles and was protective of him.

Camilla moved into Earl's small apartment on the Lower West Side. Meanwhile Earl had left his job with the Spoleto Festival and was working for Fred Coe, the producer and director. It was a steady job, but he was not earning much. Cecil, mollified by his fatherly instincts, stepped in to complement their income by giving Camilla a stipend. As for Mimì, perhaps unsurprisingly, she was the first in the family to eventually come around to her American son-in-law.

Earl and Camilla moved to a more comfortable apartment at 27 East Sixty-Second Street, which became their home for the following ten years. They tried to have children. It turned out Camilla couldn't have any. For good measure, Earl had his sperm count checked, to his satisfaction. They quickly put the issue behind them. "You have your children, I have Earl," she told her friends.

Camilla threw herself into her new life, meeting Earl's friends downtown while cultivating on her own terms the old New York connections she had inherited from her family. She took her Nikon with her wherever she went. As

Nadia Stancioff remembers, "Camilla was very reserved and rather shy by nature, but her camera gave her a feeling of security, and she used it to get closer to people. It was all done very discreetly."

The apparent casualness with which she began to chronicle their life in New York belied the growing sense of purpose behind her work, which eluded many of her friends at the time but which becomes quite evident today as one slowly turns the pages of her meticulously assembled albums.

————

Earl suddenly became interested in writing scripts and producing movies. He left Fred Coe and went to work at the New York offices of 20th Century–Fox, first in the talent department, then in story development. He didn't last long. By 1965, anxious to move back to California, he quit his job, applied for unemployment, and traveled to Los Angeles to look for opportunities. He took a room at the Chateau Marmont, rented office space on Wilshire Boulevard, and started borrowing money from Camilla "for various professional expenses and investments": so reads an agreement between them that they signed at the time.

Camilla was not thrilled by this turn of events. She liked California and had fond memories of her time there during the war. But she didn't want to give up New York, where she felt more at home than in any other place where she had lived, to start all over in Los Angeles. Earl's insistence that they move to the West Coast caused the first serious friction in their young marriage. Camilla took off to Europe and brooded about it over a very long summer. She received frantic letters from Earl. Where was she? Why wasn't she writing to him?

When Camilla returned, she set out new terms. If Earl wanted to spend most of his time in LA, so be it; she was going to stay in New York and come visit him out west. It was a risky deal, and one that would probably have undone a weaker marriage.

Earl, however, got off to a promising start. Thanks to his connections at Fox, he met people in the movie business and started working on a couple of scripts. Through Dominick Dunne and his wife, Lenny, he met Dominick's brother John Gregory and his wife, Joan Didion, who became his closest friends in LA. "The three of them—John, Joan, and Earl—were always together," says Griffin Dunne, Dominick and Lenny's son. "John and Earl's tempers could flare up, and the two often argued. Joan had a calming effect on both of them."

Griffin remembers very well his first taste of Earl's wacky humor: "He came over to the house. I must have been twelve or thirteen. I'd never seen him before and he'd just recently met my parents. Suddenly he asked my mother if she had some silverware with which to make a magic trick. My mother fetched some weighty silver that had belonged to my grandfather and we kids got

excited. Earl placed all the knives in a linen napkin and held the bundle above his head. We all thought he was going to make the knives disappear and show us an empty napkin. Instead he threw the bundle to the ground and all the knives went crashing to the floor. It was totally absurd. After a long silence, everyone burst out laughing."

Earl led a wild bachelor's life in LA when he was there on his own. Then Camilla would arrive and he would shape up. The suite at the Chateau Marmont had a large terrace where the McGraths gave Sunday brunches that were popular with their eclectic mix of new friends. The albums of those years include photographs of artists as well as movie people like Roman Polanski, Sharon Tate, and Dennis Hopper. Also included are all the Dunnes: Nick and John Gregory and their families. "Camilla was very warm and maternal with us younger ones," Griffin remembers, "always ready to corral us to some place on the terrace where she could take pictures."

Camilla took many pictures of a young Harrison Ford, who became a close friend of Earl's when he moved out to Los Angeles to act in the seventies. One day Ford brought home a stray mutt, and Mary Marquardt, his wife at the time, pointed out that the dog was pregnant. Ford said he'd had no idea; he'd just thought she had very large breasts. Earl was often at the house, and when the dog gave birth, Ford gave him one of the puppies. And

that's how Jiminy came into Earl and Camilla's life.

Earl finished two scripts during this period, "The Freeway" and "The Birdwatcher," which he tried to sell. Meanwhile his expenses were piling up, and Camilla had to put her foot down. Cecil had left her some money when he died in 1966, which her brother, Dino, now managed. I suspect Dino was behind the legal warning Camilla sent to Earl in January 1968, listing the monies loaned ($55,000) for the period 1965–68, which were—she reminded him—"payable on demand, with an interest of 5% per annum." Earl was no doubt miffed, but he agreed to the terms and countersigned the letter.

That year he sold "The Freeway" to Hall Bartlett, the Hollywood director and producer. To Camilla's relief, some money finally trickled in. Earl found a run-down commercial property at 454 North Robertson Boulevard in West Hollywood, and they decided to buy it as an investment with a notion of fixing it up as a residence. Camilla, meanwhile, continued to fly back and forth between New York and LA and to spend long summers in Italy without Earl.

Ironically, the sale of "The Freeway" marked the end of Earl's short career in the movie business. Around 1967 he started spending more time with Ahmet Ertegun, the cofounder of Atlantic Records. They knew each other from New York, and whenever Ahmet was in LA for business, he and Earl would hang

out together, listen to bands, go clubbing with writer Eve Babitz, or simply chill out at Ahmet's bungalow at the Beverly Hills Hotel. As George W. S. Trow once wrote in a *New Yorker* profile of Ahmet, Earl was the person "with whom Ahmet was best able to relax." Meanwhile, Earl was learning about the music business from the most successful producer around.

In 1970 Ahmet offered Earl the chance to run his own label within Atlantic Records. His status in town changed overnight. "Hanging around with clean-cut record biz types," one gossip sheet noted, "has had a sobering effect on Earl McGrath, writer, bon vivant and confidant to tycoons." He was now living at his place on North Robertson Boulevard, where many talented young musicians came by to play their songs for him.

The following year, Clean Records ("Everybody deserves a clean record," Earl joked) released its first album, by a five-member country-rock band called Country. Earl had a real instinct for discovering talent, and there were some good songs in the album, but he was still a relatively inexperienced producer, and after the first week Ahmet's own people at Atlantic were calling the record "a stiff."

Earl then got excited about Daryl Hall and John Oates, a young pop-rock duo from Philadelphia. But before signing them up with Clean Records, he made them play for Ahmet, and Ahmet took them away from him and signed them up with Atlantic as Daryl Hall & John Oates; their first album, *Whole Oats,* was released in 1972.

Earl's second album was *Delbert & Glen* by the country-blues duo Delbert McClinton and Glen Clark and their band. There was a bigger publicity budget this time around, and Camilla flew in from New York in October 1972 for the launch party at Big Al's. The band gave a live performance; strippers pranced about the stage. Cat Stevens, John Mayall, and other big-name musicians came to lend their support. So did Jack Nicholson. Bob Rauschenberg, who was passing through town, was also there, as well as Earl's close friends Larry Rivers, Ron Cooper, and John Gregory Dunne and Joan Didion. A few weeks later there was a second launch party in New York, at Max's Kansas City, with Atlantic Records' top brass and a crowd of uptown socialites in attendance.

Delbert & Glen did only marginally better than the first album (one song, "I Received a Letter," made it into the Top 100), but Clean Records was not making any money, and by the end of 1973, after a third unsuccessful release, the label folded.

Still, Ahmet wasn't about to cut Earl. He was very fond of him and liked to have him in his entourage. So he asked him to come back to New York and work directly under him at Atlantic Records, looking for and developing new talent. That was something Earl was good at, and his career in the music

business gained traction. Camilla was happy to have him back in New York, with a job he liked and a check at the end of the month. In 1974, they moved to their two-bedroom apartment on Fifty-Seventh Street facing Carnegie Hall, where they finally had some wall space for their growing art collection.

The big change came in 1977. With Ahmet's backing, Earl took over from Marshall Chess as president of Rolling Stones Records, which was distributed by Atlantic Records in the United States. During his four-year tenure, the Stones released *Some Girls* in 1978—the album includes "When the Whip Comes Down," one of Camilla's favorites—and *Emotional Rescue* in 1980. Earl was also instrumental in signing up Peter Tosh, the Jamaican musician who had been a founding member of the Wailers along with Bob Marley and Bunny Wailer. Jagger and Richards were deeply into reggae music, and Earl later said that bringing Tosh in helped keep the Stones together at a time of great tension in the band.

Earl and Camilla's social life took on a dizzying pace. Uptown, downtown, they were on everyone's A-list. There were private jets to Europe and the Caribbean, with vacations on Mustique and Barbados. In the tabloids, they became known as "the Countess and the Disc Jockey."

Still, they remained safely moored at Fifty-Seventh Street. Their apartment became a haven for celebrities, perhaps because it was so relaxed and casual. After a Rolling Stones concert at Madison Square Garden, Diana Vreeland, Lee Radziwill, Andy Warhol, Faye Dunaway, and others came over to Earl and Camilla's for an after party. Most of the guests left before dawn, and Jagger, Richards, Ron Wood, John Phillips, and Eric Clapton started a jam session in the master bedroom. Annie Leibovitz, the official photographer of the tour, probably took pictures as did Camilla, and her photographs are here, including when she handed her camera to someone to take a photograph of her and Earl in the kitchen. Camilla would hand over her camera from time to time so she could be in a shot.

There was a suggestion of Mimì in the world Earl and Camilla created around them, the difference being that Mimì was the sun around which everyone else revolved, while Earl and Camilla worked as a team. Earl was a very warm and well-practiced host; he brought life and energy and humor to their parties, and always made sure the level of inebriation in the room remained constant, filling glasses with Antinori and passing out joints. Camilla, more self-effacing, moved quietly about when she was not in the kitchen, happy to let Earl have the stage. She took pleasure in his antics, his effrontery, his wicked humor, and was always the first to laugh at his jokes. For me, one of the best things

about going to Earl and Camilla's was the chance to meet people of different generations, including the sons and daughters of their famous friends. Perhaps because they did not have children of their own, they had a gift for creating a family atmosphere around them.

"The kids and the stars were treated the same way," according to Griffin Dunne, who was trying to make it as an actor in New York in the seventies. "I'd drop by after my shift at Beefsteak Charlie's and finish the day eating a plate of leftover pasta with Mick Jagger."

———

Once everyone was properly fed, Camilla would start working the room discreetly with her camera, nudging this or that guest in the direction of a window. "'Come here—no, over there,' she would say, always looking for the best light," Beatrice Monti remembers affectionately. "She was able to capture something of each one of us even in the middle of a party."

Camilla was technically an amateur in the sense that she didn't sell her pictures or work on commission. Nor did she show them as works of art, but she was a professional in every other way, and worked with diligence and method. She was not interested in landscapes. When she moved to New York in 1963 she did some reportage and photographed street scenes, but from the start she was more interested in portraits of people in their social setting, preferably three-quarter profiles. She mainly worked with black-and-white film, and natural light was essential to her. "Over the years she developed her own very recognizable style, using chiaroscuro to reveal a more intimate side of her subjects," says Pietro Cicognani.

For a long time Camilla kept a proper darkroom in their New York apartment. Later, she had her photographs developed professionally. She always kept a lab at Marlia, in the children's wing of the villa, and every summer she worked on her photographs and catalogued them and collected names and dates and assembled her albums. She made the bindings herself, having learned the craft in a course she took after moving to New York.

———

In November 1981 Ahmet and Mica Ertegun threw a big dinner party for Earl's fiftieth birthday at Trax, a cozy uptown club that the music industry often used to showcase rock bands. Earl had resigned from his position at Rolling Stones Records the year before—Tosh was not getting along with the Stones, and Jagger wanted to go solo. After a decade in the music business, Earl was moving away from that world, and the evening at Trax had a goodbye-to-all-that feel to it. Still, it was a star-studded affair by any measure,

with John Belushi giving a very funny speech about Earl, and everyone singing a Christopher Sykes song along the lines of "Earl may be fifty / But he's still pretty nifty."

The seventies were definitely over.

——————

For a while Earl was restless in New York, not knowing what his next step should be and not wanting to become dependent on Camilla again. Freddy Eberstadt tells a funny story from that time that somehow captures Earl's state of mind. They were at an elegant dinner uptown, and Earl was getting bored and decided to make a little mischief. He picked up a miniature marble elephant from a table, then went to introduce himself to a perfect stranger and told her he'd just bought the elephant as a present for Camilla, and could she keep it in her purse until later? "And the lady, of course, said yes," says Eberstadt, who watched the scene in disbelief. "Then he went over to the hostess, pointed at the lady, and said she had just put the elephant in her bag. 'Oh my god, what do we do?' asked the hostess. Earl said she should leave it to him. Then he went back to the lady, told her he wanted the elephant back, and later placed it on the table where it had been before, with a wink and a nod to the hostess on the other side of the room."

Earl soon rebounded, and went through yet another metamorphosis. He had many friends in the art world: Larry Rivers, Ed Ruscha, Jasper Johns, Robert Rauschenberg, Bruce Nauman, Robert Graham, and Cy Twombly. In the seventies Earl had grown especially close to Brice Marden. "Whenever I had some deep question, I always wanted to consult Earl," Brice remembers. "He had a kind of natural wisdom, and it was reassuring to hear what he had to say."

Earl liked the company of artists, and he liked the idea of opening a gallery to show the work of established names as well as new talents. He was feeling the pull of Los Angeles again, and there was money enough now to renovate the house at 454 North Robertson Boulevard. Arata Isozaki, the Japanese architect, was supervising the construction of the new Museum of Contemporary Art (MOCA) in Los Angeles and often stayed at Earl and Camilla's. In exchange for the hospitality, he redesigned the house, creating a gallery space on the ground floor and a small apartment on the first floor. The terraced patio had a large orange tree, bamboo and hibiscus enclosed by tall walls painted a very pale green, with a lavender entrance gate. It became a perfect space for lunches and dinners as it was airy, open, and filled with light.

Although a bit wary, Camilla agreed to become a silent partner in the new gallery. Earl had mellowed compared with his earlier, wilder days in Los Angeles, but he still loved to give parties and bring people together, and the gallery quickly became popular.

"There was a really nice vibe," says Charles Evans Jr., the film producer and documentary maker who showed a series of his photographs, *The Sex Life of the Manikins*, at 454 North Robertson. "It was always festive, and Earl took a lot of pleasure in connecting people." Among them were his old pal Robert Graham and Anjelica Huston, who fell in love and got married.

Earl and Camilla were back to their transcontinental relationship, with Earl spending more time in LA and Camilla more in New York and Europe. "I guess that's partly what made their marriage work, all that separate time," says Gwynne Rivers, Larry and Clarice's daughter, who worked at the gallery one summer. "When Camilla came to LA, Earl would get a little cranky at first, but he was happy she was there. Although they entertained more when she was in town, Earl gave a lot of parties on his own as well. His specialty was 'Earl's carbonara.' It was very good, but he never made it if Camilla was around."

Running the LA gallery was easy; the overhead was low, as there was no rent to pay. It was enough to sell a few paintings to cover the parties and stay afloat.

———

At the time, much of Camilla's energy was focused on the estate at Marlia, which was run jointly by the Pecci-Blunt siblings; but Camilla's twin sister, Graziella, had died in 1984, and the property was becoming something of a financial burden. Earl rarely went over, and when he did, he never stayed long. He felt caged and complained that Camilla's sisters only talked about the servants. At night the estate was locked up but Earl would try to find a way out to get to the village. Camilla had to scold him several times. "I think in the end she arranged for him to have a set of keys," Gaia de Beaumont remembers.

In the summer of 1988, Earl and Camilla threw a big party at Marlia for their twenty-fifth wedding anniversary. Given Earl's dislike for the place, his consent to the venue had to be seen as an act of true love toward Camilla. It turned out to be a memorable night, filled with music and dancing, and even some merry cavorting among the not-so-young in the topiary bushes. Many of Earl's close friends flew in from New York and LA, and for one night he was happy to be, if not the King of Marlia, at least the Prince Consort.

———

Back in LA, the gallery was not losing money, but it wasn't making much, either. The art world was centered in New York, and if Earl wanted to be a player, that was where he needed to be. But instead of closing the gallery in LA, he opened a second one in New York. Now the stakes were higher, and so

were the expenses. Despite her reservations, Camilla agreed to back Earl, feeling it would be easier for her to keep an eye on things.

The Earl McGrath Gallery, at 20 West Fifty-Seventh, designed by Pietro Cicognani, opened in 1995 and was just down the street from their apartment. It had a good ten-year run. Earl showed the work of established artists—Brice Marden, Jasper Johns, Bruce Nauman, Robert Graham—to finance shows of younger artists like Mark Ryden, Eric White, Tobias Keene, Vincenzo Amato, and Alessandro Twombly. "I never had the impression that he was in it to make money," says Joshua Dov Levy, the young director of the gallery. "He just liked to be around artists, and to give them an opportunity to show their work." From the start, Camilla played a greater role in the New York gallery than in the one in LA. According to Joshua, whenever Earl's expenses got

out of hand, "she would put on a face and reel him in." After a prohibitive rent hike in 2005, Camilla decided it was time to close the gallery.

A series of small strokes had slowed her down considerably. She no longer had the energy to put together her albums—the collection stops in 1999. The burden of Marlia, furthermore, continued to weigh on her; Dino, the head of the family, had died in 1997. She and Earl fussed over financial matters. He became cantankerous and often complained about her; she became increasingly impatient. "Yet it was in those later years that I realized how really close they were," says Joshua, who continued to work for Earl and Camilla as an assistant after the gallery closed. "Camilla felt she was going to die and she was thinking about Earl and telling me, 'Joshua, you are going to have to do this for him, and that . . .'"

———

Clarice Rivers once asked Camilla point-blank why she stayed with Earl. "She looked at me and said, 'Because I love him.' And that was that." Earl would probably have answered the same way. Reinaldo Herrera tells a touching anecdote about Earl and Camilla from their waning days. It was raining and he and Carolina had arrived by car at the Knickerbocker Club for a party. In front of them was a cab. Earl stepped out from the right side and rushed up the steps; Camilla got out from the

left hand side and walked behind the cab just as it lurched backwards and knocked her to the ground. "I never saw such a look of terror as the one I saw that moment in Earl's face," Reinaldo remembers. "He was paralyzed. Carolina ran out of our car and threw her coat over Camilla, who was lying on the ground. Eventually she was taken to the hospital but Earl was completely useless. That day I realized that Camilla was all his life."

Camilla died in 2007 from compli-

cations after a stroke. Beating all odds, their unusual marriage had lasted well over four decades. She left everything she owned to Earl, including—the ironic twist—her share of the estate at Marlia. To his friends, Earl seemed a lost person without her. "He was never really the same," says Joshua, who grew even closer to Earl—as Camilla had wanted.

Earl finally closed the LA gallery in 2008. Now that he had some money, he decided to reopen the gallery in New York, in a new space diagonally across from the apartment on Fifty-Seventh Street. But his heart wasn't in it, and he closed it in 2011. He died five years later, also after a stroke.

Before Earl died, Charles Evans Jr. went to see him at the New York apartment. They started talking about Camilla, and Earl pulled out one of the two fat index volumes that came with the album collection she had left him. Sitting at the round dining table, Earl started turning the pages of the index, occasionally reading a name or two out loud, marveling at the accuracy of Camilla's documentation. Charles turned his camera on. It's a rough, five-minute clip. "...Jagger...Javits...Johns...There are a lot of famous people in here," Earl says, lost in a reverie. "She started doing this in 1948..."

It is a touching scene. Although Earl sometimes disparaged Camilla's work in public—"the Nikon Nazi!"—he knew all along the value of what she was slowly putting together. Now that her entire collection was in his hands, he seemed at once confused and terribly proud.

———

When Knopf asked me to write an essay for a book of Camilla's photographs, I decided to begin my research by going over Mimi's albums, which are in the care of Sabina Bernard, Camilla's grandniece, in Rome. We looked at the pictures together for several days. In the evening, Sabina sometimes opened a bottle of wine and asked me questions about her great-aunt; she in turn shared her own memories. She told me the last time she saw Camilla was at Marlia. It was late summer and it was mostly family and a guest or two, and no Earl. A game of charades was on, and when it was her turn, Camilla got up and the-atrically trudged across the room pretending to flagellate herself. "Our small party looked very puzzled," Sabina told me. "'Oh, come on!' Camilla laughed, 'I *grrruuuh* up on that song!' Nobody guessed. Nobody even came close."

It was her impersonation of "When the Whip Comes Down," the Rolling Stones song she loved. And as Sabina finished her story, it suddenly occurred to me that Camilla, that evening in Marlia, with Earl back in New York, was not just playing charades but paying tribute in her own private way to her husband and the good times they had together.

Birreria
'L Caval d' bron's
Torino

MARK

Greek Gold Wine
ARCADIA

ANDREW P. CAMBAS Co Ltd
ATHENS - GREECE

VILLA AGNELLI

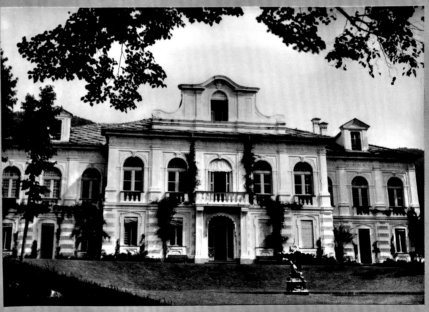

GIANNI E MARELLA AGNELLI

Before Earl

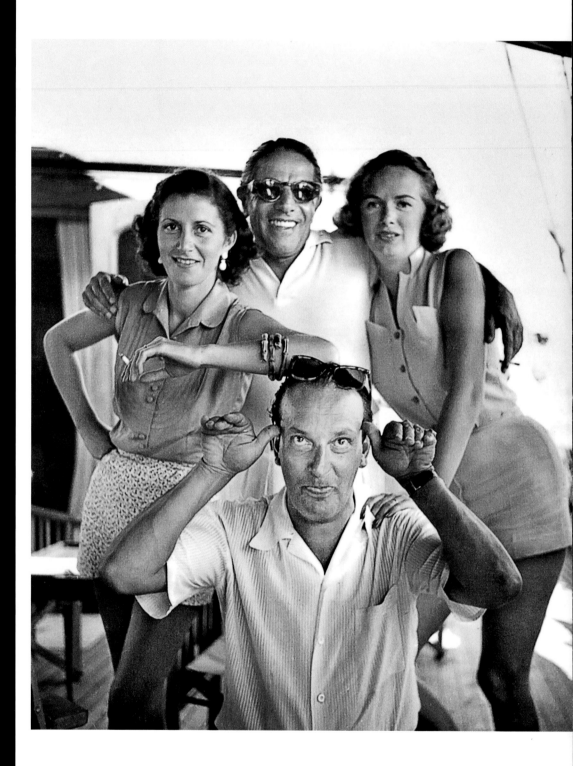

efore Camilla Pecci-Blunt met Earl McGrath in Spoleto in 1958, she was traveling all over Europe, often to well-known watering holes, in the company of family and friends.

Summer 1953: lunch on Stavros Niarchos's boat the *Creole*

opposite: *left to right,* Eugenia Niarchos, Aristotle Onassis, Dara Emmanuel, and Georges Emmanuel

below: *left to right,* Gianni Agnelli, Umberto Agnelli, Carlino di Robilant

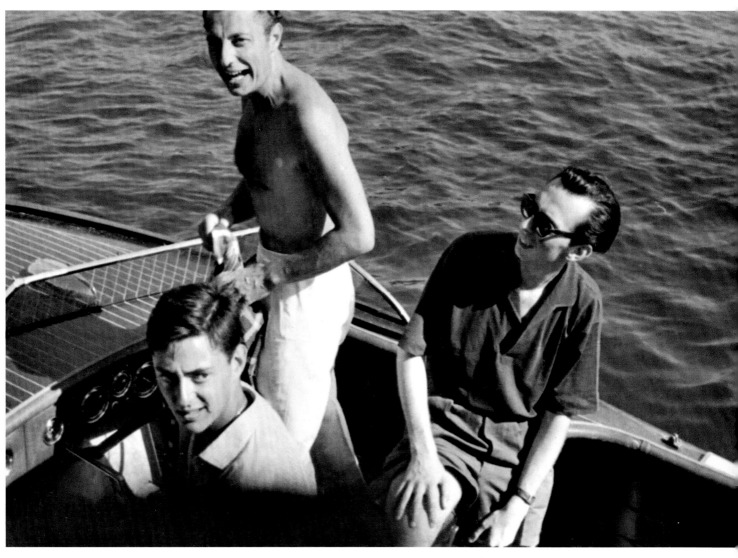

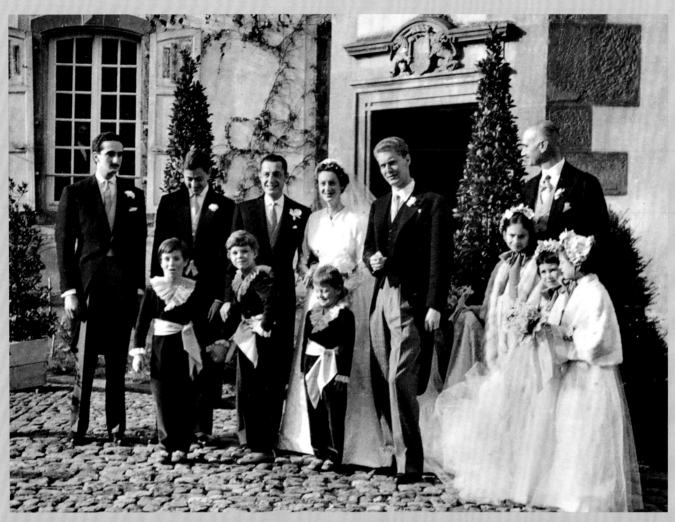

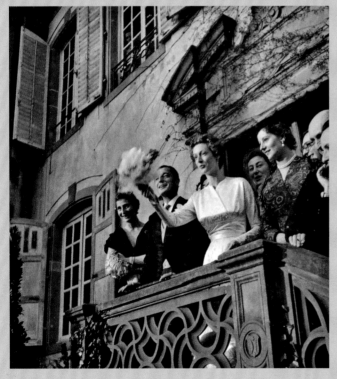

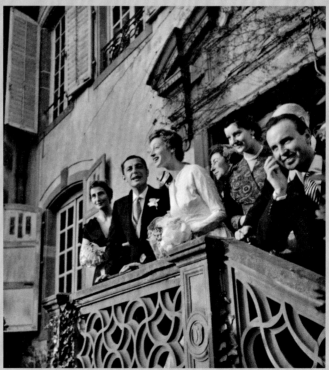

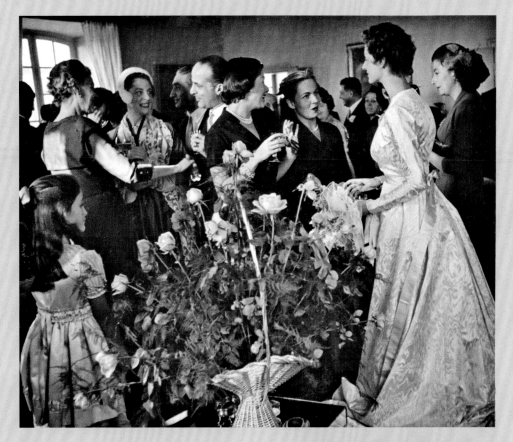

The wedding of Donna Marella Caracciolo di Castagneto and Gianni Agnelli took place at the chapel of Osthoffen Castle, outside of Strasbourg, in November 1953. Camilla attended and took the pictures in front of the castle.

opposite, top: *left to right*, Giorgio Agnelli, Umberto Agnelli, Gianni Agnelli, Marella, Carlo Caracciolo, and Adolfo Caracciolo di Melito

opposite, below: The throwing of the bouquet from the balcony: *left to right*, Susanna "Suni" Agnelli Rattazzi, who in 1976 was elected to the Italian Parliament and in 1995 became Italy's first female minister of foreign affairs; the newlyweds; another Agnelli sister, Maria Sole Campello; Renata Cittadini; and Urbano Rattazzi

this page, above: The bride in white satin Balenciaga wedding dress talking to Camilla. On Agnelli's right, Maria Sole Campello

this page, left: Leaving the castle

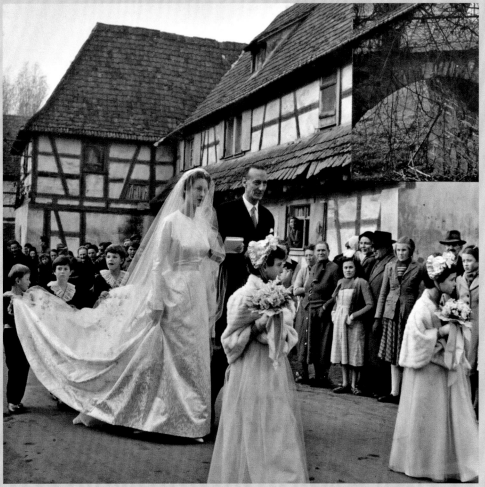

In March 1955, Gianni and Marella Agnelli invited sixty of their friends from Rome, Paris, London, and New York to stay at the Hotel Principi di Piemonte in Sestriere, the Italian ski resort near Turin founded in 1931 by Edoardo Agnelli.

bottom left: Bessie de Cuevas, Marella Agnelli, Maria Sole, Cristiana Brandolini

bottom right: Camilla's brother, Dino, with Gianni Agnelli

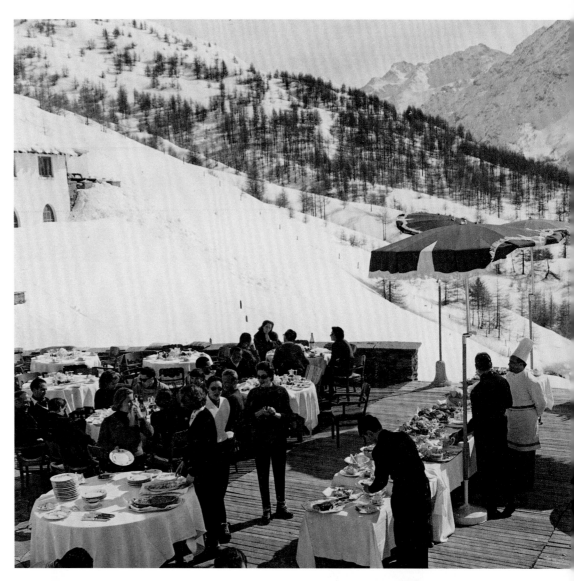

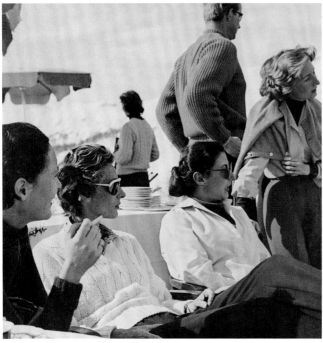

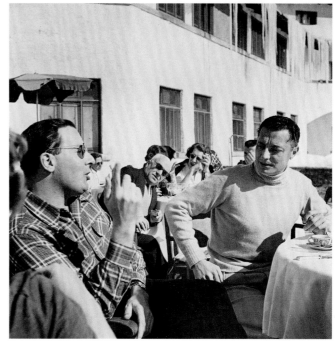

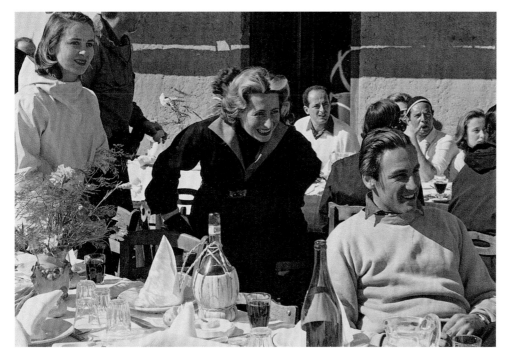

left: Muriel Zervudachi, Cristiana Brandolini, and David Somerset

below: Lunch on the deck: *back row, left to right in profile,* Stephan Viasto; *facing,* Muriel Zervudachi, Nicky Pignatelli, Marella Agnelli, Luciana Pignatelli, Tonino Grassi, Maria Grazia Gawronska, Sandy Bertrand, Moreschina Arrivabene; *front row, from left to right,* Peter Zervudachi, Rudi Crespi, Ghislaine van der Burch, and Consuelo Crespi

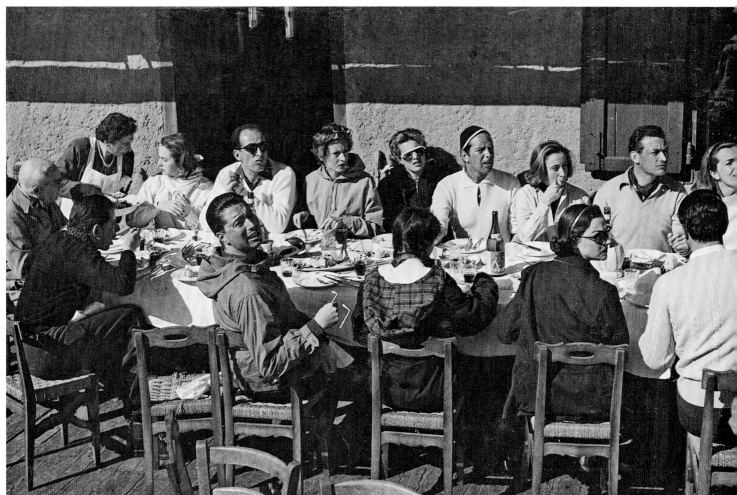

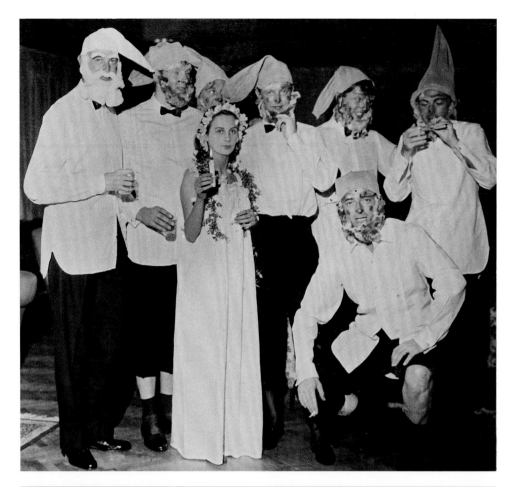

top: Evening entertainment—
Snow White and the Seven
Dwarfs: *clockwise,* Adolfo
Caracciolo; Charles and Michel
de Ganay; Marella Agnelli's older
brother, Carlo Caracciolo, who
set up the N.E.R. publishing
house and founded the
magazine *L'Espresso* and the
newspaper *La Repubblica*; Carlo
di Robilant; Brando Brandolini;
Nicky Pignatelli; and
Muriel Zervudachi

below: Camilla and Marella
Agnelli on the slopes

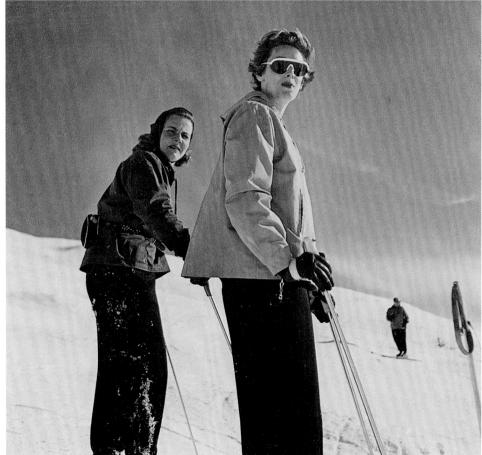

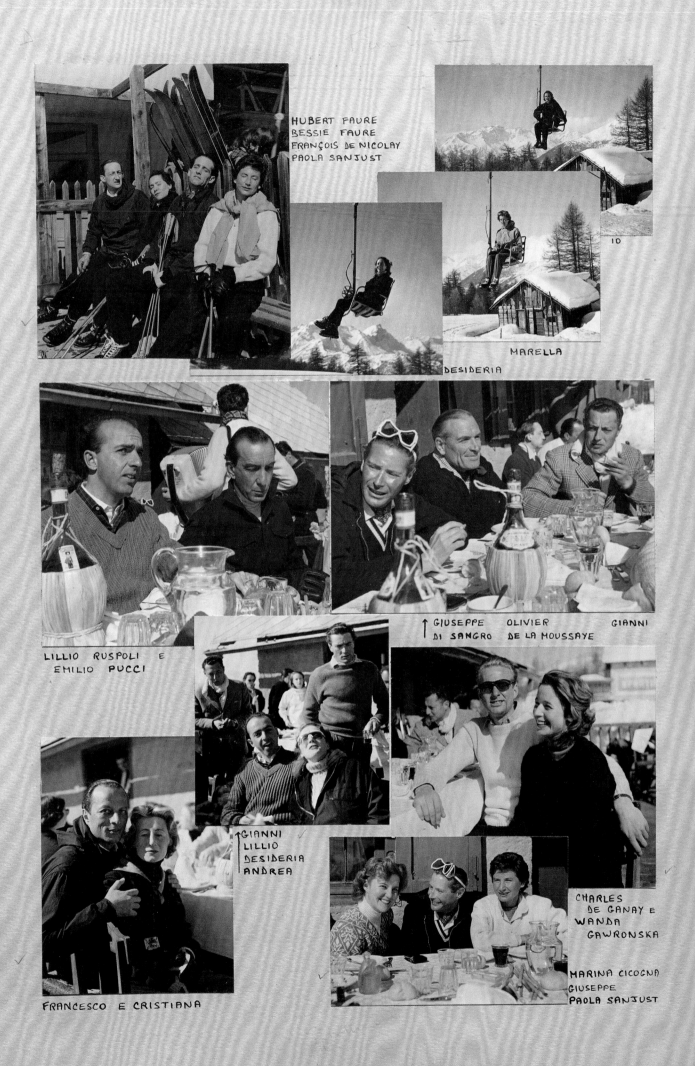

HUBERT FAURE
BESSIE FAURE
FRANÇOIS DE NICOLAY
PAOLA SANJUST

10

MARELLA

DESIDERIA

LILLIO RUSPOLI E
EMILIO PUCCI

↑ GIUSEPPE OLIVIER GIANNI
DI SANGRO DE LA MOUSSAYE

↑GIANNI
LILLIO
DESIDERIA
ANDREA

CHARLES
DE GANAY E
WANDA
GAWRONSKA

MARINA CICOGNA
GIUSEPPE
PAOLA SANJUST

FRANCESCO E CRISTIANA

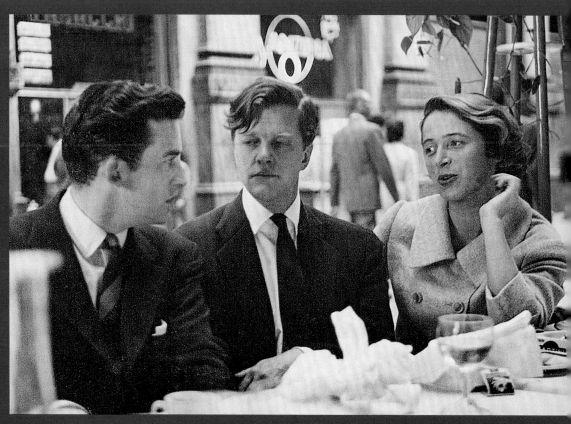

Lunch in the Galleria in Milan, May 1955

top: *left to right*, celebrated American conductor Thomas Schippers; Chandler Cowles, a Broadway producer and a great friend of George Balanchine's; and Wanda Gawronska, who would carry on the missionary work of her uncle Pier Giorgio Frassati

below, left: Gian Carlo Menotti and Camilla's sister Laetitia

below, right: Tommy Schippers

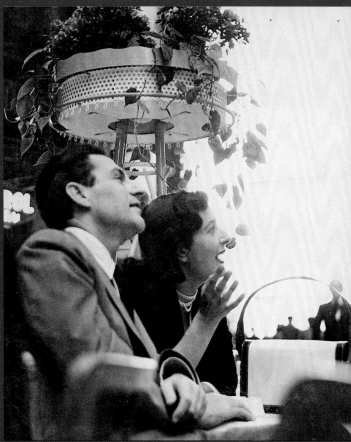

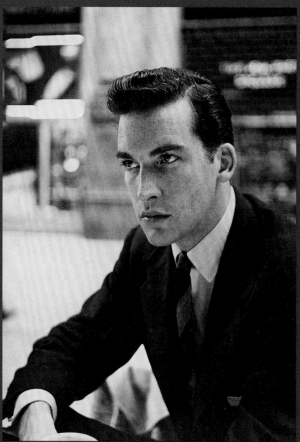

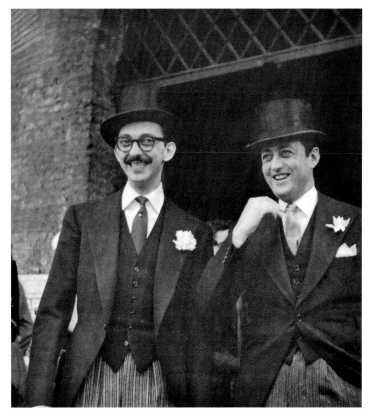

At the Rome wedding of family friend Alvise di Robilant to American Elizabeth Stokes at the eleventh-century Santa Maria in Cosmedin in Rome, with the famous Bocca della Verità on its north side, April 30, 1956

top: Two ushers, Carlino di Robilant, brother of the groom, and Guido Brandolini; Camilla was rumored to have had a crush on Brandolini.

below: The bride and groom

Venice, 1956: Elsa Maxwell's
dinner for the Benedetto
Marcello Conservatory of
Music, August 27

above: *left to right*, Charles
Bestequi, Clare Boothe Luce,
Guido Brandolini D'Assa, Mrs.
Charles Wrightsman, Elsa
Maxwell. Camilla attended this
but did not take the pictures.

below: Camilla's mother
flanked by, *left*, Serge Lifar,
the celebrated dancer and
choreographer, and *right*,
pianist Arthur Rubinstein

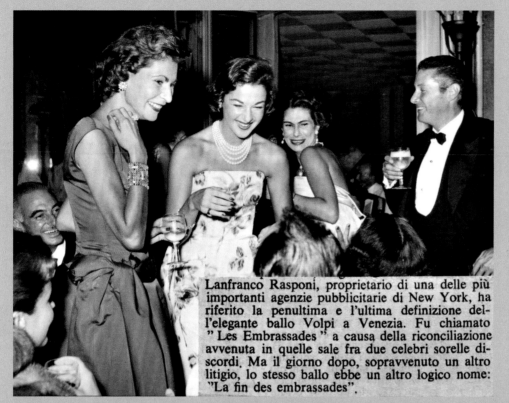

Lanfranco Rasponi, proprietario di una delle più importanti agenzie pubblicitarie di New York, ha riferito la penultima e l'ultima definizione dell'elegante ballo Volpi a Venezia. Fu chiamato "Les Embrassades" a causa della riconciliazione avvenuta in quelle sale fra due celebri sorelle discordi. Ma il giorno dopo, sopravvenuto un altro litigio, lo stesso ballo ebbe un altro logico nome: "La fin des embrassades".

top: *left to right*, Mita Corti, Consuela Crespi, designer Simonetta Visconti, and Lanfranco Rasponi, a New York publicist for many opera singers and two New York restaurants (The Colony and Quo Vadis), who brought about a reconciliation between the two sisters Mita and Simonetta, at his Volpi ball in Venice

bottom, left: Giuseppe di Sangro with Ivy Nicholson, model and actress, who years later would appear in Warhol screen tests and films

bottom, right: Jacqueline de Ribes

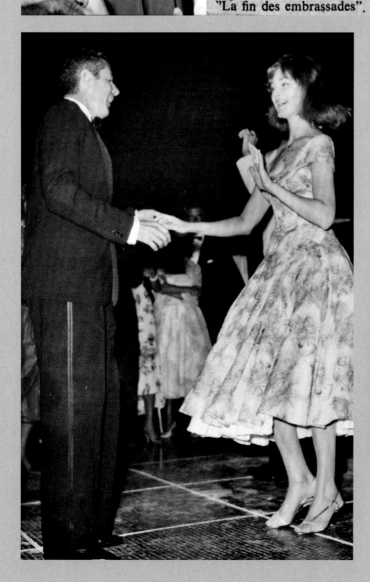

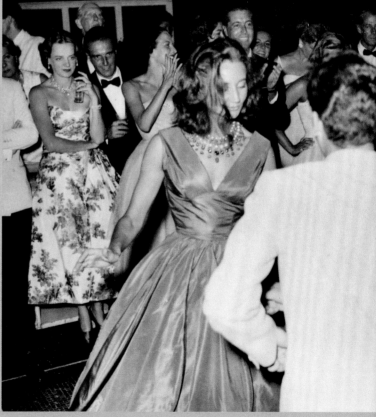

Visiting the Agnellis' Villa La Leopolda in Villefranche-sur-Mer, July 13, 1957

top, right: On the terrace: *left to right,* Benno Graziani, Carlo Caracciolo, Marella Agnelli, and Carlo di Robilant

below: Poolside: Carlo Caracciolo, Floriana Solaroli, Marella Agnelli, and Gianni Agnelli

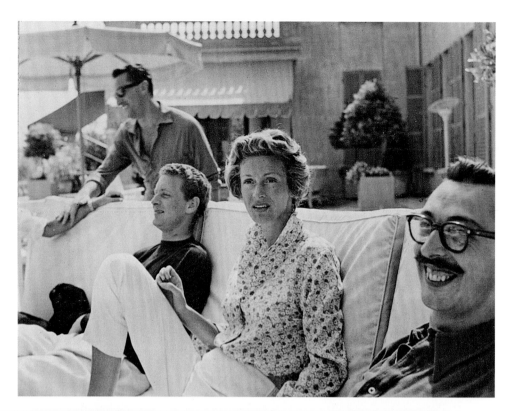

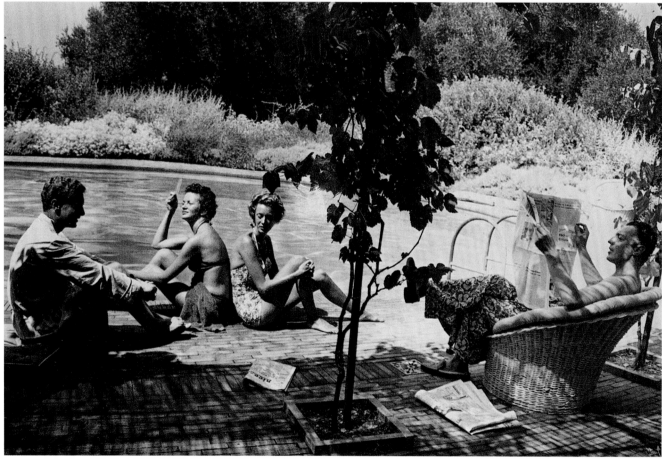

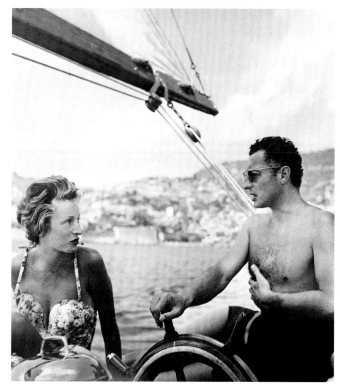

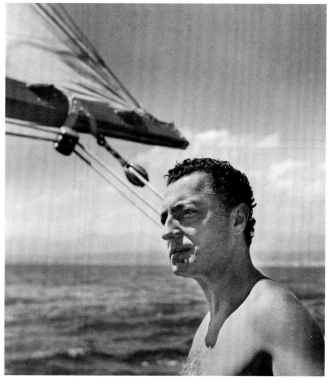

Sailing in the South of France, July 1957

top, left: Marella and Gianni Agnelli

top, right: Gianni Agnelli

below: *left to right*, Gianni Agnelli, Marella, Benno Grazioni, and Wanda Gawronska

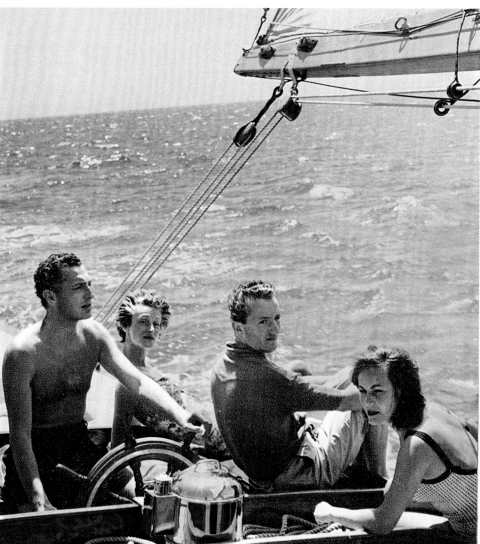

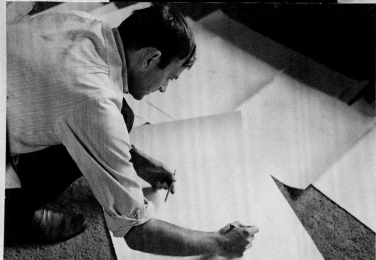

CY TWOMBLY

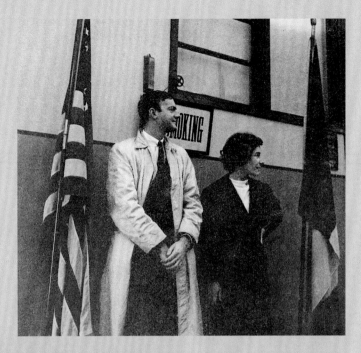

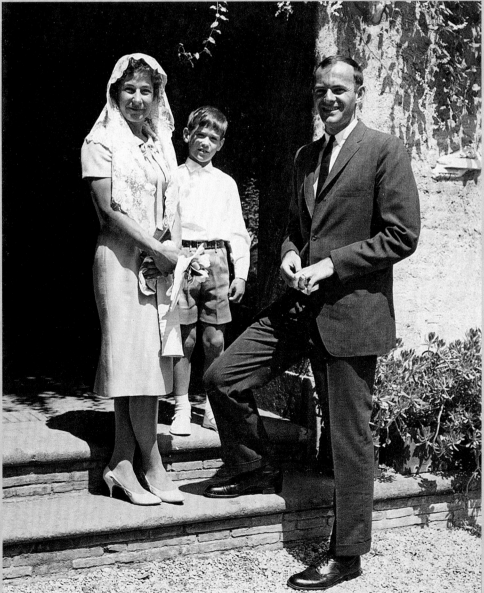

opposite: Cy Twombly at work in New York, April 1959

above: Cy Twombly and Tatia Franchetti about to get married, City Hall, April 20, 1959

left: Their church ceremony in Rome in July 1959, with Stefano Franchetti

**Visiting the racing-car driver
Francesco Santovetti in
Grottaferrata, ten miles
southwest of Rome, 1960**

top, left: Twombly

top, right: Alvise di Robilant
and Tatia Twombly

right: Betty di Robilant

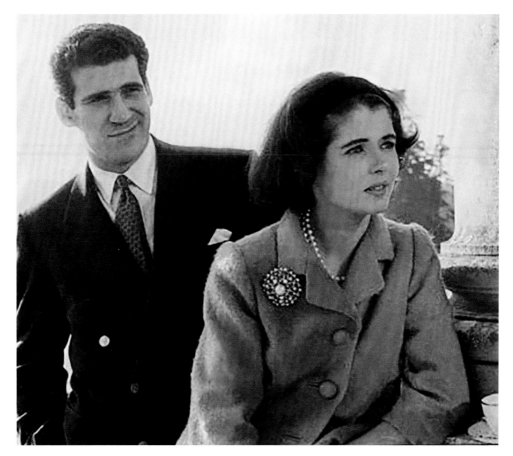

November 9, 1961, at Ferrières, the nineteenth-century château designed by Sir Joseph Paxton for Mayer Amschel de Rothschild. Guy and Marie-Hélène de Rothschild were the last family members to live there.

left: Teddy and Gabrielle van Zuylen; Marie-Hélène de Rothschild was his sister. Gabrielle von Zuylen was a landscape architect and writer.

below: *left to right,* Samir Mansour, Marie-Hélène de Rothschild, Gabrielle van Zuylen, writer Irwin Shaw, and playwright, novelist, and screenwriter Harry Kurnitz

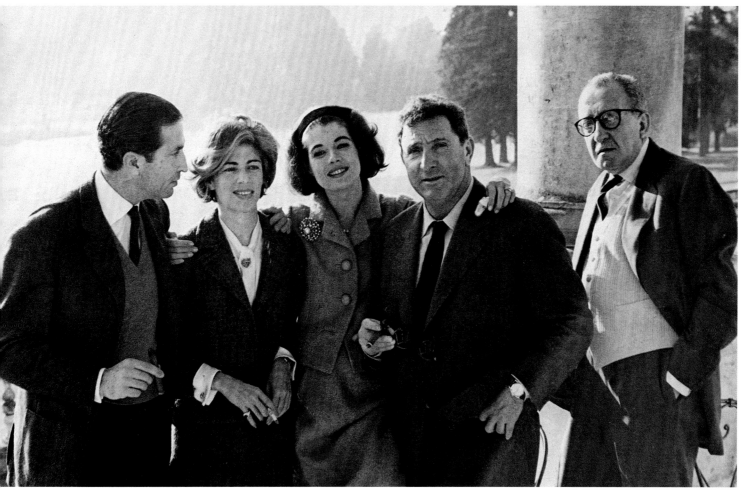

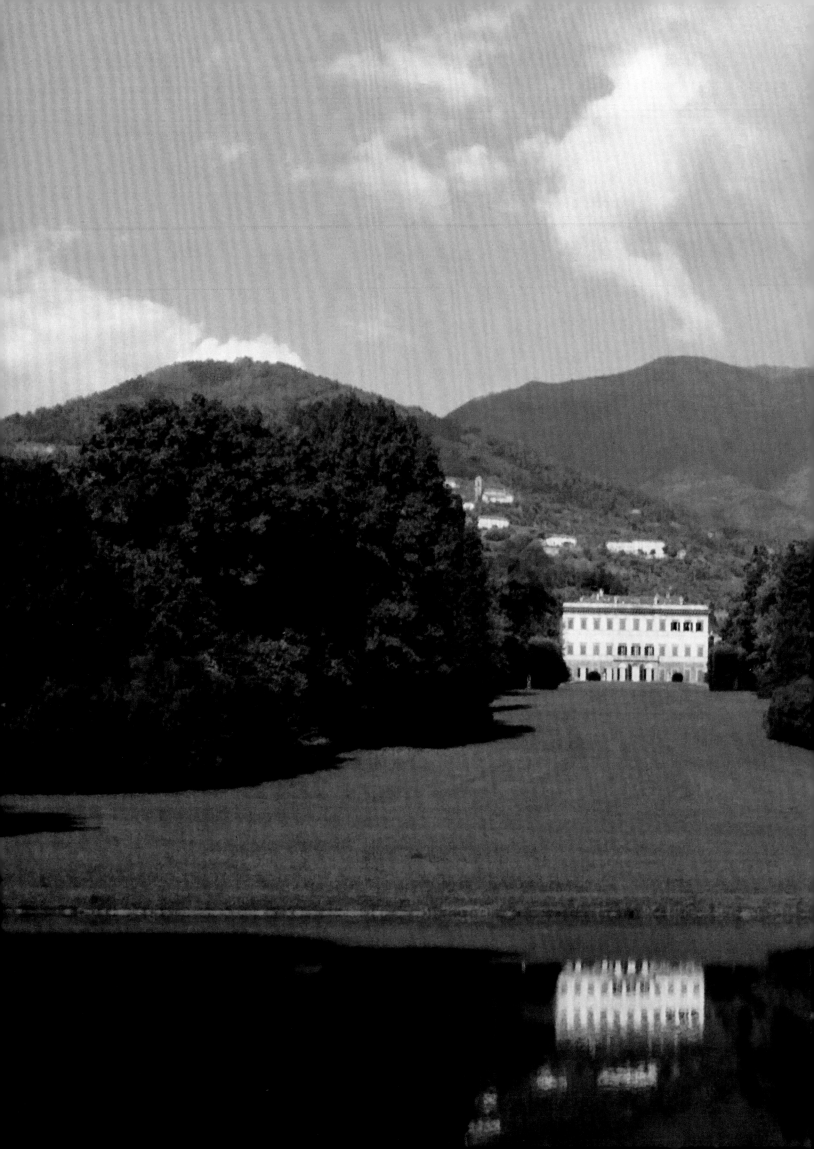

Marlia

Built in the seventeenth century, the Villa Reale di Marlia, near Lucca, was home in the nineteenth to Napoleon's sister Elisa Baciocchi, who had been made Princess of Lucca and Piombino and Grand Duchess of Tuscany, and later to other royals, until it was bought by Camilla's father in 1923.

Camilla was often at Marlia in the summer and fall, and the photographs are a mix of her family and their friends and hers, and then, after her mother's death in 1971, Camilla's and Earl's.

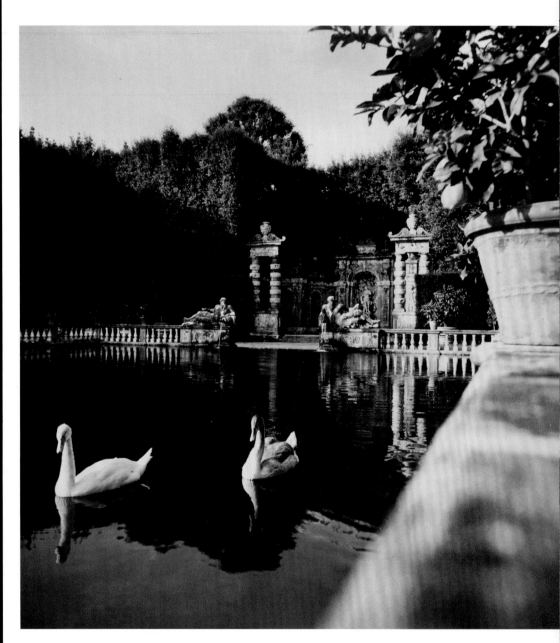

Henry Clarke's photograph of potted lemon trees around the reflecting pool and, beyond, a sixteenth-century nymphaeum with figures of the Arno and Serchio Rivers.

overleaf: One of Camilla's pictures of the back of Villa Reale di Marlia, looking across the pond

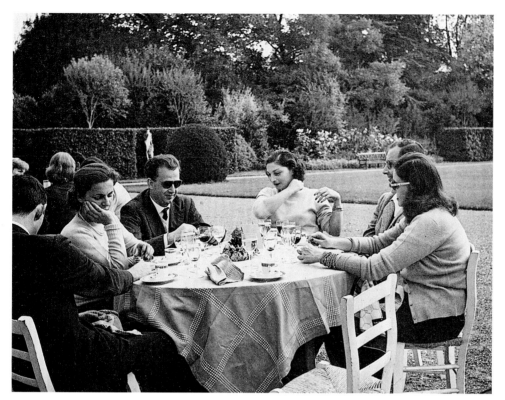

**Lunch in the garden,
November 2, 1957**

top: *left to right,* Cy Twombly,
Camilla, Giovanni Lancellotti,
Laura Mansi, Dino, and
Annadora Grabau

below: *left to right,* Alvise di
Robilant, Dino, Leo Salom,
Betty di Robilant, and Camilla

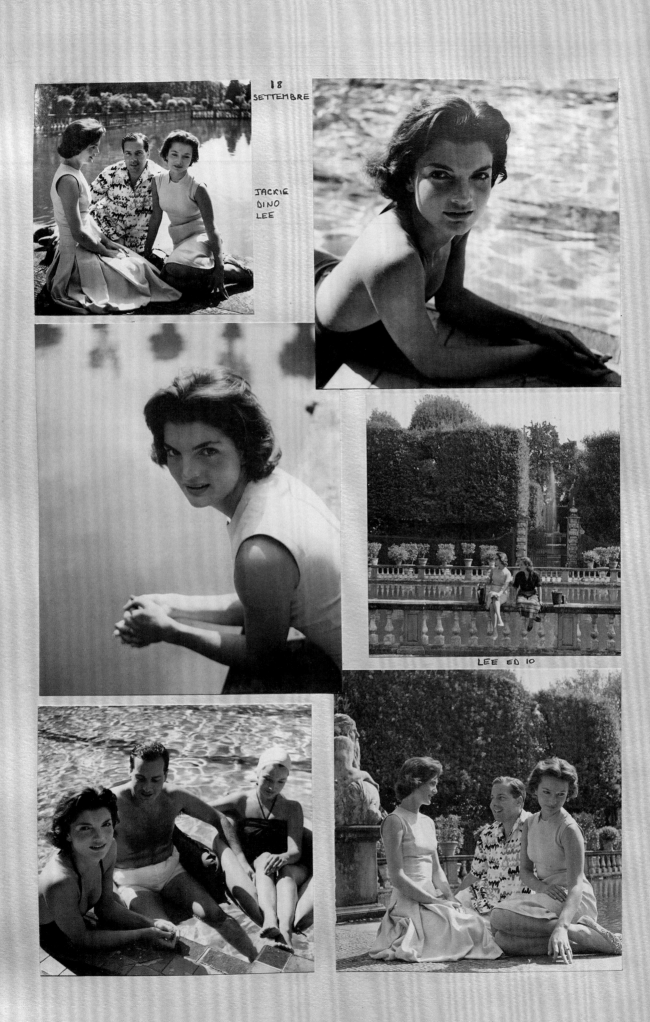

18
SETTEMBRE

JACKIE
DINO
LEE

LEE ED 10

On September 18, 1955, Jacqueline
Kennedy and Lee Canfield visited Marlia
and posed at the pool and in the gardens
with Dino.

LEE CANFIELD →

One of the many themed costume balls Camilla's mother was fond of at Marlia: "King and Queen," 1957

right: Camilla's father, Cecil Pecci-Blunt, was Philip II of Spain.

below, left: Judy Gendel, wife of art critic and photographer, Milton Gendel, was Henry III of France, and jeweler Fulco di Verdura was Catherine de' Medici.

below, right: Mimì Pecci-Blunt, Camilla's mother, was Queen of the Night.

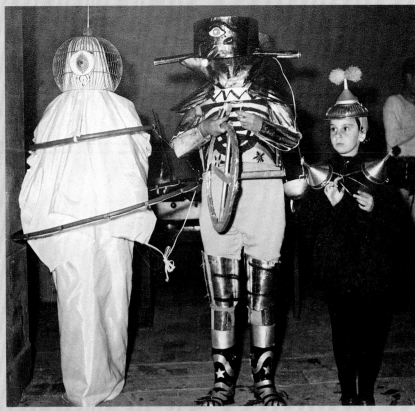

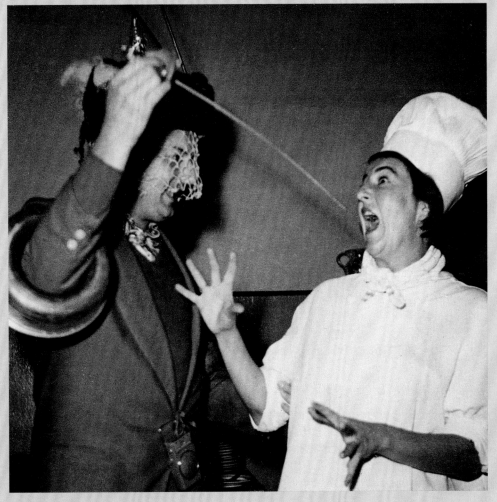

The arrival of the Martians for lunch was another dress-up event.

top, left: Desideria Pasolini and Sasha Bobrinsky

top, right: Francesca Boncompagni, Mimì, and Gaia de Beaumont

left: Dino and Judy Gendel

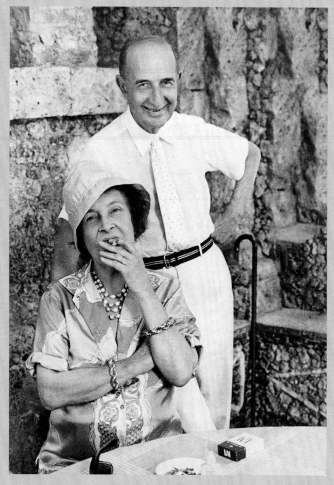

top: Camilla's parents,
Mimì and Cecil Pecci-Blunt;
below: Mimì with her great
friend Fulco di Verdura, 1961

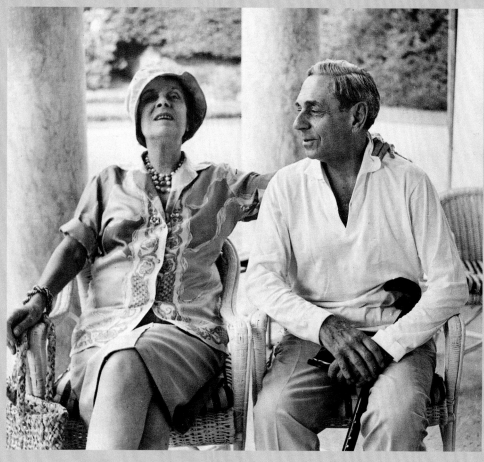

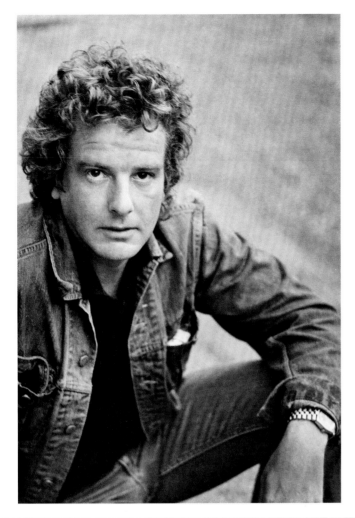

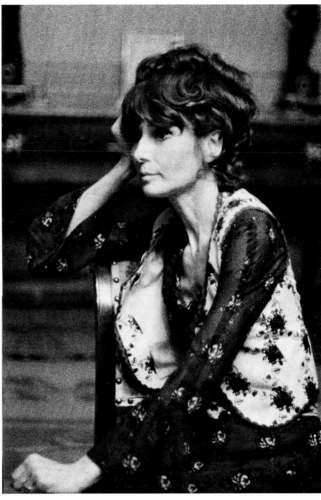

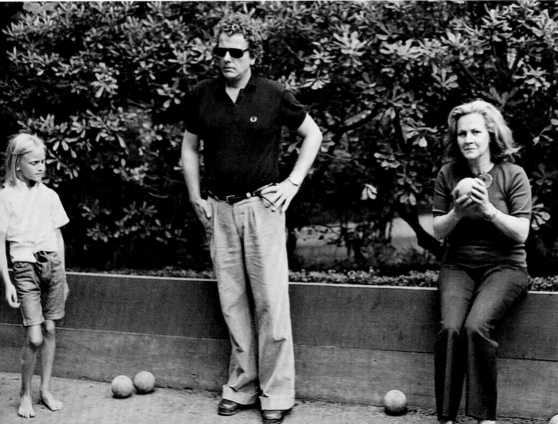

top, left: Nicky Haslam, writer and designer, July 22, 1973; and right: Audrey Hepburn, August 1971

left: Nicky on the bocce court with Tristano di Robilant and Camilla

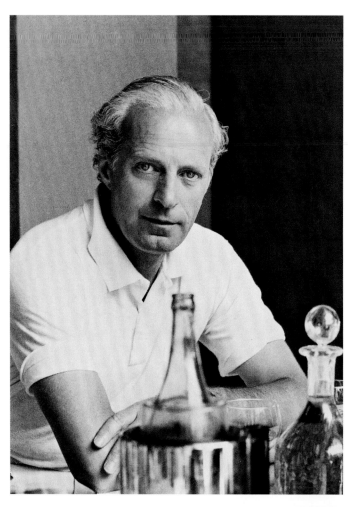

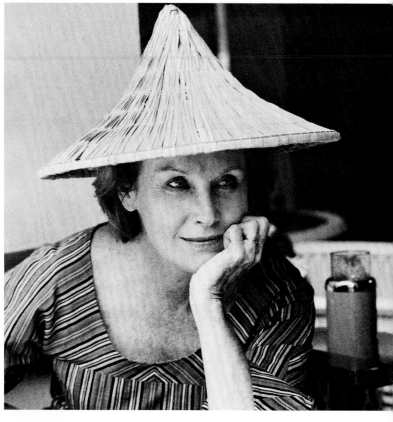

top, left: Stephane Groueff—the son of Bulgarian King Boris III's chief of cabinet, killed by the Communists in 1945—was a journalist for *Paris-Match* and its New York bureau chief for twenty years.

top, right: Lil Groueff, a model in the 1940s, was first married to Philip Henry Isles, a grandson of Philip Lehman.

right: Sheridan Dufferin, Marquess of Dufferin and Ava. He had been a partner of John Kasmin's in his celebrated London gallery and was a trustee of the National Gallery and the Wallace Collection; the writer Caroline Blackwood was one of his sisters.

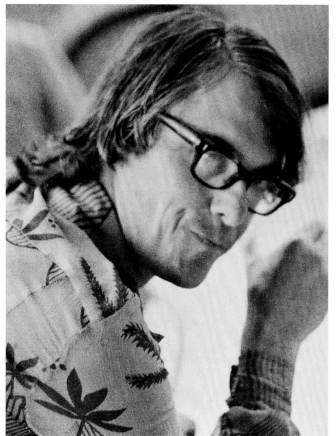

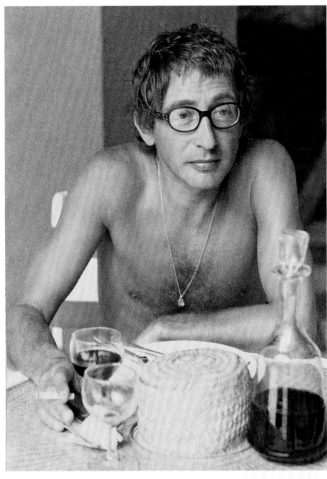

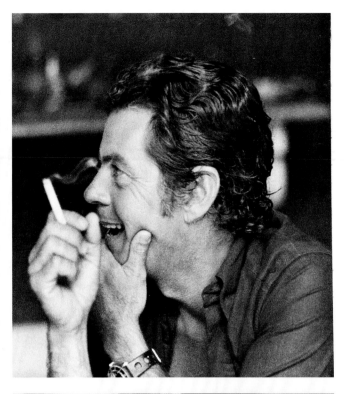

August 7, 1974

top, left: English gallerist
John Kasmin

top, right: English watercolorist
Teddy Millington-Drake

above: British interior designer
John Stefanidis

left: Writer Bruce Chatwin

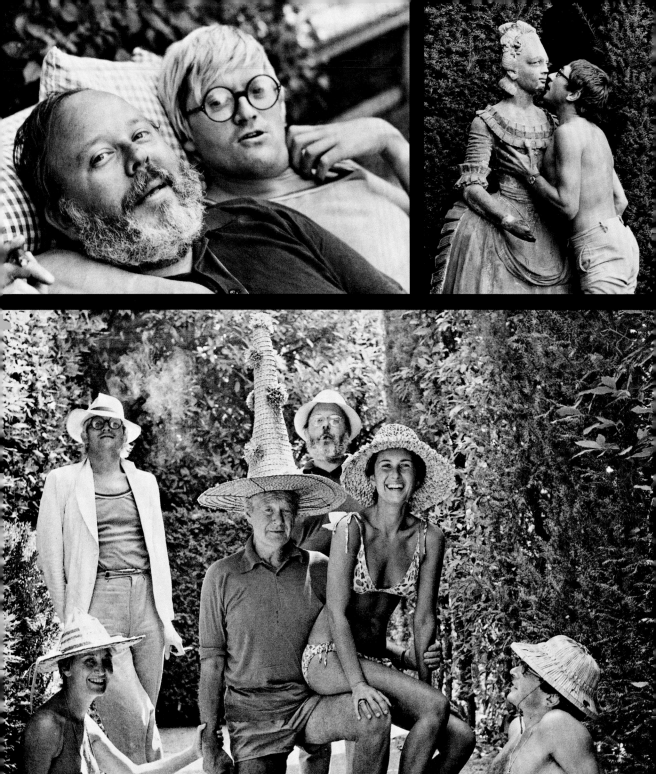

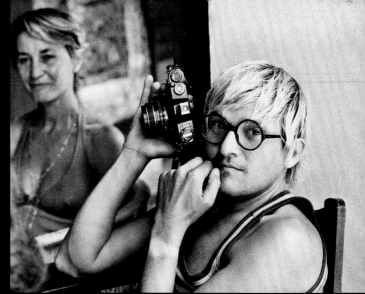

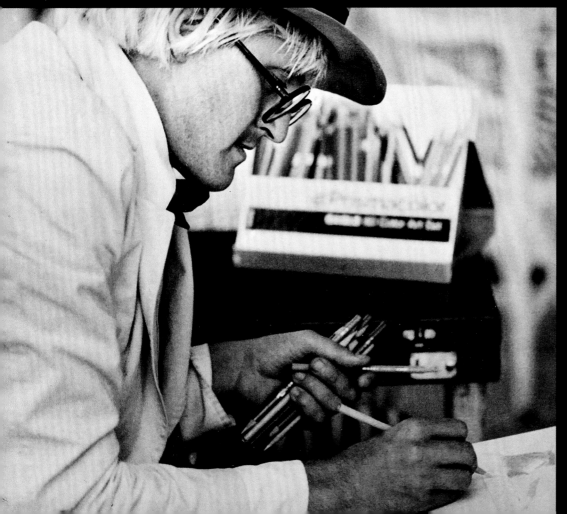

August 25, 1973

opposite, top left: Henry Geldzahler, the groundbreaking curator of American art at the Metropolitan Museum, and David Hockney

opposite, top right: Kasmin embracing one of the terra-cotta statues representing the masks of the commedia dell'arte

opposite, below: Clowning around in the Teatro di Verdura, *left to right*, Beatrice Monti, whose celebrated contemporary Galleria dell'Ariete in Milan showed everyone from Mark Rothko and Willem de Kooning to Jackson Pollock and Barnett Newman; Hockney; the writer Gregor von Rezzori; Geldzahler; Francesca Antinori; and Kasmin

this page, top and below: Hockney sketching a portrait of Geldzahler

top, right: Beatrice Monti and Hockney

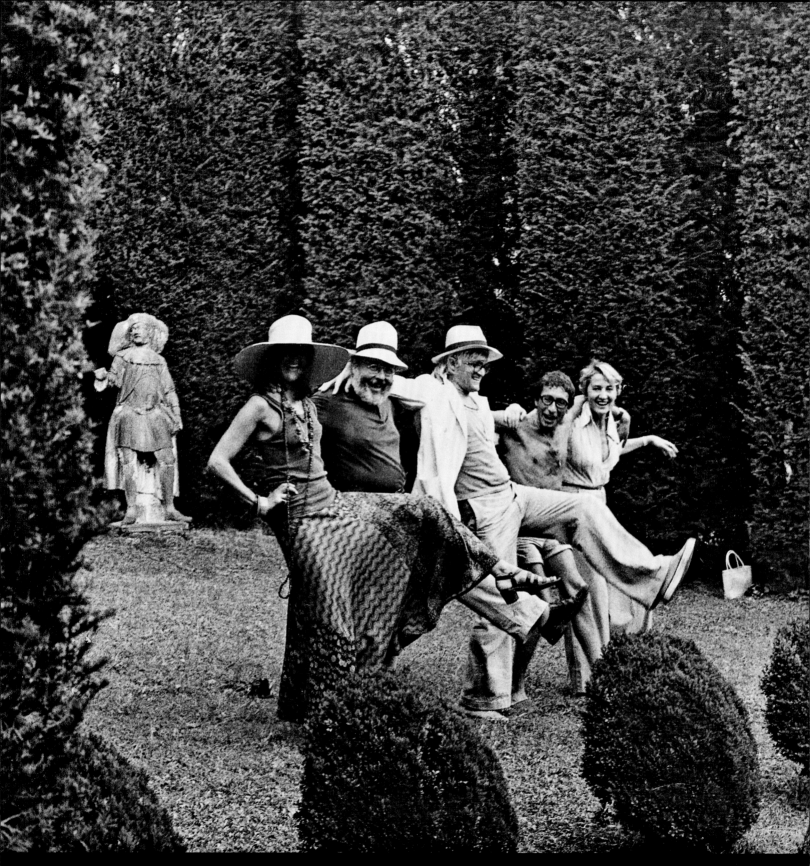

A chorus line in the semicircular Teatro di Verdura, whose yew hedges were first planted in 1690 by the Orsetti family

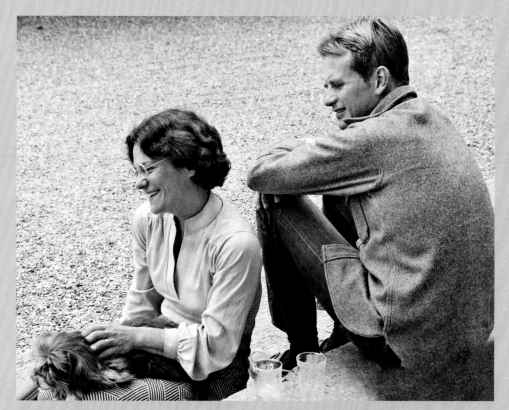

October 7, 1977

left: Bruce Chatwin with his wife, Elizabeth

below, left: With Teddy Millington-Drake

below, right: Teddy Millington-Drake

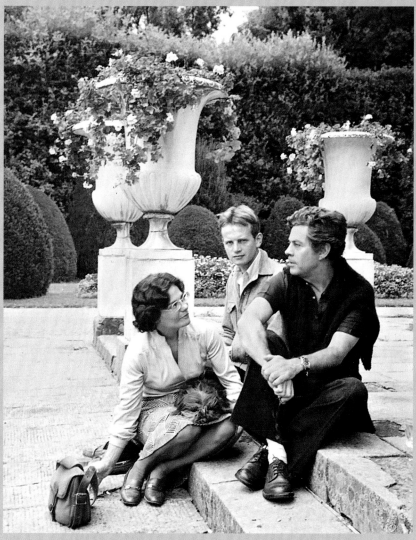

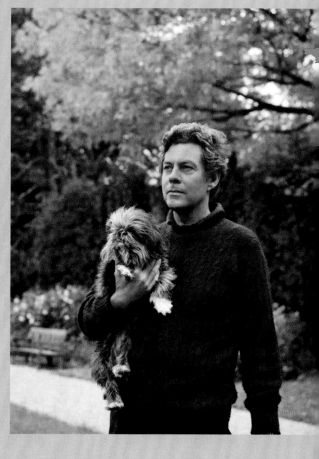

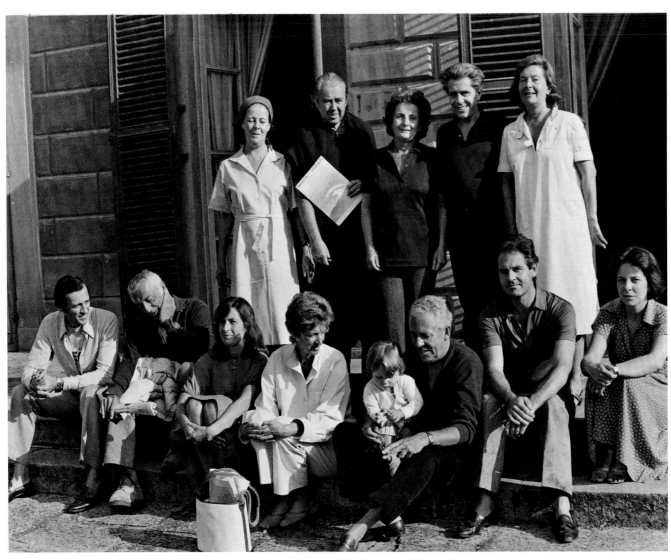

Lunch for the Agnellis, who arrived and left by helicopter, September 16, 1978

above: *standing, left to right,* Camilla's twin sister, Graziella; Sandro d'Urso (father of Mario, who lived in New York for years before becoming an Italian senator); another sister, Viviana; Ascanio Branca; Laetitia; *seated, left to right,* Frederick Vreeland; Gianni Agnelli; Francesca Antinori; Marella Agnelli; Sabina Bernard; Henri de Beaumont; Piero Antinori; and Camilla's niece Gaia de Beaumont, Graziella's daughter

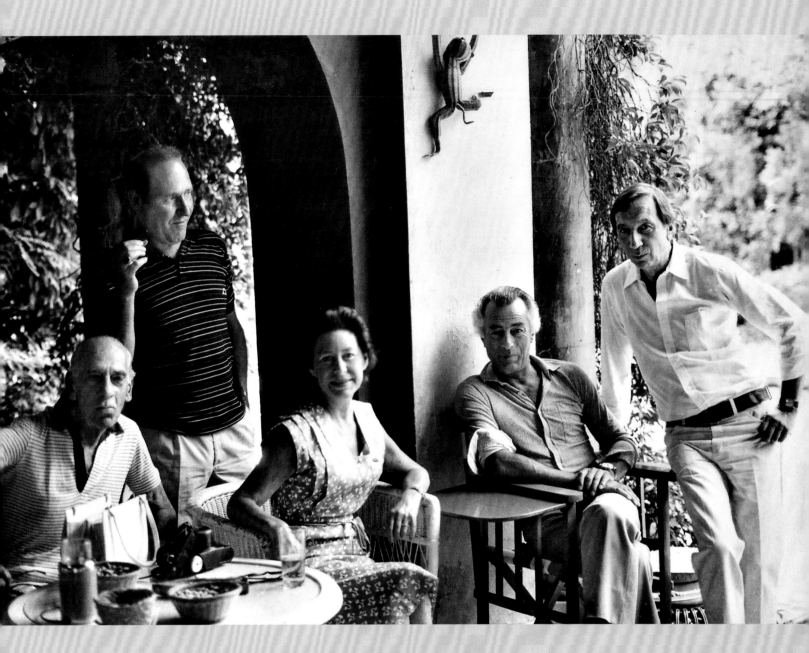

Lunch for Princess Margaret: *left to right,* Ferdinando di Bagno, Maurizio della Porta, Princess Margaret, Rufo Ruffo, and photographer and art critic Milton Gendel

Lunch set up in the Teatro di Verdura, September 9, 1983

top, right: Fran Lebowitz

right: Jesse Gerstein, Jerome Robbins, and Fran Lebowitz

below: Fran and Jerry on the bocce court

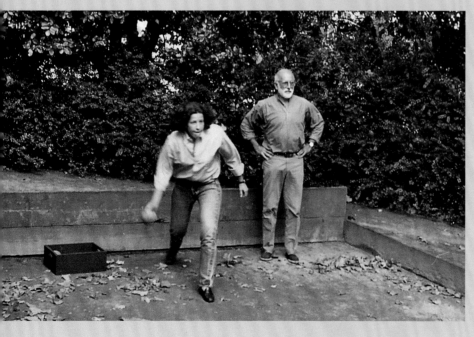

Camilla and Earl each had worlds that were normally completely separate. The worlds of rock 'n' roll, of the Italian aristocracy, and of artists. I did not know Earl before he lived in New York, I didn't know him in LA. I must have met them together, but I really don't recall. I don't remember how, but it was certainly in New York. I don't remember where. It's not a lack of memory, but I just was always going out all the time. So when people ask me where I met certain people and I cannot remember, I just say, "I met them at a party." Because I've been to a hundred million parties, so it's most likely. It must have been at their apartment, someone must have brought me there.

When I was young I had the impression that their apartment was gigantic. It probably wasn't, but it was the seventies and I was living in an apartment the size of a shoebox so their place felt gigantic to me. It was not without intent, but it wasn't grandly decorated. I don't remember the furniture at all, but I remember the art. Camilla wasn't trying to make a statement with it. She let it sort of be Earl's apartment.

I mostly remember the dinners, partly because they were delicious and I'm a glutton. I would never deliberately turn down an invitation from them because it was always fun and there would always be people you like, and people you didn't know from another world that you wouldn't meet otherwise because someone was always bringing someone else. Musicians, artists, writers, always pretty girls there, always pretty boys. It was casual, but I would never have gone there uninvited. I am certain, though, that some people did.

When I was young I definitely knew more people like Earl than like Camilla. Most people like Camilla did not live on Fifty-Seventh Street in New York, and have all these kinds of people in their apartment. She retained all of her standards, and you could see she would get angry with certain people's behavior, and I'm not sure Camilla loved it all so much as she loved Earl. You know, if Earl disappeared, I don't think a lot of those people would have been there. That would be my guess. Not that I ever discussed it with her. But you could meet anyone there. There was a guy I met there named Vincenzo Amato who I think is one of Earl's one million godsons. I am guessing he is in his forties or fifties now. One night there someone said, "Oh, he's a fantastic singer." He was an actor and also an artist and he just got up and sang a song in Italian. There were many famous singers there too, and he just got up and did it. And he was a fantastic singer.

The evenings were unstructured. One thing about Earl and Camilla is that at that time there would be these dinner parties on the Upper East Side that were black tie in people's apartments, but that was never, ever Earl and Camilla's way. You could always wear blue jeans in their apartment, which really wasn't possible in a lot of other homes then. Some people would come later, some people weren't even invited. You could also get away with that at their parties. I can't think of any other people who had nice apartments and would have parties like this. I knew plenty of people giving parties, but they were making three thousand dollars a year so it wasn't like what the McGraths were like.

Food was not the preoccupation that it is now. If they were serving good food at parties I didn't know about it. But the food at Camilla's was always good because Camilla was a good cook. I don't remember people back then talking about food like they do now, no one was talking about food, thinking about food. People in their twenties ask me now, "When you were my age in New York what restaurants did you used to go to?" and I say "NONE!" We never went to restaurants: (a) we had no money and (b) we never thought about it. I always say to them, "You shouldn't be sitting around at dinners when you're in your twenties. That is a pleasure of middle age." I think it's actually because they are not promiscuous enough. They don't have the kind of sex lives that we had. That's *all* I thought about. I didn't think every day: Where am I going to eat? What am I going to eat? I hardly remember eating at all. Obviously I did, because I'm alive, but

I hardly remember eating at all. We sought different pleasures, and maybe it's because they can't since there are all these diseases and they also have to make so much money just to live. This world of Camilla and Earl's, which was a combination of *at least* two worlds, just does not exist now at all. It would be very hard to explain this to someone who is twenty-five.

Marlia was a world unto itself. The first time I was there was the late seventies. I had already traveled around quite a bit, but this was unique. The house, Villa Reale, was supposedly built for Napoleon's sister, not just grand, but of a very specific sensibility. Camilla or one of the three other sisters told me that when they were young there were twenty-five full-time gardeners working there. A couple of things there were incredibly riveting. One was this topiary theater. Obviously, it took a tremendous amount of skill and work and patience to keep it because every day it grew out a little bit. That was near the pool. The outside walls of what they called the pool house were collaged with photographs taken by Camilla's mother. Taking photographs all the time was something Camilla got from her mother. So on the walls were these photographs that went from the floor to the roof and one of the photographs was of Nijinsky dancing on this stage. I remember that vividly, it was shocking. I remember thinking that can't really be Nijinsky, and I went to Camilla and asked and she said yes. I don't think there could be many places you could match to that place in terms of the min-gling of the arts. There were always people around, sometimes I wouldn't recognize them but then I would ask and find out they were some deeply important artist of the twentieth century.

Her mother had somewhere in the house a dollhouse of Villa Reale that included all of the buildings on the property. And it was fantastic. It was so detailed. In one building, there was a little laundry room where the laundress was ironing something and there was a little table, and on the table was a little half-eaten ham sandwich. It was so detailed. I think it was something that Camilla's mother had commissioned. I think it was made for the children, but maybe just as a piece of art. Her mother was also an early collector of Native American artifacts, tons of them, and they would be out all over the place. I know nothing about that sort of thing, but they were fantastic. Shoes, masks, beads, blankets, headdresses. They were all still there in the house.

Then there was the grotto. During the Second World War the father took the family to live in New York and the house was occupied by the Nazis. The Nazis used the grotto as a kind of nightclub while they were living there. And they painted murals on the walls. When the family came back to reclaim the house, which they did—not everyone got to do that they saw the murals painted in the grotto and they left them there. And once in a while we would have drinks down there. It was Nazi graffiti. Mostly dirty pictures of girls, the sort of thing you might expect young soldiers to paint on the walls.

There was also a pool that had swans in it, not for swimming, but one day Camilla, Jerry Robbins, Jesse Gerstein, and I were walking around. I don't remember why we were outside but it was raining and Jerry had this thing that he bought somewhere that was like a poncho in a little waterproof envelope so he said to go get that, and I did, and when I came back out it was raining harder so I put the envelope on my head like a hat. I'd seen many swans but had never actually been close to them, so I leaned down to look at one of the swans and the swan, much to my shock, walked out of the pool. I know this sounds ridiculous, because I was not three years old, but I didn't know swans had legs. I think I always imagined that swans floated on top. So there I am with this swan running after me, and Jerry is collapsed with laughter, and I later find out swans are very dangerous and can break your arms. The reason I was scared was not because I knew swans were dangerous, I had no idea. The reason I was scared and running away was because I didn't know swans had legs. I was thirty, and totally terrified. And Camilla took a picture of that. It would be irresistible to take a picture of someone being chased by a swan.

The world of Lucca, the nearby town, was something the other sisters were much more embedded in than Camilla was. One morning at breakfast one of the sisters tells us the so-and-sos are having a dinner tonight. And Camilla didn't want to go, so the sister tells her she has to go to represent "the house." Camilla looks at me and Jesse and says, "*You* will go and represent the house." So we went to this house, and when we arrived someone was handing out halved playing cards. That was how you found where you were sitting. I was talking to this girl before dinner, and she opened her handbag to get a cigarette and there was a gun in there. A little handgun. I was so shocked and I said, "You have a gun?" and she said, "Of course, as you know, both my brothers were kidnapped." That was the thing about those people. They think you would know. She told me her name, which meant nothing to me but everyone there would know. She continued, "My father said after my second brother was kidnapped that he is paying no more ransoms. So I carry the gun just in case I am kidnapped because I'll have to shoot the kidnappers to get away."

I also remember I went into the house to find the bathroom. I got lost and ended up in this big library, and on the desk in the library were several photos of Mussolini inscribed with great love to the owners of the house. I was quite shocked, so when I came out I told this girl, the one with the handgun, and she said, "Oh, yes, well, of course." Apparently there are some bankers in Paris named Lebowitz and I remember the man sitting next to me at dinner assumed I must be one of them and said to me, "Madame, are you from Paris?" And I said, "No." He couldn't figure out why I was there. It was very annoying to him. I found the whole thing very interesting, but it was a strange, very insular world. Camilla kind of broke

out of that, though. She was still interested in it, it was still a part of her, but she broke free from that. And I think if they went to New York and saw her life with Earl they would probably think it was insane. In my estimation Earl was likely not the family favorite. He didn't love going over there, because the sisters didn't treat him very well. Camilla's sisters made no bones about who they liked and who they didn't like. One of the sisters liked nobody but me. Everyone was baffled by it, they all looked at me like why does she like you, she doesn't like anybody. My theory is that I would play bocce with her whenever she wanted and I'd always lose.

I have never been any place that is anything like Marlia. I mean, I'd been to estates, people with huge houses and sprawling properties in Italy with murals on the walls from the Renaissance, and we'd be awestruck by them, but they were in the sensibilities of those people. This house was the sensibility of, I believe, the mother, who was a very unusual person for her time, and so was Camilla. Camilla's mother, I never met her, but she seemed like a one-off. Very eccentric and artistic. And you know, if she had been a man I think she would have expressed it in a different way, but she made her domestic world into this incredible creation. And I loved going there. I think I went four or five times. Every single time I would look at the same things, and they would live on in my mind.

Camilla's connection to American life was Earl. And Earl's life was so unusual. So she had no concept of American life, because most Americans lived nothing like Earl. I remember her telling me that some Americans wanted to rent Marlia for a wedding. She was so puzzled by this, and said, "Why would you have a wedding if it's not your house?" She didn't understand that was how Americans do things. In the world she was from you had your wedding at your home. She was genuinely puzzled. She had just no connection to the average American life. Even if you are very worldly, it's often hard to understand the difference between the presented culture and "real" life. Even for someone like me who thinks she understands her country very well because I'm old now and have seen a lot, the things that people do—that is, my fellow Americans—still just shock me. Time also makes you know the world, not just places. In 2019 if you're twenty, it is a different world than in 1970 when I was twenty. It's always hard to understand different cultures and places, and the situation with Camilla was unique. There were no other people like this. There was one person like this. Her sisters and brother even weren't like her. They were much more traditional than she was. They stayed within their world. Camilla came to this New York that was very different and she was able to adapt. None of her sisters would have married someone like Earl, either.

—FRAN LEBOWITZ

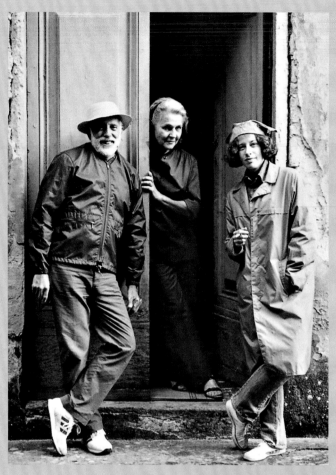

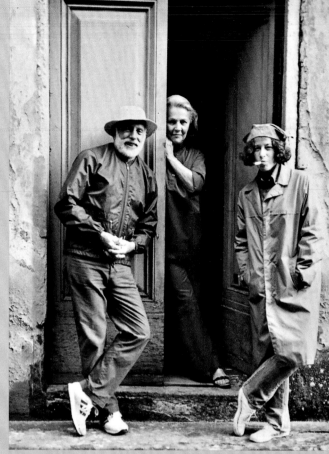

In the garden, September 10, 1983

above: Jerry Robbins, Camilla, Fran Lebowitz

below: Fran and an angry swan from the reflecting pool

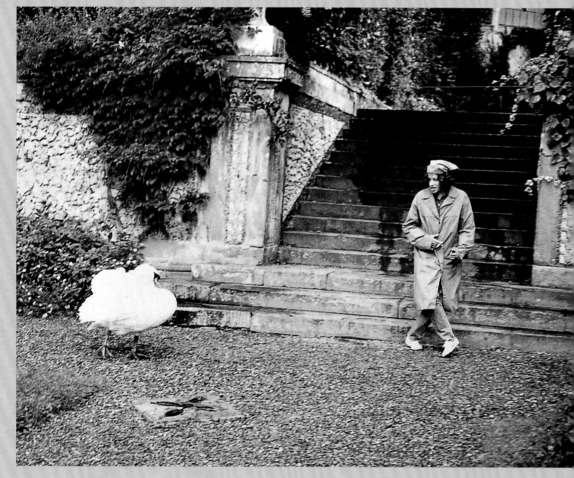

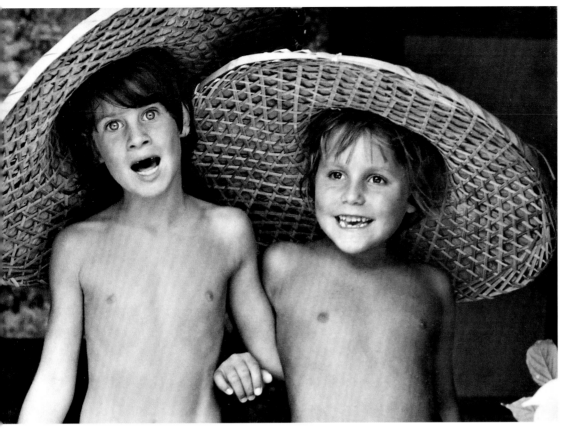

Camilla loved children and photographed the children of her family and friends.

left: Alessia Antinori with Sabina Bernard

below, left: Sabina and Alessia

below, right: Albiera Antinori, Sabina, and Alessia

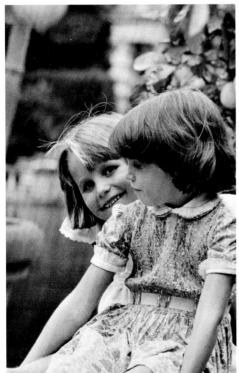

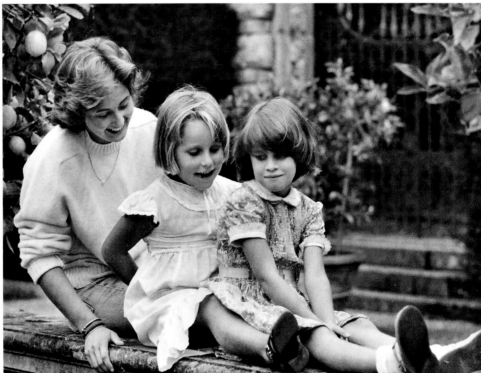

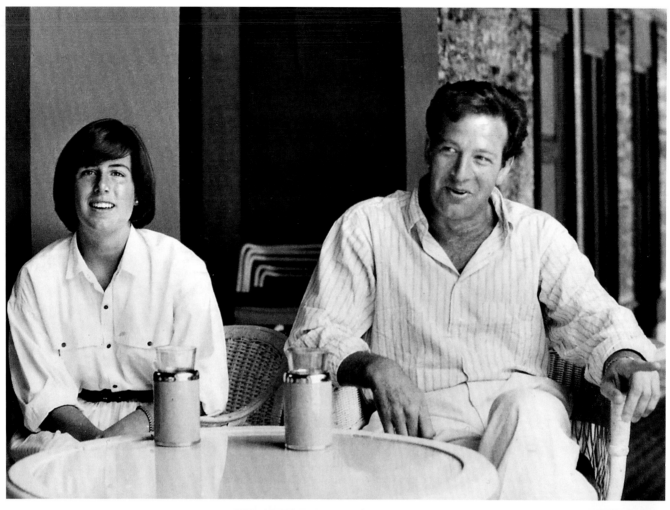

August 22, 1984

above: Nancy Pelosi's daughter, Nancy, with her father, Paul

right: Dianne Feinstein was mayor of San Francisco, 1978–88, before being elected to the U.S. Senate.

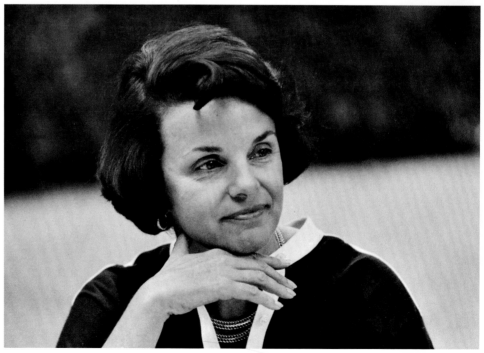

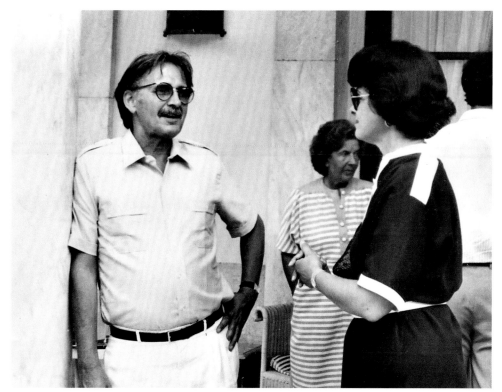

left: Feinstein talking to Earl

below: *back row standing,* Francesco Cari, Earl, Donatella Zegna, Nico Pari, Henri de Beaumont, Dianne Feinstein, Richard Blum, Laetitia (Camilla's sister), Nancy Pelosi, who had been chair of the California Democratic Party (1981–83) and would be elected to the U.S. House of Representatives four years later, with her husband, Paul, Marisa Recchi, Dino; *sitting,* Maria Pia Fanfani, Miss Nancy Pelosi

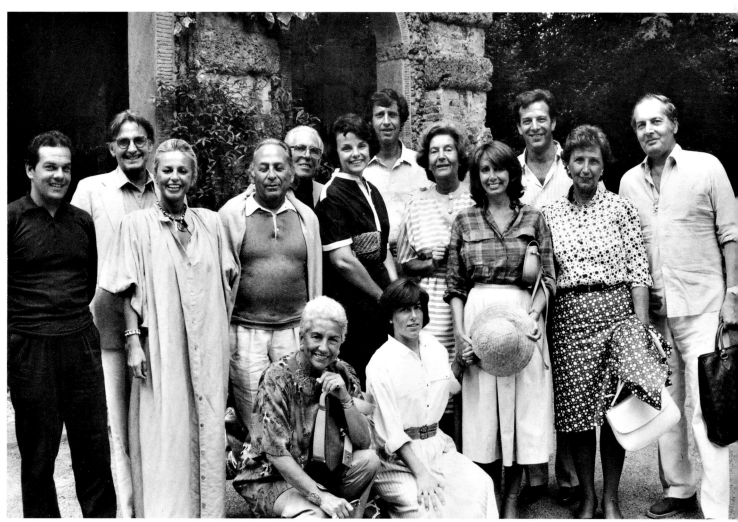

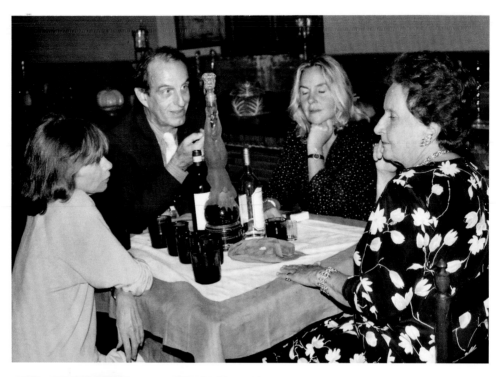

right: At dinner, 1988: *left to right,* Joan Didion, Freddy Eberstadt, Sophie Irvin, and Camilla's sister Viviana

below, left: Griffin Dunne

below, right: Joan Didion with her husband, John Gregory Dunne

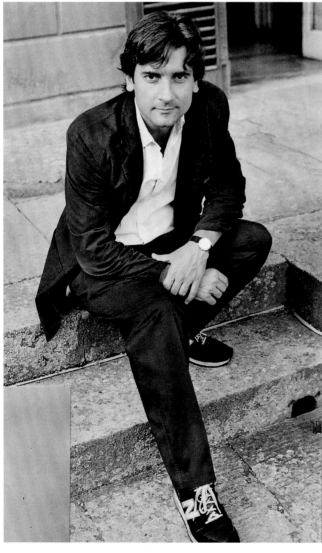

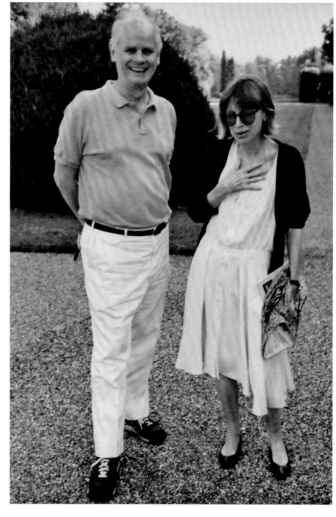

Pool antics in 1956 and 1988

top, left: Filippo di Robilant with Alessia Antinori and Pietro Cicognani with Nerina Corsini

top, right: Peter Sharp and Francesca Antinori

bottom, left: Leone Benni walking by the pool; in the water, Dino, Camilla's brother, and Luciano, and Ernie Moos; on shoulders, Alvise di Robilant and Sandro Lancellotti

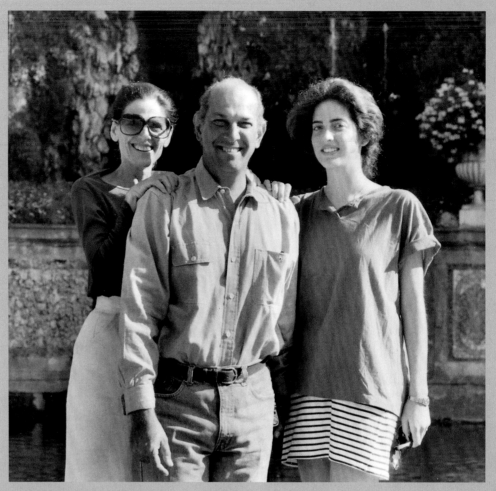

right: Annette Reed, *left,* the year before she married Oscar de la Renta, *center,* with her daughter Eliza Reed, 1988

below: *standing, left to right,* Jann Wenner, Henri de Beaumont, Alvise di Robilant, Calvin Klein; *seated, left to right,* Fran Lebowitz, Jane Wenner, Kelly Klein, August 23, 1989

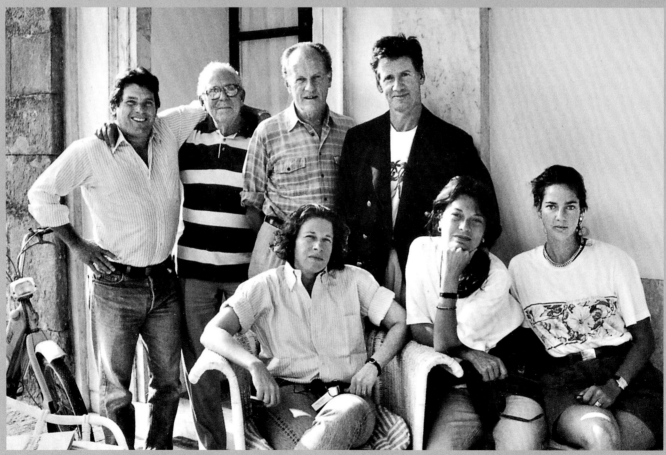

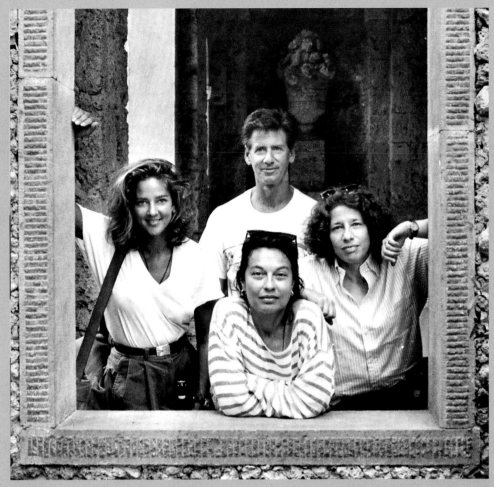

left: *clockwise,* Kelly Klein, Calvin Klein, Fran Lebowitz, Jane Wenner

below, left: Jann and Jane Wenner

below, right: Kelly and Calvin Klein

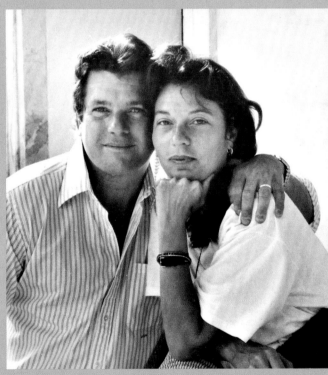

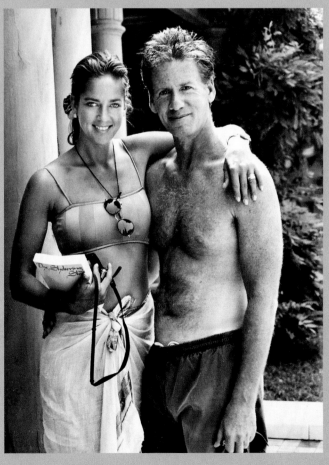

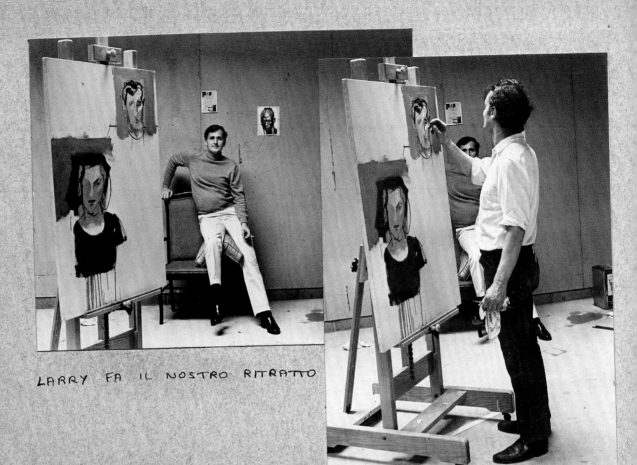

LARRY FA IL NOSTRO RITRATTO

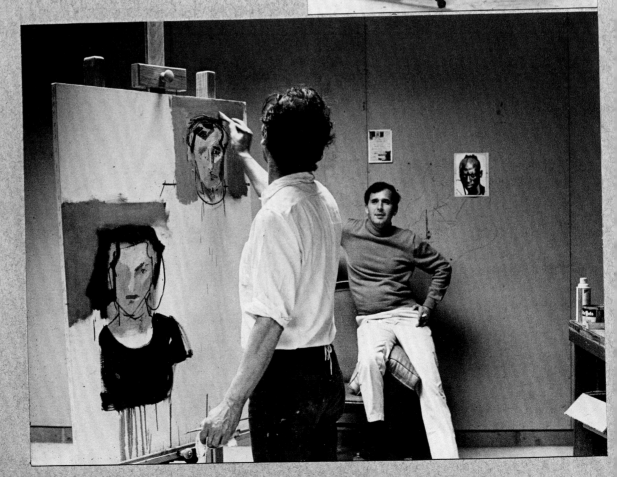

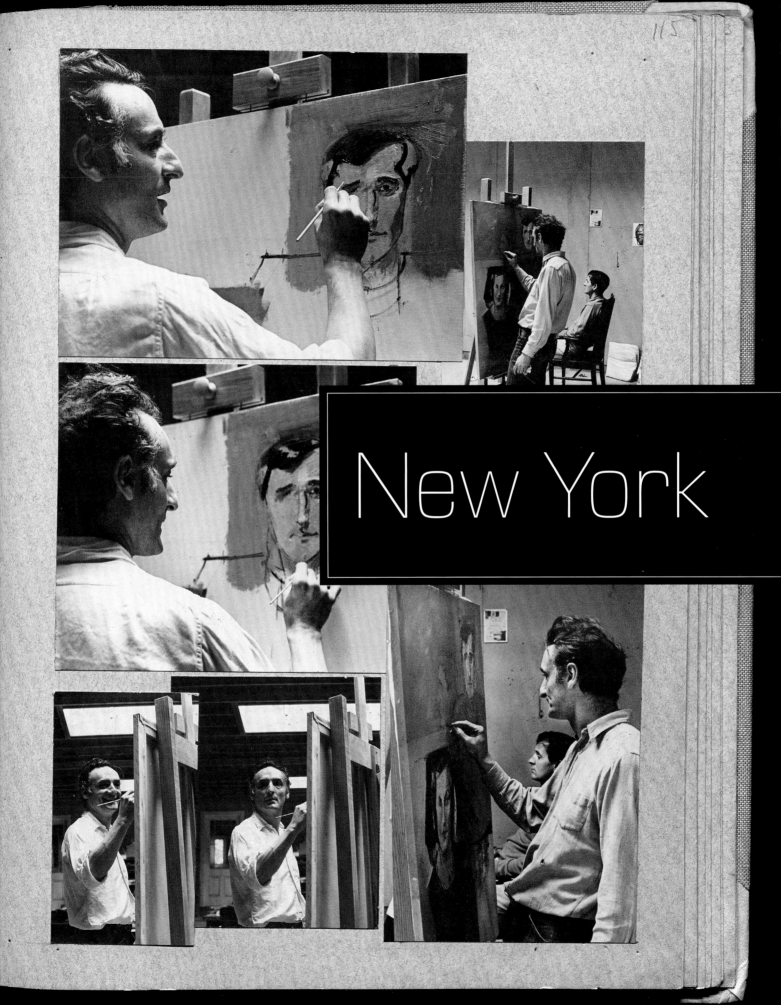

New York

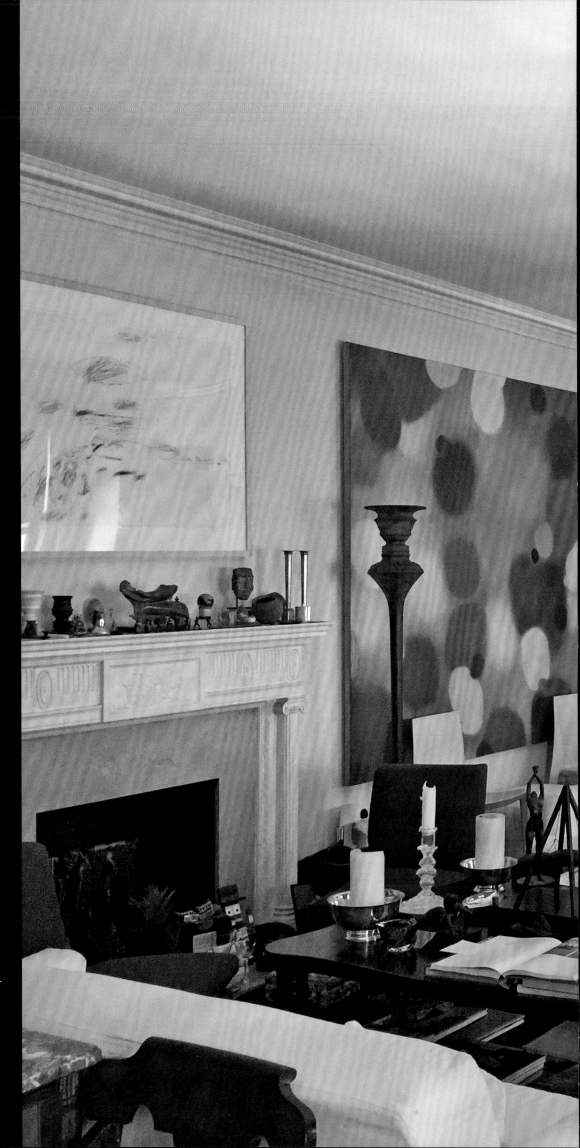

The living room of Earl and Camilla's apartment at 171 West Fifty-Seventh Street, on the corner of Seventh Avenue, opposite the entrance to Carnegie Hall. The round table in this room or the one beyond was used for sit-down meals or putting out the buffet. There was another white couch in this room and one in the room beyond, so there was a lot of seating for buffet dinners or cocktail parties. The art on the walls, often by friends of Earl and Camilla's, was always changing.

Here, Larry Rivers's portrait of Camilla and Earl to the far right of the fireplace, which is flanked by two Robert Graham statues. A Twombly hangs over the mantel, and to the right is a Jeff Kowatch, one of the artists Earl worked with.

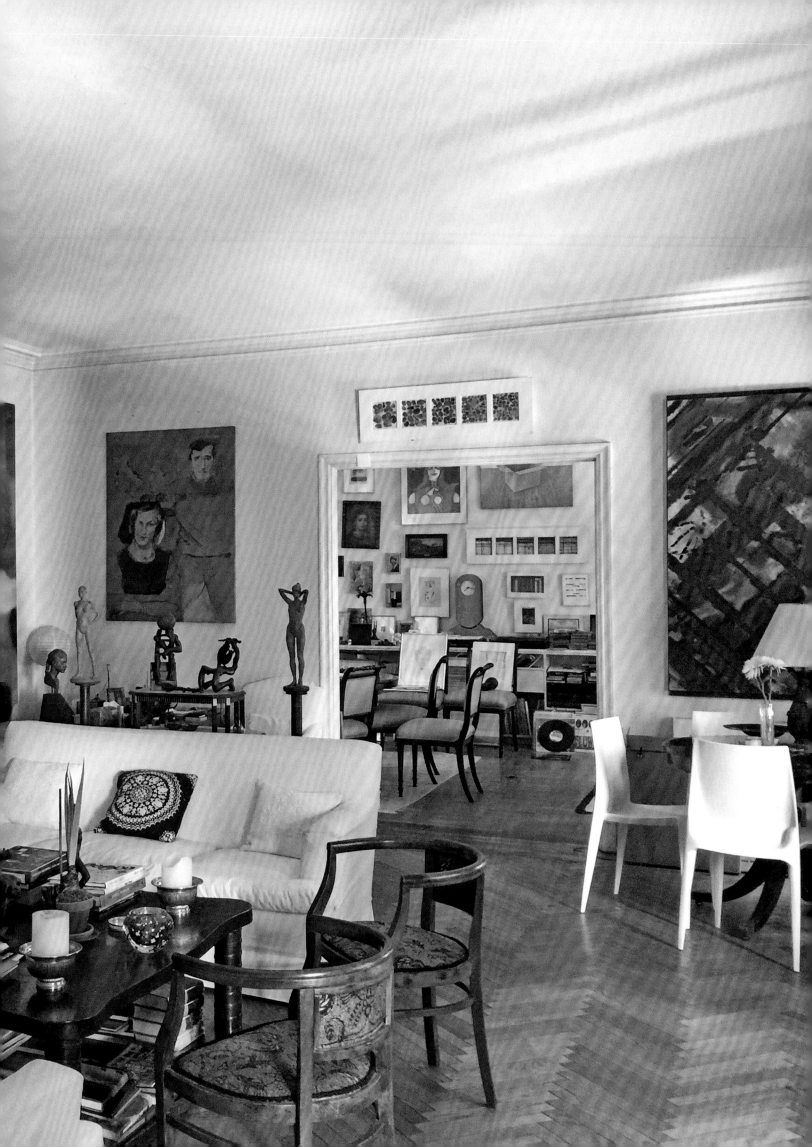

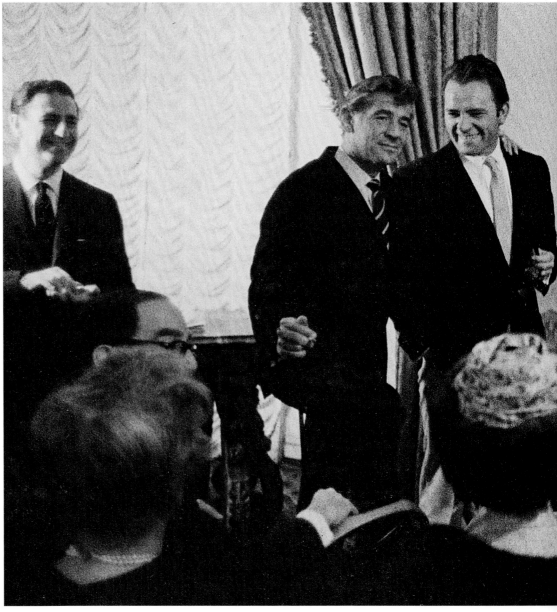

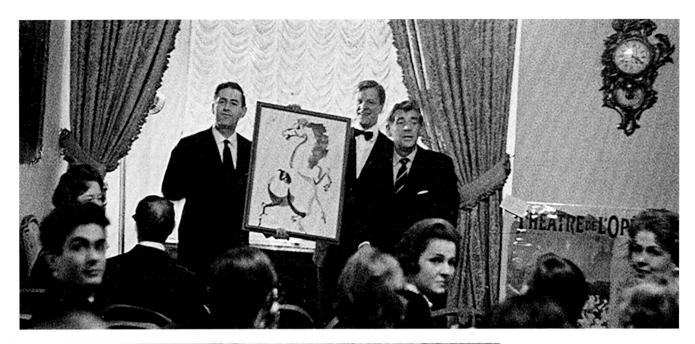

A 1960 auction at the home of
the Italian ambassador to the
United Nations, Egidio Ortona,
to raise money for Gian Carlo
Menotti's Festival of Two
Worlds in Spoleto. Leonard
Bernstein auctioned off
actor Richard Burton to Elsa
Maxwell, the gossip columnist
and celebrated party giver;
Menotti and Thomas Schippers
were also auctioned off. Camilla
did not take these photographs.

opposite, top left: Menotti
auctioning a fan; top, right:
Leonard Bernstein auctioning
a drawing; above: Menotti,
Chandler Cowles, and Bernstein
working together

below: *left to right*, Menotti,
Bernstein, Richard Burton,
and producer Chandler Cowles

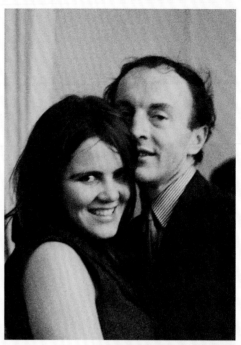
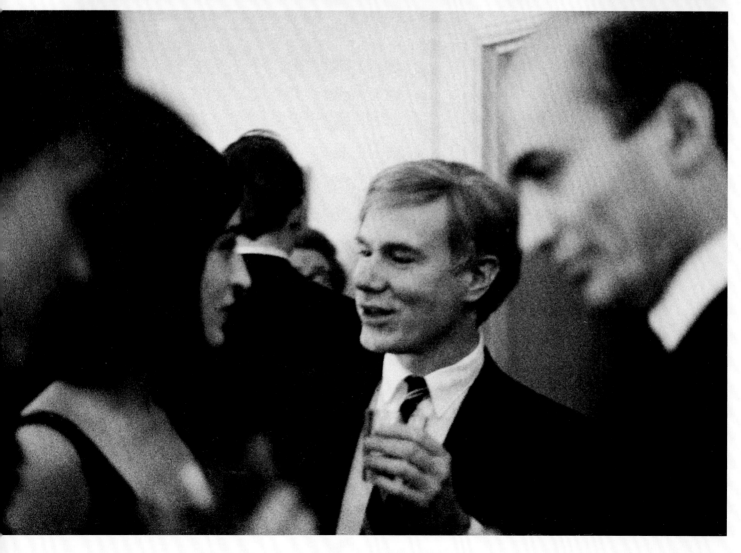

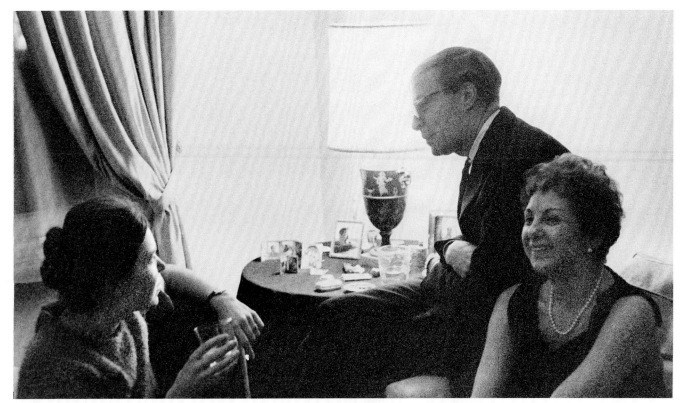

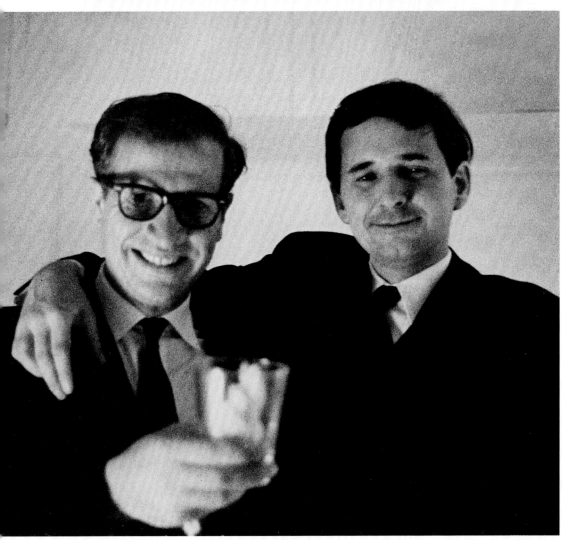

Christmas Eve dinner, 1963, at the McGraths' first apartment, 27 East Sixty-Second Street; Gian Carlo Menotti had an apartment in the same building.

opposite, top left: Jerry Robbins and Earl

opposite, top right: Clarice Rivers with poet Frank O'Hara

opposite, below: *left to right*, artists Marisol Escobar, Andy Warhol, Manoucher Yektai

this page, top: *left to right*, Joyce Coe; writer Bowden Broadwater, former husband of the author Mary McCarthy; and writer Elaine Dundy, author of *The Dud Avocado* and wife of critic Kenneth Tynan

this page, below: Joe Hazan with Earl—Hazan had studied ballet, knew Lincoln Kirstein and the dance critic David Denby, and was rumored to have brought his pet monkey on his first date with his future wife, the painter Jane Freilicher.

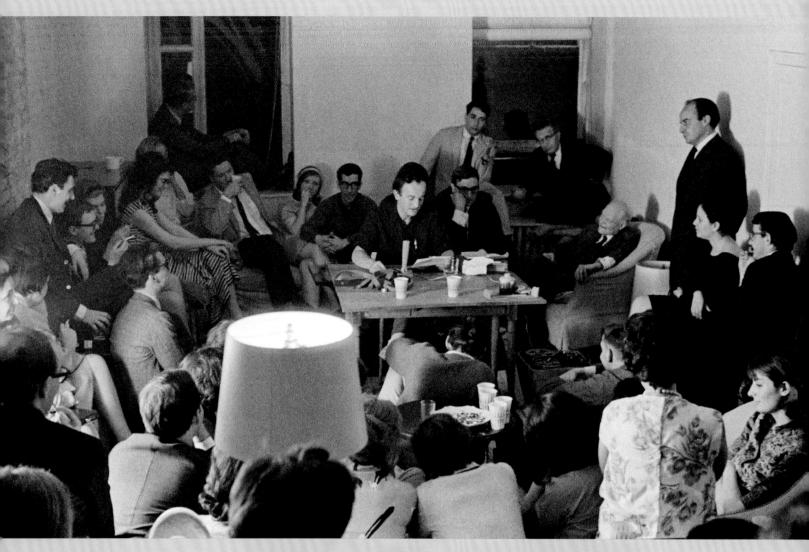

A gathering at the home of artist Mario-Schifano on May 2, 1964: the Italian modernist poet Giuseppe Ungaretti; several composers; a group of American poets that included Kenneth Koch, Allen Ginsberg, Frank O'Hara, Barbara Guest, and LeRoi Jones, later known as Amiri Baraka; and the English photographer Derry Moore, 12th Earl of Drogheda. The McGraths were there, too: Earl had been interested in poetry since his youthful correspondence with W. H. Auden in the mid-1950s.

right: Ungaretti reading to the assembled, who include, *left to right*, Lucio Manisco, Sandy Berrigan, and Barbara Guest.

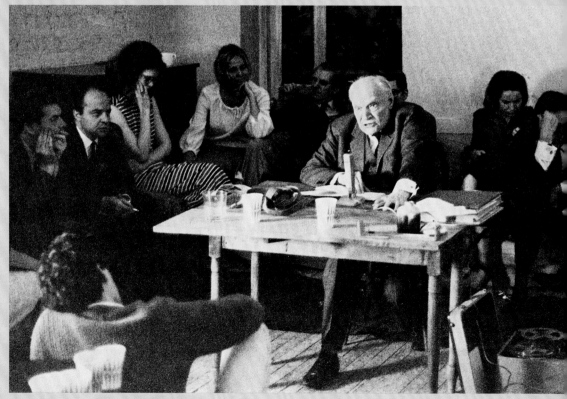

opposite, top: Earl seated above the group with photographer Derry Moore; Frank O'Hara is reading at the table.

top, left: Ungaretti talking to French-American composer Edgard Varèse, known as "the Father of Electronic Music"

top, right: Ginsberg and Frank O'Hara

below: Allen Ginsberg reading to, *left to right in profile,* Earl (only his nose is visible), Kenneth Koch, and *hidden on the right,* Ungaretti

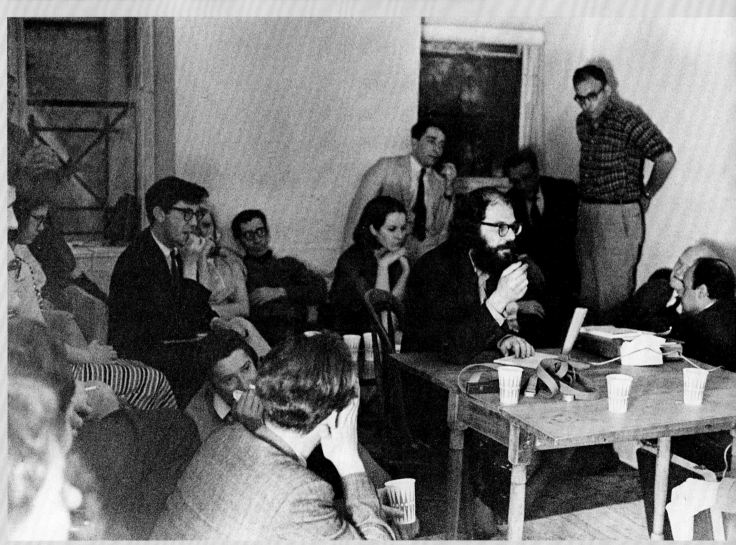

"Broadway Salutes," a free, late-night, open-air rally on Fifty-Third Street between Broadway and Eighth Avenue organized by Ted Mann and Earl, October 27, 1964. Among the participants were Carol Channing, Sammy Davis Jr., Tammy Grimes, and John Stewart of the Kingston Trio.

top: At the rally: Ethel Kennedy, Carol Channing, Ted Mann, Earl, Bobby Kennedy, Sammy Davis Jr.

middle: On stage, *left to right,* Ethel Kennedy, Carol Channing, Earl, Harry Guardino, Bobby Kennedy

below: Mary "Piedy" Gimbel with Kennedy; after her divorce from Peter Gimbel, the documentary filmmaker, she married director Sidney Lumet in 1980.

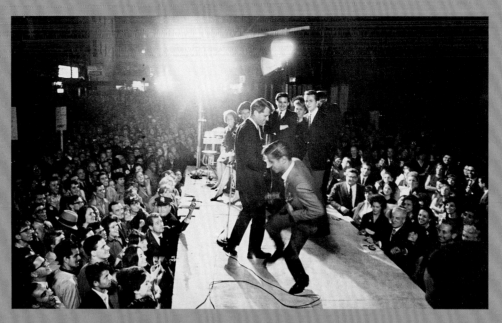

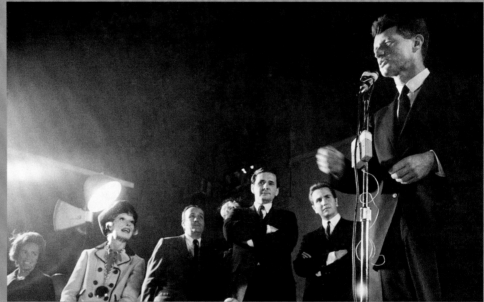

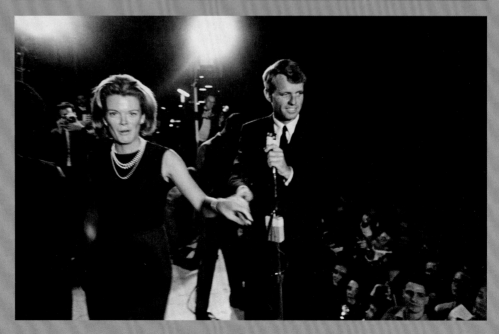

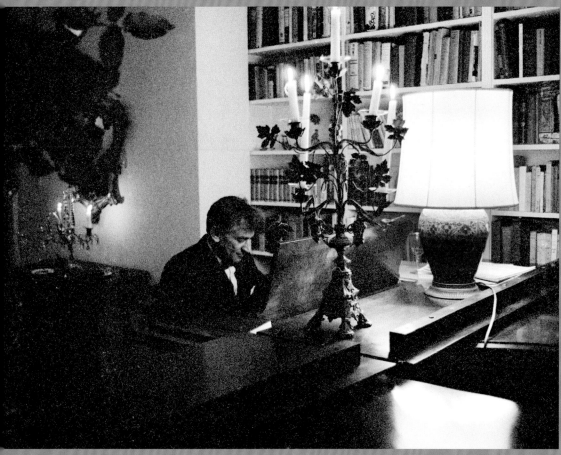

A New Year's Eve party, 1967, at the apartment of the well-known duo, pianists Arthur Gold and Robert Fizdale, who also coauthored books such as *Misia: The Life of Misia Sert.*

right: Leonard Bernstein at the piano

below: Bernstein and his wife, Felicia Montealegre, with Earl

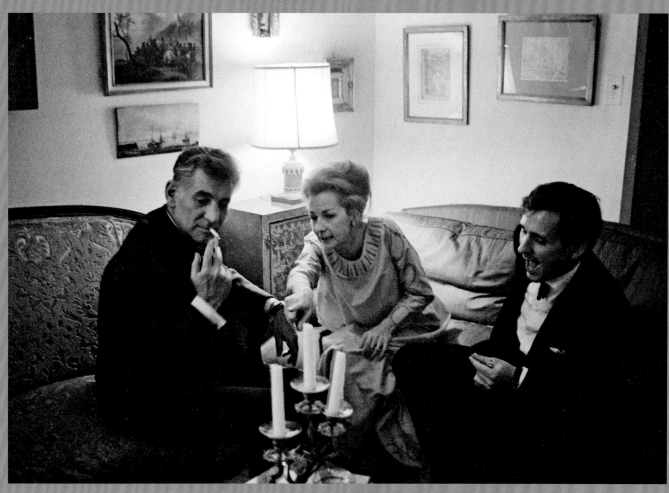

A weekend at Larry Rivers's in Southampton, 1965

opposite, top: In Rivers's studio, *left to right,* artists Jean Tinguely, Niki de Saint Phalle (whom Tinguely would marry in 1971), and Rivers

opposite, bottom: Earl's goddaughter Gwynne Rivers in the studio

this page, top: Tinguely at work

below, left: Rivers and Gwynne

below, right: Tinguely, Saint Phalle, and Clarice Rivers

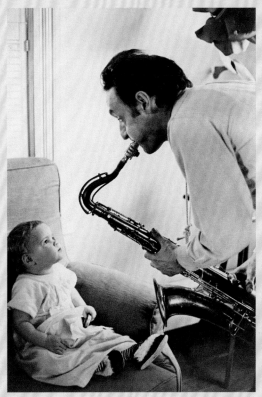

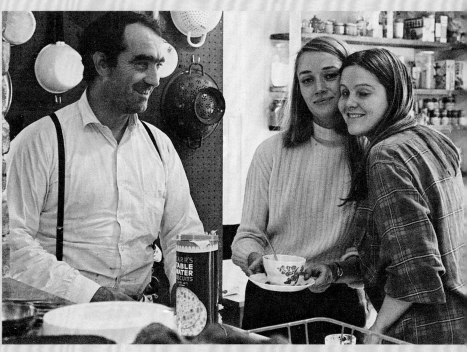

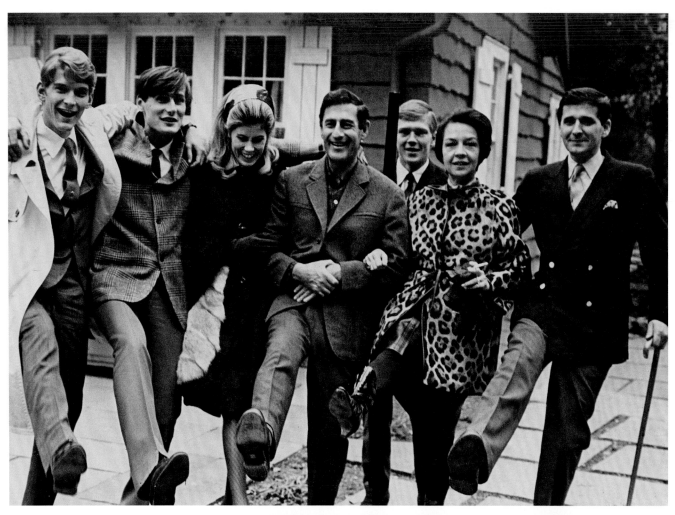

At Gian Carlo Menotti's house in Mount Kisco, November 25, 1965, with the Spoleto Festival group

above: *left to right,* architect Manfred Ibel; Nonie Schippers, the conductor Tommy Schippers's wife; Gian Carlo Menotti; actor Ruth Ford (sister of Charles Henri Ford, a poet, filmmaker, and photographer whose partner was the artist Pavel Tchelitchew); and Earl.

right: Gian Carlo Menotti

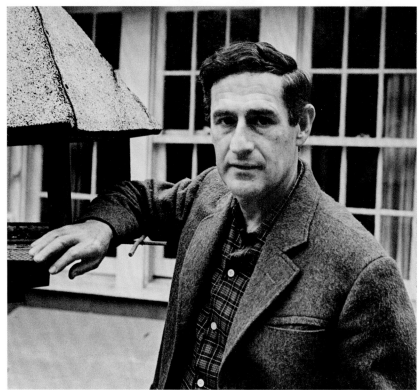

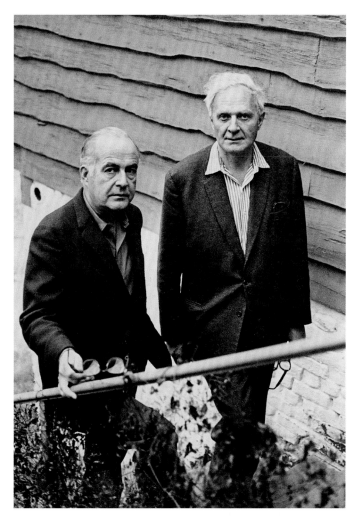

left: Samuel Barber, the celebrated composer who won two Pulitzer Prizes, and poet Stephen Spender

below, right: Nonie and Earl

below, left: Tommy Schippers with Nonie

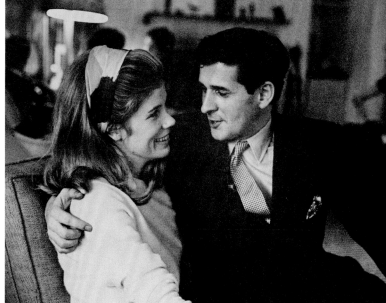

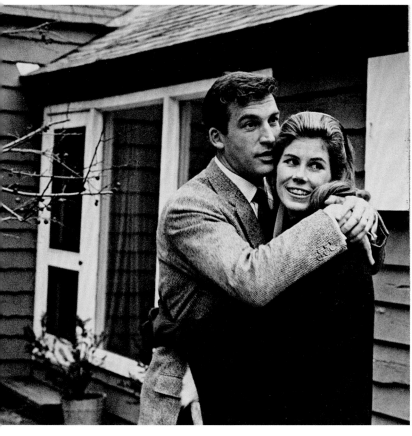

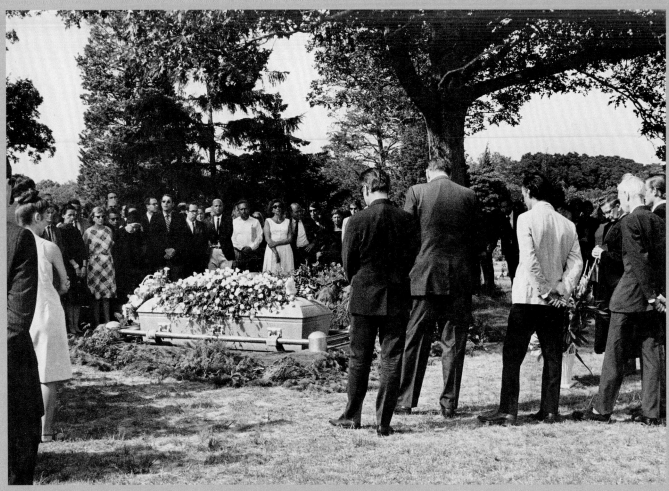

Frank O'Hara's funeral in the Springs, New York, July 27, 1966; O'Hara, age forty, had been run over on the beach at Fire Island in the early morning of July 24.

top: Prayer around the coffin

right: Elaine de Kooning and artist Saul Steinberg

opposite, top: Larry Rivers, in the *foreground,* and, *left to right, behind,* poet Bill Berkson (his mother was the fashion publicist Eleanor Lambert), critic and poet Edwin Denby, and poet John Ashbery

opposite, below: Leaving the service, Allen Ginsberg and Kenneth Koch

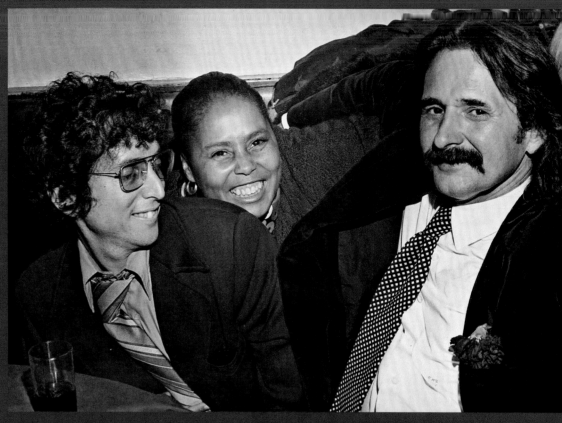

Earl's launch party for the first album by Delbert & Glen, which he produced, at Max's Kansas City, October 24, 1972

top: *left to right*, Jerry Greenberg, music executive who became president of Atlantic Records in 1974; Noreen Woods, a vice president of Atlantic Records; and Earl; bottom: *left to right*, producer Lester Persky, Glen Clark of Delbert & Glen, and Warhol director Paul Morrissey

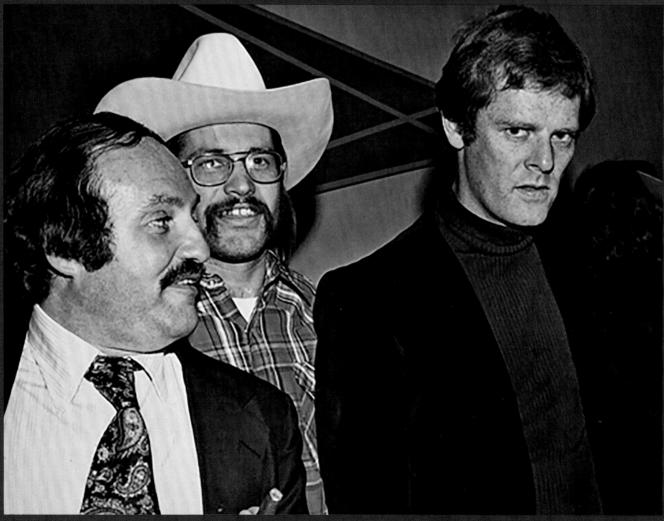

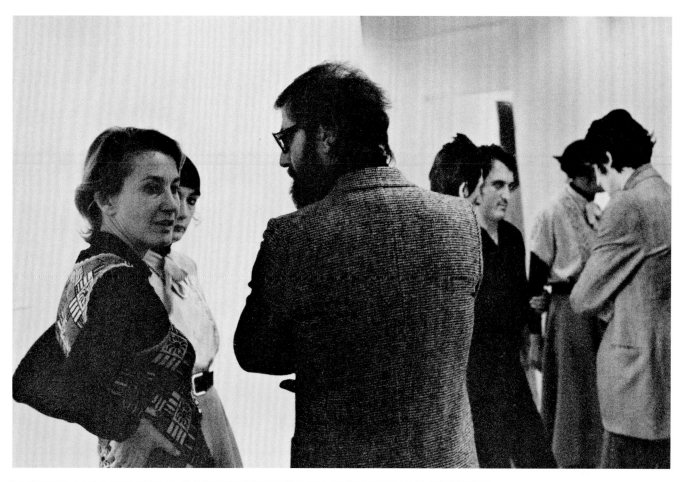

At the 1974 opening of a show
of the work of Michelangelo
Pistoletto, Beatrice von
Rezzori talks to the artist.

below: Pistoletto

Dinner at the McGraths', February 24, 1974

this page, top: *left to right,* Enrico d'Assia, an artist and set designer also known as Prince Heinrich Wilhelm Konstantin Viktor Franz of Hesse-Kassel; Georgie Abreu; art dealer Charles Byron; and Camilla's sister Viviana

this page, bottom: *left to right,* John Richardson; Slim Keith, ex-wife of director Howard Hawks and producer Leland Hayward; fashion executive Boaz Mazor; and Mica Ertegun

opposite, top: *left to right,* Cy Twombly; Alessandro Albrizzi, who designed modern furniture and had a late-seventeenth-century Venetian palazzo with famously elaborate stucco work ceilings of lifesize putti; Ahmet Ertegun; and Earl

opposite, bottom left: Mick Jagger and Ahmet

opposite, bottom right: Earl with Caroline Cholmondeley, whose family owns Houghton Hall

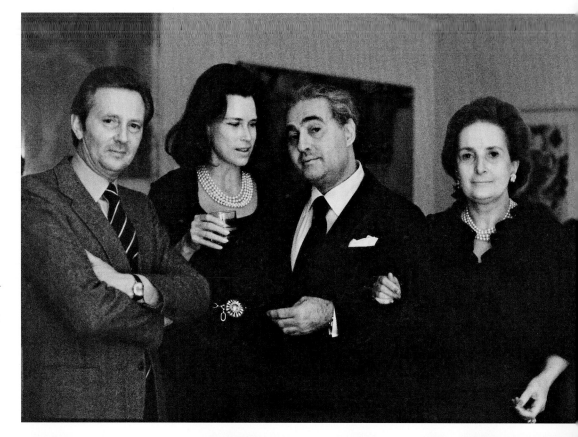

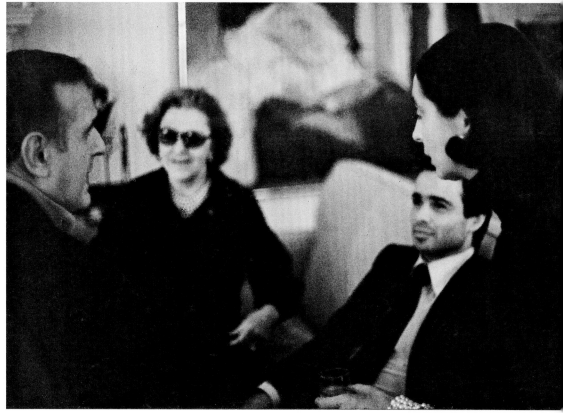

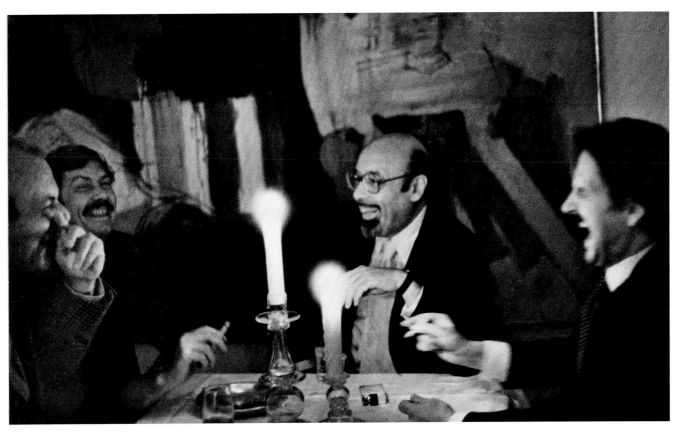

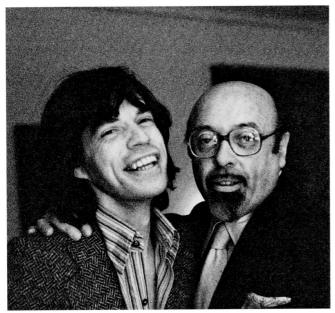

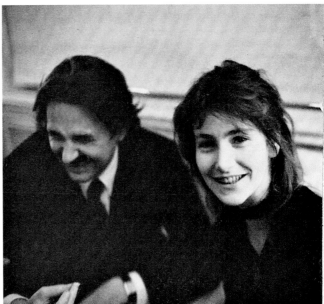

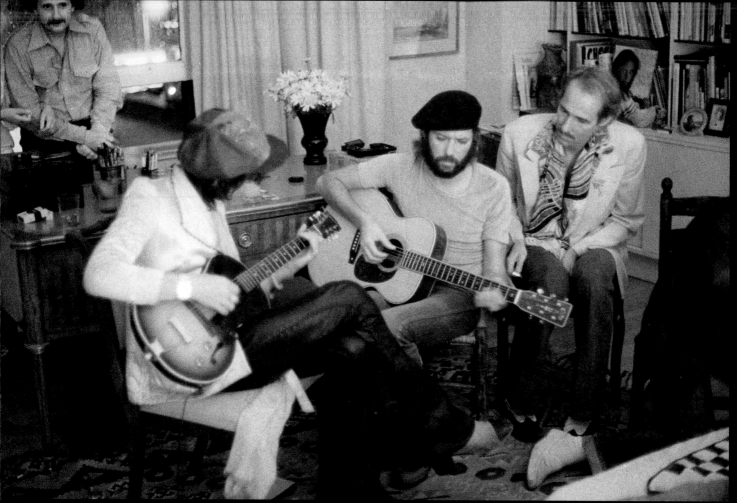

After their June 26 concert
at Madison Square Garden
on their 1975 tour, the
Rolling Stones, along with
photographers Christopher
Sykes and Annie Leibovitz,
Eric Clapton (who played with
them during the encore) and
John Phillips, Geneviève Waïte,
Rupert Loewenstein, Bianca
Jagger, and others, headed
for the McGraths' apartment.
There was a jam session in the
master bedroom, and Camilla
and Earl provided some late-
night food and drink. Some
pictures were taken by others
there when Camilla handed the
camera to them.

top: In the master bedroom,
left to right, Keith Richards,
Eric Clapton, and John Phillips;
Earl behind sitting in the window

right: Richards, Clapton,
Phillips, and Mick Jagger

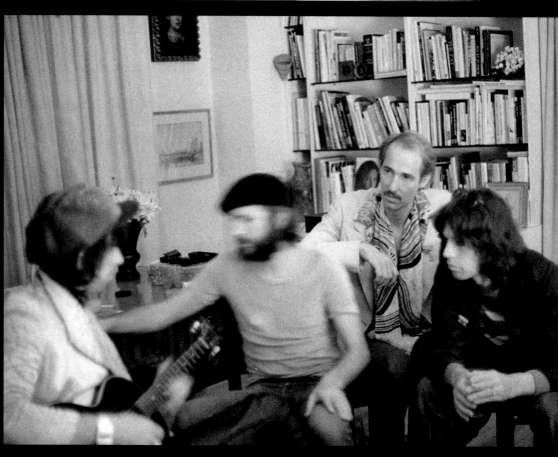

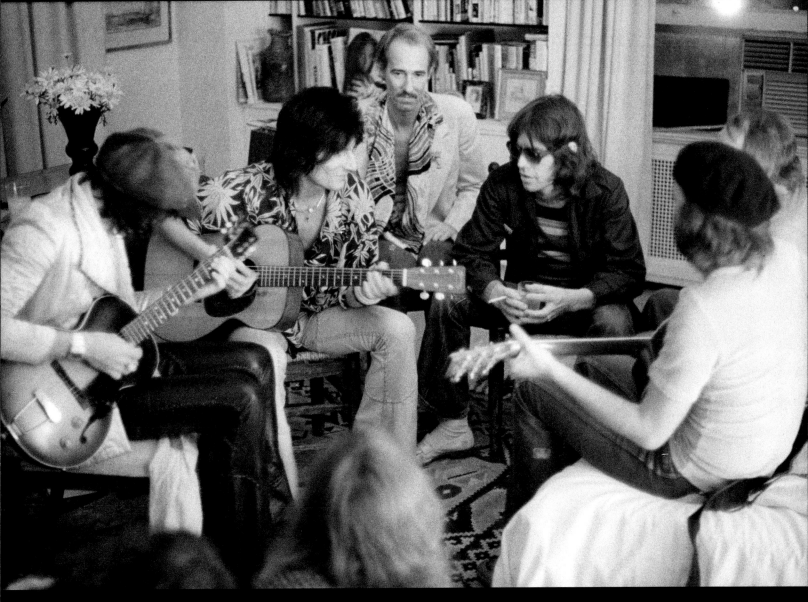

left to right, Richards, Ronnie Wood, Phillips, Jagger, with Clapton on the bed

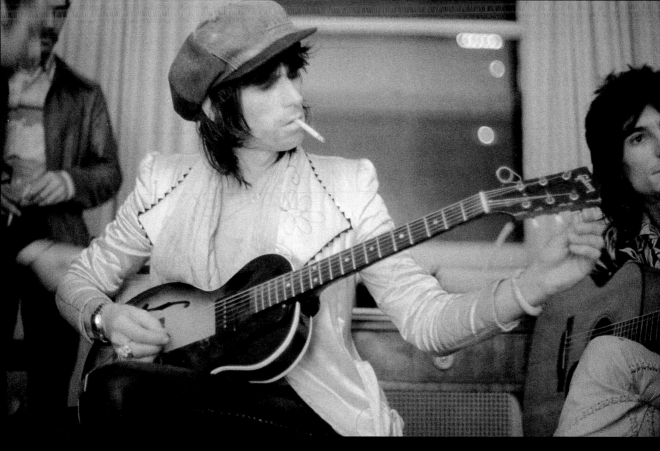

this page: Keith Richards

opposite page
top: Eric Clapton
below, left: Clapton with
Pattie Boyd
right: Geneviève Waïte

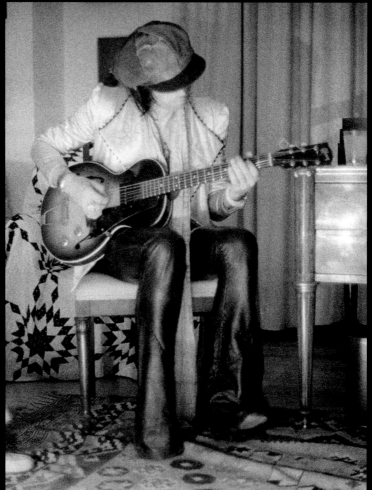

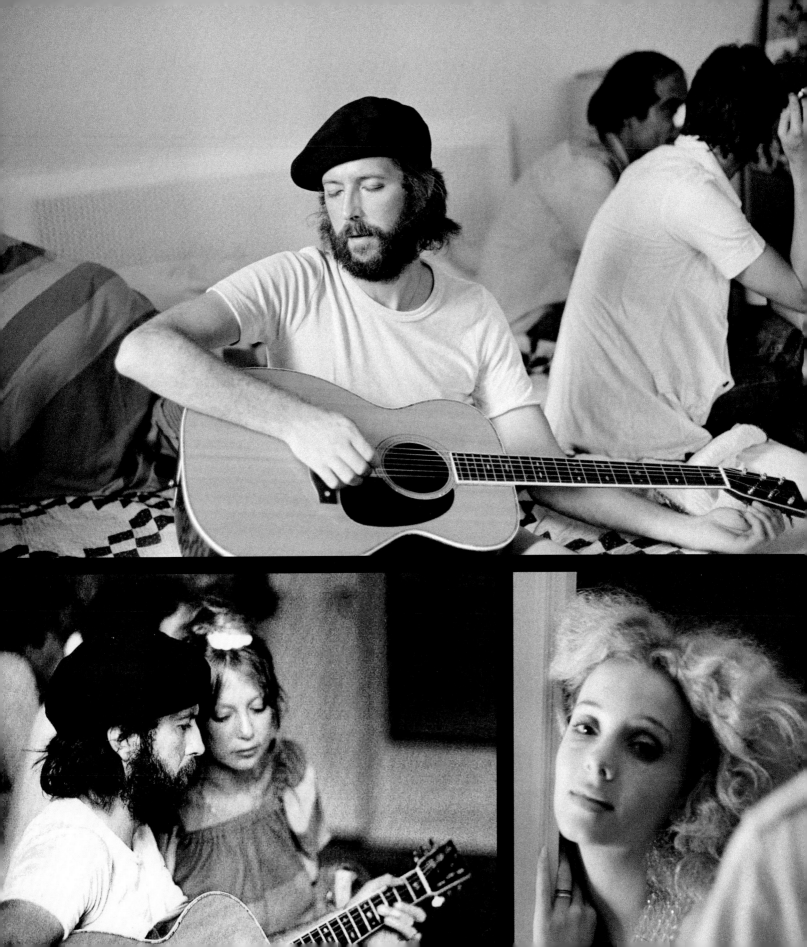

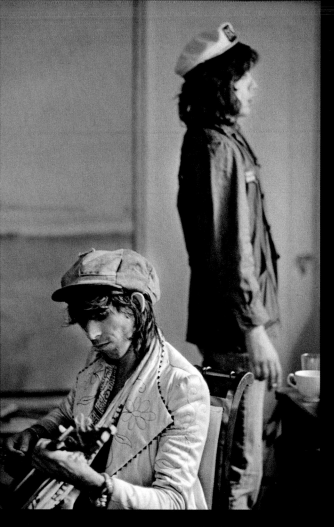

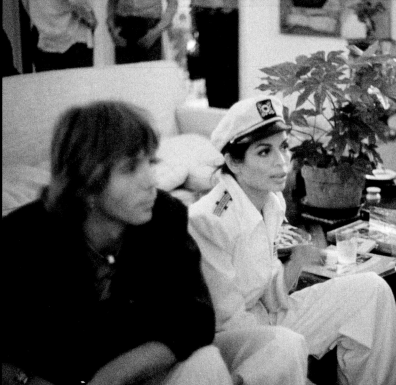

above, left: Richards and
Jagger wearing Bianca's hat

above, right: Bianca

right: photographer
Annie Leibovitz

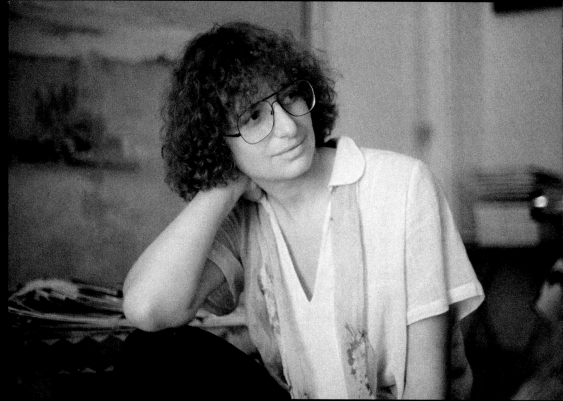

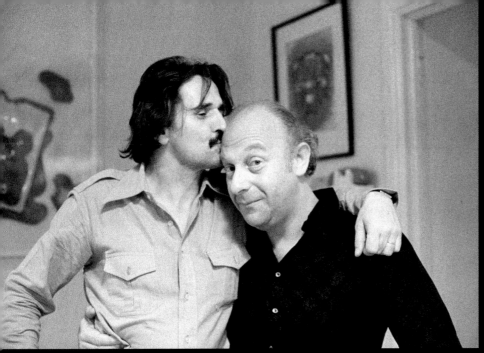

left: Earl and the Rolling Stones's longtime friend and financial manager, Bavarian blueblood Rupert Loewenstein

below: Camilla and Earl on clean-up duty after the late-night meal following the concert

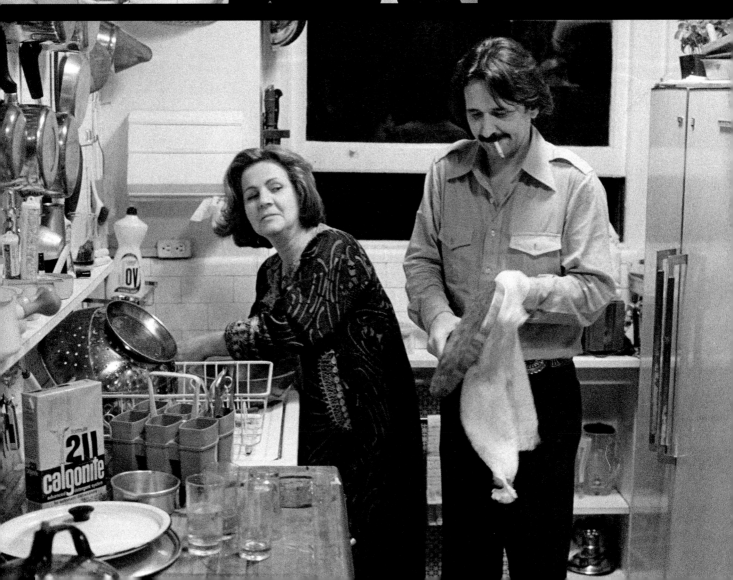

A weekend with Shelly and Vincent Fremont in Montauk at Andy Warhol's compound, July 25–26, 1976

right: Earl with Shelly and Vincent

below, left: Andy Warhol, with his daschund, Archie

below, right: Earl with Jiminy, given to him by Harrison Ford

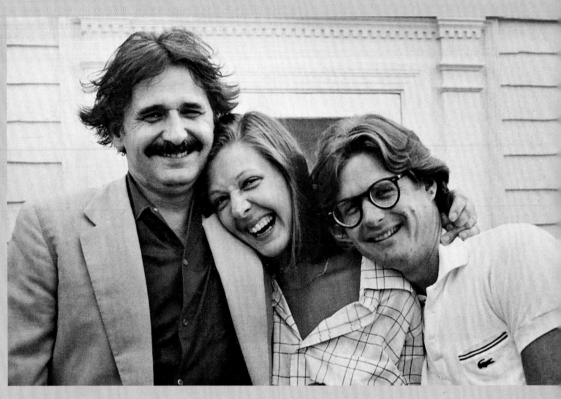

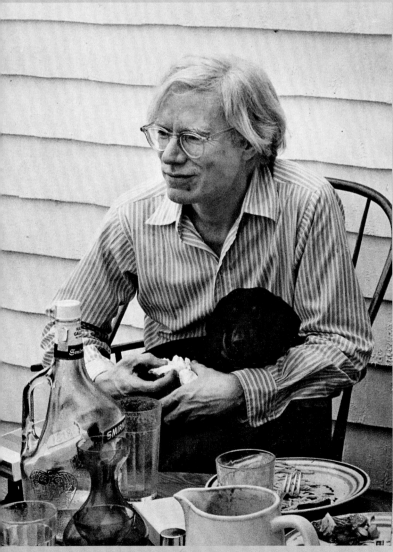

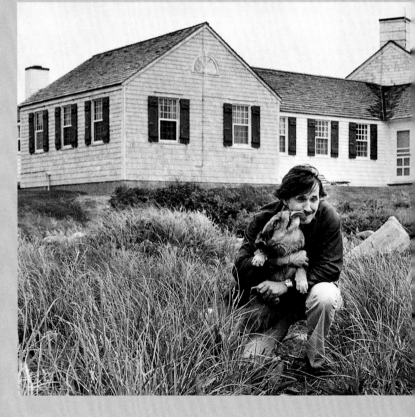

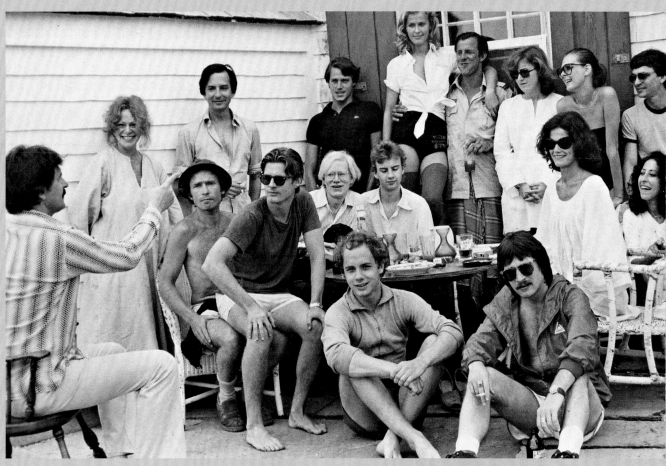

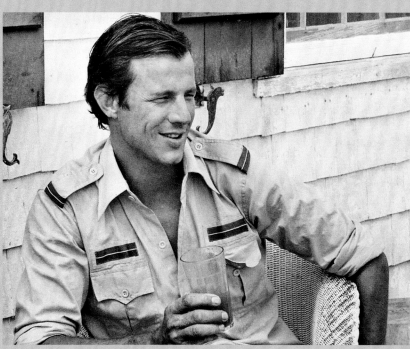

top: Earl directing the shoot: *standing, left to right,* Suzie Frankfurt, Fred Hughes, Jed Johnson, Marguerite, Peter Beard, Catherine Guinness, Shelly Fremont; *seated, left to right,* Dick Cavett, Vincent Fremont, Andy, Valentine Guinness, Barbara Allen, Jennifer Jakobsen

left: François de Menil, who was making documentaries on artists

above: Peter Beard, African adventurer and photographer

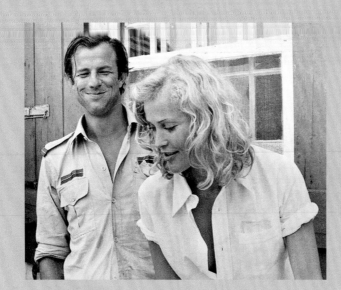

top: Peter Beard and
Marguerite, his model girlfriend

middle: *left to right*, Dick
Cavett, Vincent Fremont, Andy,
Valentine Guinness

bottom: Factory girl Barbara
Allen and Cavett

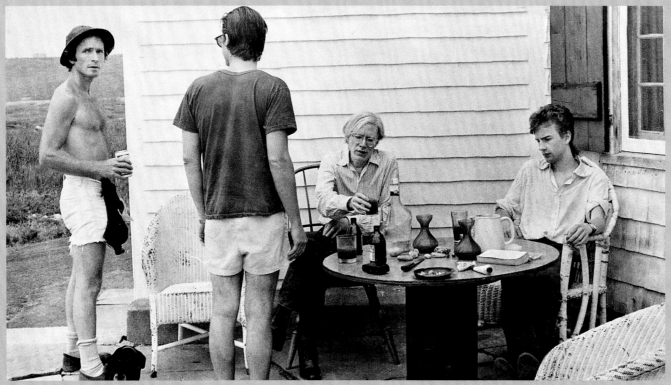

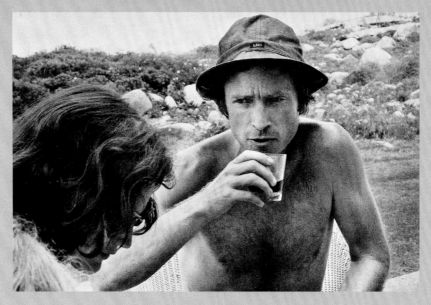

Earl and Camilla invited us to many dinners and cocktail parties at their apartment. One evening Earl hosted a party for the cast of the new film *Star Wars,* with Harrison Ford, Carrie Fisher, and Mark Hamill in attendance. The other invited guests were a who's who of Manhattan's glitterati.

In the summer, when Camilla went to Italy to visit her sisters and stay at Marlia, Earl would have us up to his place for brunches on Sunday. We had Earl and Camilla to our apartment on lower Fifth Avenue for parties and dinners as well. After we had renovated our apartment we invited Earl to come by for a drink before going out to dinner. Earl took out a dollar bill and asked for some tape, and then quickly taped the dollar to the side of the new custom cabinet in the kitchen for good luck, like people do when a restaurant opens up.

It was always difficult to get Earl and Camilla to come out to Long Island, even in the 1970s when we would invite people to stay at Andy's compound in Montauk and it was a much-sought-after invitation. I remember just two occasions Earl stayed in Montauk, once with Camilla and another time when Mick Jagger was renting the place. Camilla took a wonderful photo of Earl sitting in a chair pointing his finger at a group of us. It was on the stone porch of the main house facing the ocean, and in the photo are Andy; Peter Beard and his blond Swedish girlfriend, Marguerite; Barbara Allen; Suzie Frankfurt; Jed Johnson; me sitting on Dick Cavett's lap; Shelly; Fred Hughes; Catherine Guinness and her brother Valentine; and a few others. On the other occasion, when he stayed alone with his dog, Jiminy, Earl's mischievous side came out. We were having drinks after dinner one evening when Earl thought it would be a brilliant idea for Mick, him, and me to visit Dick Cavett that night. Cavett and his wife, Carrie Nye, lived in one of the Stanford White houses on a bluff overlooking the ocean. Cavett would often show up at the edge of Andy's property on the ocean side and stand waiting to be invited to come in. Lee Radizwill had rented the main house in 1972 and 1973 and gave Andy a flag-pole as a surprise for his birthday. Once it was installed, we ran up the Stars and Stripes every morning. When Dick saw the flag he knew we were there, and that there was a good chance one of Andy's guests or visitors might be a potential guest for his talk show.

That dark, moonless night, however, for some reason Mick and I agreed to Earl's suggestion to walk to Dick's house by way of the beach and then climb up the steep cliff to the house. We couldn't see a thing, and it took much longer than we'd thought it would. It must have been nine or ten when we approached the house unannounced and rang the door-bell. A male houseguest of the Cavetts', wearing a caftan, warily opened the door, and behind him in the living room was Cavett. Dick sees Mick Jagger standing there and quickly asks us to come in. Carrie Nye came downstairs to join us for a round of drinks and conversation. After a while it was getting late and we decided we should leave, but we did not want to go back the way we came. Mick called John Phillips of the Mama and the Papas, who was staying at one of the cottages at the compound, and John managed to drive over and pick us up— who knows what kind of condition he was in! But we made it back safely.

———

Besides Andy, Earl was, in a way, one of my mentors, and I would often go to his apartment after work and ask for his advice. I remember when I turned thirty, I was trying to figure out if I was on the right trajectory working on TV ideas with Andy and other art-related projects as well as running his studio. I was restless, and Earl helped me realize I was doing the right thing. Andy, who was always incredibly intuitive, sensed my angst and wrote me a bonus check out of the blue around that time to let me know he cared that I was working with him.

On one of those visits to his apartment while Camilla was away Earl started an impromptu cocktail party, with various people showing up, like Lisa Robinson, the rock 'n' roll journalist. I called Shelly to let her know I would be home soon; I did this a number of times as the evening progressed, with Earl's friends coming and going. I finally stopped calling and—a big mistake—went with Earl and the group to the Russian Tea Room across the street for dinner, then back to his apartment. I ended up the last one at Earl's, going downstairs to walk with him and his dog, Jiminy. I got home about three a.m. and Shelly was hopping mad. The next day she went out and bought a very expensive pair of shoes. Yes, Earl could get you into trouble quite easily, but it was always fun.

—VINCENT FREMONT

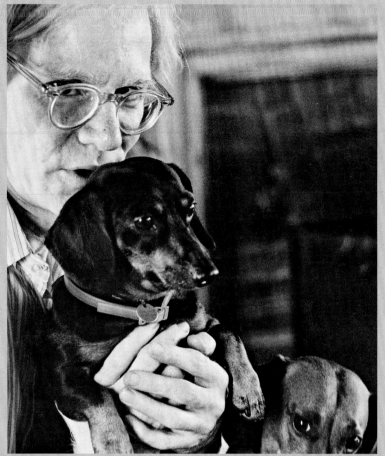

right: Andy in Montauk, holding
dacshund Archie, with Amos
below, 1977

below: Andy in the kitchen
in Montauk

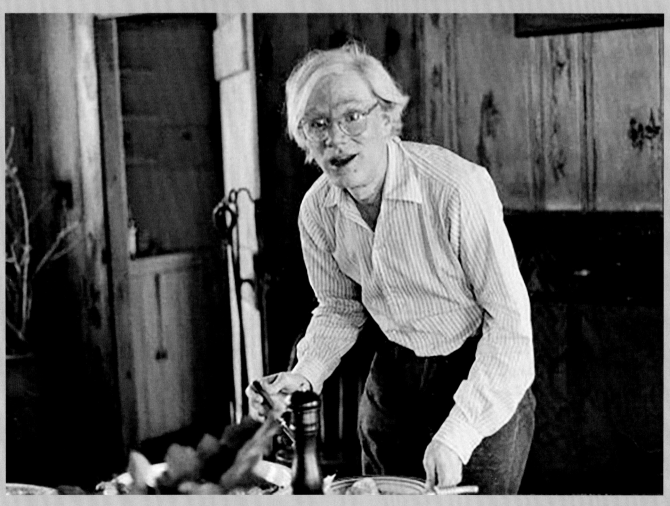

At the Costume Institute in the Metropolitan Museum of Art, 1977. Diana Vreeland, former *Vogue* editor-in-chief, was Special Consultant from 1972 to 1989

A lunch for Cy Twombly in the New York apartment

opposite, top left: Beatrice von Rezzori and Twombly; top right: Maria Teresa Train and a guest

top: *left to right,* Alessandro Twombly, Odette Benjamin, and Earl

below: *left to right,* Twombly, Earl, and Ahmet Ertegun

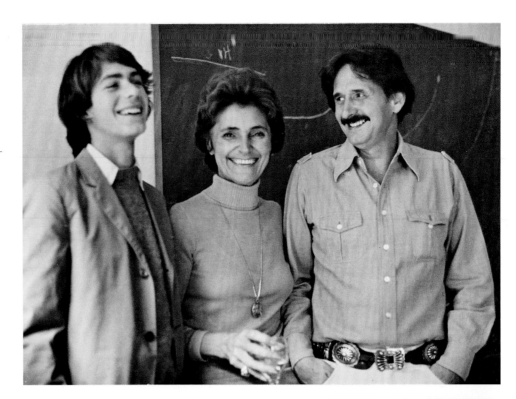

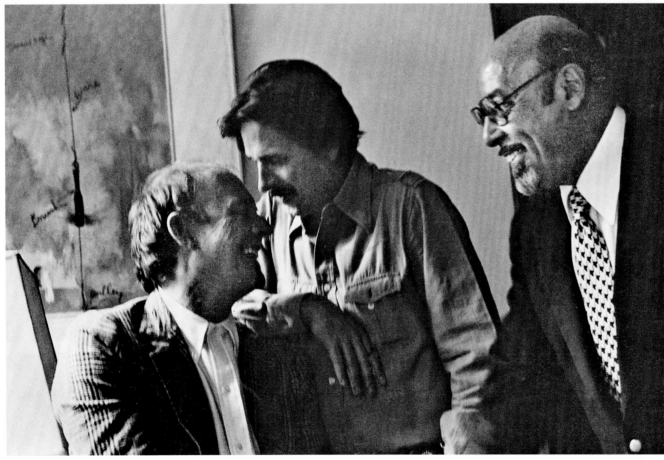

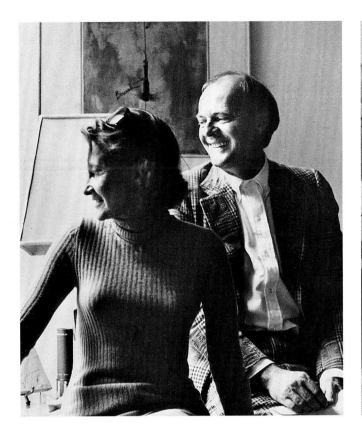

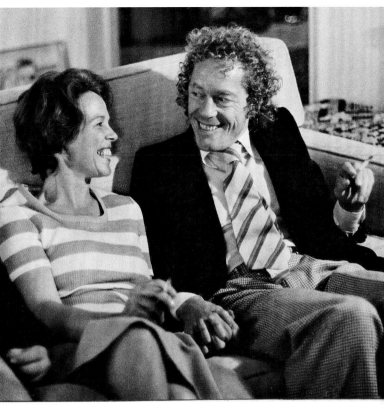

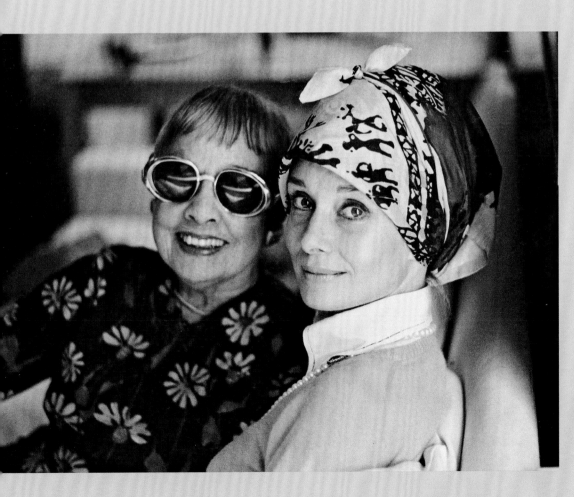

Audrey Hepburn and Anita
Loos, screenwriter, playwright,
and author of *Gentlemen Prefer
Blondes,* lived in the same
apartment building on West
Fifty-Seventh Street as Earl
and Camilla

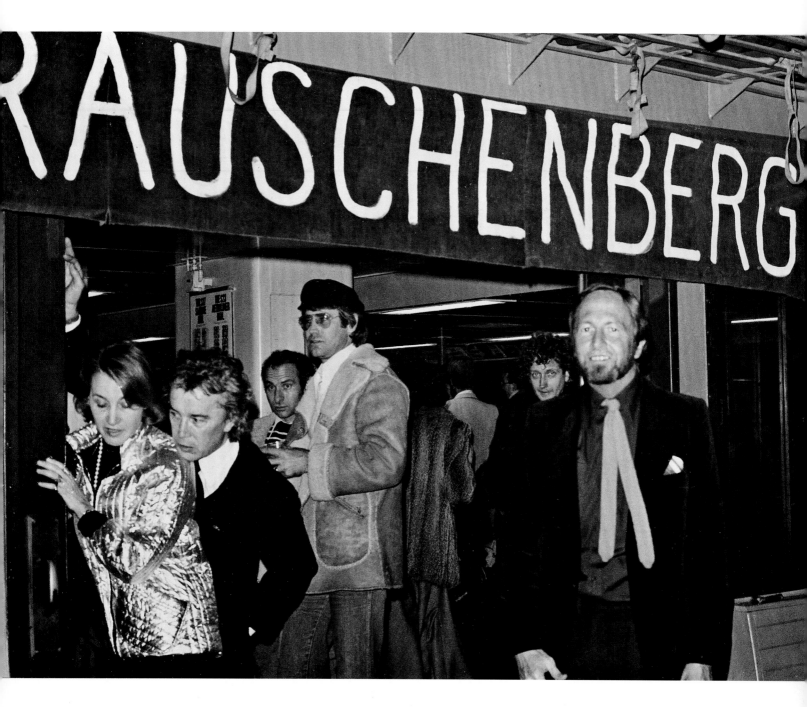

RAUSCHENBERG

After the opening of Robert Rauschenberg's show at MoMA in 1977, there was a party on the Staten Island ferry given by Stanley Grinstein and Sidney Felsen, founders of the printmaking studio Gemini G.E.L.

above: *left to right,* Beatrice von Rezzori; poet, playwright, songwriter, and novelist Michael McClure; and Robert Rauschenberg

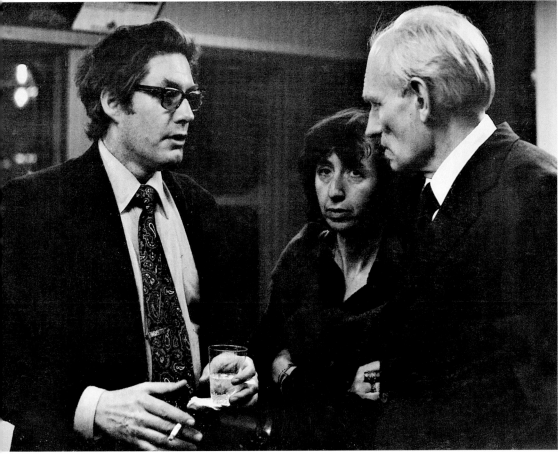

top, left: Maxime de la Falaise McKendry with Rauschenberg. Maxime grew up in high British bohemia with portraitist Sir Oswald Birley as her father; her younger brother, Mark, founded the exclusive nightclub Annabel's. She worked for Schiaparelli, wrote a food column for *Vogue,* and had many lovers, including Duff Cooper and Louis Malle.

above: Cy Twombly

bottom: *left to right,* Museum director and curator Walter Hopps, who founded the Ferus Gallery with Ed Kienholz in 1957; Julie Martin, the director of Experiments in Art and Technology (EAT), founded by Rauschenberg, Robert Whitman, Billy Klüver, and Fred Waldhauer; and Klüver, Martin's husband

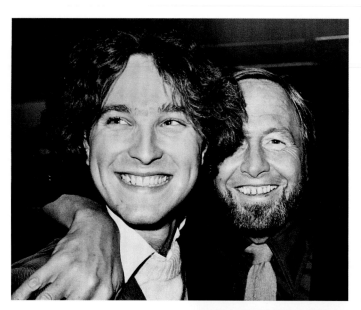

top, left: Andrea di Robilant and Rauschenberg

top, right: Watercolorist Teddy Millington-Drake lived in Tuscany and Patmos and was a close friend of interior designer John Stefanidis, writer Bruce Chatwin, and Beatrice von Rezzori, pictured here.

right: Picasso biographer John Richardson with Boaz Mazor

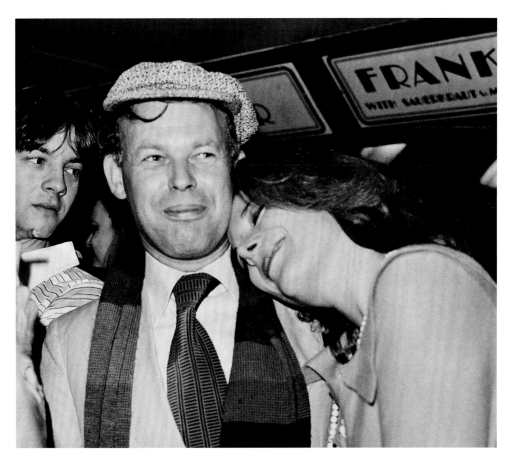

left: Mark Lancaster, an English artist and set designer, was assistant to Jasper Johns from 1974 to 1985; in 1975 he became resident designer for the Merce Cunningham Dance Company. Maxine Groffsky worked at *The Paris Review*, in its Paris years, 1965–74, and at Random House under Bennett Cerf; she later became a literary agent and a close friend of Philip Roth's.

below: Artist Kiki Kogelnik, art dealer Brooke Alexander, "social butterfly" Jerry Zipkin, and Clarice Rivers

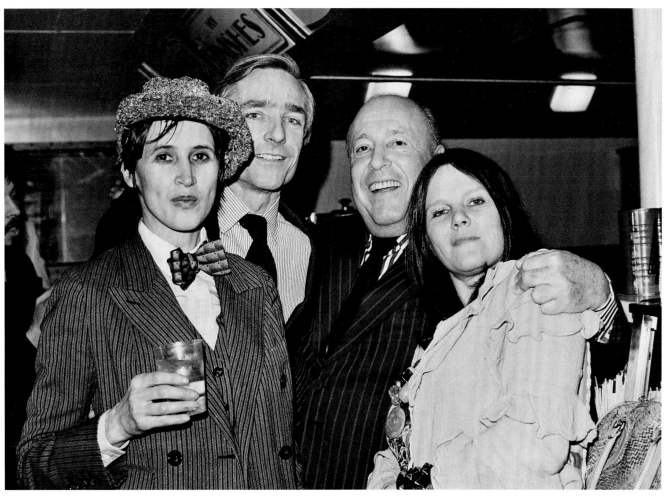

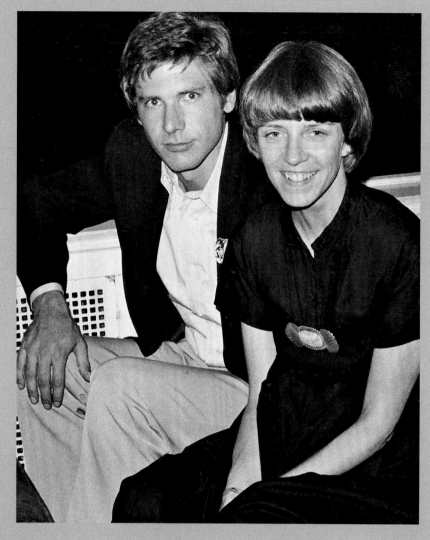

**The *Star Wars* party at the
McGraths', June 30, 1977**

opposite: Carrie Fisher and
Harrison Ford

top: Harrison Ford with
his wife, Mary Marquardt

bottom: Griffin Dunne
and Harrison Ford

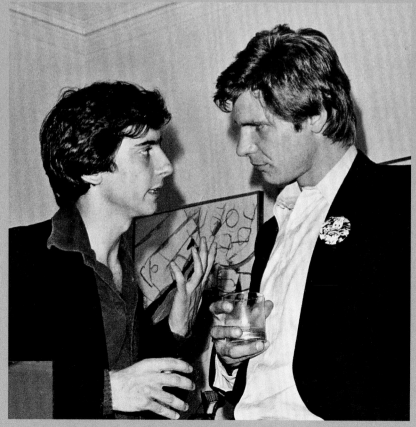

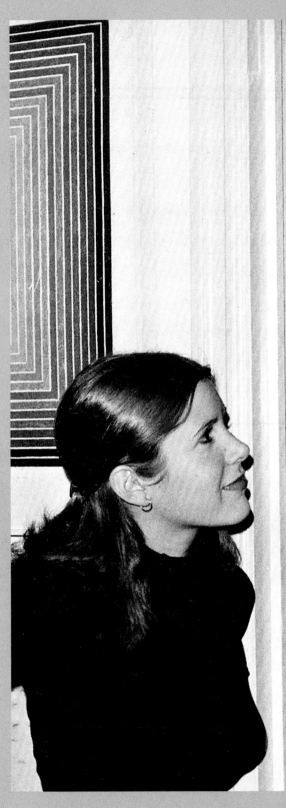
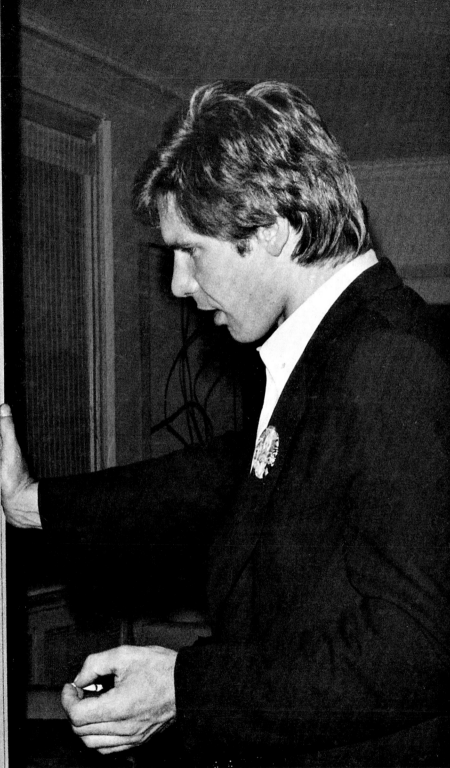

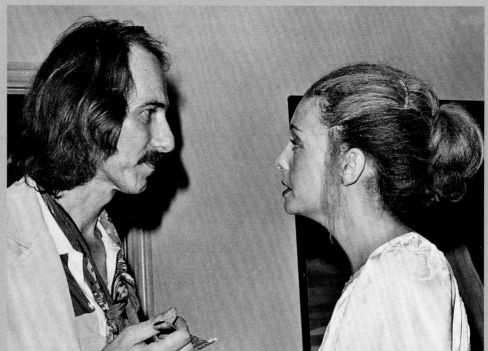

right: John and Geneviève Waïte Phillips; below: *left to right*, Griffin Dunne, Earl, John Phillips, Jann Wenner

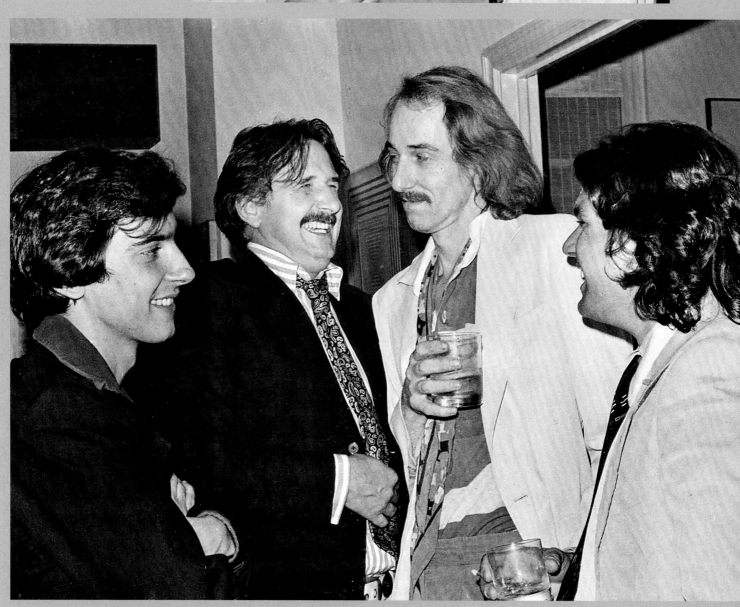

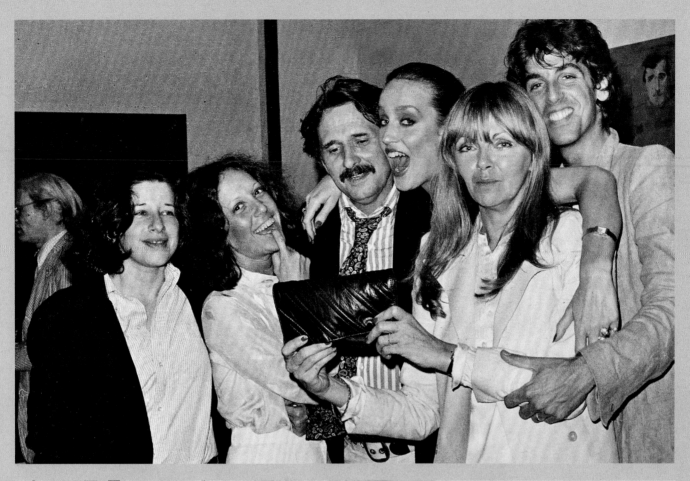

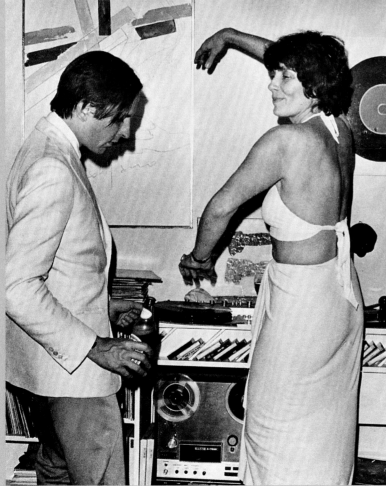

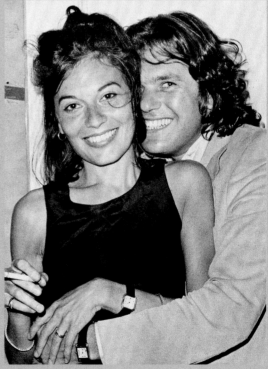

top: *left to right*, Andy Warhol, Fran Lebowitz, music journalist Lisa Robinson, Earl, Jerry Hall, Marc Balet, art director of *Interview*, and Adrianne Hunter

above, right: Jane and Jann Wenner

above, left: Fred Hughes dancing with designer Jackie Rogers

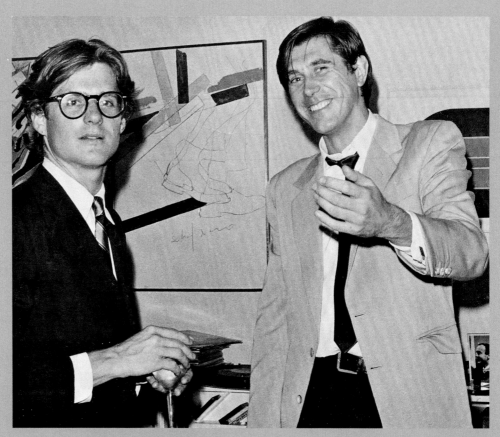

right: Vincent Fremont and Bryan Ferry

below: *left to right*, Fran Lebowitz, Marc Balet, Shelly Fremont, and Griffin Dunne

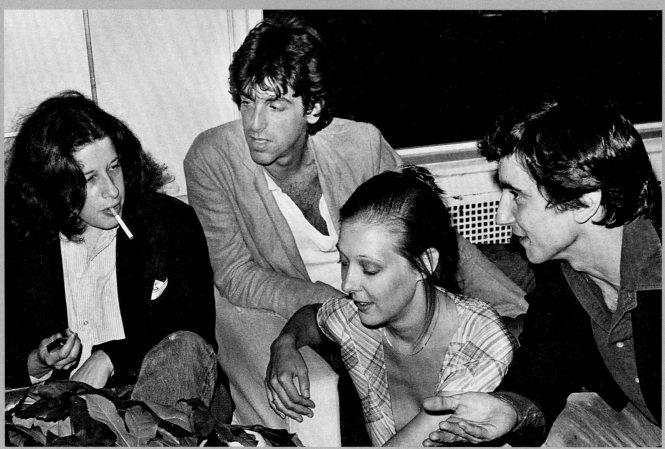

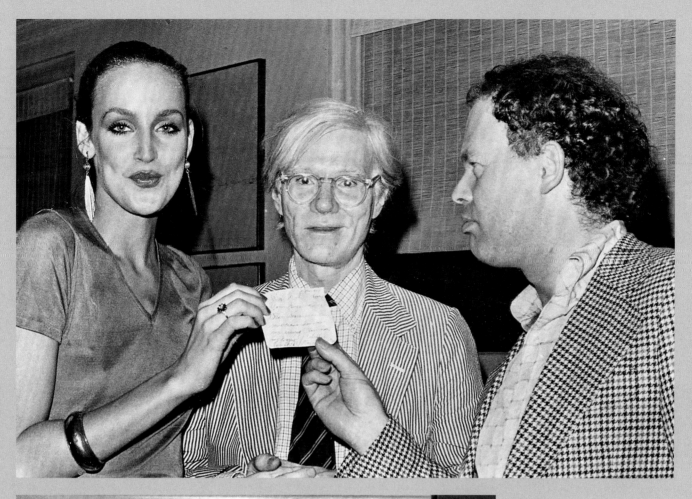

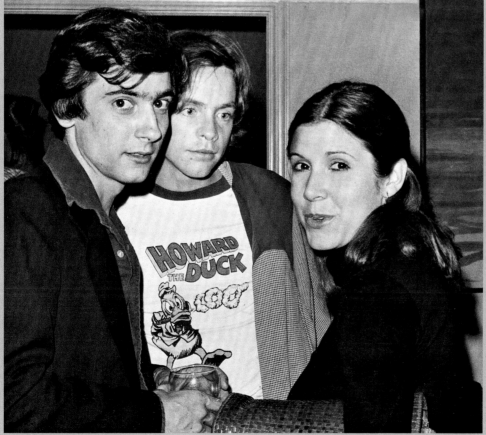

top: *left to right*, Jerry Hall, Warhol, and Mark Lancaster

bottom: *left to right*, Griffin, Mark Hamill, and Carrie Fisher

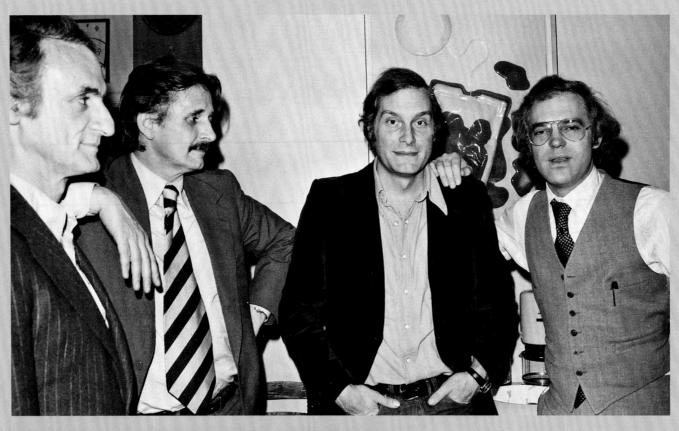

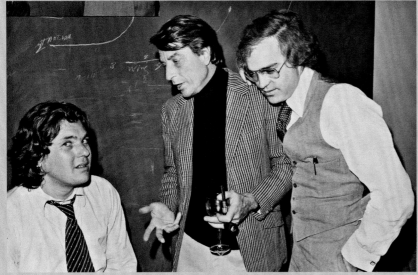

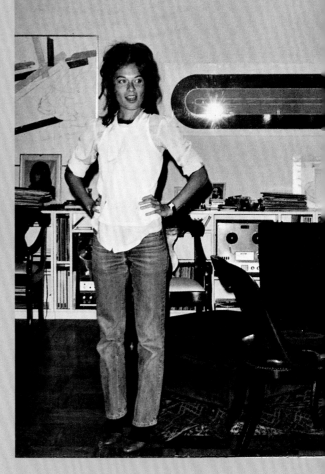

Earl's birthday, December 1, 1977, on Fifty-Seventh Street

top: *left to right,* Larry Rivers, Earl, director Barbet Schroeder, François de Menil

above: Jann Wenner, art director Dick Sylbert, François de Menil

right: Jane Wenner

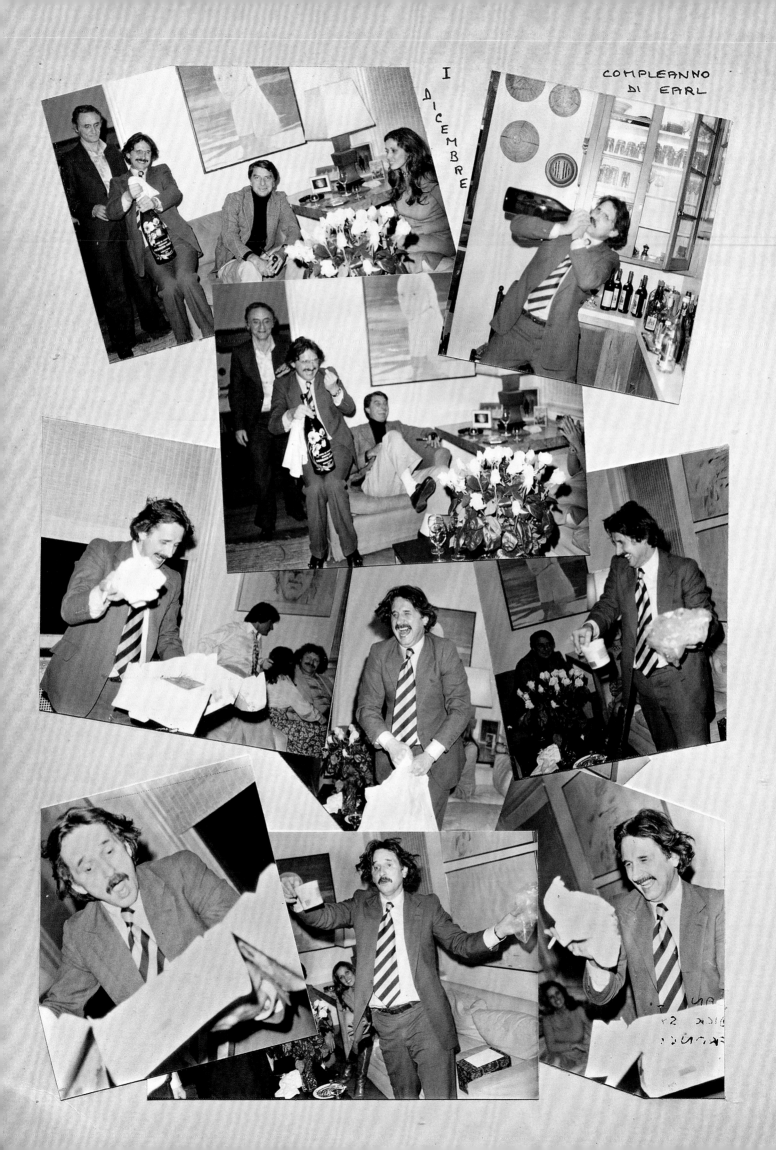

I DICEMBRE

COMPLEANNO DI EARL

A dinner on Fifty-Seventh Street, December 6, 1977

right: Mark Lancaster and Marian Javits, art patron and wife of the New York senator

below: *left to right*, Jann Wenner, writer Terry Southern, and Jean Stein, author of *Edie*

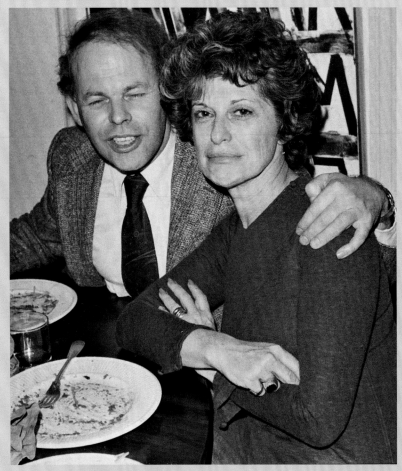

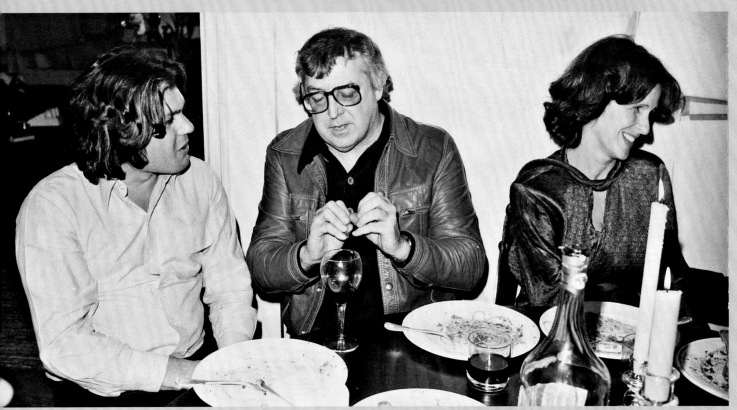

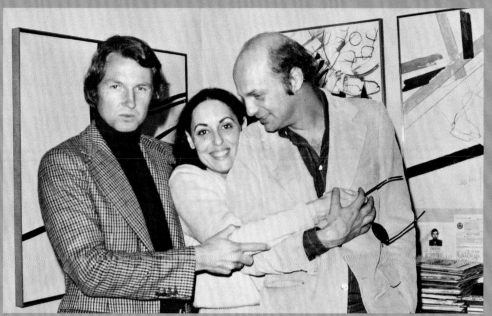

A dinner on West Fifty-Seventh, May 14, 1978

top: *left to right*, George Butler, the director of *Pumping Iron;* production designer and art director Toby Carr Rafelson of *Five Easy Pieces* and *Alice Doesn't Live Here Anymore;* and novelist and screenwriter Rudy Wurlitzer

below: *standing*, Peter Wolf, lead singer of the J. Geils Band; *seated, left to right*, Basil Comnas, Beatrice von Rezzori, Earl, and Isabel and Freddy Eberstadt

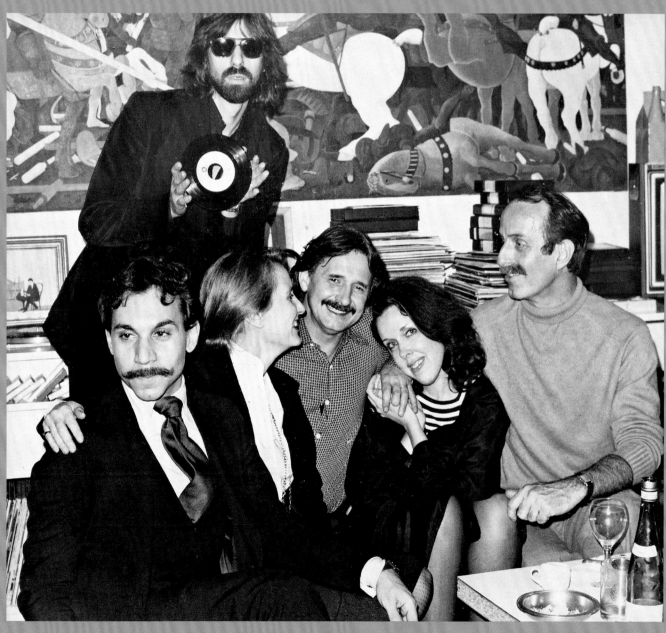

**Thanksgiving on Fifty-Seventh
Street, 1978**

top: *left to right,* Earl,
Keith Richards, Bryan Ferry

below: Jane Wenner and
Bryan Ferry

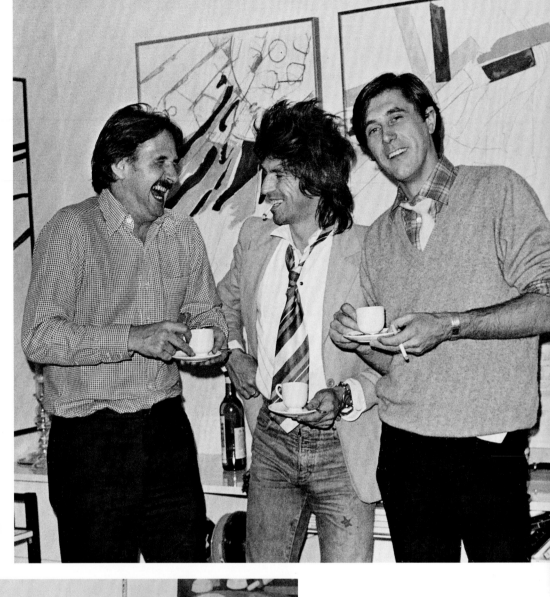

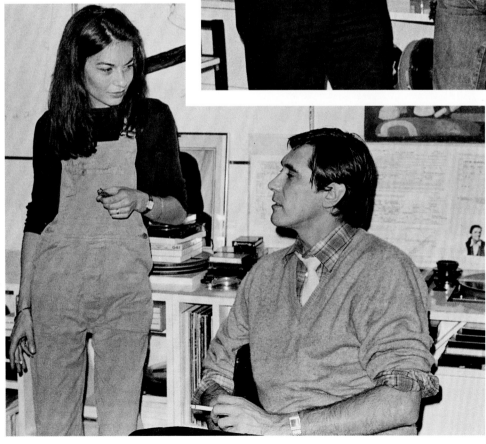

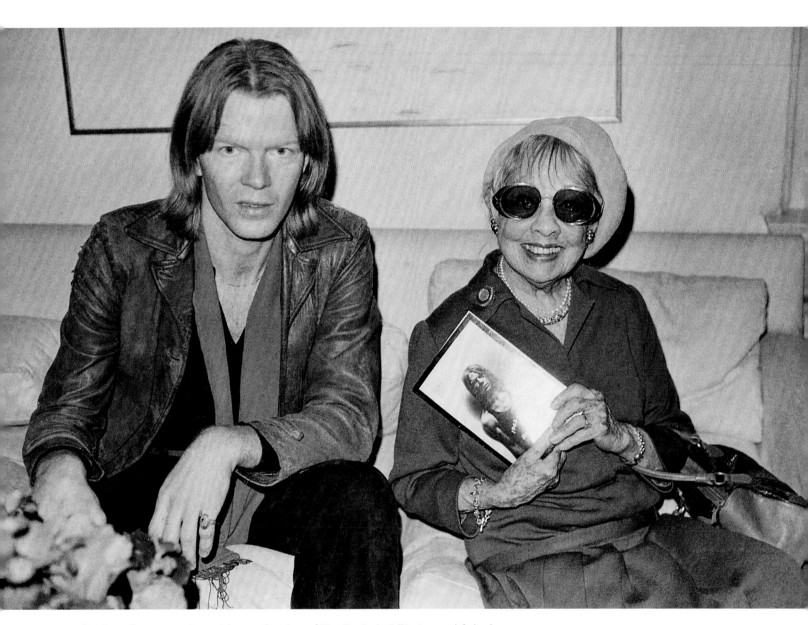

Jim Carroll, poet, punk musician, and author of *The Basketball Diaries,* and Anita Loos

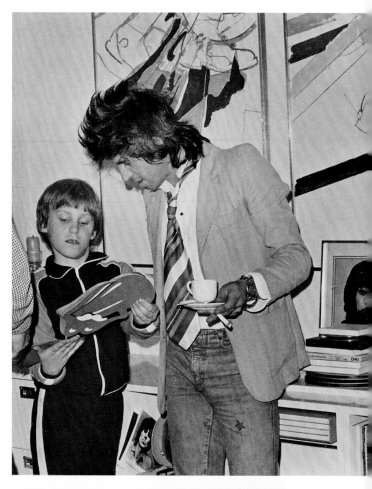

top, left: Actress and Rolling Stones muse Anita Pallenberg with Marlon, one of her three children

top, right: Marlon and his dad, Keith Richards

below: Earl being Earl with Camilla

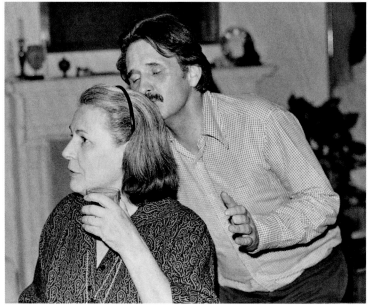

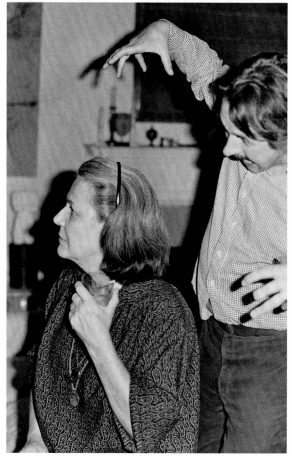

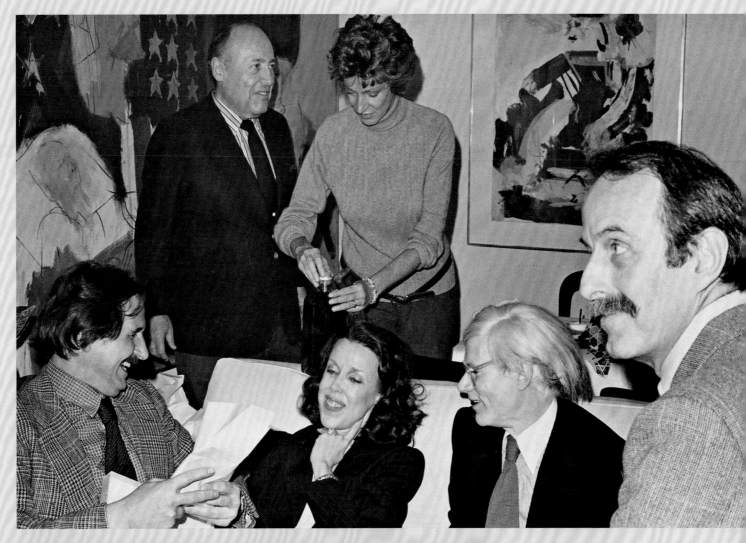

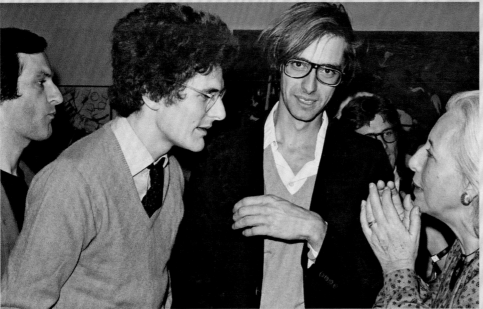

**Christmas lunch on
Fifty-Seventh Street, 1978**

top: *standing, left to right,*
Jerry Zipkin and Marella Agnelli;
seated, Earl; Isabel Eberstadt,
the daughter of poet Ogden
Nash and a Warhol muse in his
films; Andy Warhol; and Freddy
Eberstadt

below: *left to right,* Steve
Rivers, Larry's son; writer
Alain Elkann, then husband of
Margherita Agnelli; architect-
to-be Pietro Cicognani; and
artist Marie Laura Vinci

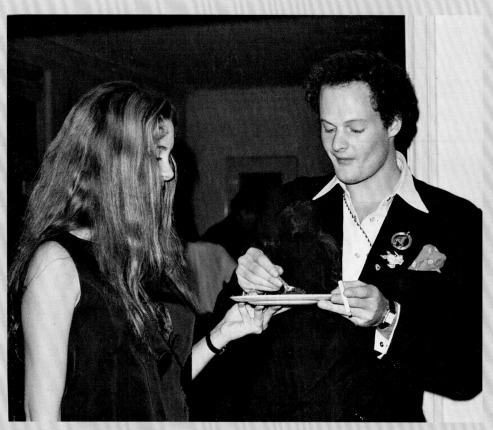

right: Fernanda Eberstadt, who would become a writer, and Harry Fane, who had just started his private London gallery, Obsidian, for vintage objets d'art

below: Marella Agnelli and Larry Rivers

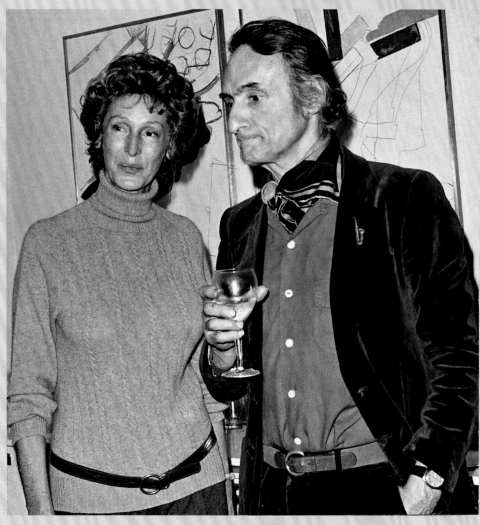

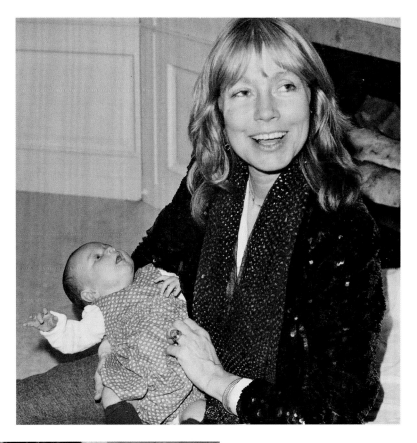

At the apartment of Isamu Noguchi's longtime companion, Priscilla Morgan, December 31, 1978

Artists Helen Marden and Brice Marden, with their daughter, Mirabelle

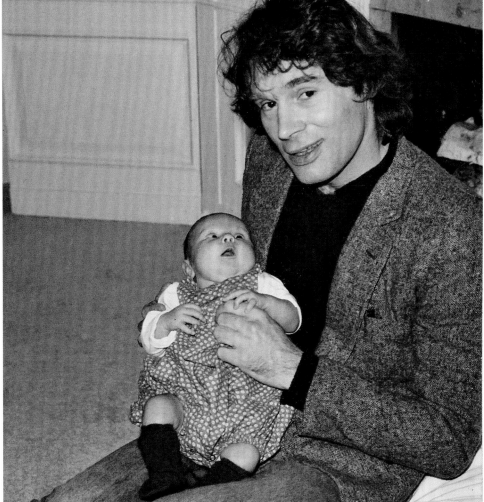

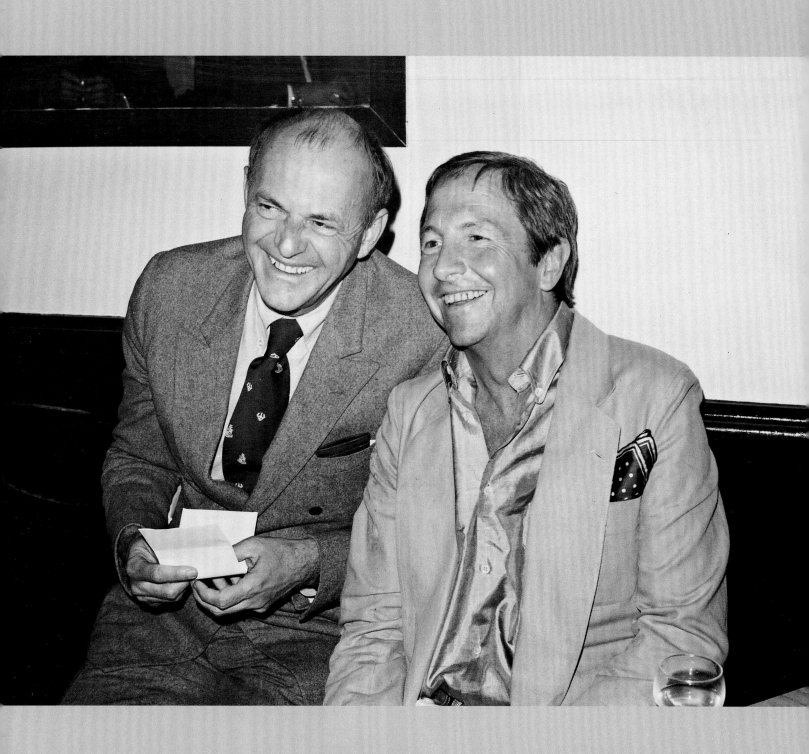

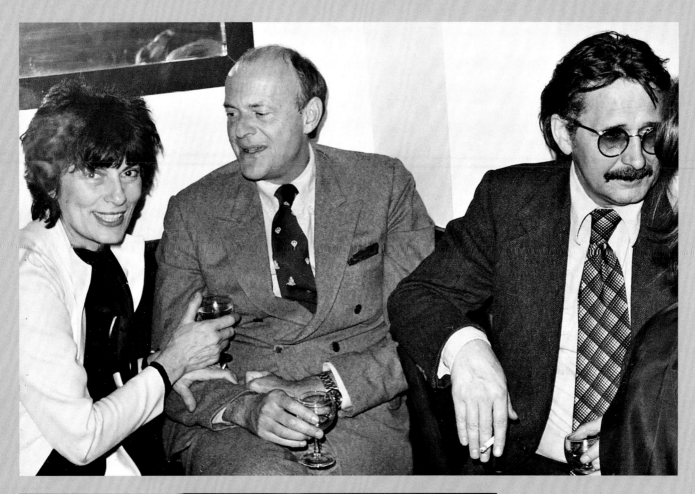

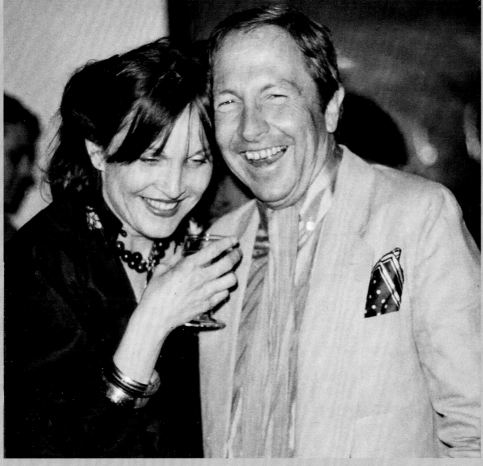

Twombly retrospective at the Whitney, April 10, 1979

opposite: Twombly and Rauschenberg

above: *left to right*, Jackie Rogers, Twombly, and Earl

below: Rauschenberg and Betty di Robilant

Lunch for the Twomblys on Fifty-Seventh Street

top: *left to right*, Twombly; Paul Peralta-Ramos, founder of the Millicent Rogers Museum in Taos in honor of his mother; and Freddy Eberstadt

below: *left to right*, Pietro Cicognani, Sabrina Guinness, Hiroshi Kawanishi, Jerry Hall, Andrea di Robilant, Earl, Alessandro Twombly, and Tomas Milian Jr.; back row: *left to right*, Enrico d'Assia; Betty di Robilant; and Tomas Milian, the Cuban-born actor with a big career in Italian films, including those of Visconti and Bertolucci

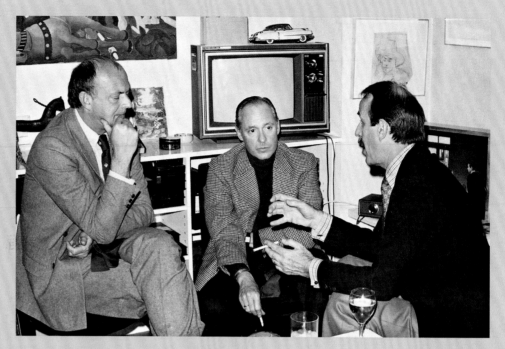

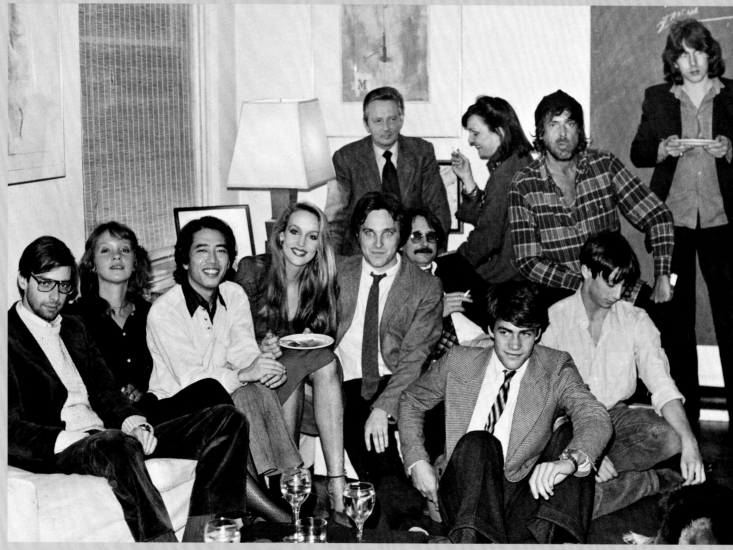

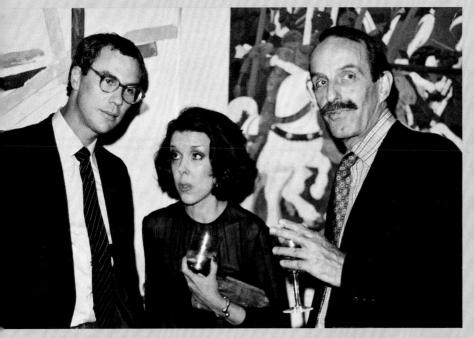

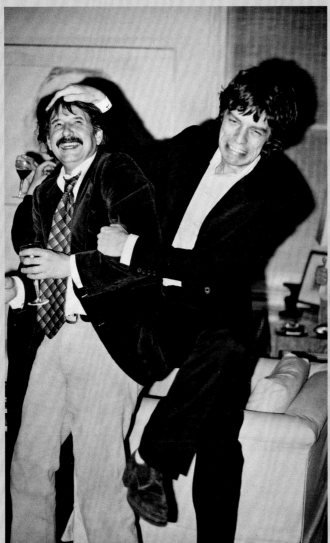

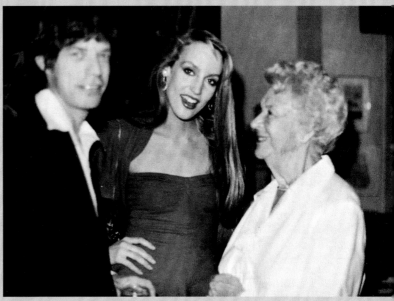

top, left: Playwright and
director Robert Wilson with
Isabel and Freddy Eberstadt

top, right: Enrico d'Assia with
Twombly's wife, Tatia

bottom, left: Earl and
Mick Jagger

bottom, right: Mick, Jerry Hall,
and Cy Twombly's mother

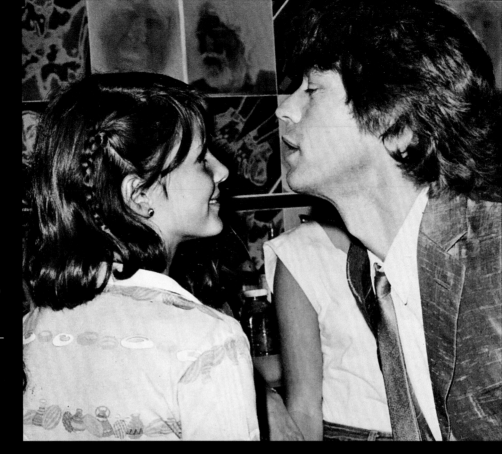

The Rolling Stones and Rolling Stones Records gave a party at the original Danceteria on West Thirty-Seventh Street to celebrate the release of their new album, *Emotional Rescue*.

top: Emma Rivers and Mick Jagger

below: Mick and Gwynne Rivers

opposite: *left to right,* Jim Carroll, Earl McGrath, and Mick Jagger

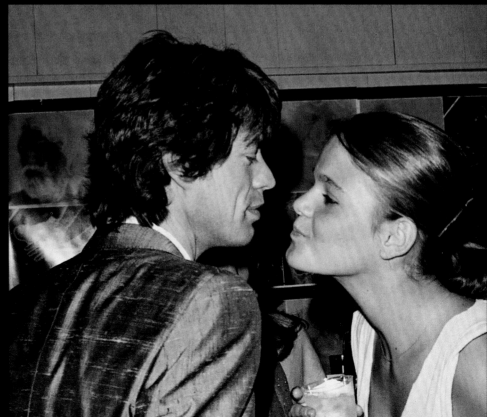

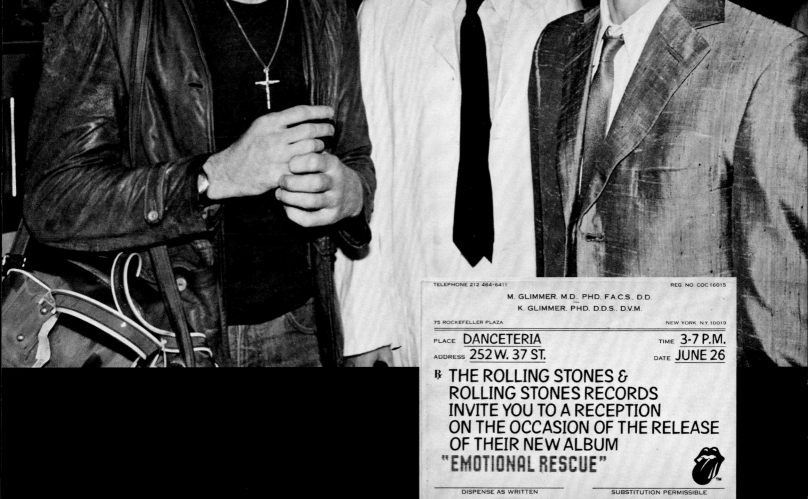

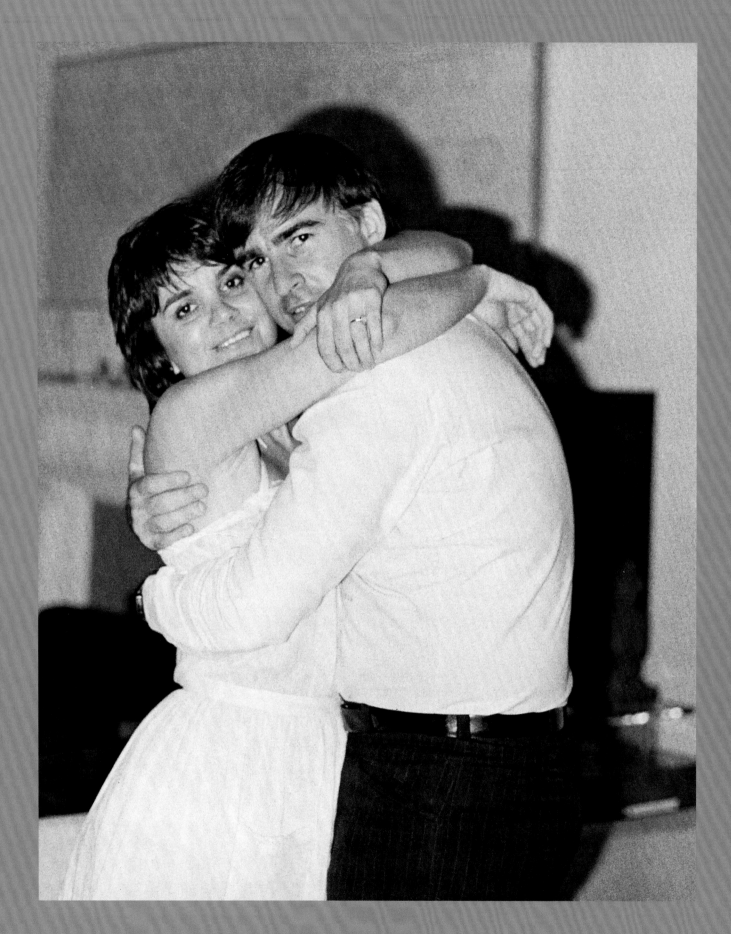

July 1980: Linda Ronstadt and Governor Jerry Brown, on Fifty-Seventh Street

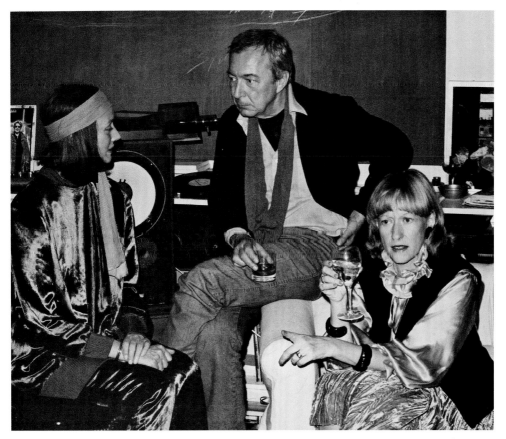

A lunch on Fifty-Seventh Street, November 6, 1980

top: *left to right*: Niki de Saint Phalle, Jasper Johns, and art historian and critic Barbara Rose, married to Jerry Lieber

below, left: Art dealer Irving Blum, who with Joe Helman opened the Blum Helman Gallery in New York in 1972, and Brooke Hayward, who had written *Haywire* in 1977

below, right: *left to right*, Jerry Leiber, the lyricist who with Mike Stoller had written such hits as "Hound Dog," "Stand By Me," and "Yakety Yak," as well as songs for the Drifters and the Coasters; artist Helen Marden; and Andrea di Robilant

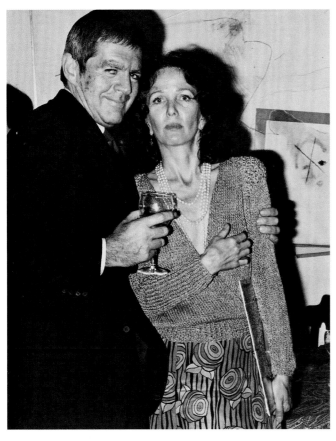

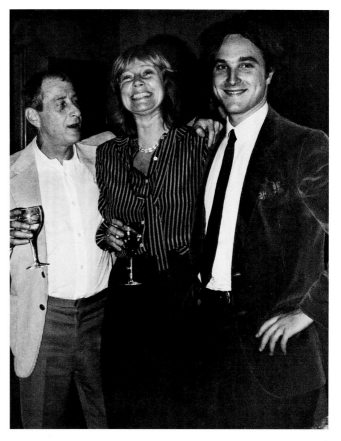

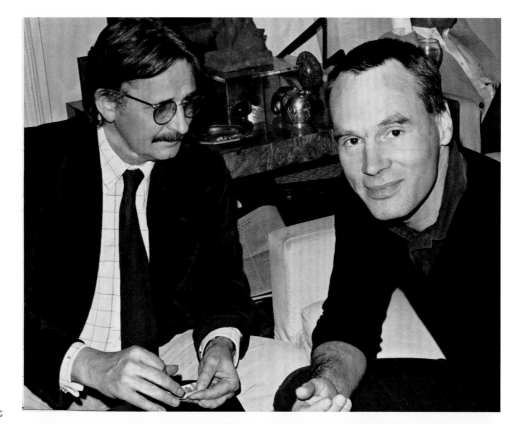

top: Earl and Brice Marden

bottom: Writer Terry Southern and Jerry Leiber

opposite, top left: Diana Vreeland's grandson Nicky Vreeland, who later became a Tibetan Buddhist monk; top right: Jasper Johns

opposite, bottom: *back row,* artist Ron Cooper and architect Madge Bemiss; *front,* art dealer Irving Blum; artist Ellen Phalen; her husband, sculptor Joel Shapiro; and Richard Diebenkorn

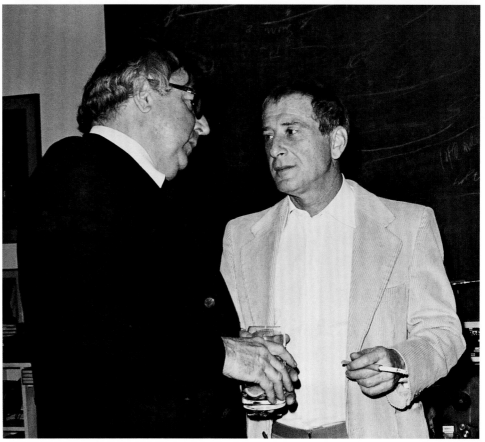

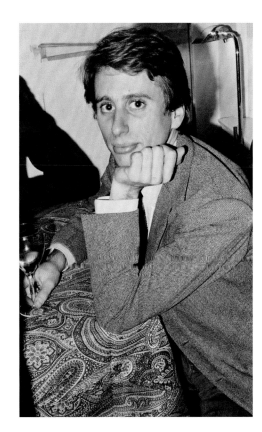

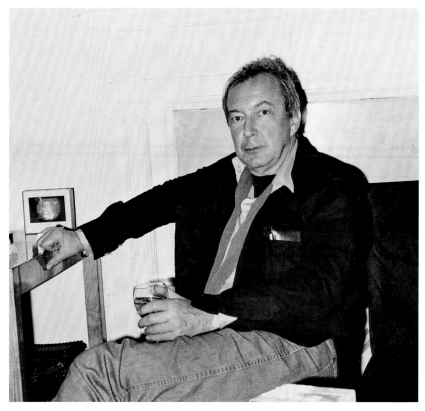

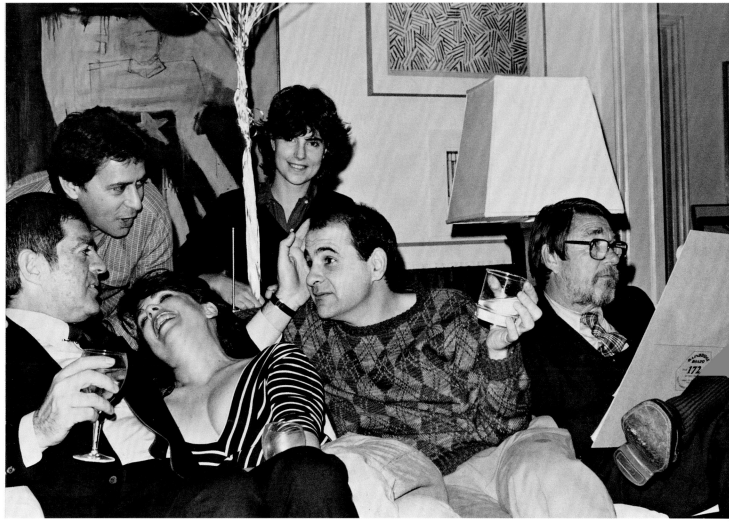

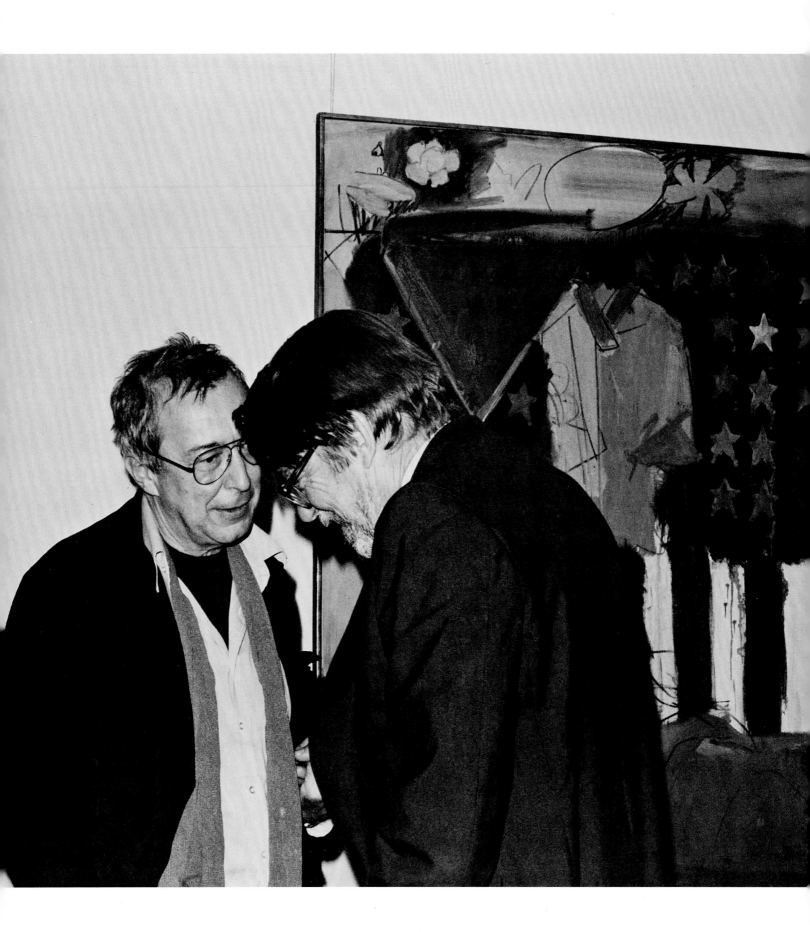

opposite: Jasper Johns and
Richard Diebenkorn

this page: Diebenkorn drawing
Johns

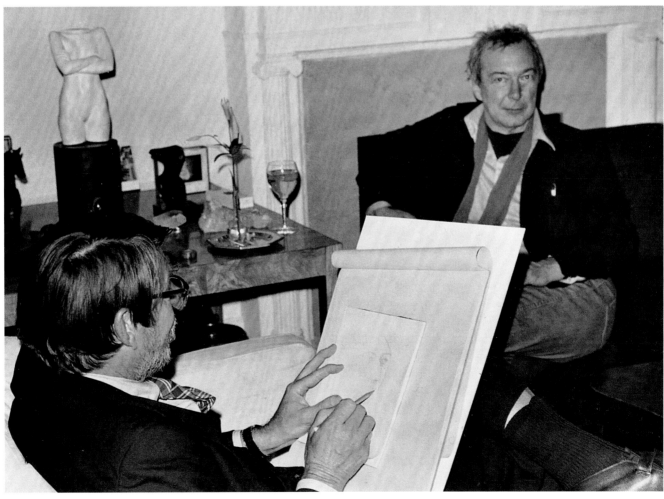

**Jerry Hall's baby shower
at home in New York,
December 19, 1983**

front row, left to right, Liz
Derringer, Geraldine Smith,
Mick Jagger, Rosy Hall, Rana;
second row, left to right, Billie
Blair, Chris Royer, Cindy Hall
Lehman, Jerry Hall, Daphne
Hall, Joanna Ellis; *third row,*
Bonny Burn; *back row, left to
right,* Vivian Marshall, Tina
Chow, Fran Lebowitz, Lisa
Robinson, Barbara Bennett,
Clarice Rivers, Bethann
Hardison

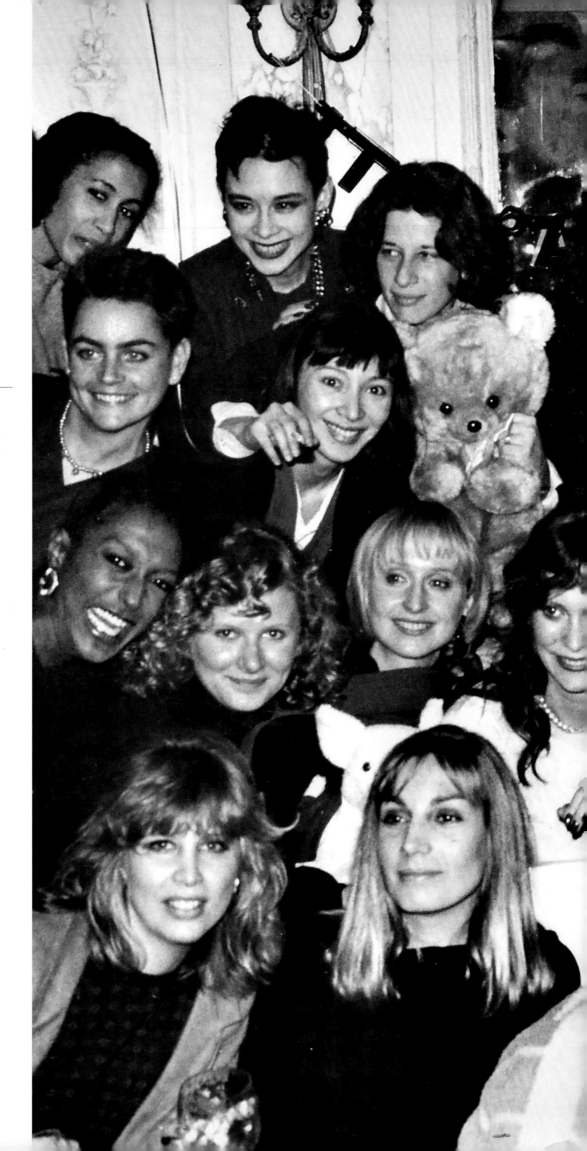

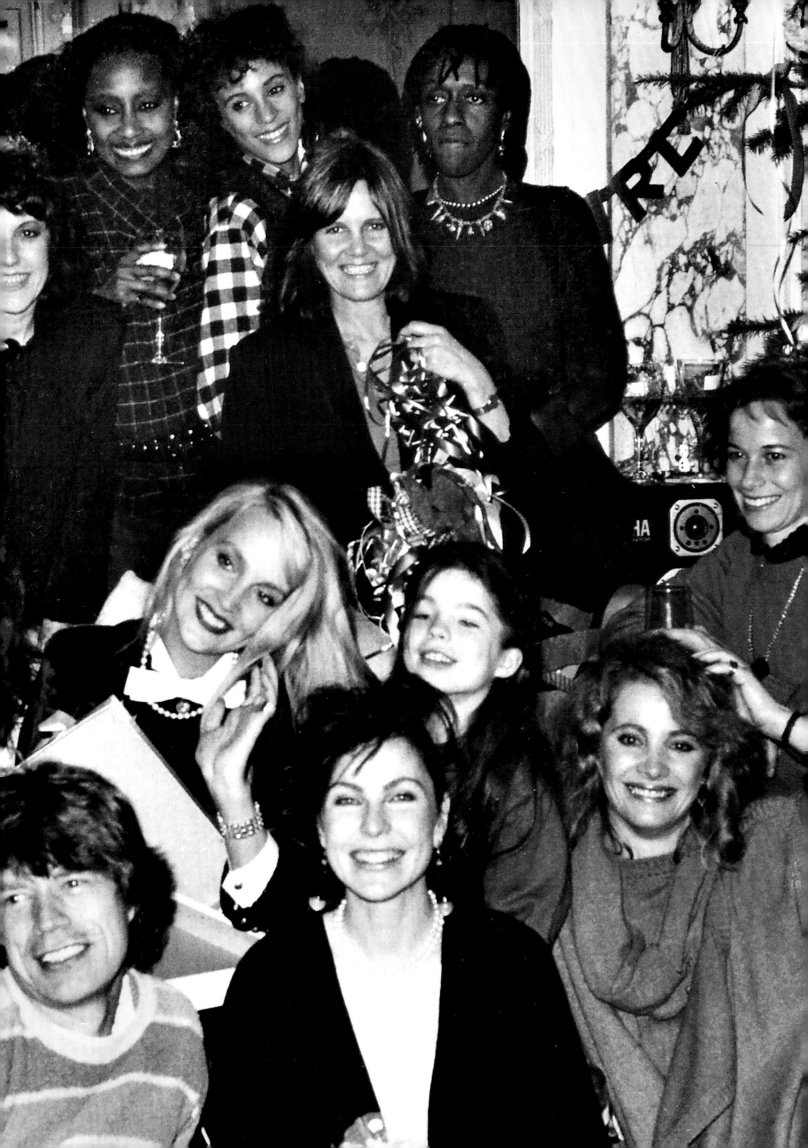

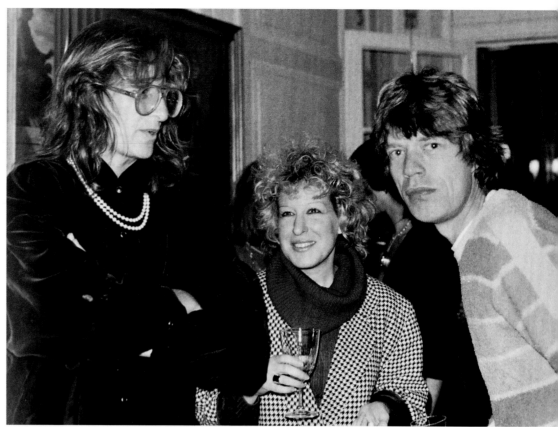

top: *left to right*, Annie Leibovitz, Bette Midler, and Mick Jagger

below: Jerry Hall and Bette Midler

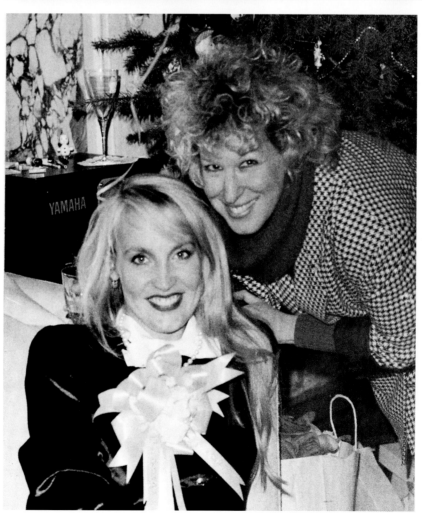

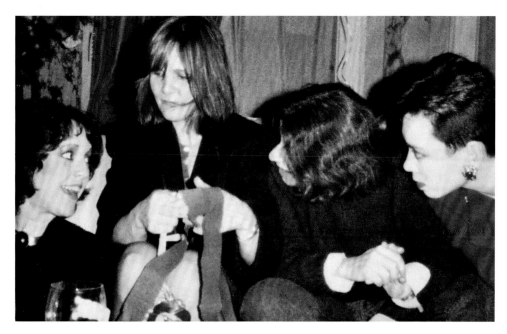

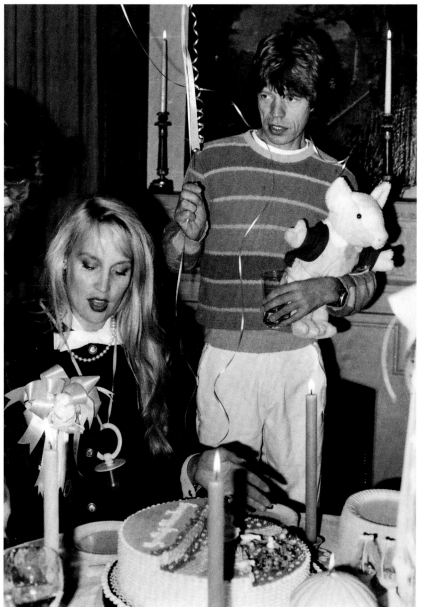

top: *left to right,* Lisa Robinson,
Clarice Rivers, Fran Lebowitz,
and Tina Chow

below, left: Mick and Jerry

below, right: Fran Lebowitz

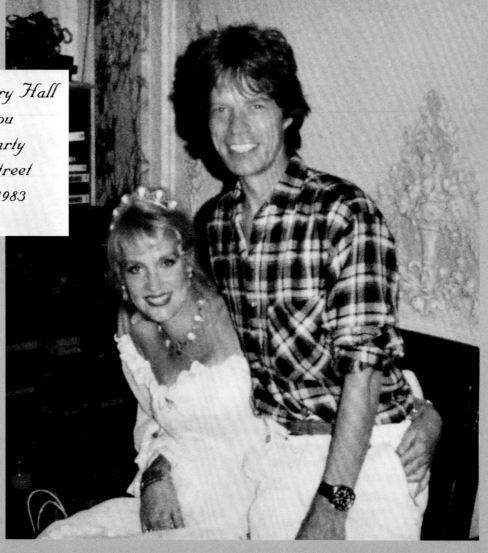

*Mick Jagger and Jerry Hall
cordially invite you
to a Christmas Party
at 304 West 81st Street
on December 21, 1983
at 8:30 P.M.*

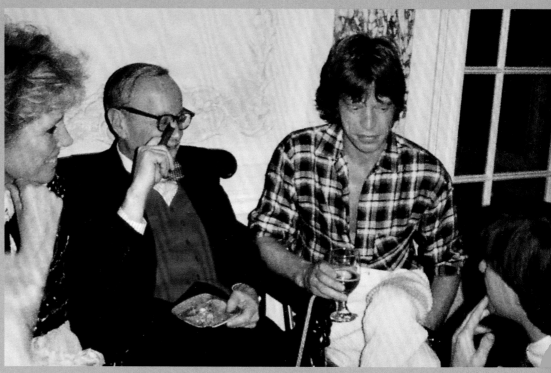

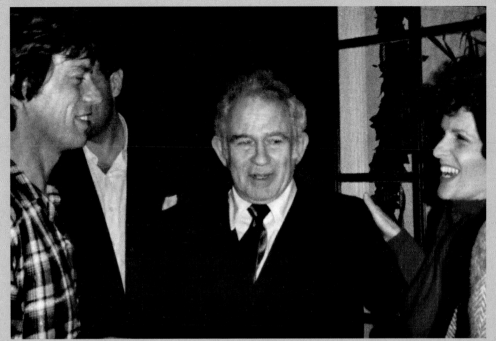

Christmas party at Mick Jagger and Jerry Hall's house, 304 West Eighty-First Street, December 21, 1983

opposite, top: the hosts

opposite, below: Historian Arthur Schlesinger and his wife, Alexandra, with Mick

left: Mick Jagger, Norman Mailer, and Jean Stein

below: *seated, left to right,* Andy Warhol, Anna Falk, Julio Santo Domingo, Vera Rechulski, model Alvinia Bridges; *second row, left to right,* Jerry Hall, Chris Hemphill, Cindy Hall Lehman, Tina Chow; *third row, left to right,* Michael Chow, Bruce Steibel, Alva Chinn

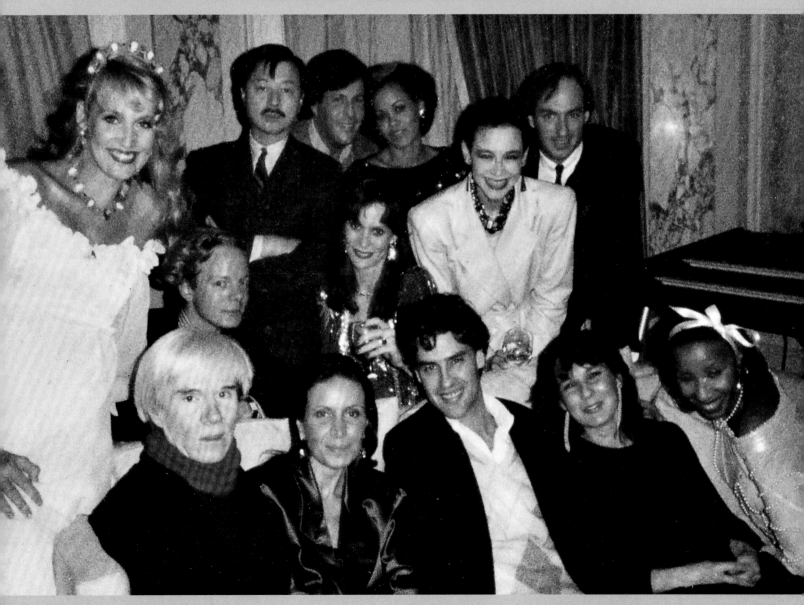

Birthday party for Sabrina Guinness and Jann Wenner, January 1985

right: Sabrina and Jann

below, left: Sabrina and Bobby Shriver

below, right: Sabrina, Brice Marden, Nelita Lectery

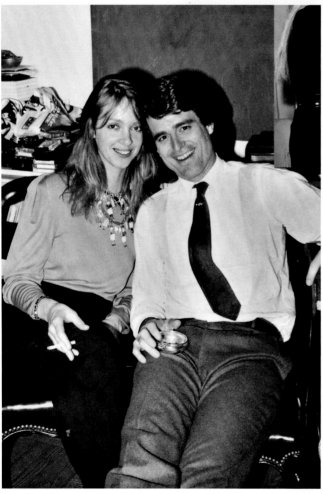

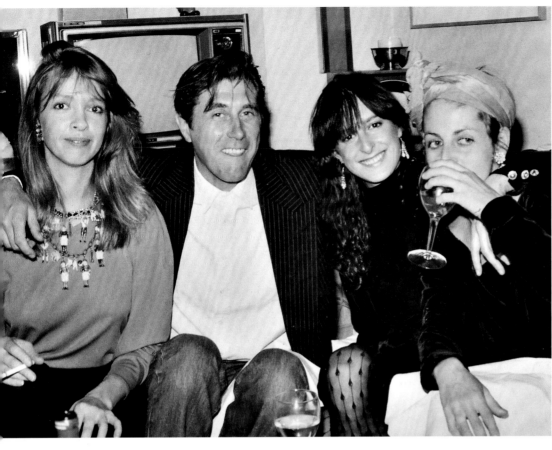

top: *left to right,* Sabrina,
Bryan Ferry, Zara Metcalf,
and Isabella Blow

below: *left to right,* Jann, Andy,
and Sabrina

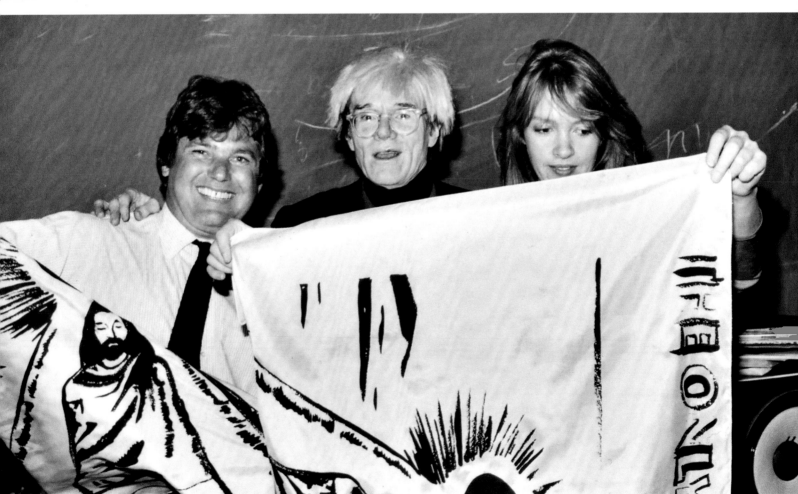

top: *left to right,* Jerry Hall, Richard Gere, and Jerry's sister Rosy Hall

below: *left to right,* Jann Wenner, Brice Marden, Jane Wenner, and Richard Gere

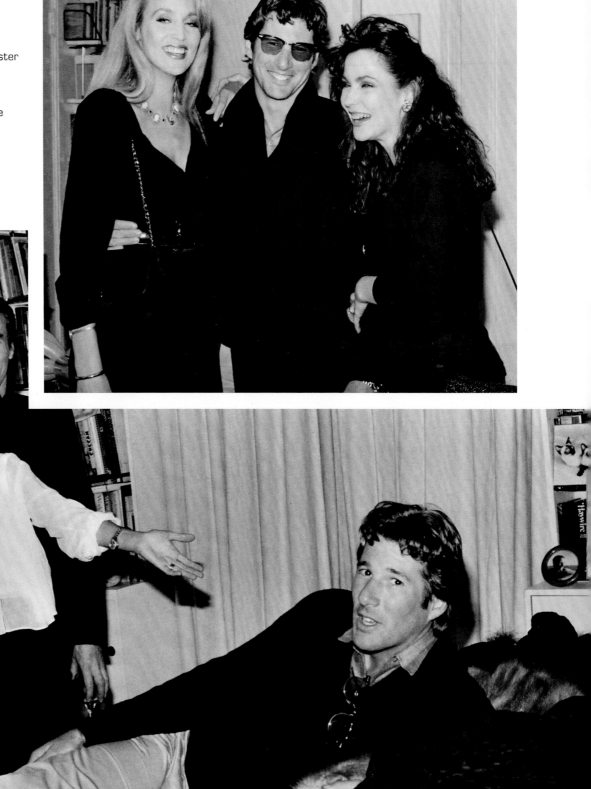

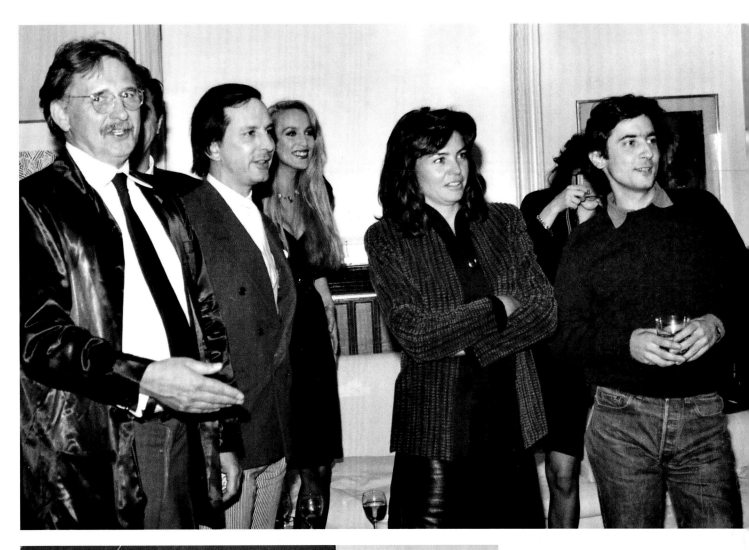

above: *left to right*, Earl, Fred Hughes, Jerry Hall, Sylvia Martins, Griffin Dunne

left: Jerry Hall and Bryan Ferry

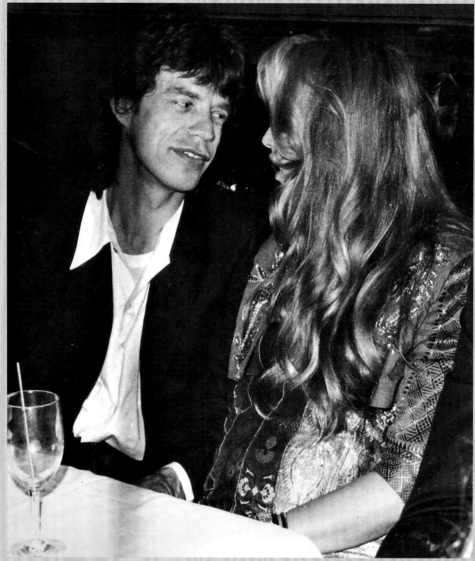

Birthday party for Jerry Hall at Mr. Chow, July 2, 1985

right: Mick Jagger and Jerry Hall

below: *left to right,* Tina Chow, Annie Leibovitz, and fashion whisperer André Leon Talley

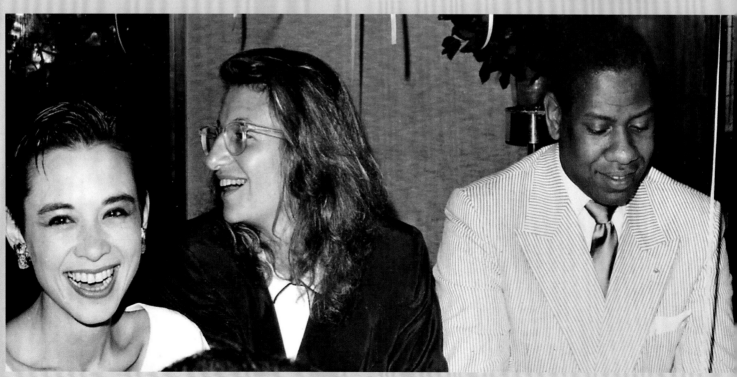

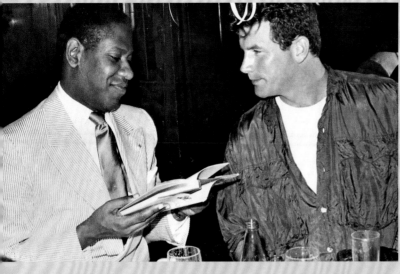

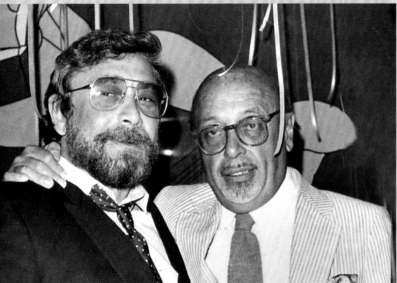

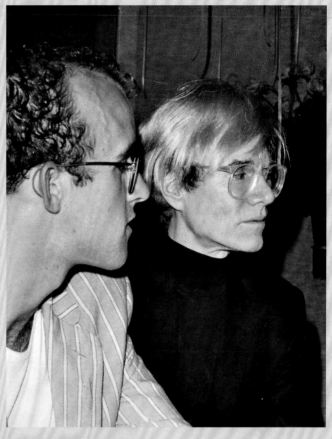

top: André Leon Talley and Mike Macleod

middle, left: Walter Yetnikoff, president and CEO of CBS Records, and Ahmet Ertegun; right: Keith Haring and Andy

bottom: Paloma Picasso's husband, Rafael Lopez-Sanchez, and Fran Lebowitz

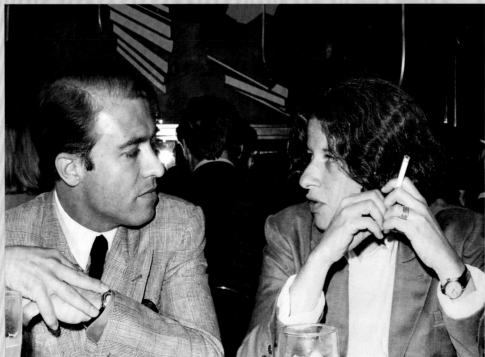

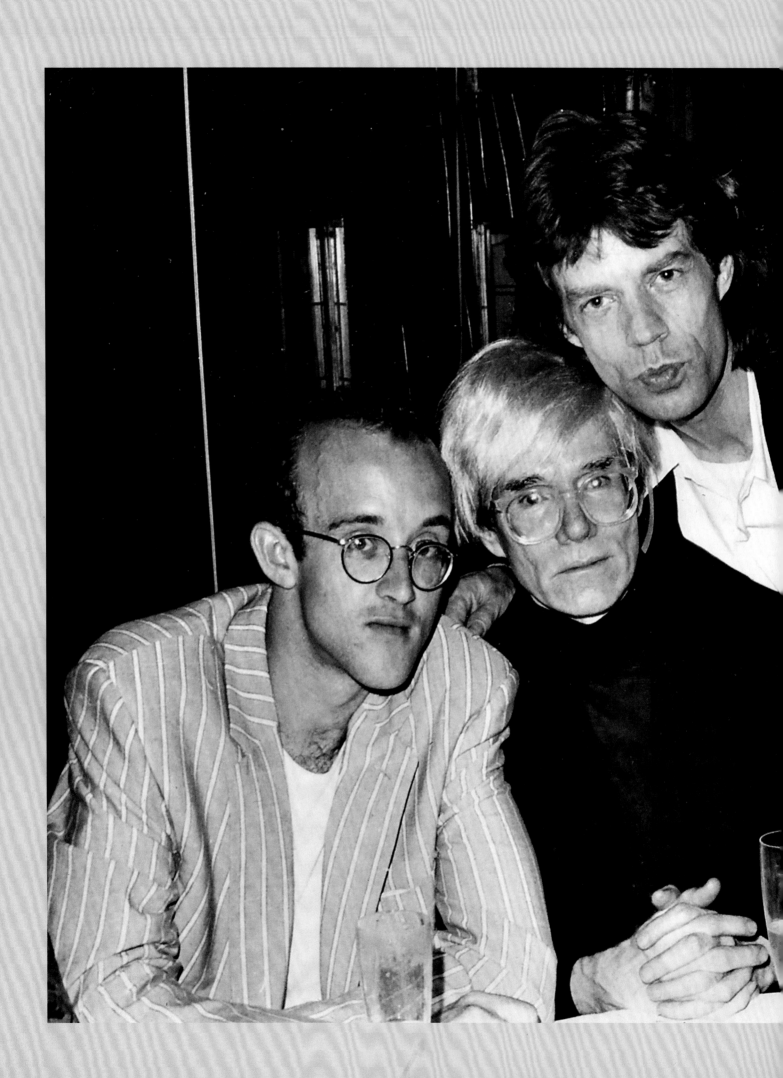

Keith Haring, Andy, Mick,
and Paloma Picasso

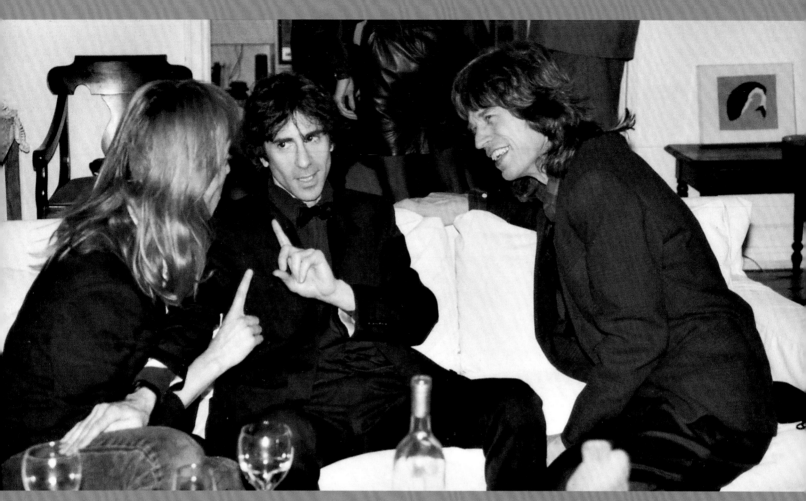

**Dinner at the McGraths',
January 22, 1988**

top: *left to right*, Miranda
Guinness, Peter Wolf, Mick
Jagger

below: *left to right*, Helen
Marden and Barbara Heizer;
behind, Michael Heizer, famous
for his earthworks, and Brice
Marden

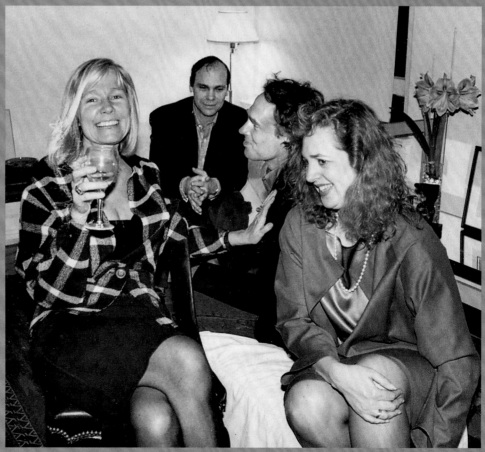

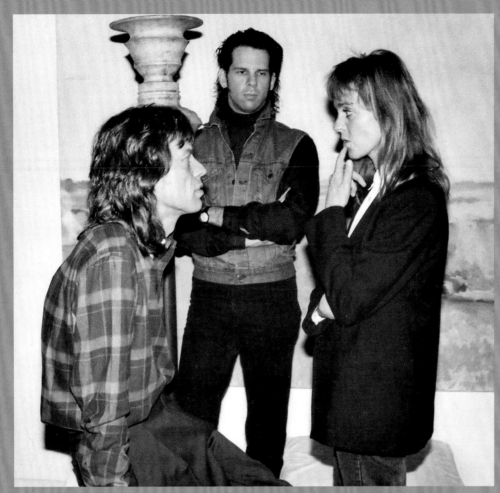

top: *left to right*, Mick Jagger,
Jimmy Ripp, and Miranda
Guinness

below: Michael Heizer

Dinner on Fifty-Seventh street, May 3, 1988

top: *left to right,* Playwright John Guare, Candice Bergen, Louis Malle, art dealer Charles Byron, and artist Monica Incisa

below, left: Fran Lebowitz and archaeologist Iris Love

below, right: Art historian and Picasso expert John Richardson, Christophe de Menil, and Brooke Hayward

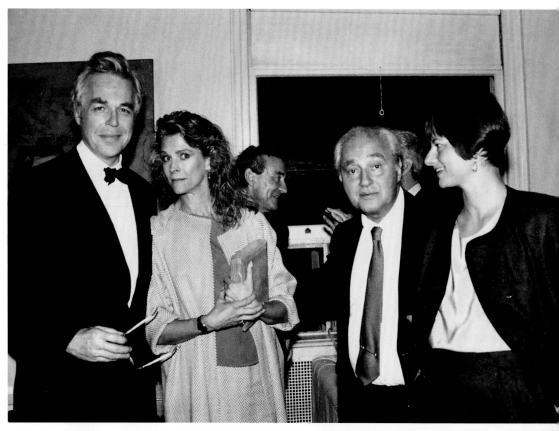

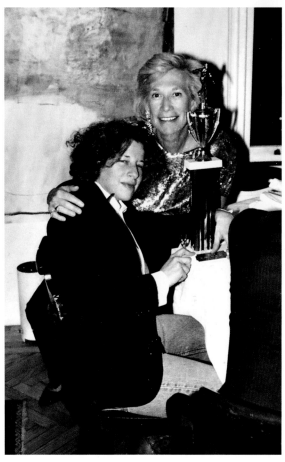

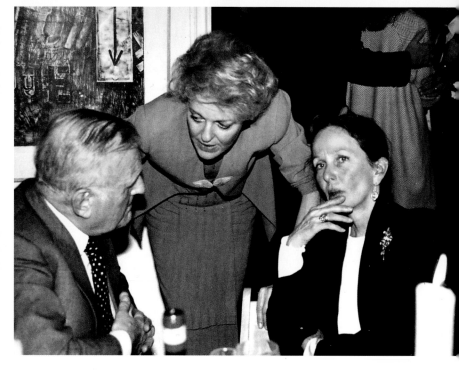

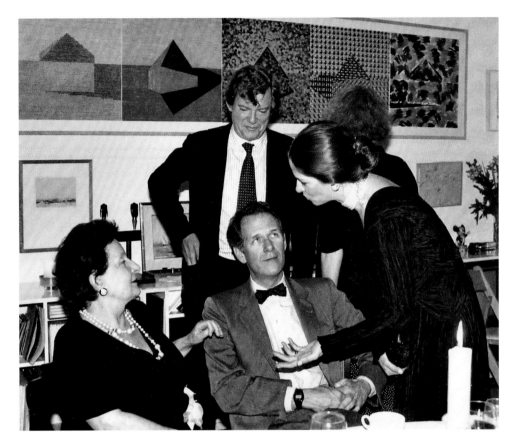

top: *standing,* Art critic Robert Hughes and Adele Chatfield-Taylor, president of the American Academy in Rome; *seated,* Camilla's sister Viviana and John Dobkin

below: *left to right,* Jann Wenner, Candice Bergen, Enrico d'Assia, Louis Malle, Charles Byron, and Monica Incisa

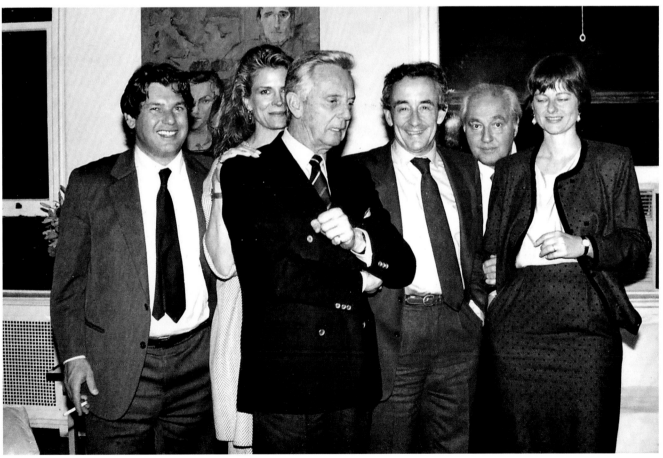

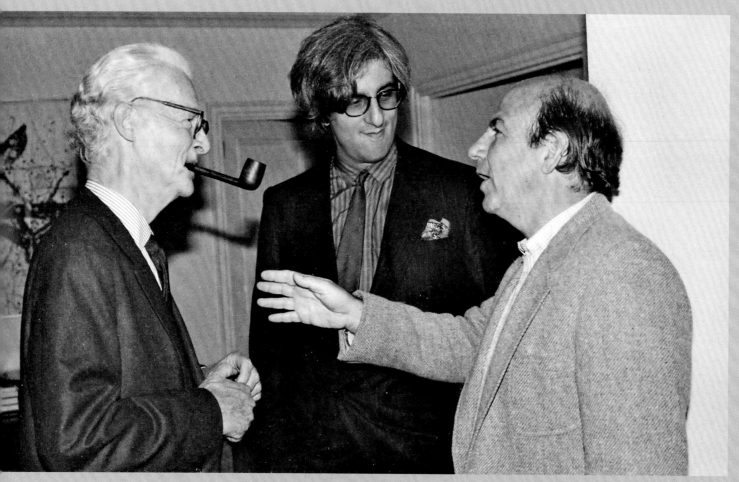

Thanksgiving at the Dunnes', November 26, 1990

above: *left to right*, Journalist Murray Kempton; Susan Sontag's son, writer David Rieff; and *New Yorker* writer Calvin Trillin

bottom: *left to right*, Watergate journalist Carl Bernstein, Swedish neurophysiologist and Nobel laureate Torsten Wiesel, and Jean Stein

opposite, top: Writers Gita Mehta and John Gregory Dunne

opposite, middle: Joan Didion and her Bouvier des Flandres, Casey

opposite, bottom: *seated*, writer, editor-in-chief of French *Vogue*, 1994–2001, Joan Juliet Buck; editor Errol MacDonald; *standing*, John Gregory Dunne and Knopf editor in chief Sonny Mehta

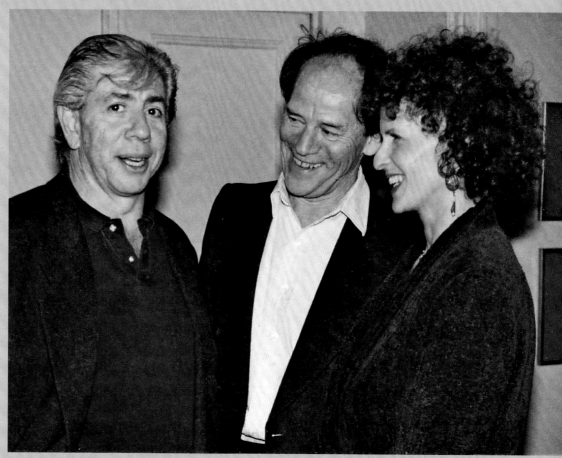

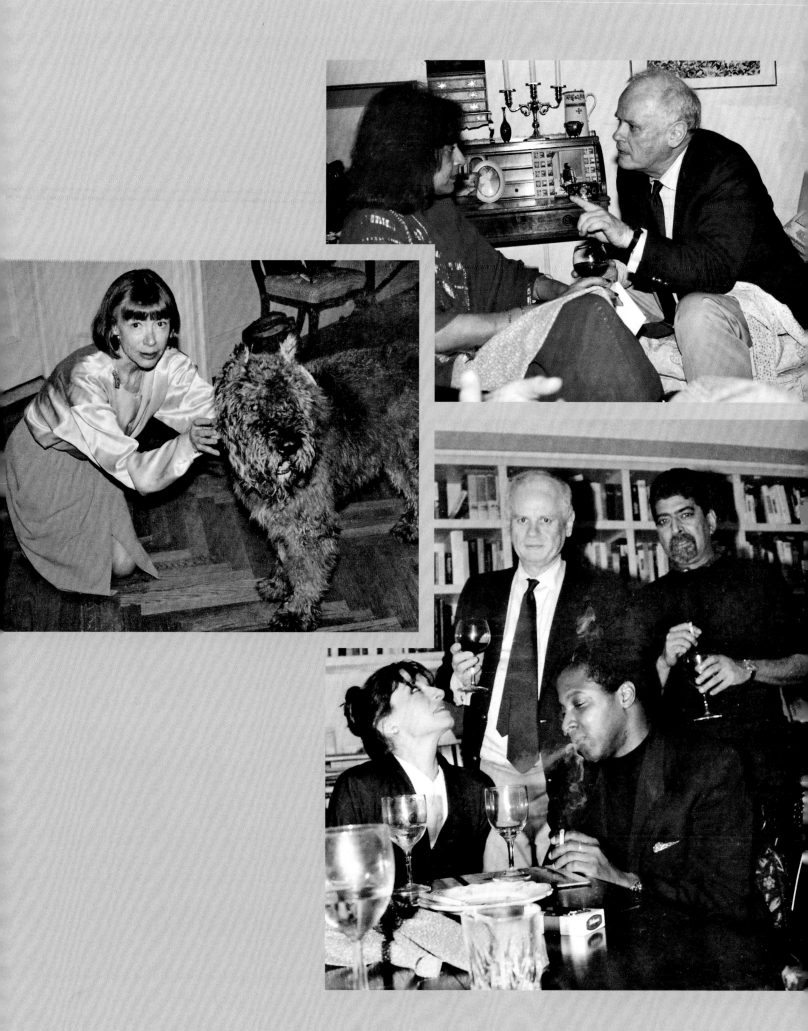

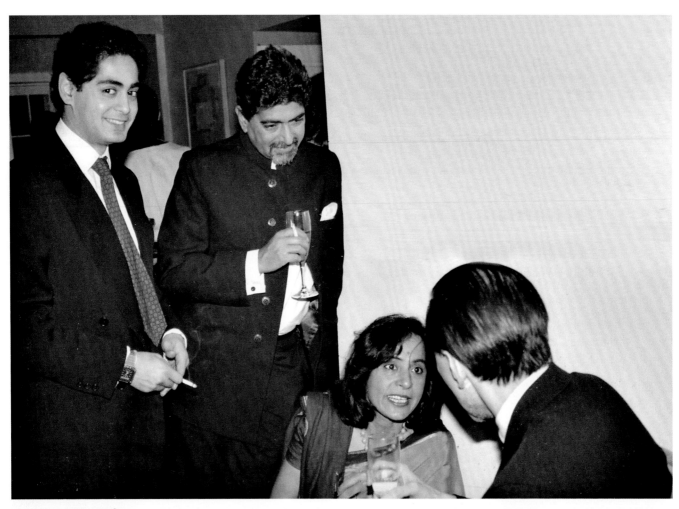

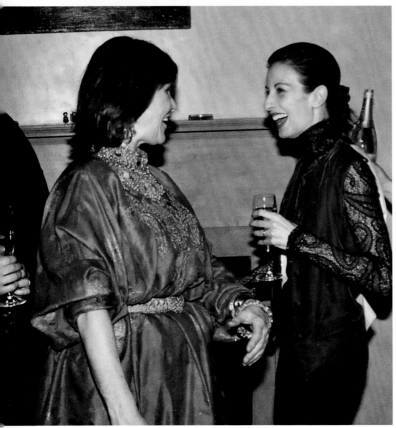

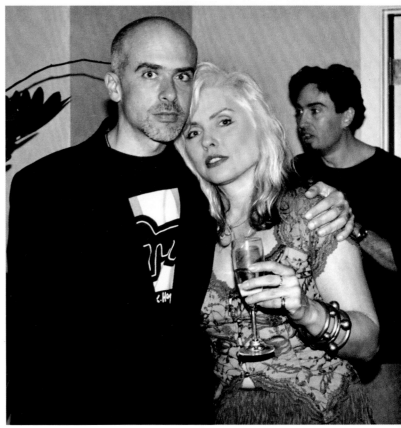

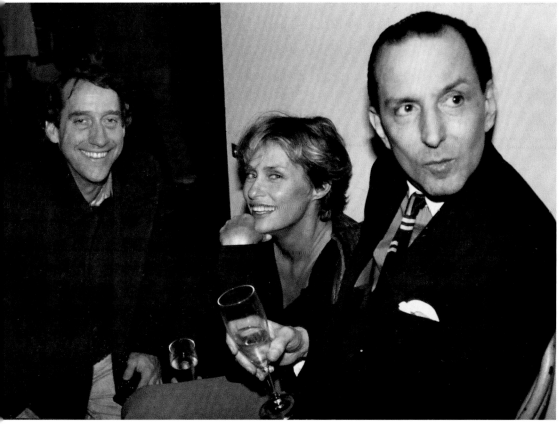

At Alba and Francesco Clemente's, January 1, 1991

opposite, top: *left to right*, Aditya, Sonny and Gita Mehta, and Fred Hughes

opposite, below left: Clarice Rivers and Alba Clemente

opposite, below right: Francesco Clemente, Deborah Harry, and DJ Johnny Dynell

left: Artist John Alexander, Lauren Hutton, and Fred Hughes

below: *left to right*, Allen Ginsberg; Jack Shuai Shu—whom Ginsberg sponsored to study in New York after meeting him on a trip to China—and Sonny Mehta

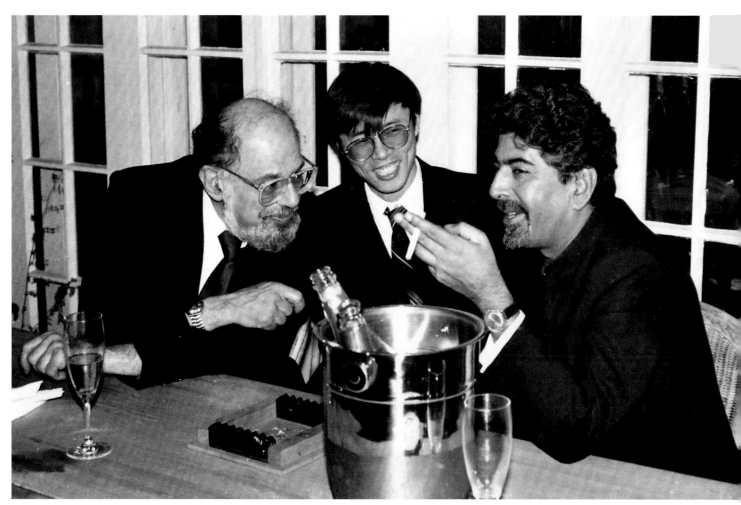

JERRY BROWN

JOAN DUNNE
EARL
JOHN DUNNE
JERRY BROWN

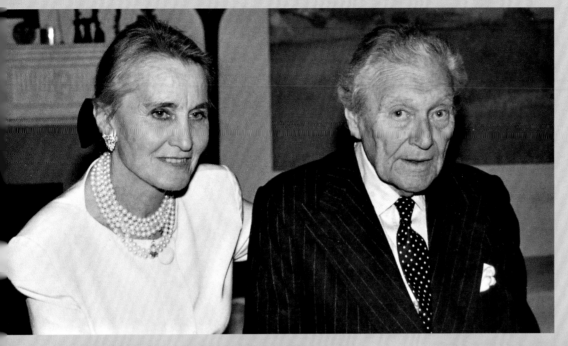

The twenty-fifth wedding anniversary of Beatrice and Gregor von Rezzori, at the McGraths', May 1, 1992

left: The Rezzoris

below, left: Beatrice von Rezzori with artists Jennifer Bartlett and Jasper Johns

below, right: Brice Marden and gallerist Paula Cooper

right: Robert Silvers, editor of *The New York Review of Books*, with Gregor von Rezzori and Grace Dudley

below: Beatrice von Rezzori, Jasper Johns, Leo Castelli, and Sonny Mehta

top: *left to right,* Jack Macrae, former editor in chief of Henry Holt; Robert Silvers; and Alexis Gregory, founder of Vendome Press

below: *left to right,* Artist Saul Steinberg, Beatrice von Rezzori, and Barry Humphries, who performed as Dame Edna

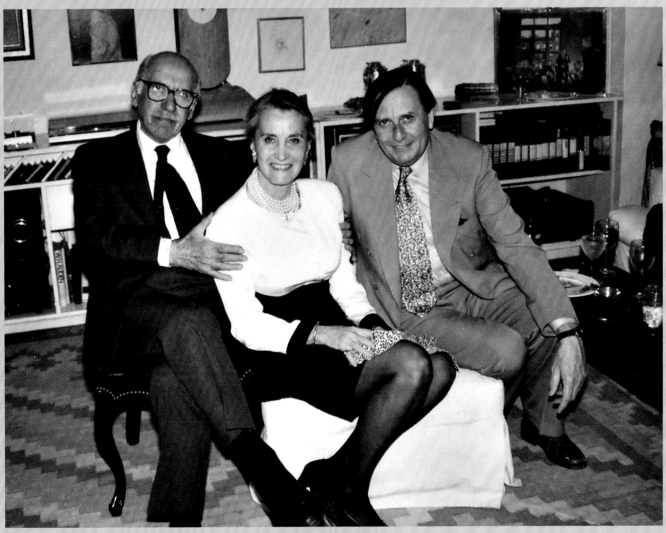

Thirty-fifth anniversary of the Leo Castelli Gallery, May 4, 1992

above, left: Sandra Bernhard, who gave a special performance, with Leo Castelli

above, right: *left to right,* dancer Jack Soto, Bill Katz, and actress Nell Campbell

right: Diane von Furstenberg, John Waters, and Patricia Hearst

opposite, top left: *left to right,* Anne Bass, art dealer Thomas Ammann, Bianca Jagger, and artist Ross Bleckner

opposite, top right: Koo Stark, an actress, photographer, and friend of England's Prince Andrew in the early 1980s, with Leo Castelli

opposite, bottom: Alba and Francesco Clemente

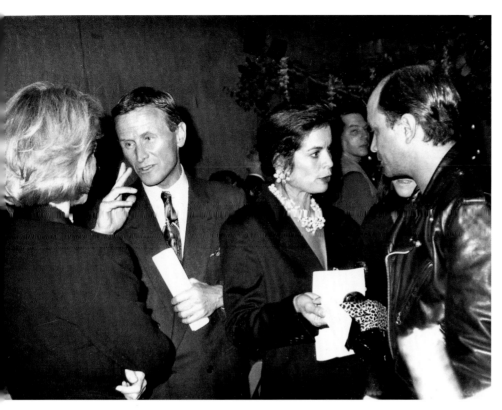

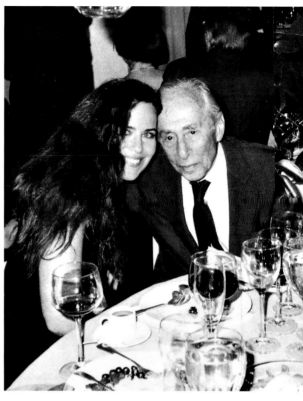

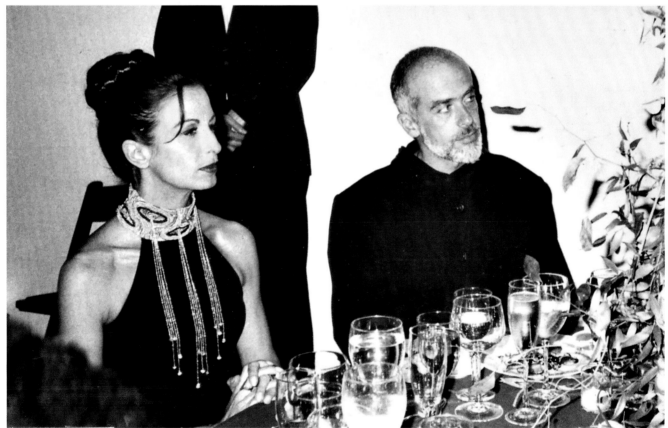

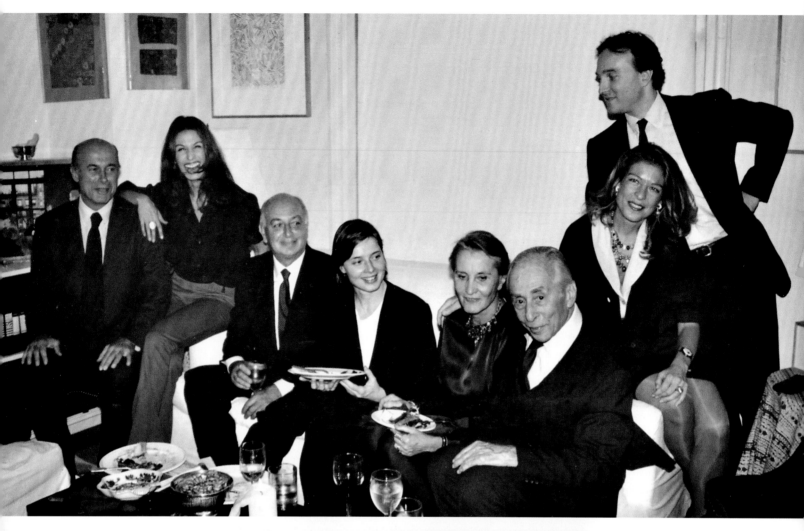

**Dinner at the McGraths',
November 4, 1992**

above: *left to right,* Journalist
and politician Jas Gawronski,
Alba Clemente, designer
Federico Forquet, Isabella
Rossellini, Beatrice von
Rezzori, Leo Castelli, Eddy
Forti Rossellini, and Andrea
di Robilant

right: John Richardson with
Camilla's sister Laetitia

left: Alba Clemente and
Brice Marden

below: left to right, James
Brown; David, Earl of Warwick,
known as Brookie; and Mary
Dunlop

Rolling Stone's twenty-fifth anniversary party, at the Four Seasons, November 12, 1992

top: *left to right,* Joan Didion, Jann Wenner, David Mortimer

below: *left to right,* Jane Holzer, art dealer Larry Gagosian, Earl

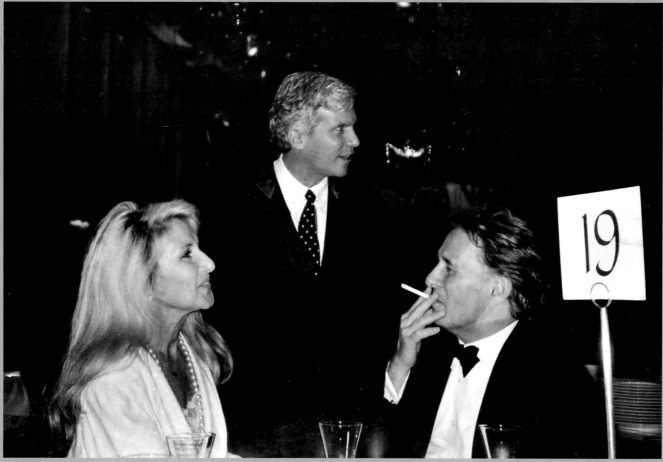

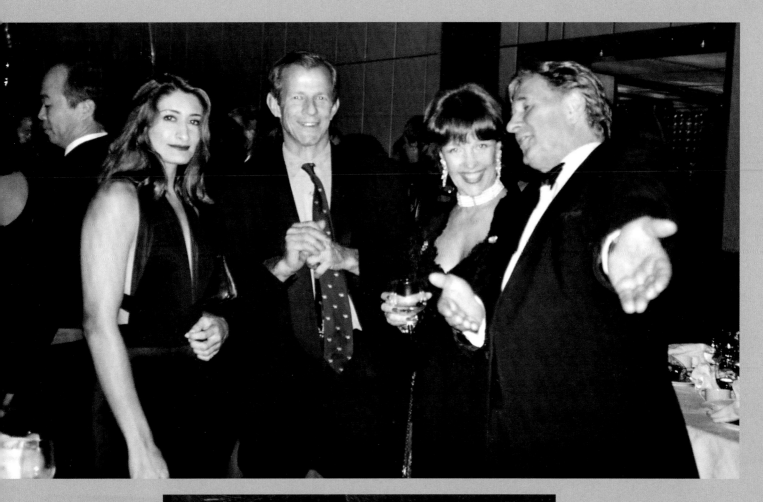

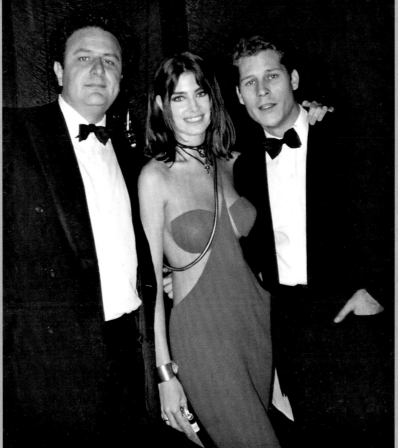

top: *left to right*, Nejma Beard, Peter Beard, Karen Lerner, and Earl

below: Photographer and art collector Johnny Pigozzi with Arpad Busson and a guest

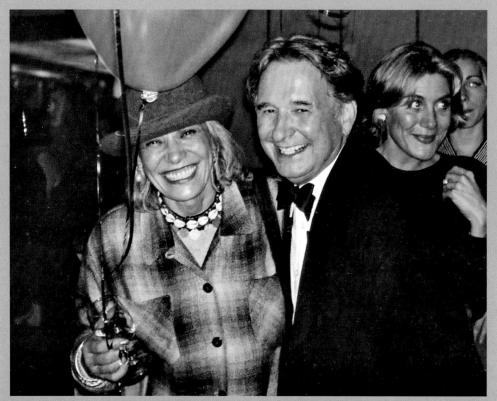

right: Anita Pallenberg and Earl

below: Jane Wenner, Hunter S. Thompson, and Ed Bradley of *60 Minutes*

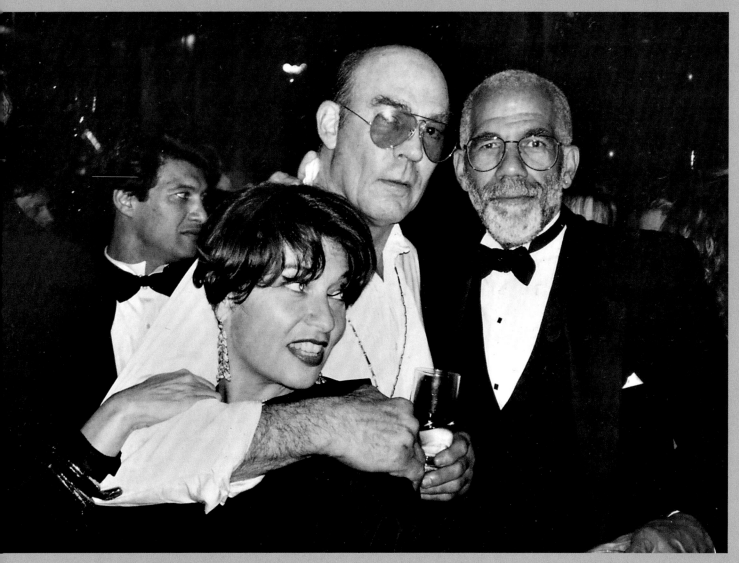

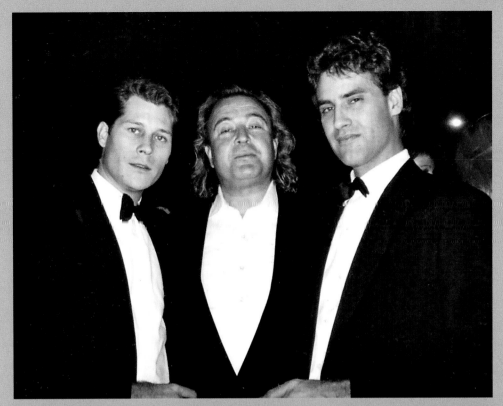

top: *left to right,* Arpad Busson,
Mick Jones of Foreigner, and
Julio Mario Santo Domingo
below: Jann and Jane Wenner

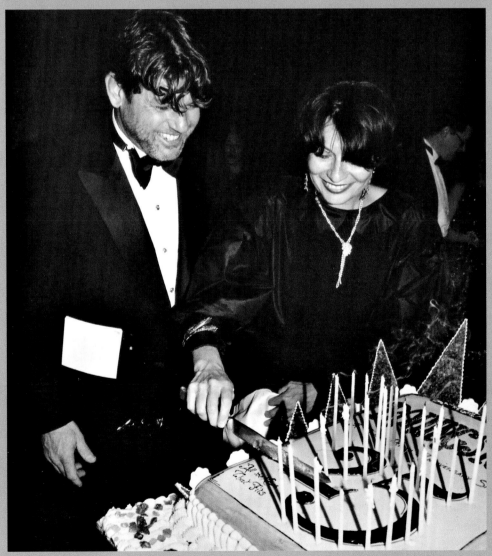

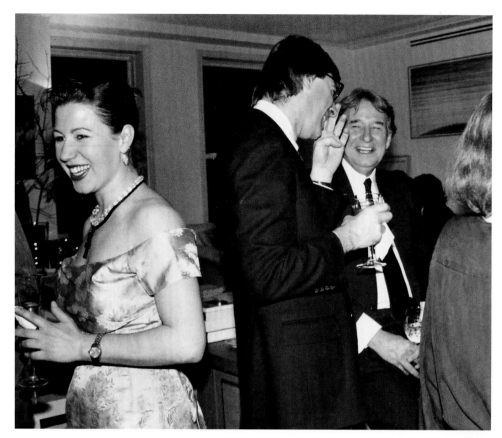

**Thanksgiving at the Dunnes',
1992**

top: *left to right,* Quintana Roo
Dunne, Pietro Cicognani, Earl

below: *in front, left to right,*
Sonny Mehta, writer Susanna
Moore, Earl; *standing,* Robert
Silvers, Joan Didion

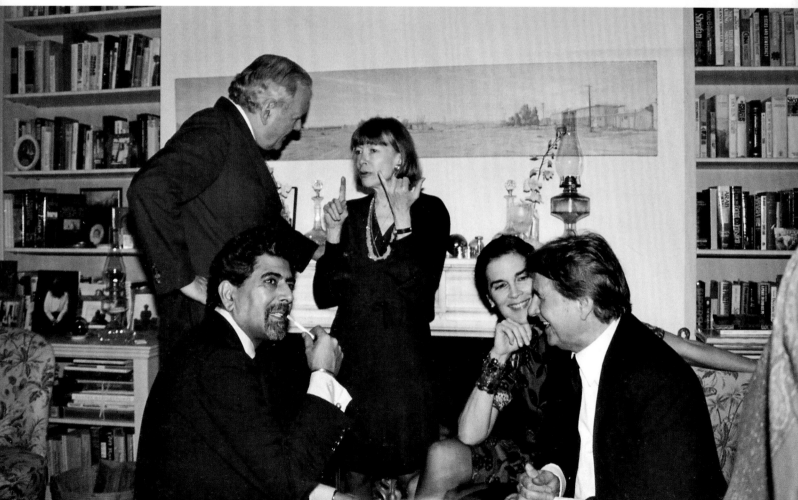

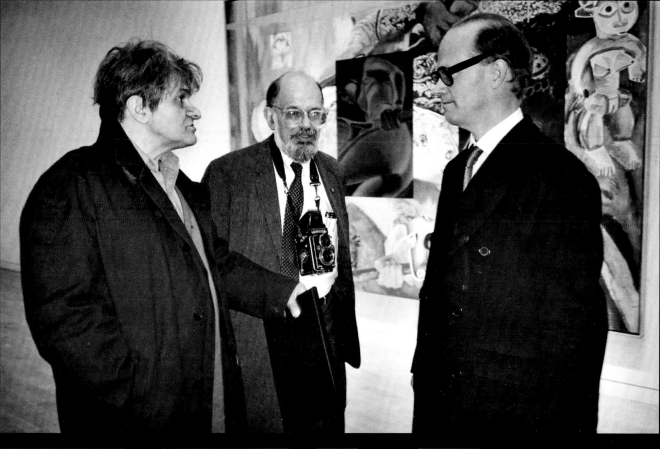

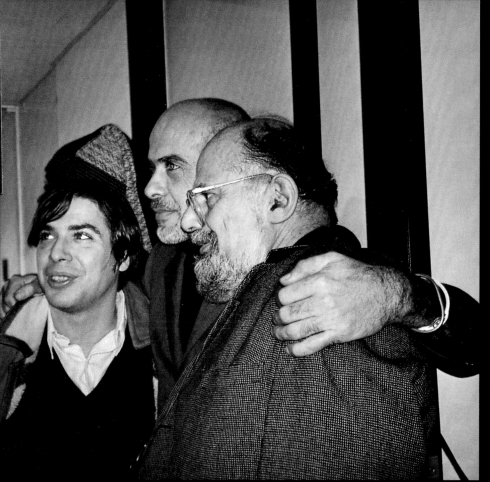

**Group show at the Gagosian
Gallery, January 14, 1993**

above: *left to right,* Poets
Gregory Corso and Allen
Ginsberg, and agent
Andrew Wylie

below: *left to right,* Artist
George Condo, Francesco
Clemente, and Allen Ginsberg

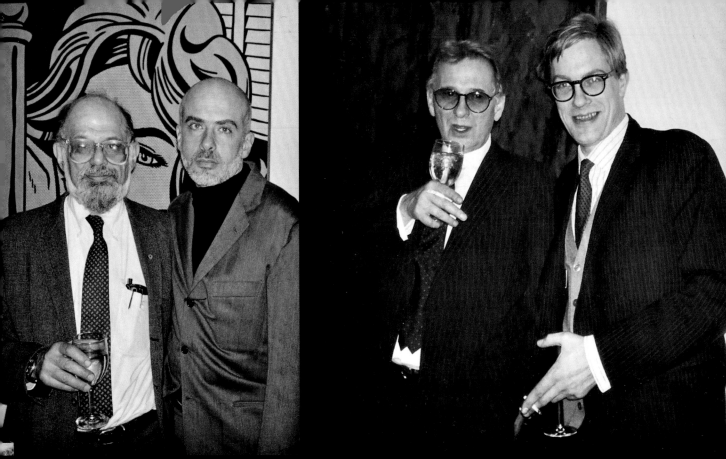

above: Allen Ginsberg and
Francesco Clemente

above, right: Earl and Tim Hunt,
who was a curator of the Andy
Warhol Foundation and later an
art dealer, younger brother of
racing driver James Hunt, who
drove for Lord Hesketh's team

right: *left to right*, Clemente,
Ginsberg, William Burroughs,
and curator, editor, and writer
Raymond Foye

opposite, top left: William
Burroughs; top right: Lauren
Hutton and Ed Ruscha

opposite, below: *left to right*,
Kirk Varnedoe, chief curator
of Painting and Sculpture at
MoMA from 1988 to 2001;
Larry Gagosian; and artist
Victor Matthews

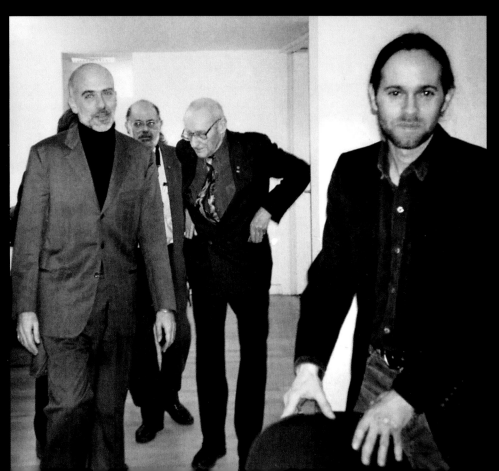

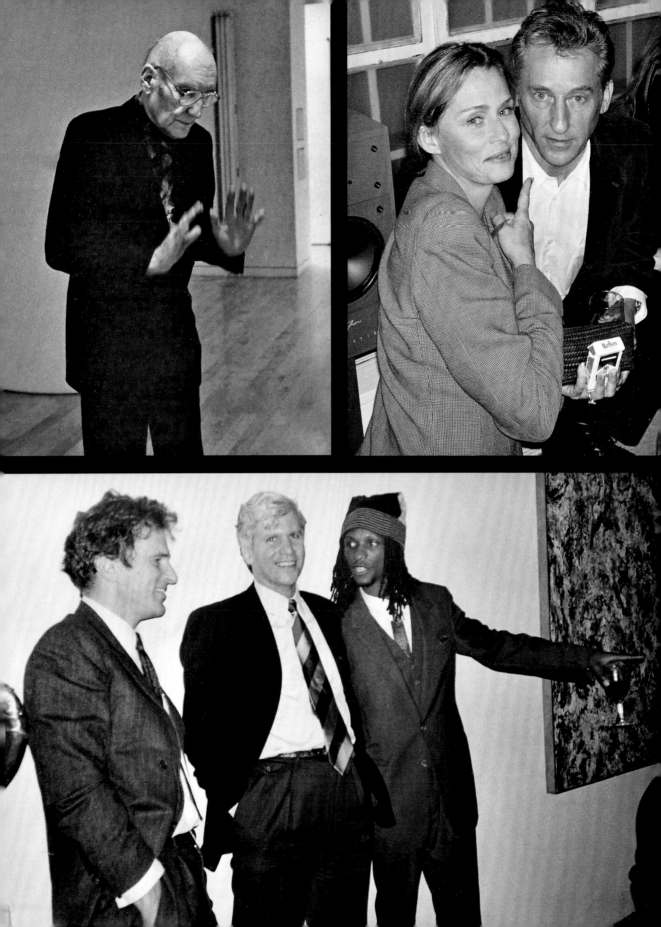

**Dinner at the apartment,
August 1993**

above: Rupert Loewenstein and
Robin Hurlstone, at the time a
very good friend of the actress
Joan Collins

right: Giovanni Volpi and
Ahmet Ertegun

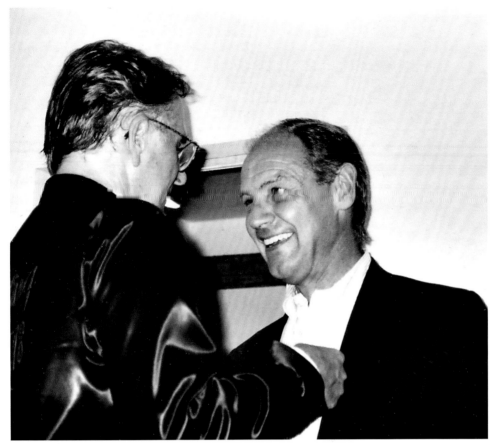

left: Carl and Giovanni Volpi

below: Joan Collins and
Ahmet Ertegun

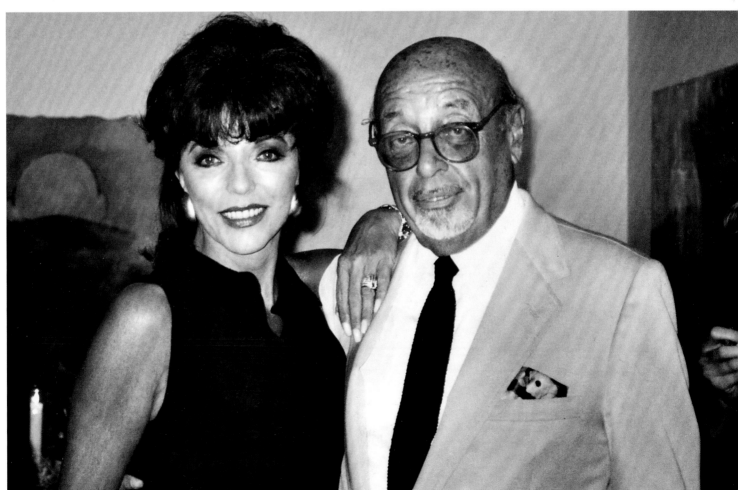

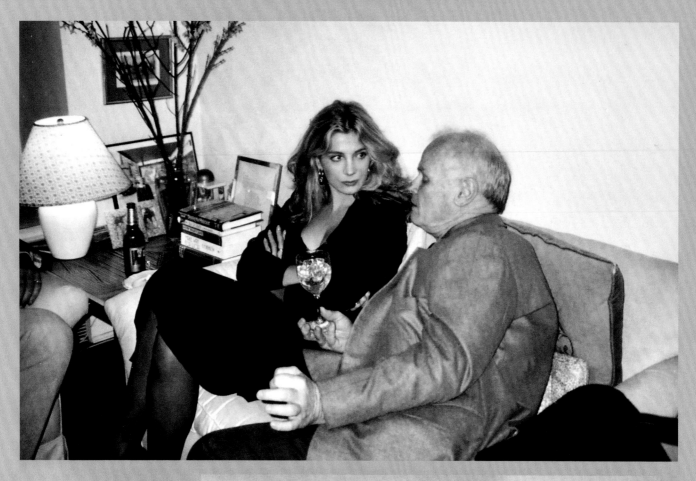

Thanksgiving at the Dunnes', 1993

above: Actress Natasha Richardson and John Gregory Dunne

right: Liam Neeson and his wife, Natasha Richardson

opposite, top left: Politician Naveen Patnaik, editor Sharon Delano, and John Richardson

opposite, top right: Journalists Murray Kempton and Frances Fitzgerald

opposite, below: *left to right*, Donna Tartt, Bret Easton Ellis, and Helmut Gausterer

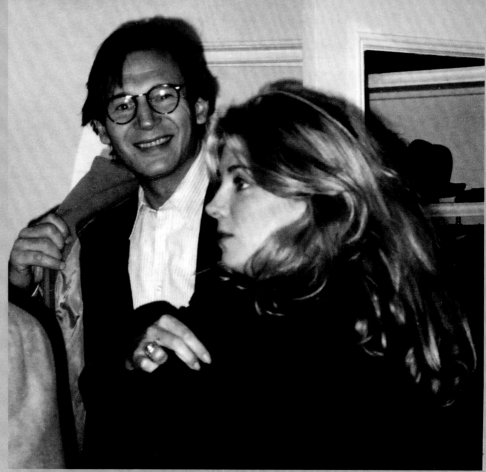

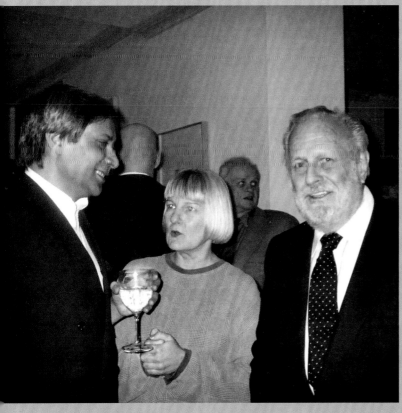

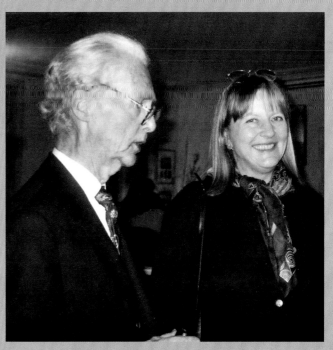

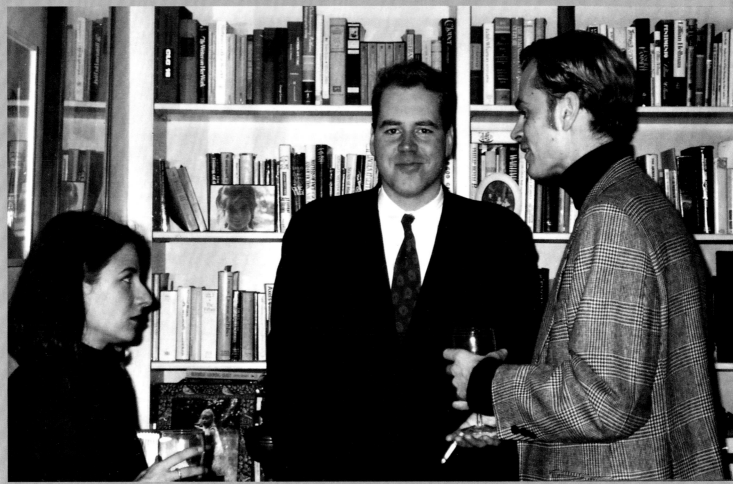

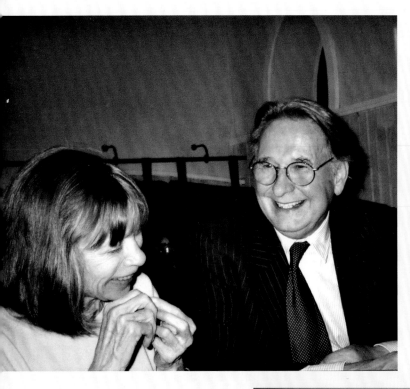

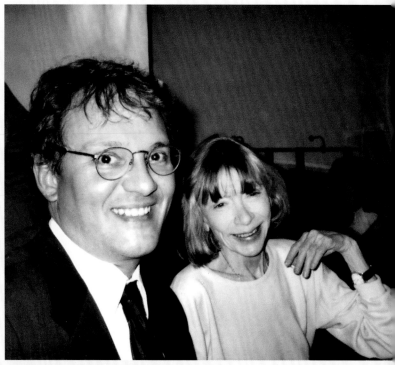

Larry Gagosian's dinner for Robert Graham, at The Lobster Club, 24 East Eightieth Street, March 12, 1996

above, left: Joan Didion and Earl; and right: Lawyer George Sampas and Joan Didion

right: *left to right,* collector Barbara Jakobson, Larry Gagosian, and Raymond Foye

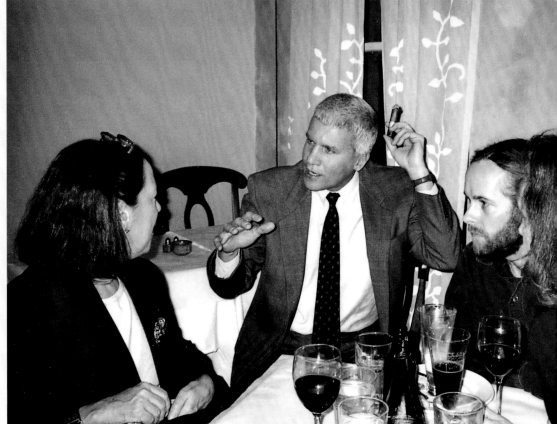

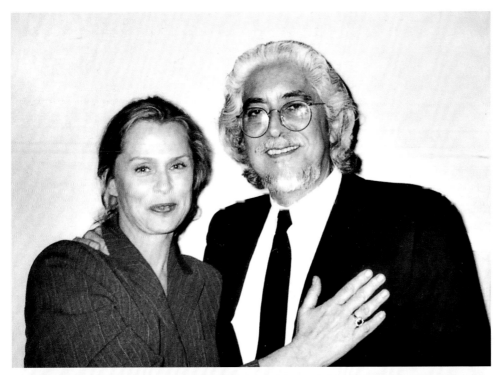

left: Lauren Hutton and Robert Graham

below: *left to right,* Anjelica Huston, Lauren Hutton, and interior designer Susan Forristal

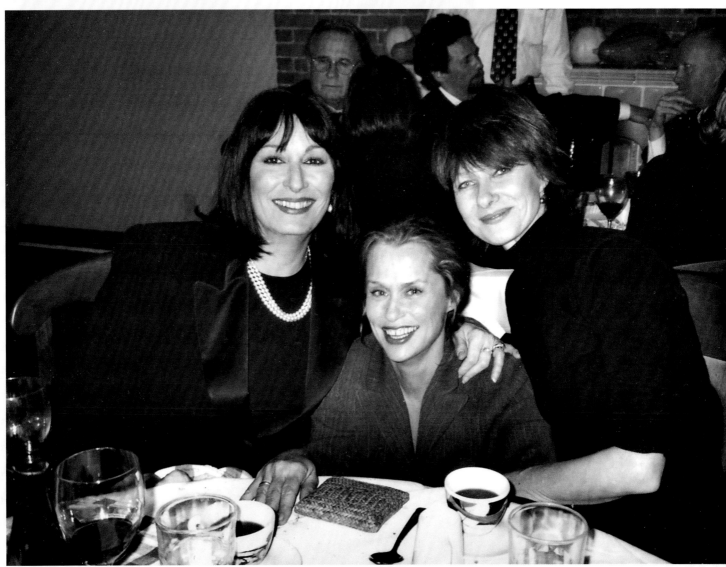

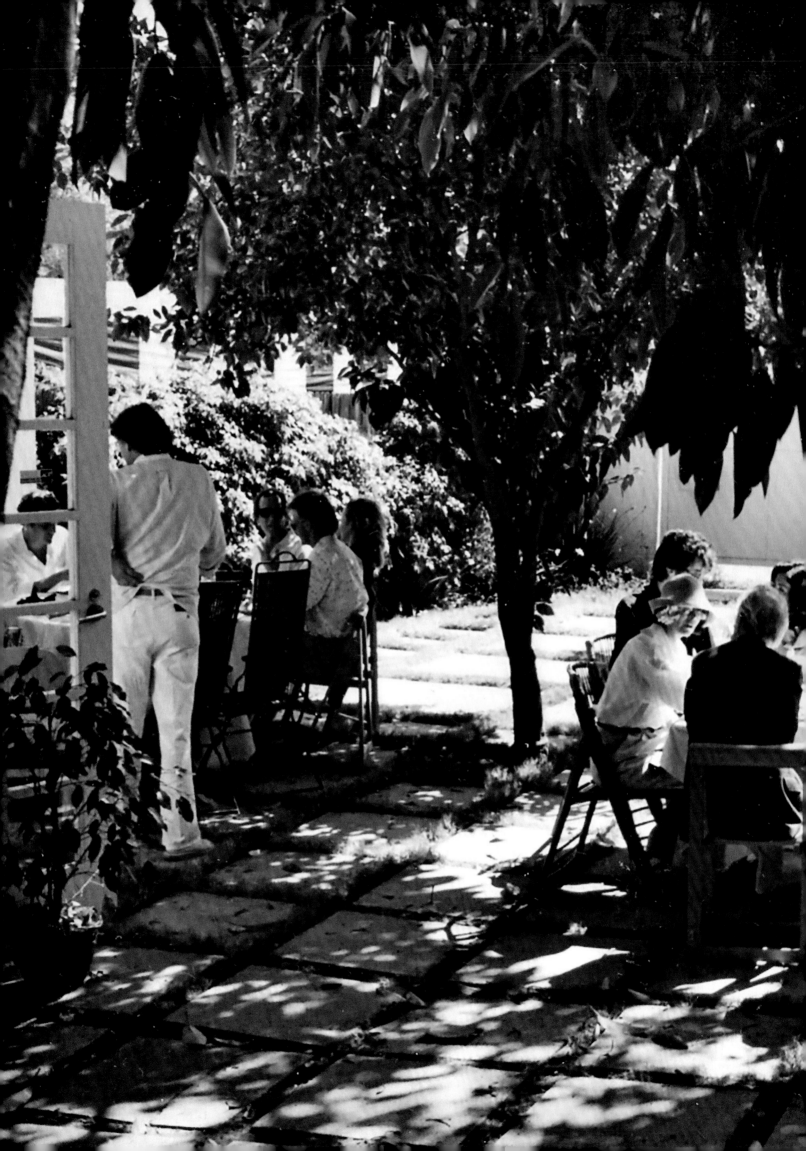

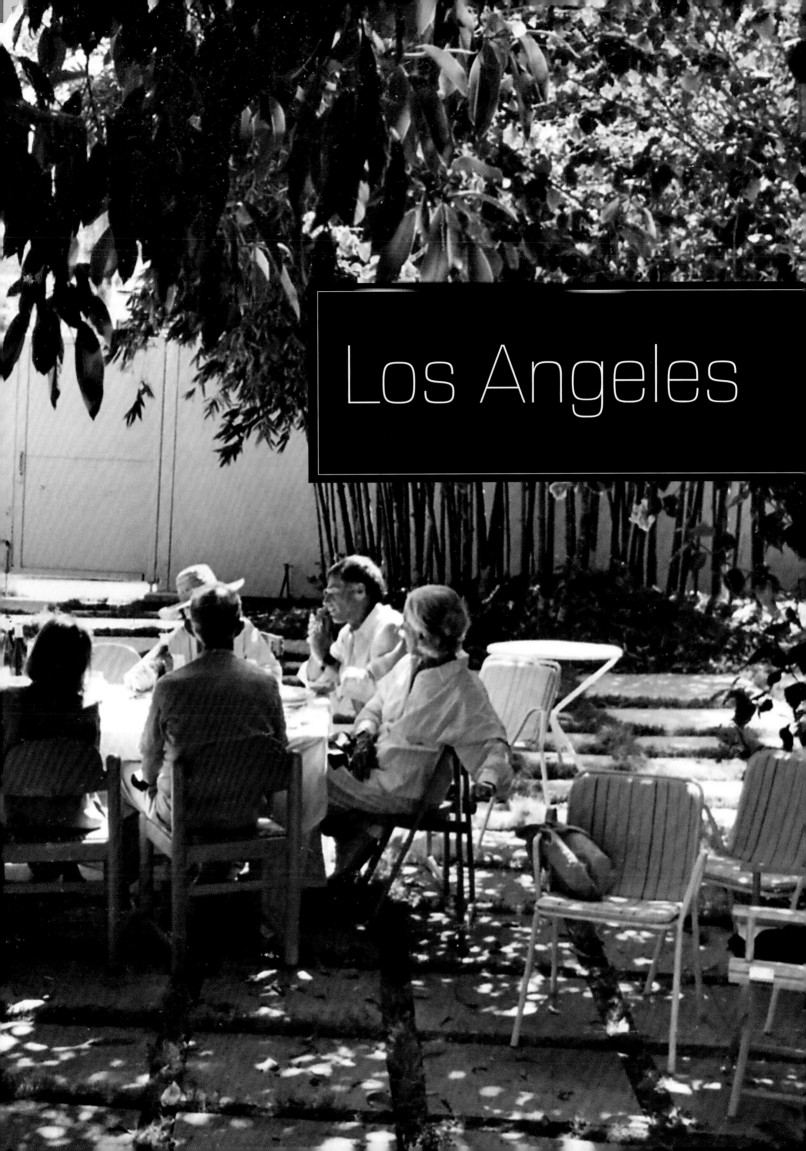

Los Angeles

n 1964, Earl imagined a film career and began working as a production assistant at 20th Century–Fox on story and property development in New York. After resigning the following year, beginning in 1966 Earl began to spend long periods of time in Los Angeles, writing two screenplays, "The Freeway," which was sold to Hall Bartlett but never produced, and "The Birdwatcher." Camilla was based in New York at their apartment on East Sixty-Second Street, but they both would go back and forth. By 1968 they would stay in the large two-bedroom apartment Earl had rented at the Chateau Marmont, but in 1968 they bought a run-down property at 454 North Robertson which Arata Isozaki redid. Earl's next reincarnation was the music world.

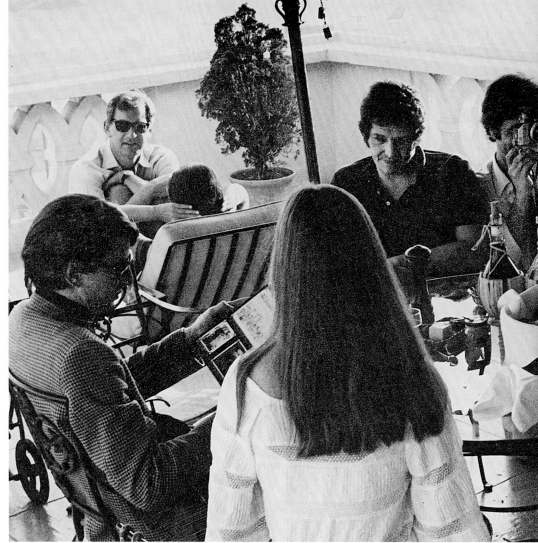

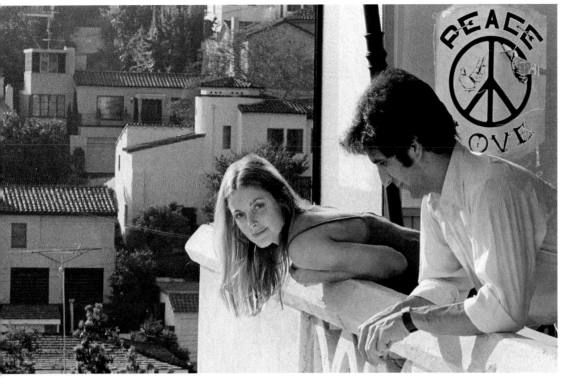

The McGraths' suite at the Chateau Marmont had a big terrace, where Earl put up a "Peace/Love" sign and where they gave Sunday brunches, such as this one on February 25, 1968

opposite: Roman Polanski in silhouette

left: Sharon Tate and Brian Morris

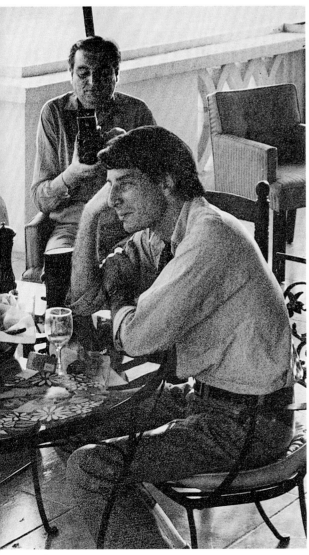

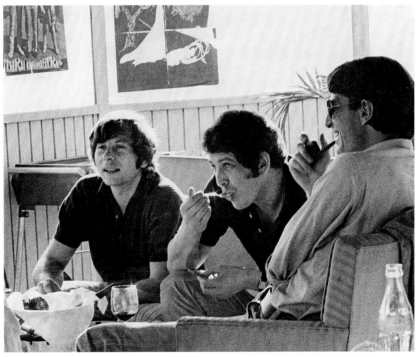

above: *left to right,* Polanski, Brian Morris, and Richard Sylbert

left: *left to right,* Production designer Paul Sylbert; actor, director, producer; and, behind the table, UA executive Sandy Whitelaw, who subtitled more than a thousand French films into English—those of Louis Malle and Godard included—and worked for producers Charles Feldman and Ray Stark; Brian Morris, another production designer; Robin McEwen; and a third production designer, Richard Sylbert, Paul's twin brother

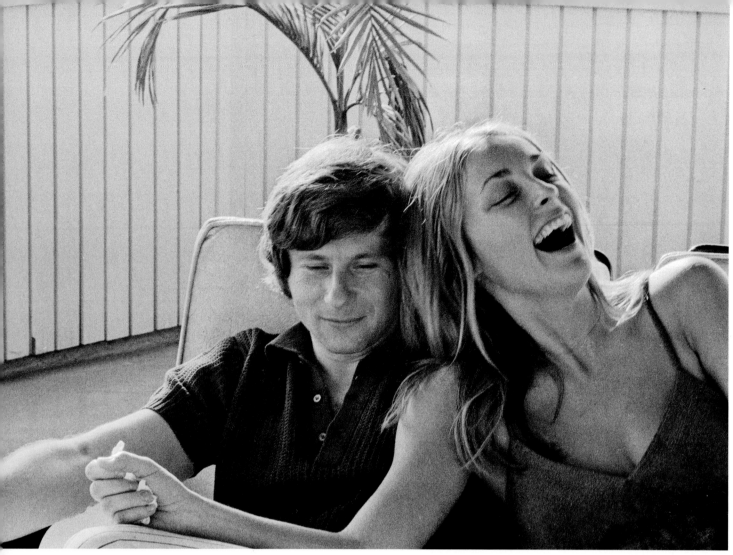

Roman Polanski and
Sharon Tate

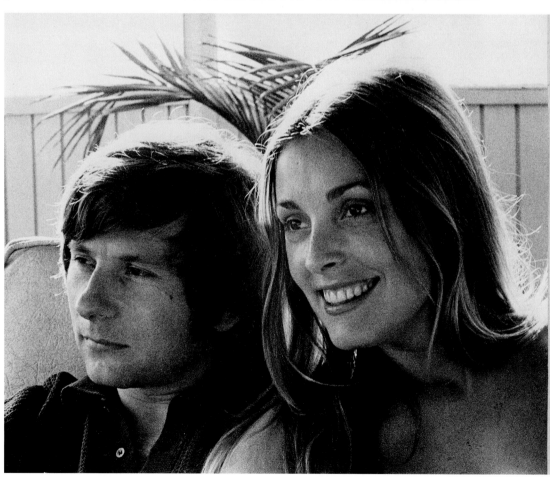

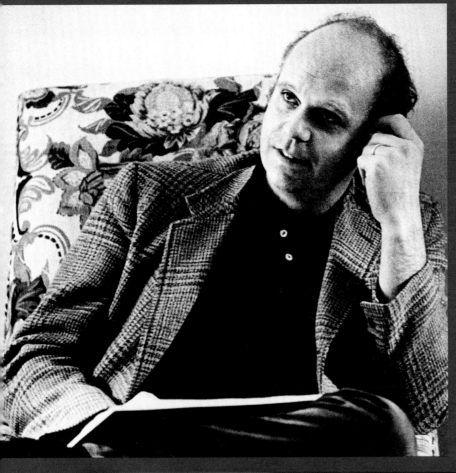

**At the Chateau Marmont,
February 19, 1968**

above, left: Claes Oldenburg

above, right: Harrison Ford

left: Dennis Hopper

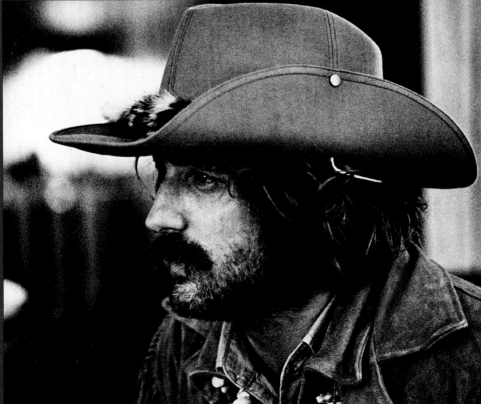

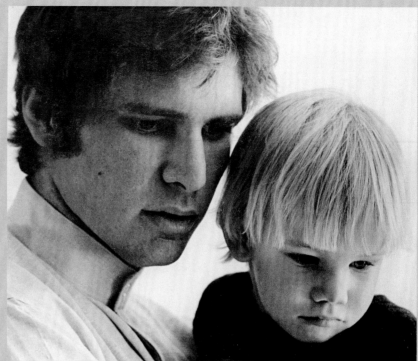

Los Angeles, June 16, 1968

above, left: Mary Marquardt
Ford

above, right: Harrison
and Benjamin Ford

Los Angeles, November 1970

Harrison Ford

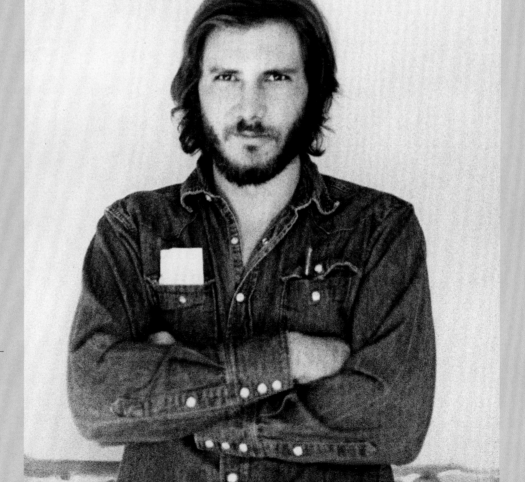

met Camilla and Earl in the mid-sixties through a friend. I was thrown out of college in 1964 and got married that summer. I moved to Los Angeles in the winter of '64 and lived in Laguna Beach in the spare room of a guy who was the head of the drama department at Ripon College, for whom I did a season of summer stock in Lake Geneva. He was also doing plays at the Laguna Playhouse and my wife, Mary, and I lived in his spare room until I got a job and our own apartment in Laguna. I guess I didn't really take up my brother-in-law Paul Lee's suggestion to seek out Earl until I moved up to LA. That was a couple years later, when I decided to go there to pursue my ambition to make a living as an actor. Paul Lee was a professor of philosophy at the University of California. He explained that Earl was a very good friend of his close friend Dick Baker, who was the first American Zen roshi and was running a Buddhist retreat of sorts at a place in Big Sur. At the time I met them,

Earl and Camilla were living in the Chateau Marmont, in an apartment that was luxurious by Chateau standards, overlooking Sunset Boulevard and the statue of Bullwinkle the Moose that was on Sunset Strip at that time. Their downstairs neighbor was Roman Polanski.

I didn't know anyone in LA, since I had just moved and was waiting to hear about an offer for a contract at Columbia Pictures, a seven-year deal. I was living in a $150-a-month apartment on Hollywood Boulevard, and one night I was invited to Earl and Camilla's apartment for a cocktail party populated by a very ritzy crowd, none of whom I had ever met before. This was a proper cocktail party, with proper cocktails served by cocktail waitresses with white jackets and little silver trays. And I was the longhaired hippie. I most likely met Joan Didion and John Dunne there. At the time Earl was working at Warner Bros. with Ahmet Ertegun. Our friendship developed over many years, and Earl became friend to all of my family through their various iterations and was more or less a constant in our lives. He is the godfather of at least two of my children, though he claimed slightly more, as Earl would.

Once my acting career was under way, I took up carpentry. I didn't become a carpenter until I determined that I didn't want to take every acting job that came along and would prefer instead to find another way to put food on the table. Earl and I were walking down the street one day and he looked in a window and he saw a table and he said, "I'm gonna buy that table," and I said, "You can't buy that table—it's fifteen hundred dollars. That's stupid, it's way too much money." At that point, he was living on North Robertson Boulevard, and he said, "I need a table for the living room." So I said, "I'll make you one," and he said, "All right," and I said, "First you have to give me five hundred bucks so I can buy the tools." He did, and I made him a couple of things and did some work on Robertson Boulevard, but I never did any work at the Chateau. Earl and Camilla moved a number of times; there were a couple of apartments after the Chateau. But I did do work for Joan and John in Malibu. And I did work there for quite a while, since the job kept expanding. I did a deck, a wall of French doors, and bookshelves for the library. It was a general remodel of the house, and I was probably there for four months. Joan would always be writing in another room. Earl did everything he could to help John maintain his status as curmudgeon. They were on each other all the time. There were times when they didn't speak to each other for months because they were pissed off about something or other. But nobody paid much attention anyway, except maybe Joan.

Earl and Camilla entertained a lot at North Robertson, and I did go to many of the lunches and dinners. It was

great. Everybody got to know different people that they would never have expected to meet, and I always enjoyed it. If Camilla was there, she cooked, but sometimes she was in New York or Europe and then Earl cooked, brilliantly, and quickly. There were times when Camilla would grow impatient with Earl and his crazy friends, but mostly not. She was very gracious and wonderful with the kids. A real elegant lady.

I told Earl not to buy the North Robertson house, that it was a piece of junk, and I was right. But he bought it anyway. Then he had Arata Isozaki redesign it, but basically he just did a sketch or two and so it was kind of a casual commitment. In fact, it was great for what Earl wanted. It was a two-story building, with a garage that was quickly converted into extra space, all of it done on the cheap over a period of time. And when he sold it he made money.

— HARRISON FORD

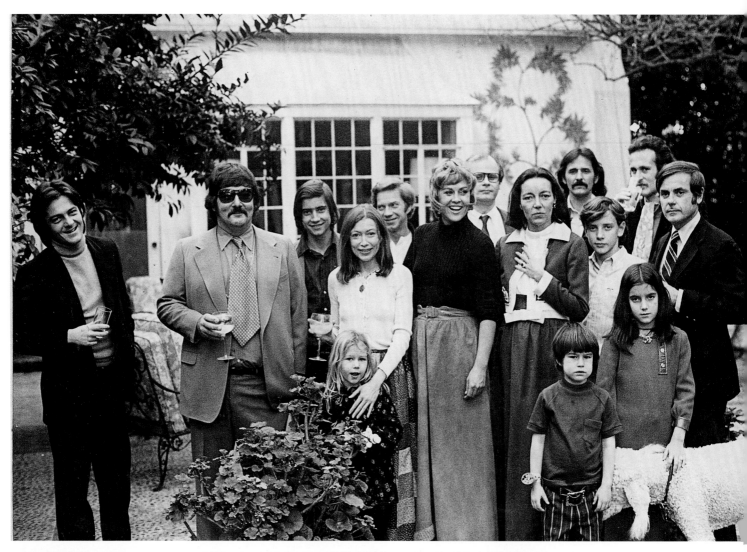

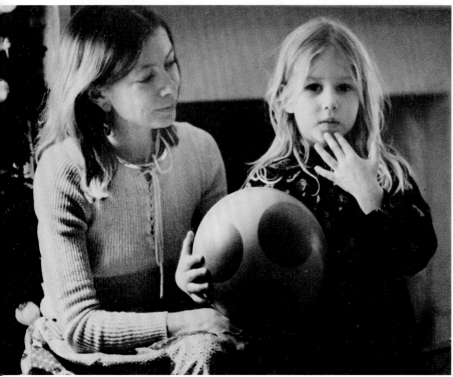

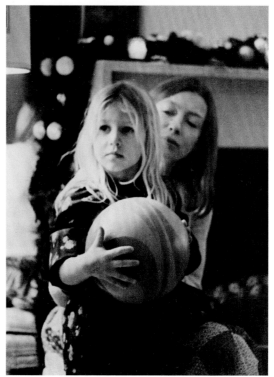

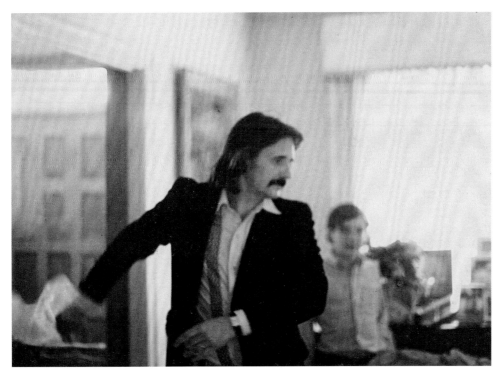

**Christmas Day lunch, 1970,
at Lenny Dunne's**

opposite, top: *left to right,*
Lodovico Antinori, director
Frank Perry; back row: Griffin
Dunne, John Gregory Dunne,
Earl, director John Irvin,
Dominick Dunne; *in front,
left to right,* Quintana Roo
Dunne, Joan Didion, Asa
Maynor Byrnes, Lenny Dunne,
Alex Dunne, Logan Byrnes,
Dominque Dunne

opposite, below left and right:
Joan with her daughter,
Quintana Roo

left: Earl doing his famous
"knife trick"

below: The Dunne brothers,
Nick and John, with Earl

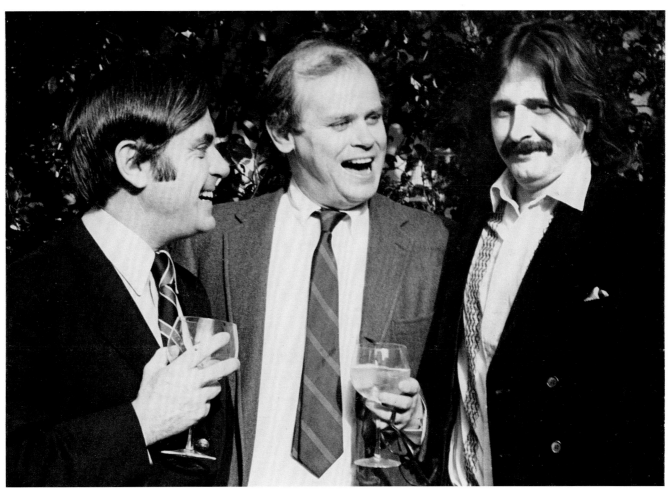

Lunch at Jasper Johns's, Malibu, 1970

right: Earl and Johns

below: Printmaker Ken Tyler, Bruce Nauman, and Johns

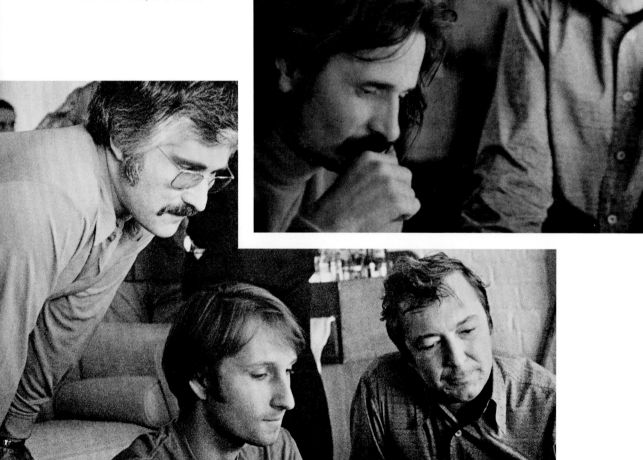

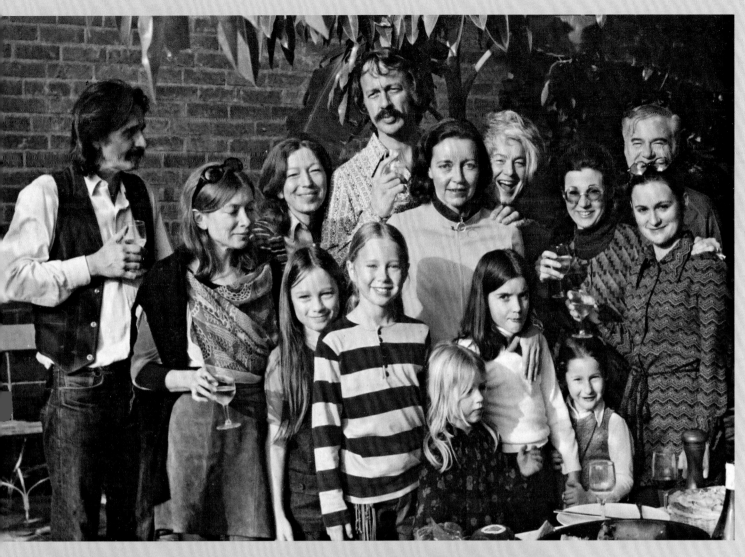

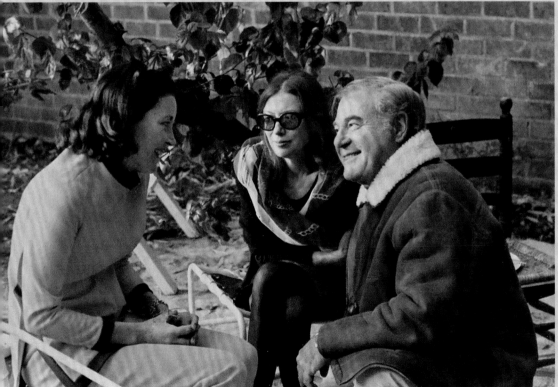

New Year's Day at 454 North Robertson, January 1, 1971

above: *back row, left to right,* Earl, Joan Didion, Jean and Timothy Vreeland, Lenny Dunne, legendary Hollywood hostess Connie Wald, Geney Bucci Casari, Barron Polan (Connie Wald's brother); *front row, left to right,* Quintana Roo Dunne, Dominique Dunne, Cristina Bucci Casari

left: Lenny Dunne, Joan Didion, Barron Polan

At Jasper Johns's in Malibu, with artists, their printmaker, and others, 1971

Earl was friends with Ken Tyler, who started the great print atelier Gemini Ltd. and later, with the backing of Sidney Felsen and Stanley Grinstein, Gemini G.E.L.; in 1973 he founded Tyler Workshop Ltd. in Bedford Village, New York.

right: Jasper Johns and Earl

below: *left to right,* Larry Bell, Earl, Sidney Felsen (with his back to the camera), and John Chamberlain

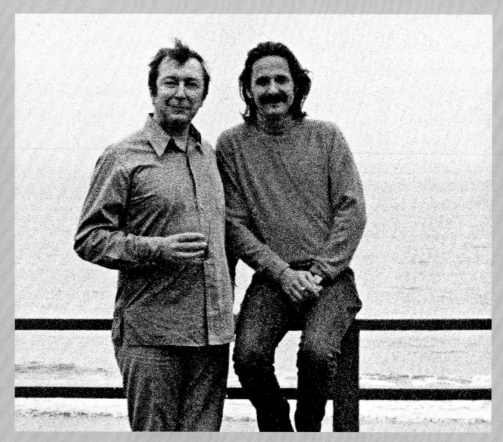

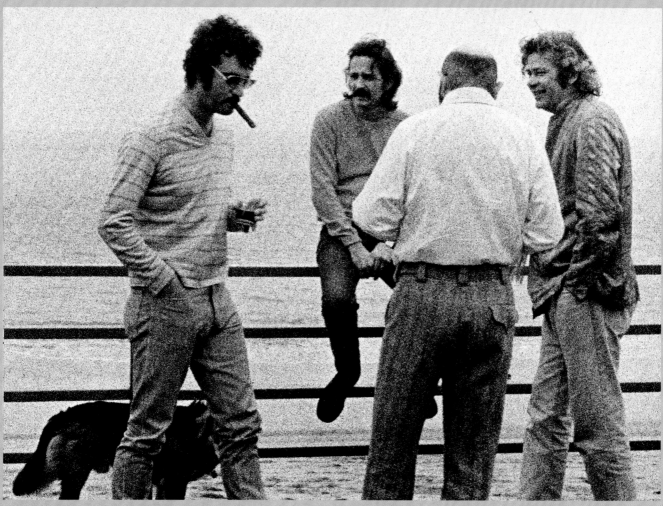

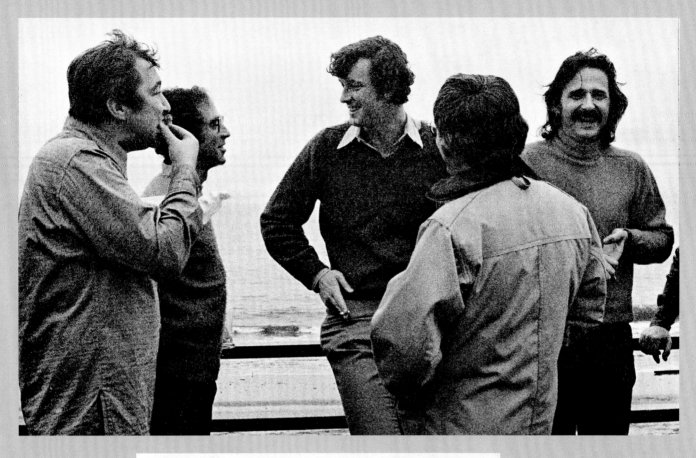

above: *left to right,* Jasper Johns, TV producer and agent Frank Konigsberg, writer Michael Crichton, Ken Tyler (with his back to the camera), and Earl

left: Michael Crichton and Earl

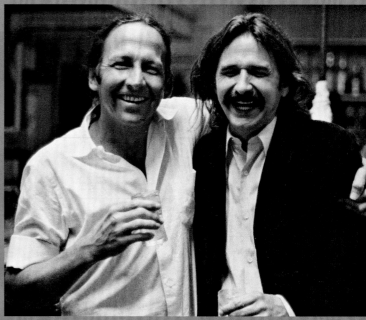

In 1972, Earl McGrath had
his gallery at 454 North
Robertson but he was also
president of the custom label
Clean Records, distributed
by Atlantic. He gave a star-
studded party for Delbert &
Glen's debut album at Big Al's,
with Joan Didion, John Gregory
Dunne, David Geffen

top, left: *left to right*, Robert
Rauschenberg, Earl, Larry
Rivers, and Tandy Brody

top, right: Robert
Rauschenberg and Earl

right: Ron Cooper and
Jack Nicholson

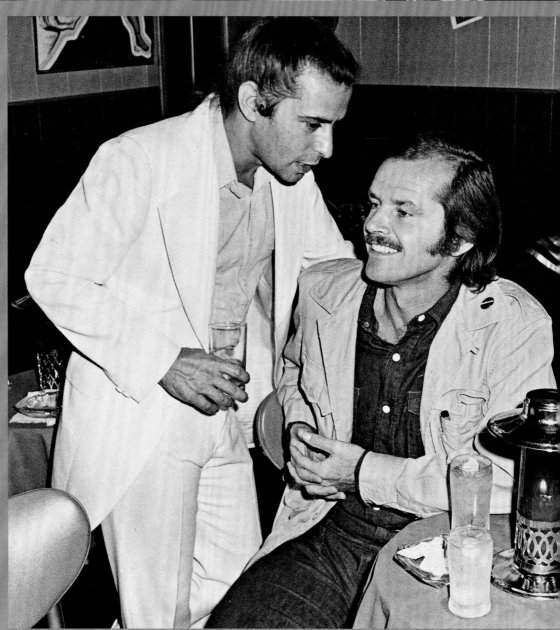

Christmas dinner at Joan and John Dunne's, 1973

top, left: Quintana Roo Dunne

top, right: Joan Didion

left: Earl and Quintana Roo

below: John Hartford on the violin, with Earl and Quintana Roo

above: *left to right,* Artist Brian Hunt, Wendy Stark, Earl, and Annie Leibovitz

Ellsworth Kelly had a show at the Pasadena Museum of Modern Art, January 1974

right: *left to right,* Art dealer Rosamund Felsen, Earl, Ellsworth Kelly, and Elyse Grinstein

Lunch at North Robertson, June 25

Photographer Joan Townsend and Maria Schneider of Bertolucci's *Last Tango in Paris* (1972) fame

Lunch at North Robertson, 1974

Tim Vreeland with Diana Vreeland, his mother

Lunch at Joan Didion and John Gregory Dunne's in Trancas, 1974

top: *left to right*, Alessandro Albrizzi; Mel Ferrer, actor, director and first husband of Audrey Hepburn; actress and photographer Jean Howard Santoro (first wife of legendary agent and producer Charles Feldman); Lisa Ferrer; and architect Tony Cloughley

bottom: *left to right*, John Gregory Dunne, Clarice Rivers, Joan Didion, Quintana Roo Dunne, Earl, Rainer von Hessen (Prince Philip's nephew), and the Dunnes' Bouvier des Flandres, Casey

opposite: Joan and Earl

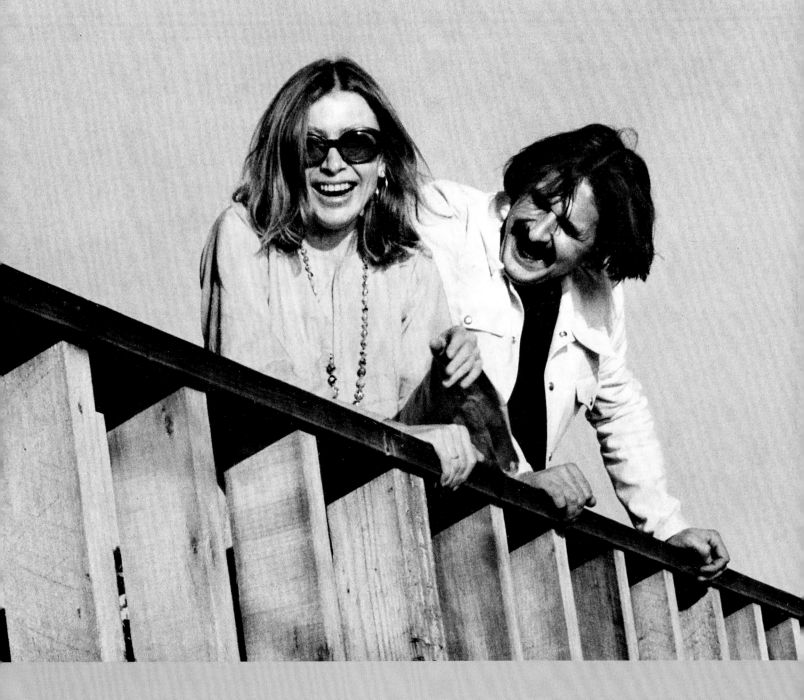

Lunch at North Robertson, 1974

top: Brooke Hayward embracing Jules Stein, founder of MCA, while Nick Dunne, Doris Stein, and Diana Vreeland look on

below, left: Earl and Brooke Hayward

below, right: Director Tony Richardson

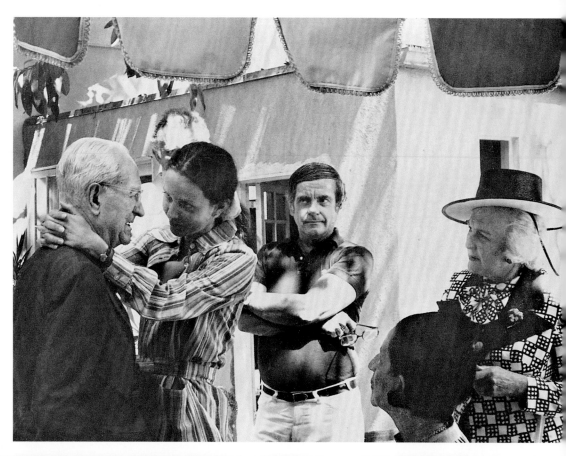

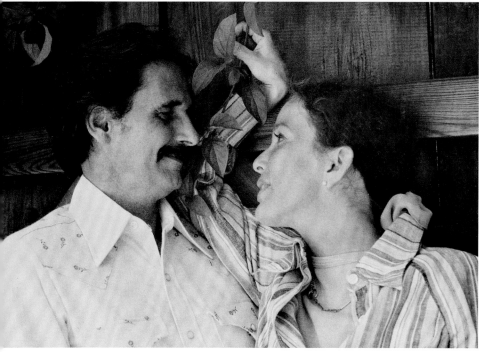

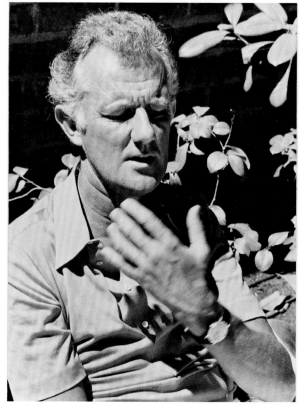

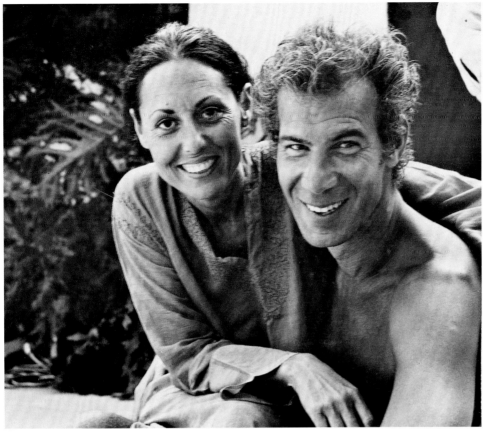

Lunch at North Robertson, 1974, with the Rafelsons: producer, designer, and art director Toby and her husband, director Bob

At the house, July 1974

Don Everly of the Everly Brothers, Earl, and Griffin

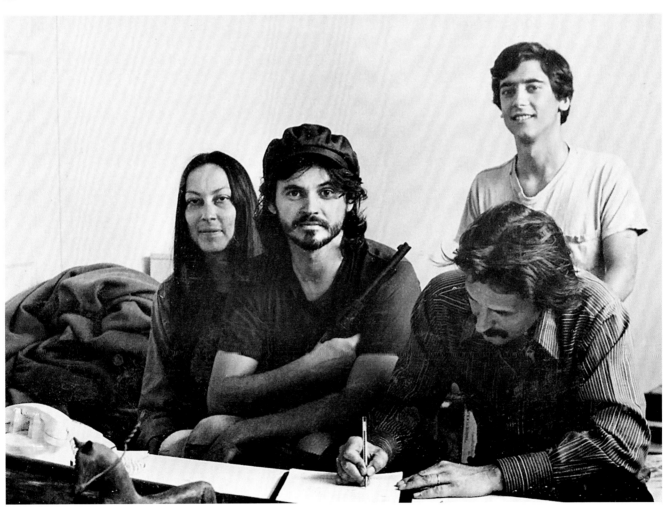

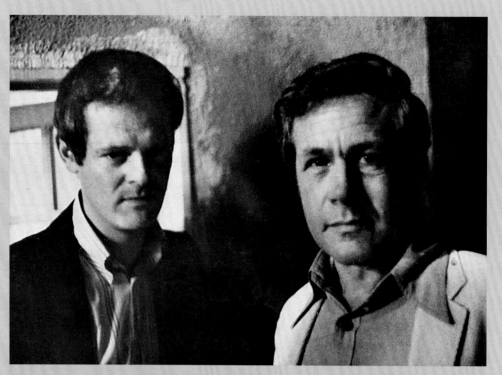

Last party at North Robertson before the redesign by Arata Isozaki; music by Rubber Band, 1974

right: Paul Morrissey and Jack Larson

below: David Geffen and Annie Marshall

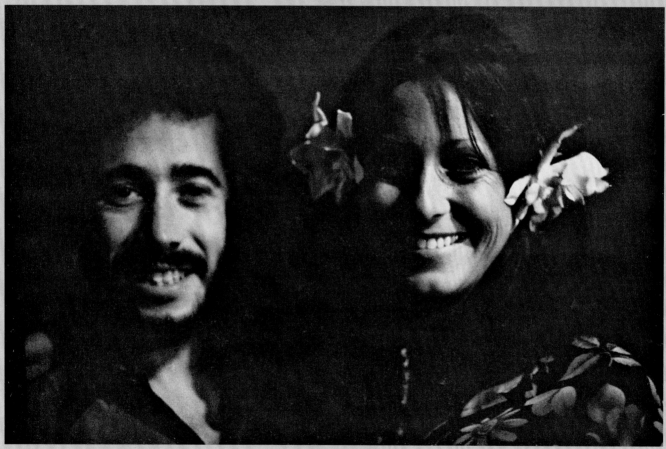

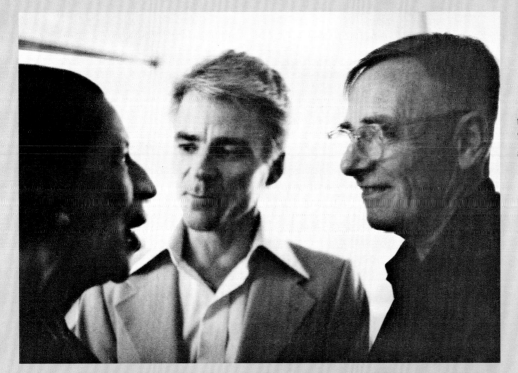

top: *left to right,* Diana Vreeland, Don Bachardy, and Christopher Isherwood

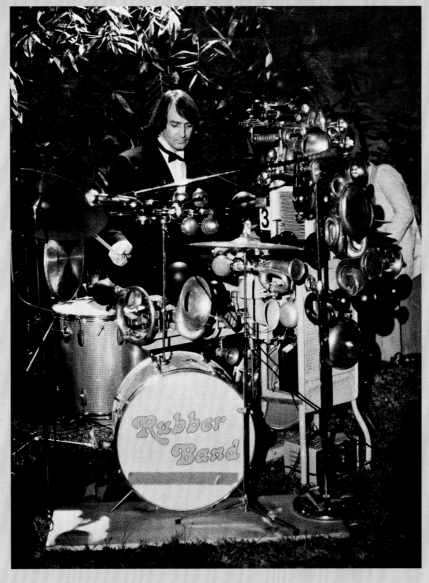

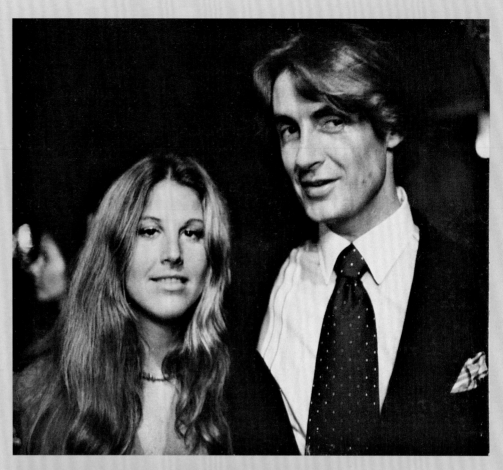

top: Wendy Stark and
Joel Schumacher

below: John Phillips with
Anjelica Huston

At Toby Rafelson's after Roxy Music's concert at the Hollywood Palladium, 1976

top: *left to right*, Art dealer Nicholas Wilder talking with another guest, and Paul Morrissey and Camilla

bottom: *left to right*, Henry Geldzahler, Earl, David Hockney, and Bryan Ferry

August 22, 1982, lunch at Marguerite and Mark Littman's. Known for their London dinners, he was a barrister and Queen's Counselor in London and Marguerite was said to have coached Elizabeth Taylor on her southern accent for *Cat on a Hot Tin Roof* and been an inspiration for Truman Capote's southern heroine, Holly Golightly.

right: Reinaldo Herrera and interior designer Melissa Wyndham, whose great-aunt was Nancy Lancaster

below: *left to right*, Bob Colacello, Melissa Wyndham, Josephine Loewenstein, and Mark Littman

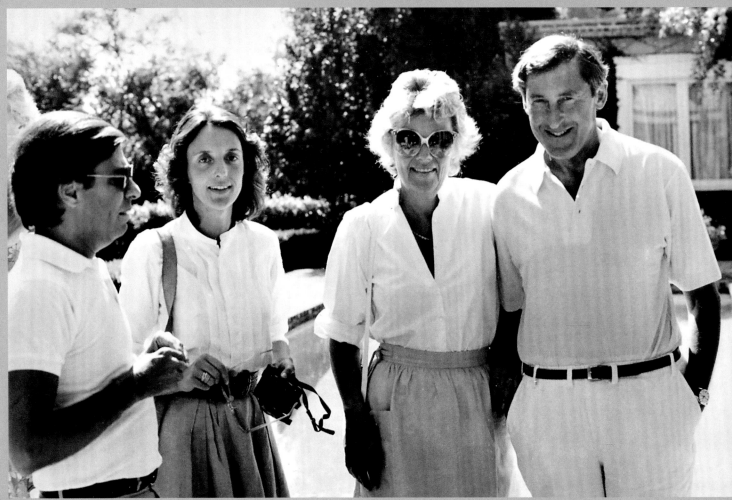

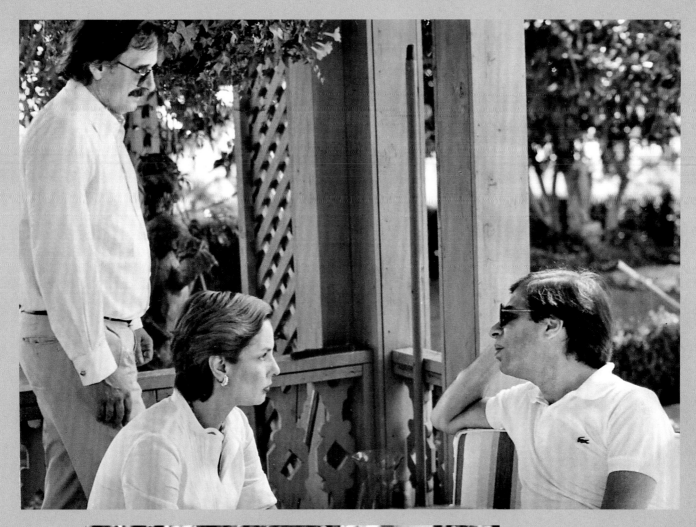

above: Earl, Carolina Herrera,
and Bob Colacello

left: Marguerite Littman
and Lenny Dunne

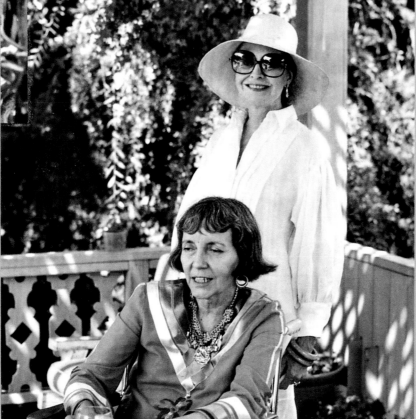

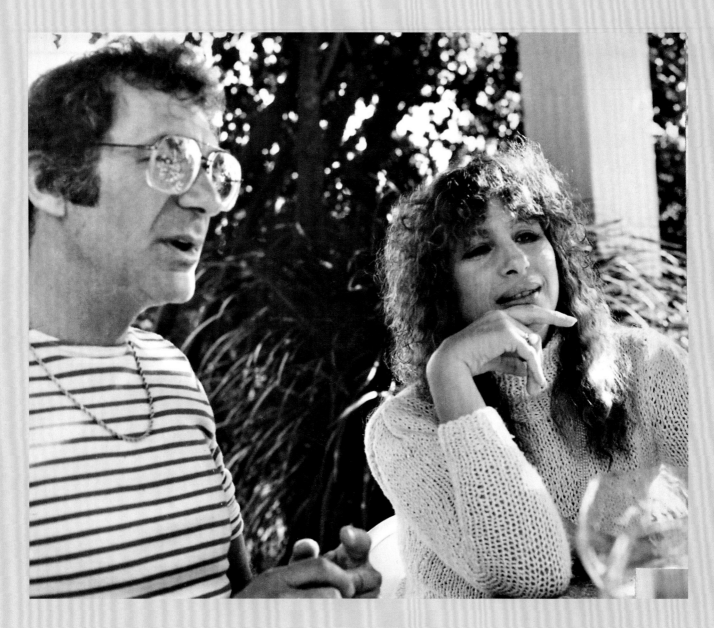

Lunch at Linda Palewski's, January 5, 1983

Sydney Pollack and Barbra Streisand

Lunch at the house on North Robertson

Brooke Adams and
Griffin Dunne

Lunch, February 12, 1983

Eve Babitz

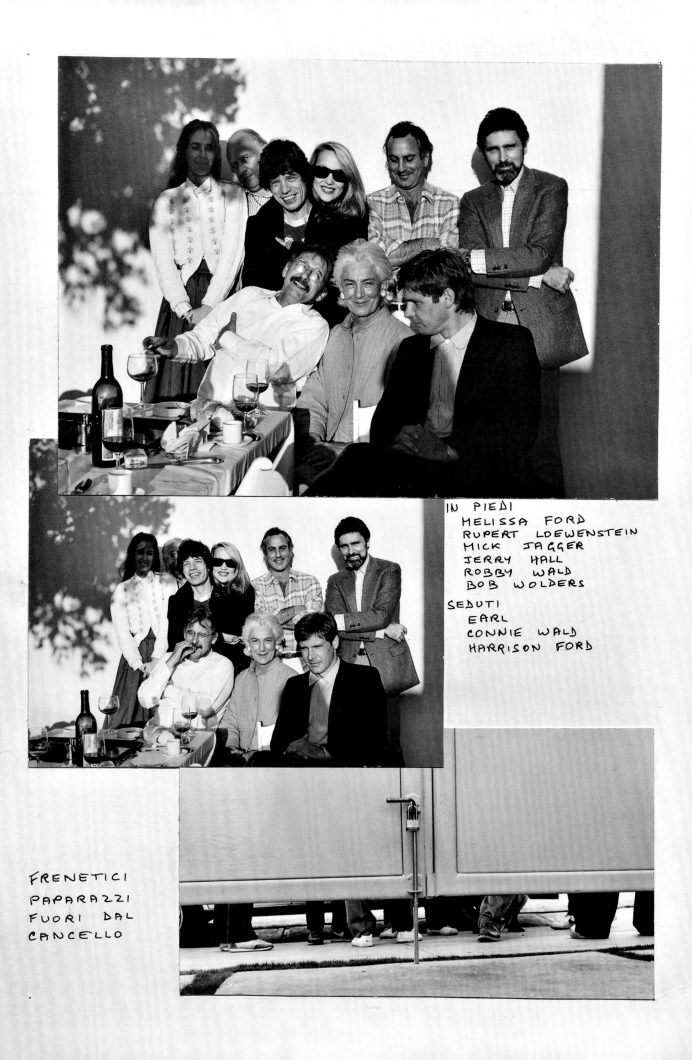

IN PIEDI
MELISSA FORD
RUPERT LOEWENSTEIN
MICK JAGGER
JERRY HALL
ROBBY WALD
BOB WOLDERS

SEDUTI
EARL
CONNIE WALD
HARRISON FORD

FRENETICI
PAPARAZZI
FUORI DAL
CANCELLO

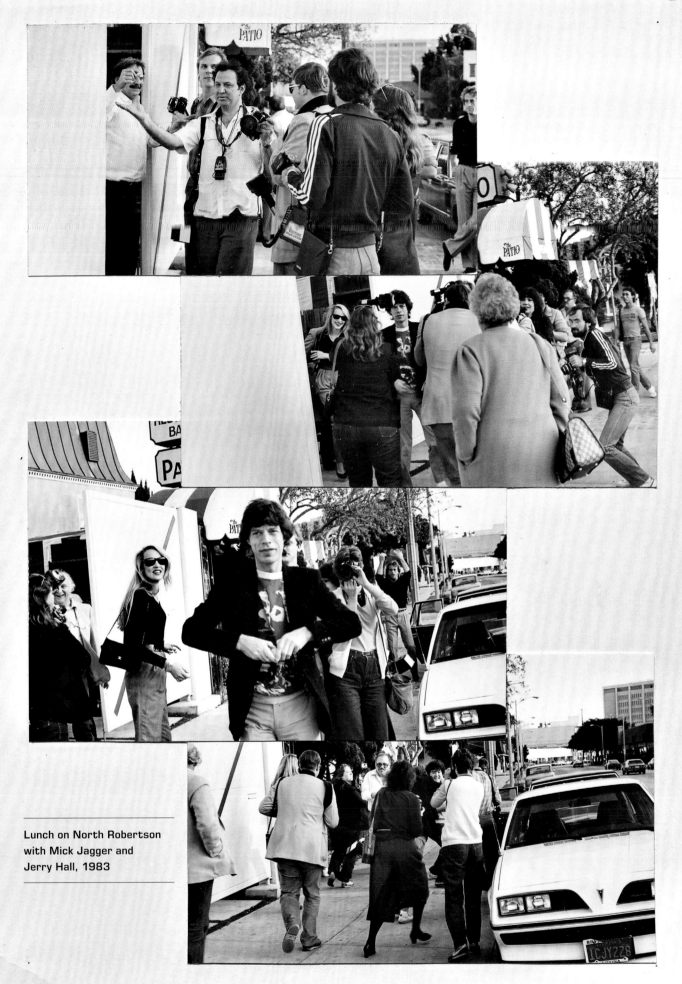

Lunch on North Robertson
with Mick Jagger and
Jerry Hall, 1983

The McGraths' twentieth-anniversary party at the house, January 1983

right: Ahmet Ertegun and Denise Hale

below: Writer Joan Juliet Buck

top: *left to right*, Bob Becker, Harrison's son Ben Ford, Sally Baker, Harrison Ford, and Richard Baker, a longtime friend of Harrison Ford and Earl McGrath, and American Sōtō Zen Master and founder of Dharma Sangha

below: *left to right*, Producer Richard Roth, Dagny Corcoran, interior designer Verde Visconti, and architect Kiki Kiser

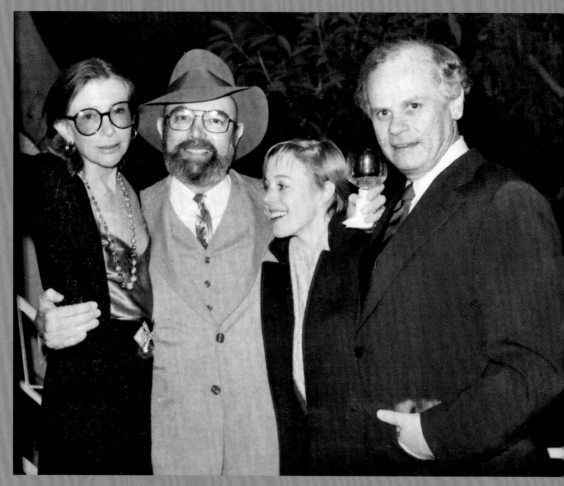

top: *left to right*, Joan Didion, Sidney Felsen, Joni Weyl, John Gregory Dunne

below: *left to right*, Director and producer Fred de Cordova with producer Martin Manulis and his wife, Kathy

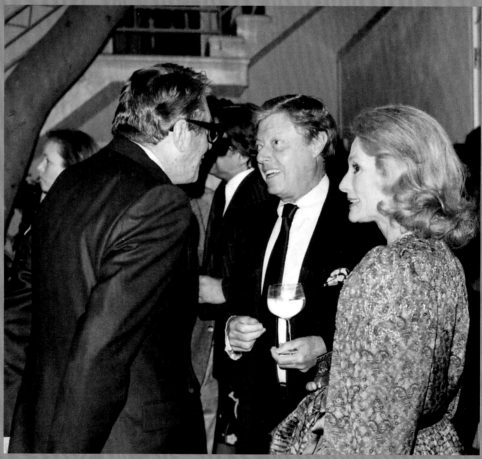

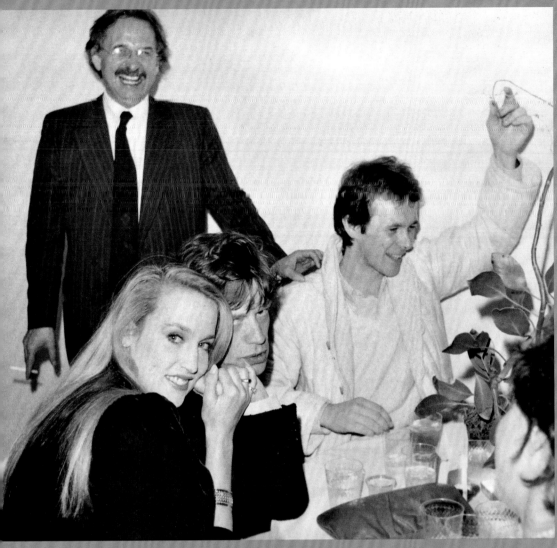

top: Earl, Jerry Hall, Mick Jagger, and producer Bill Oakes

below: *left to right*, Don Bachardy, Jerry Hall, Richard Sylbert, Christopher Isherwood, John Gregory Dunne, Linda Palewski, Sammy Colt

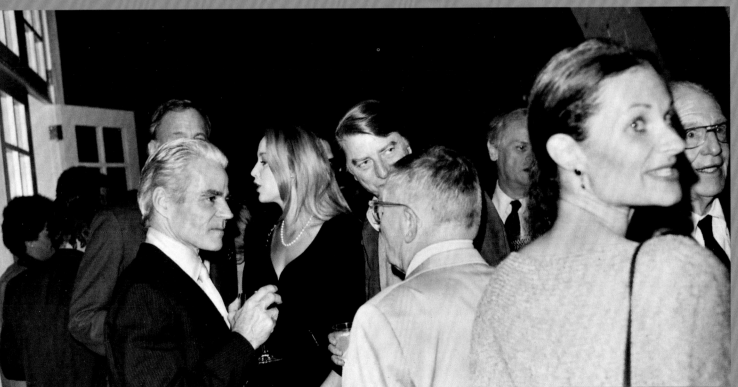

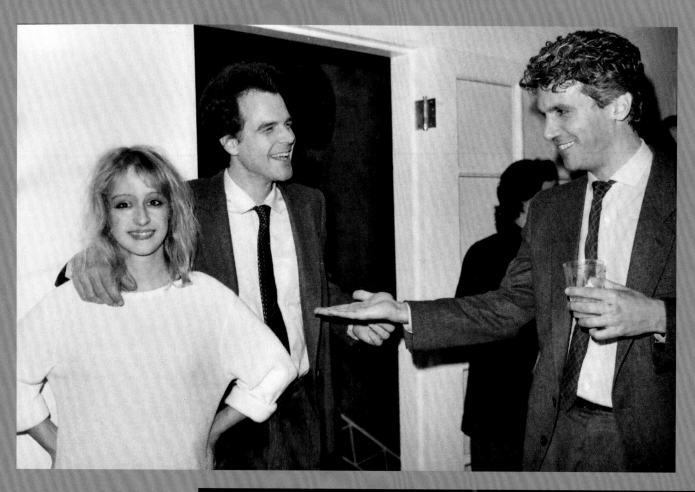

above: Carmen and Peter
Bartlett with Larry Gagosian

right: Producer Bill Hayward,
Brooke's brother; his wife,
Fiona Lewis Hayward; and
Marin Hopper, daughter of
Brooke and Dennis Hopper

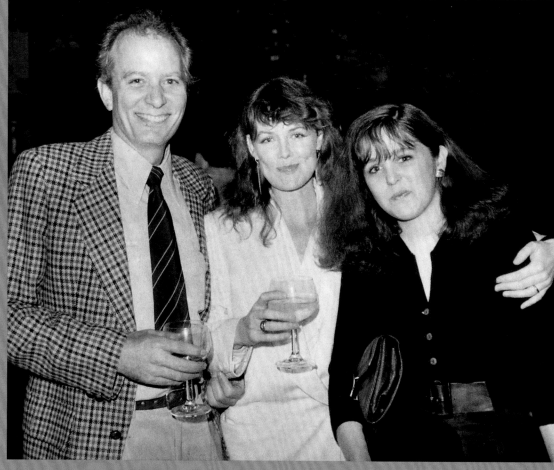

Lunch at the house, July 1, 1984

above: Architect Michael Graves, interior designer Kitty Hawks, architect Frank Gehry, Earl, and Alejo Gehry, Gehry's son

left: Michelle Phillips and her son Austin Hines

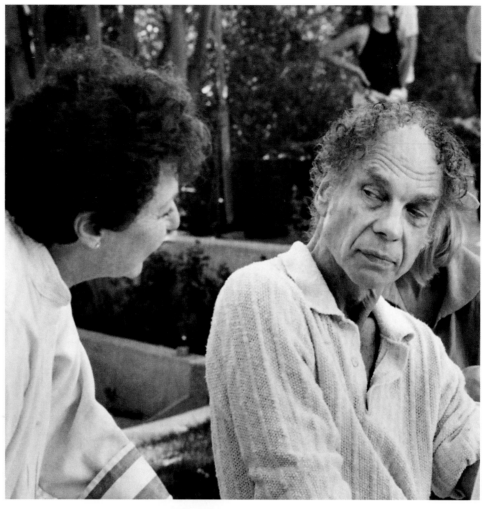

**Lunch for the Merce
Cunningham Dance Company at
Elyse and Stanley Grinstein's,
July 4, 1984**

right: Elyse Grinstein with
Merce Cunningham

below: Elyse with John Cage

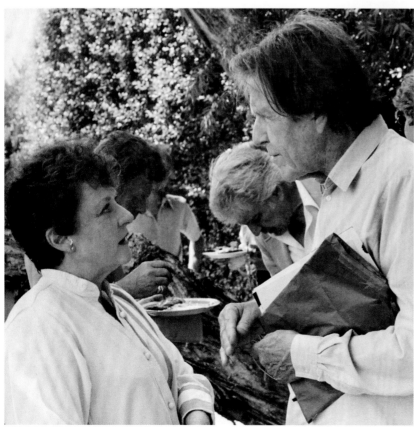

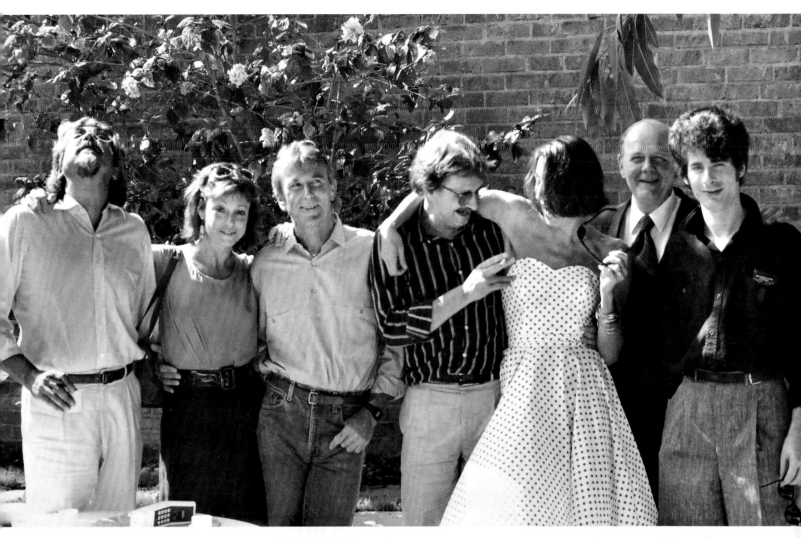

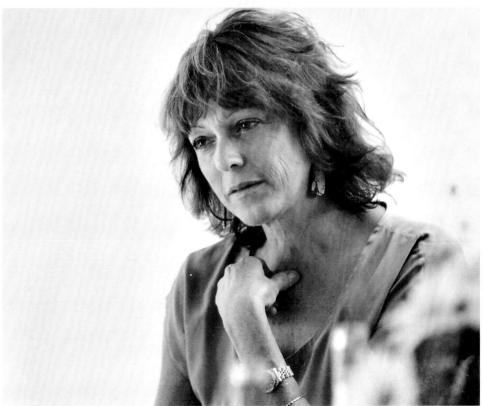

July 17, 1984

above: *left to right*, Robert Graham, Annie Marshall, Billy Al Bengston, Earl, Anjelica Huston, philosopher Paul Lee, and Warren Klein

left: Annie Marshall

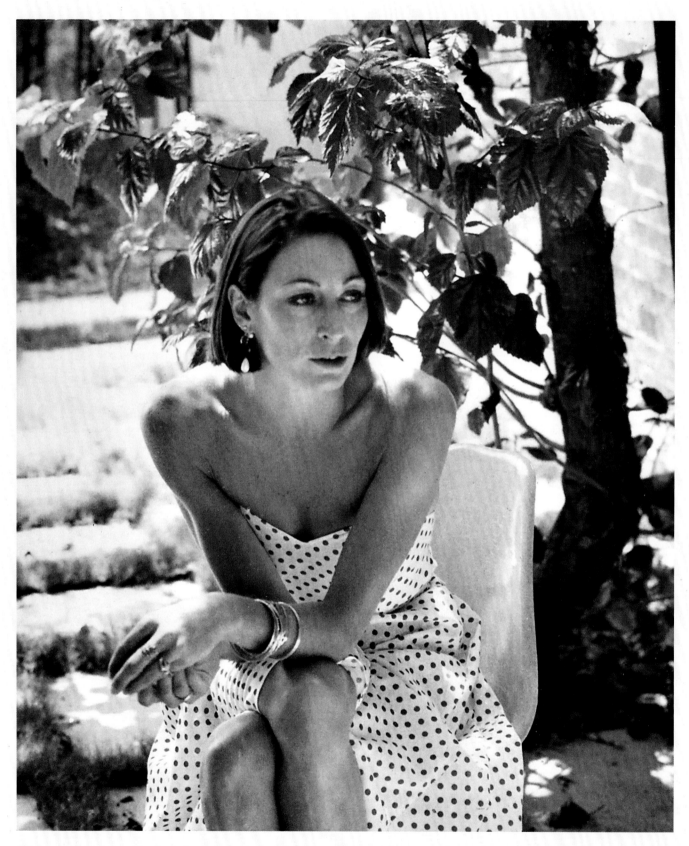

Anjelica Huston

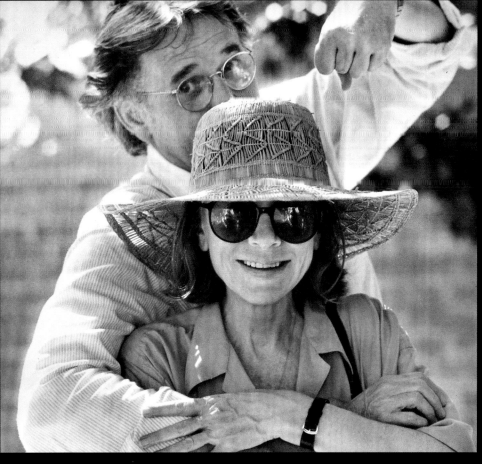

Lunch at North Robertson,
June 9, 1985

left: Earl and Joan Didion

below: Billy Al Bengston

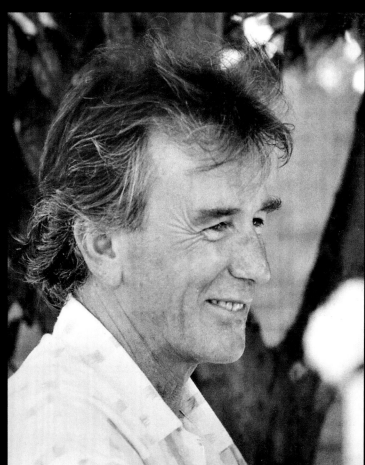

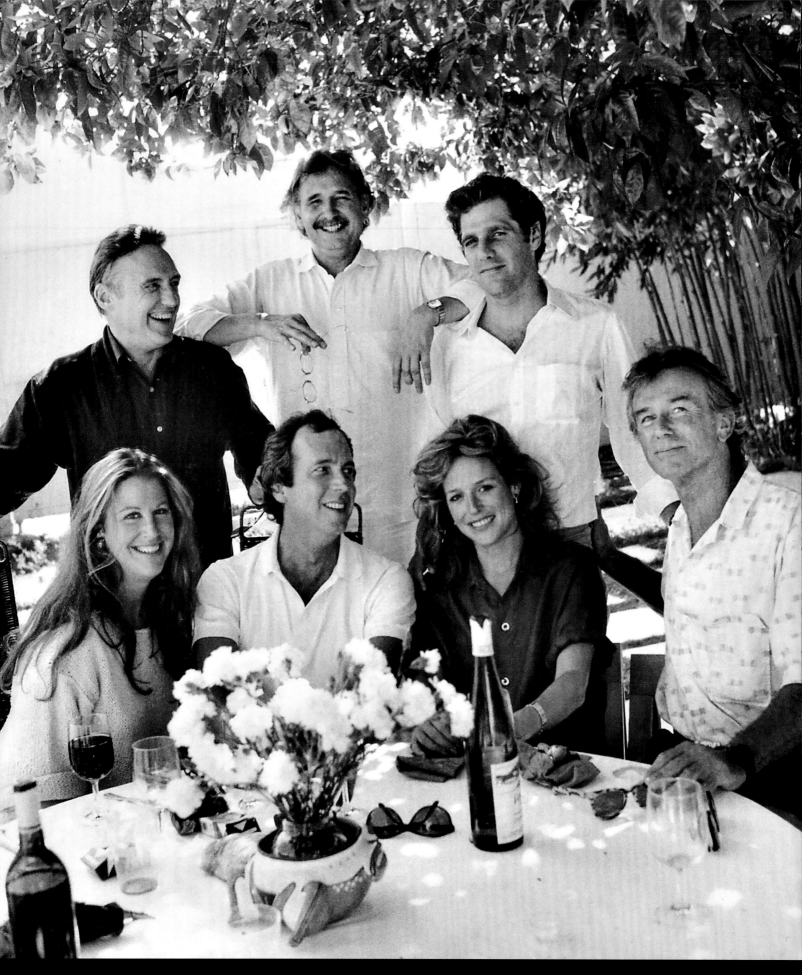

standing, left to right, Dennis Hopper, Earl, Eagles founder Glenn Frey; *sitting,*
Wendy Stark, filmmaker David Giler, Janie Frey, Billy Al Bengston

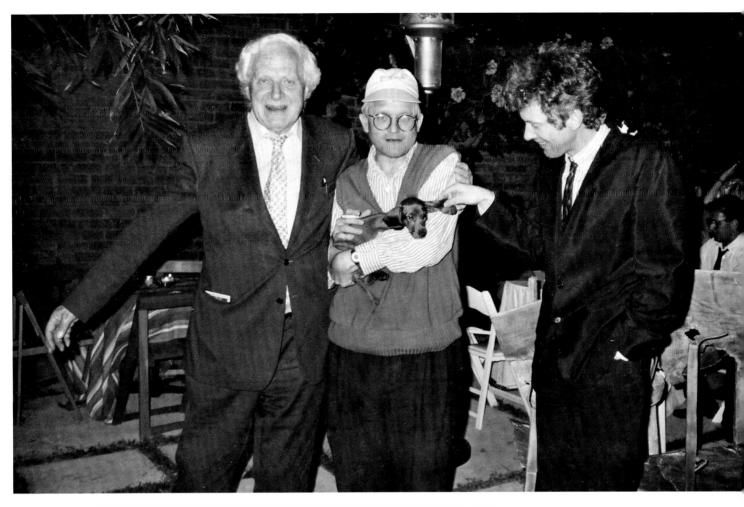

Dinner at the house for
poet Stephen Spender,
November 3, 1986

top: *left to right*, Stephen
Spender, David Hockney,
Patrick Morrison

below: *left to right*, curator
Charlie Scheips, David Hockney,
Bryan Ferry

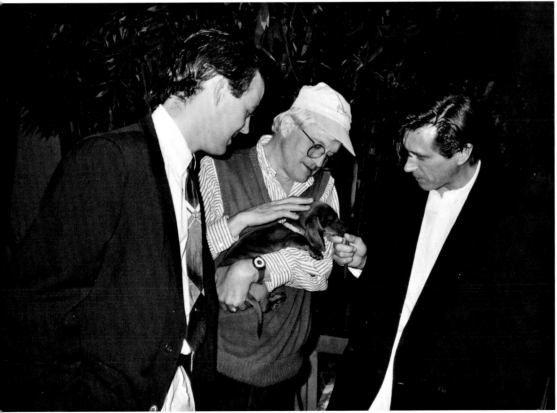

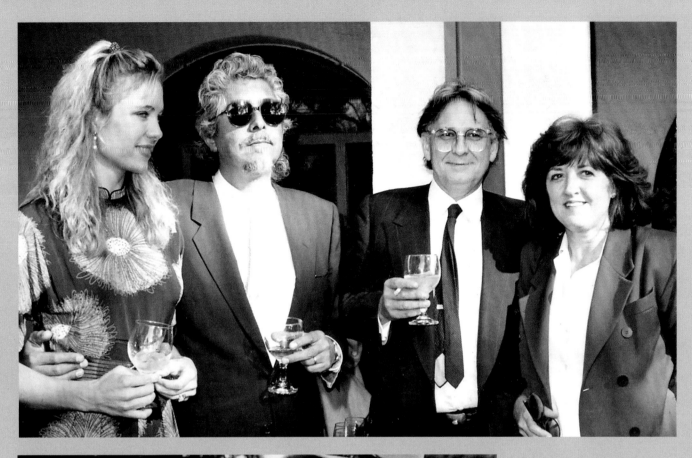

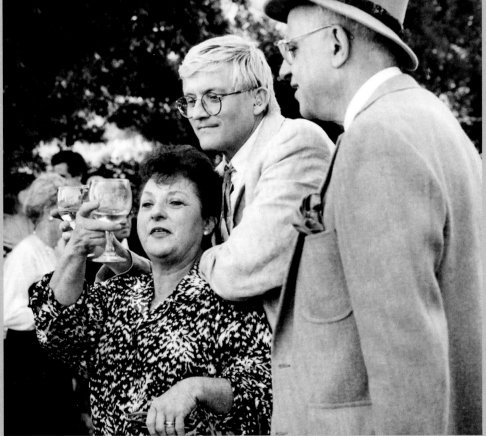

Wedding of Joni Weyl and Sidney Felsen, 1986

opposite, top: *left to right*, Robert Rauschenberg, Sidney Felsen, David Hockney, Ellsworth Kelly, and Don Flavin

opposite, below: *standing, left to right*, Thurston Twigg-Smith, Ed Ruscha, Joni, Earl, Robert Graham, Dana Ruscha, Laila Roster Twigg-Smith; *seated, left to right*, Katie Arnoldi and Annie Graham

top: *left to right*, Annie and Robert Graham, Earl, Vija Celmins

bottom: *left to right*, Elyse Grinstein, David Hockney, and George Christy, longtime gossip columnist for *The Hollywood Reporter*

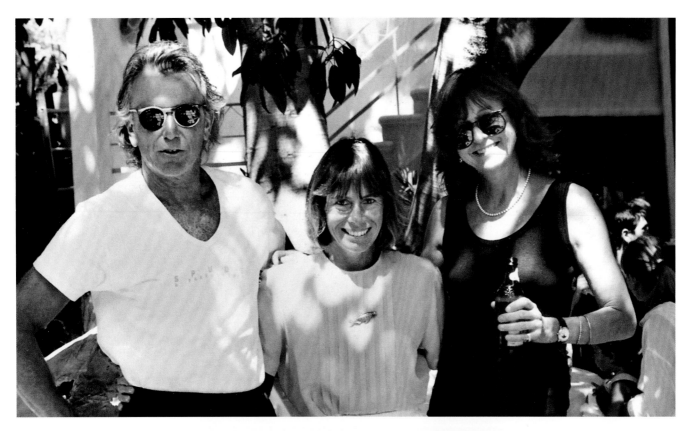

After leaving his job as president of Rolling Stones Records, Earl founded his art gallery at 454 North Robertson Boulevard in 1985.

A lunch for the artists, June 29, 1986

above: *left to right,* Billy Al Bengston, writer Penny Little, and Annie Marshall

right: Robert Graham and Earl

opposite: Candy Clark and Steve Martin

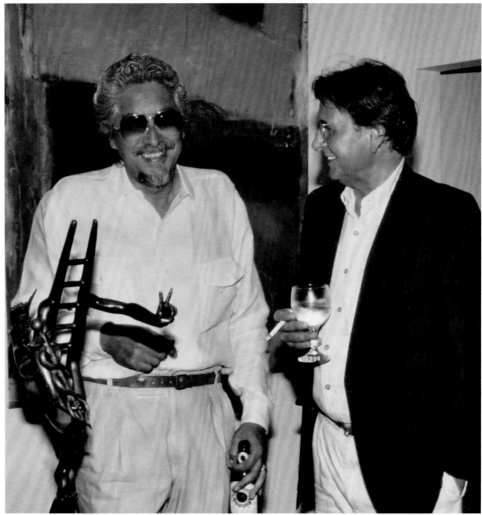

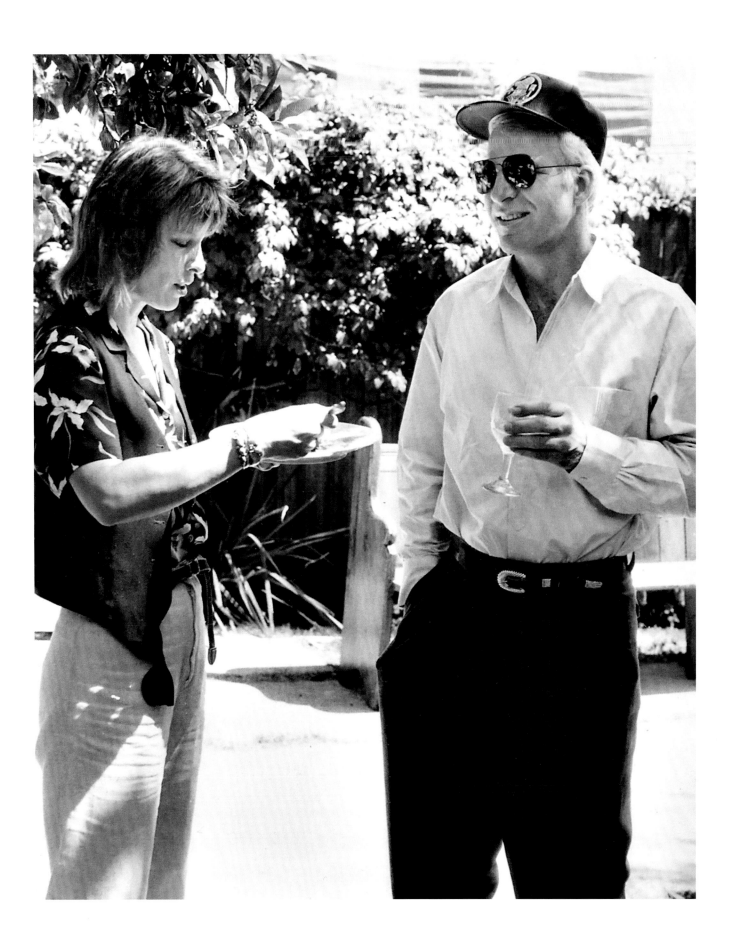

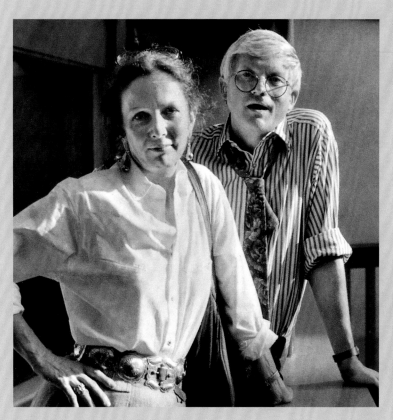

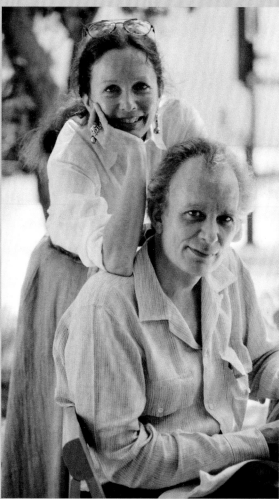

**Lunch at David Hockney's,
May 18, 1986**

above, left: Brooke and
David Hockney

above, right: Brooke and
Bill Hayward

below: David Hockney

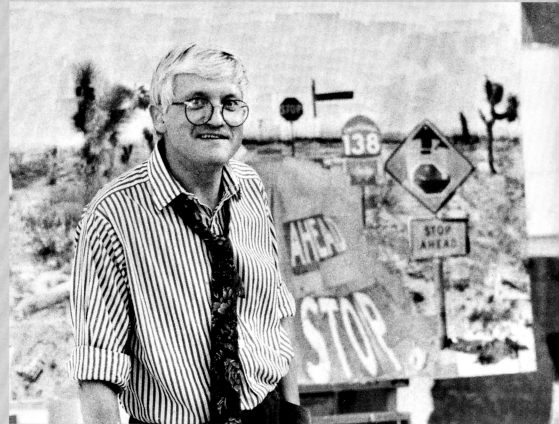

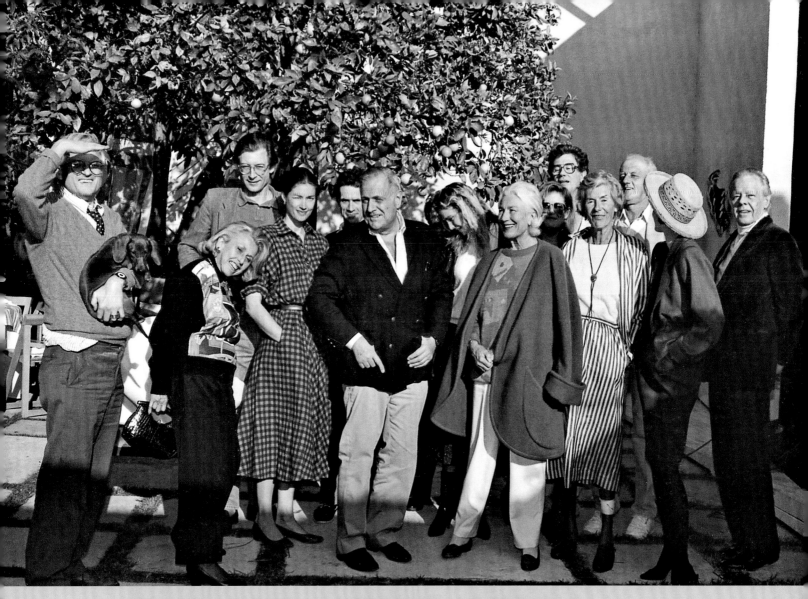

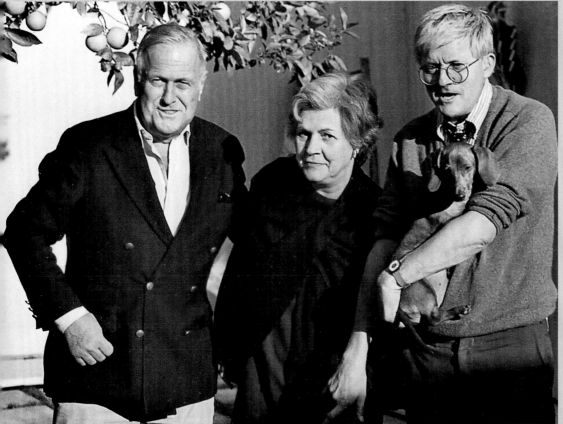

**Breakfast at the house,
January 1987**

above: *left to right,* David
Hockney; art collector Marsha
Weisman; physicist Sebastian
White; his wife, Kristin
White; Michael Ester; John
Richardson; Annie Graham;
Connie Wald; Dagny Corcoran;
Natalia Grosvenor, duchess of
Westminster; Tony Richardson;
Lucy Ferry, wife of Bryan Ferry;
screenwriter Ivan Moffatt

right: John Richardson, Camilla,
Hockney

Opening of a show of drawings and prints by Rolling Stones band member Ronnie Wood, 454 North Robertson, December 12, 1987

above, left: Ronnie and Josephine Wood

above, right: Self-portrait

left: Ronnie Wood and Timothy Leary

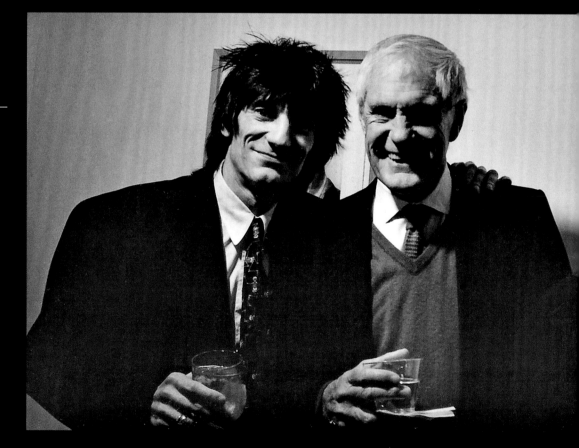

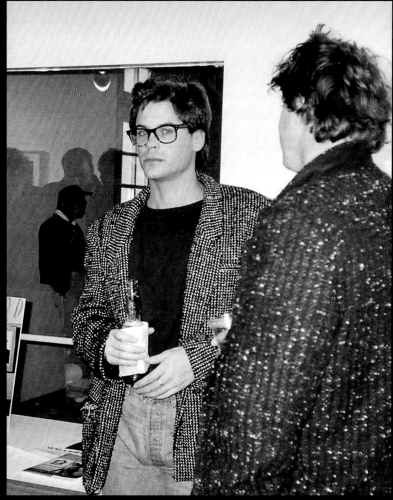

left: Rob Lowe

below, left: Producer Dimitri Villard and Lauren Hutton

below, right: Producer Uberto Pasolini and Diego Pignatelli

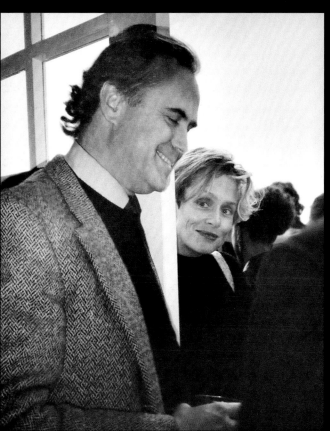

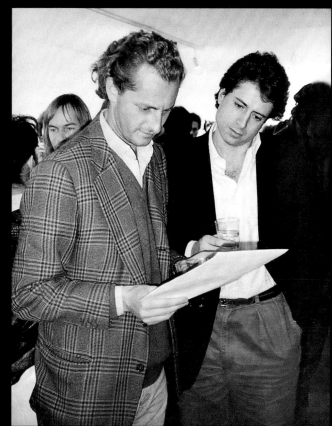

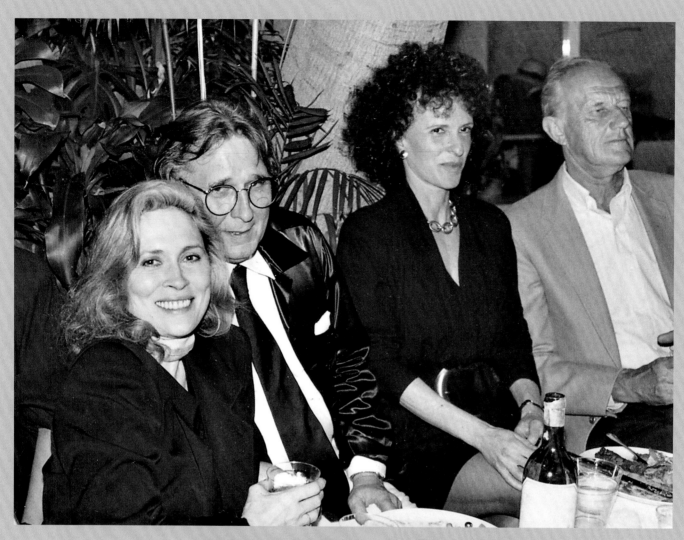

Dinner at the house for Joan Didion and John Gregory Dunne before their move to New York in 1988

above: *left to right,* Faye Dunaway, Earl, Jean Stein, Tony Richardson

below: Ivan Moffat, Camilla McGrath, Ed Ruscha

left: George Stevens and
Rose Styron

below: Agents Bob Bookman
and Lynn Nesbit, producer
Mike Medavoy, Patricia Duff
Medavoy, John Gregory Dunne

top: *left to right,* Joan Didion, Terry Southern, and Jean Stein

below: *left to right,* Dana Ruscha, artist and writer Eve Babitz, Ed Ruscha, Melissa Mathison Ford, Annie Marshall

opposite, top: Songwriters Alan and Marilyn Bergman with, *center,* Rose Styron

opposite, below left: Defense attorney Leslie Abramson and her husband, journalist Tim Rutten, who worked at the *Los Angeles Times* from 1971 to 2011

opposite, below right: Robert Scheer was a founder of Truthdig and was at the *Los Angeles Times* from 1976 to 1993.

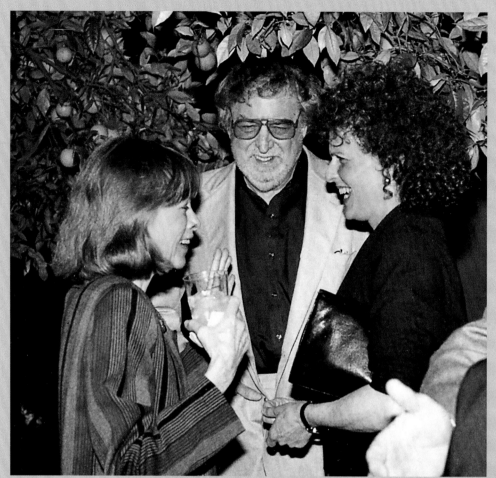

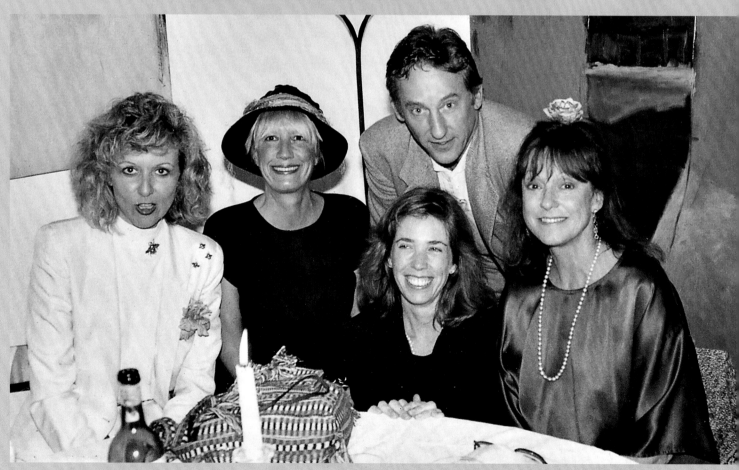

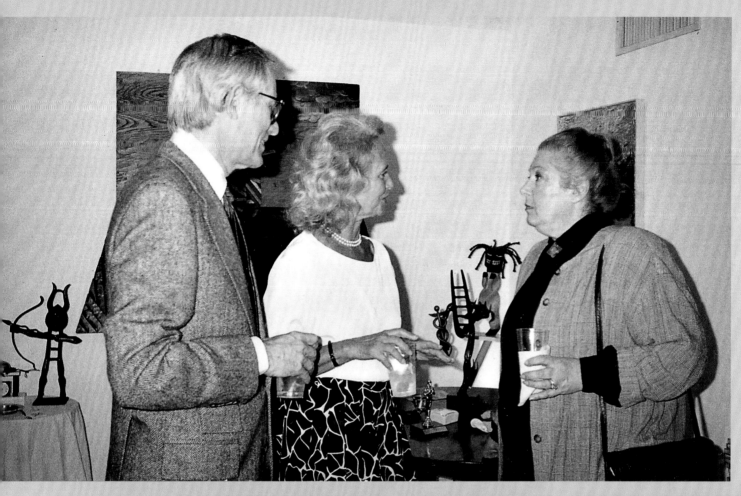

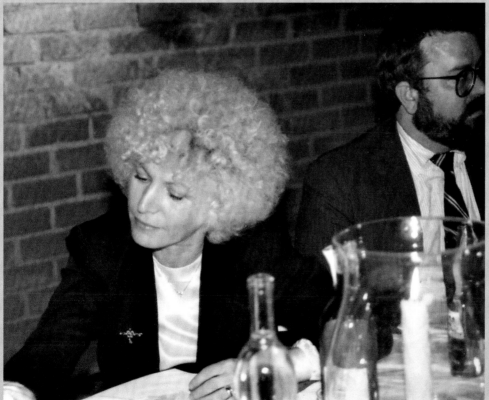

above: *left to right*, Madge
Bemiss, Richard Roth, Caroline
Graham, Billy Hitchcock, and
artist Dianne Blell

right: Andrea Sylbert and
Toby Rafelson

was thirteen when I met Camilla and Earl at our house on Walden Drive in Beverly Hills. My parents were divorced or separated, but every December 25th they would have a drop-by in the afternoon for people who had nowhere to go on Christmas. It always drew an interesting crowd. One year François Truffaut was in Los Angeles and had nowhere to go on Christmas Day, so Rupert Allan, who was the publicist for Marilyn Monroe, among others, brought Truffaut. Earl and Camilla were living in the Chateau Marmont at the time. When my dad introduced me, Earl said, "I'm gonna be your new fake uncle. You call me Uncle Earl." It made perfect sense to me. After my father wandered off to talk to some people, Earl said, "Hold out your hand," and he reached into his pocket and pulled out a roach of pot, maybe three or four inches long, and he dropped it into my palm. He was very much the prankster. They came to many Christmases after that. Camilla would always herd us all into the backyard for a group Christmas photo.

We would often see Camilla and Earl for Sunday lunch at the Chateau, where they had Suite 64, once lived in by Howard Hughes. There is a great Edward R. Murrow interview with Sophia Loren in that suite where he's in New York and she's walking around in the suite. Earl once told me he was paying four hundred a month for that two-bedroom apartment, which was the biggest in the Chateau. He realized that he never used the other bedroom, so he called Harrison Ford, who was doing carpentry at the time, and Harrison came over with a wood frame and put that over the door, hammered it shut, and Earl called downstairs to the famous guy who worked the switchboard at the time and he said, "I just blocked off my second bedroom and I only want to pay two hundred dollars." And they said okay. But Harrison has said he never did carpentry there, so it must have been an Earl tall tale.

Lunch was always on the enormous terrace, which was so big you could play tennis on it. People rarely take that apartment now; it's only used for parties. During the 1966 Sunset Strip riots, there was a shop down on the Strip called Pandora's Box where a bank is now. At the time, it was a head shop for pot, and the cops were going to shut it down. There was supposed to be a protest that somehow everyone knew was going to turn into a mini riot. Earl called my parents and said, "You have to bring the kids over so we can all watch the riot." Suite 64 overlooked the Strip with a perfect view. When we got there it was just about to start. It was as though we were waiting for a show to begin. Earl passed out cap guns and threw firecrackers off the roof and we would yell, "Off the pigs!" We were watching cars being turned over. Somehow it was a happy memory. This was just a few cars getting turned over and some hippies getting beaten with batons.

In 1968, I was taken to a party at the run-down 1920s Spanish-style house with six bedrooms on Franklin Avenue that my aunt Joan and uncle John had rented for a song. In the back were orange trees and a tennis court overgrown with weeds and moss. The occasion was a book party for Tom Wolfe's *The Electric Kool-Aid Acid Test.* Janis Joplin was there, and it made such an impression on me that I later wrote and directed a short film about it called *Duke of Groove,* with Toby Maguire and Kate Capshaw, which was nominated for an Academy Award. Harrison came dressed all in black and Earl all in white and they would walk together back-to-back up to someone and Earl, all in white, would start the conversation, and then Harrison, all in black, would continue it. It was this sort of silly performance piece that seemed very funny at the time.

In 1971 Joan and John moved from Franklin Avenue to a one-story wooden house in Trancas perched on a cliff overlooking the Pacific. Harrison would often be out there building the

deck and I'd be bumming cigarettes from him. And then I'd go swimming. Earl, of course, was there all the time. Joan and John would have parties that Earl and Camilla went to, that started around eight and ended quite late it was the seventies, and people had a good time. The drive home was a bitch.

Later, in the eighties, I was living in New York but coming back home a great deal for work, and to see my mom. If ever there was a lunch at 454 North Robertson, where Camilla and Earl had bought a small house, I would go. They lived in the decorating district, with fancy florists and high-end designers and interior decorators with showrooms. The lunches were always on Sunday, so the area was completely quiet and it was easy to park. Tables were set up outside in the courtyard, and Camilla cooked—usually a pasta to start that was so good I would eat too much and be too full for the main course. There would always be salad after the main course. It felt very European. I was a kid and I'd be sitting next to Anjelica Huston who was sitting next to some great artist who was sitting next to my sister who was sitting next to someone like Mario d'Urso who knew Camilla from Italy. It was always an extraordinary mix of people and generations.

I moved to New York when I was eighteen to be an actor and had the usual career course where you are basically a waiter for the first few years. I'd get all my tips together around ten thirty at night and I'd head to Earl and Camilla's. I remember some of the art— which was always changing—but at that time there was a Willard Dixon painting of a girl half submerged in a pool on a wall in the living room, and a Cy Twombly, and a small Robert Graham nude statue on a stand. I'd go from serving food at a place with a salad bar and bottomless sangria to Earl and Camilla's, where I was hanging out with Larry Rivers. It made no sense at all. It was always a good place, even when they weren't having a party; Earl would be up and you could go and unwind and have a vodka. He always drank vodka on the rocks.

Years later, I took a trip with my daughter, Hannah, to Rome. She was having a hard time in school, and I was having a hard time separated from her mother. Hannah was maybe fifteen or sixteen, and I said, "You wanna get the hell out of here? Let's put this city behind us and go to Italy." And she said, "Okay," and we did, and one of our stops was at Marlia, the grand palazzo outside Lucca that belonged to Camilla's family. I was always amazed at how Camilla treated Hannah like an adult. There were outdoor tables for dinner, and Camilla said to Hannah, "Now, Hannah, you're not sitting with your father. I'm sitting you here," and she put her next to Carl Bernstein on one side and the American ambassador to the Vatican on the other. There were always unexpected, interesting people in both arts and politics. At first

Hannah was nervous about having to sit with these adults, but in the end she was totally energized and she was saying to me, "He was the ambassador to the Vatican, and did you know the Pope was a Nazi sympathizer?!"

I think I was in the first generation of fake nephews, but as we all got older we had kids, so Hannah knew Earl, and every kid after would meet Earl and Camilla around the same age that I had. When Earl was dying, all those kids were around his bed in the hospital. And when I say "kids" I mean people my age, but people who met him when we were all young. Camilla and Earl both loved children, in their different ways: she was maternal and he was naughty, but you always felt taken care of and protected by both of them.

—GRIFFIN DUNNE

At Connie Wald's house, 1988

Connie Wald, actor Robert Wolders, and Audrey Hepburn

The birthday of Malcolm Ford at the Fords'

right: Melissa Mathison Ford

below, left: Malcolm Ford

below, right: Savannah Buffett

opposite, top: *left to right,* Melissa with Malcolm; *seated in the background,* producer Doug Wick; and Max Spielberg

opposite, bottom left: Jane Buffett, wife of Jimmy Buffett

opposite, bottom right: Melissa and Amy Irving Spielberg

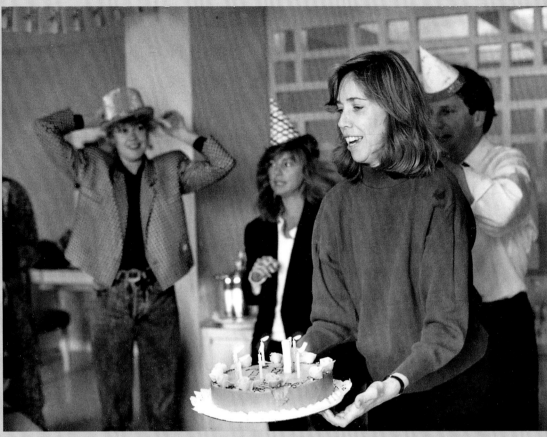

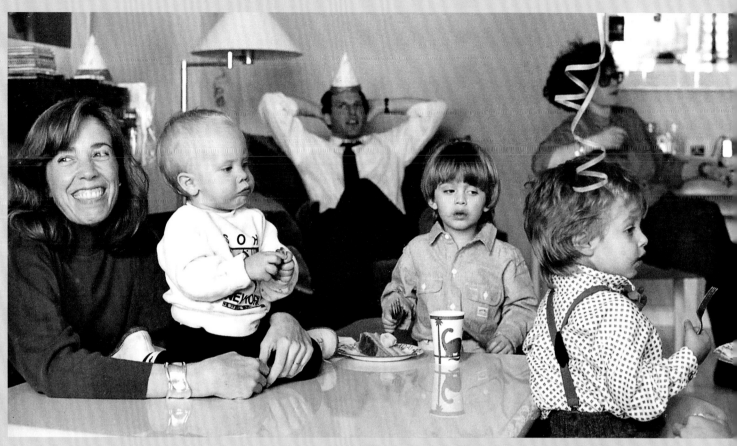

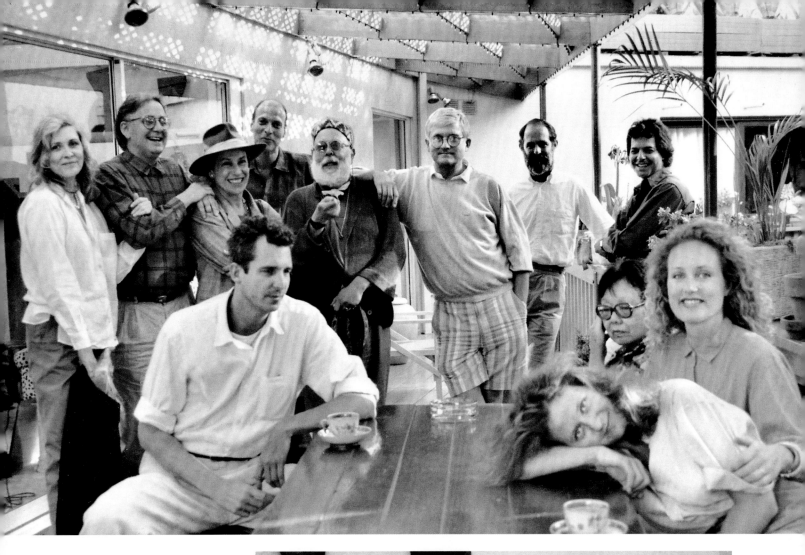

At David Hockney's, May 1988

above: *standing, left to right,* Faye Dunaway, Earl, Princess Marina of Greece, Bill Katz, Henry Geldzahler, David Hockney, Christopher Scott, Anthony Farmer; *seated, left to right,* James Brown, Nounou, Alexandra Brown, artist Julia Condon

right: Faye Dunaway and James Brown

opposite: *left to right,* Hockney, Earl, and Princess Marina in the studio

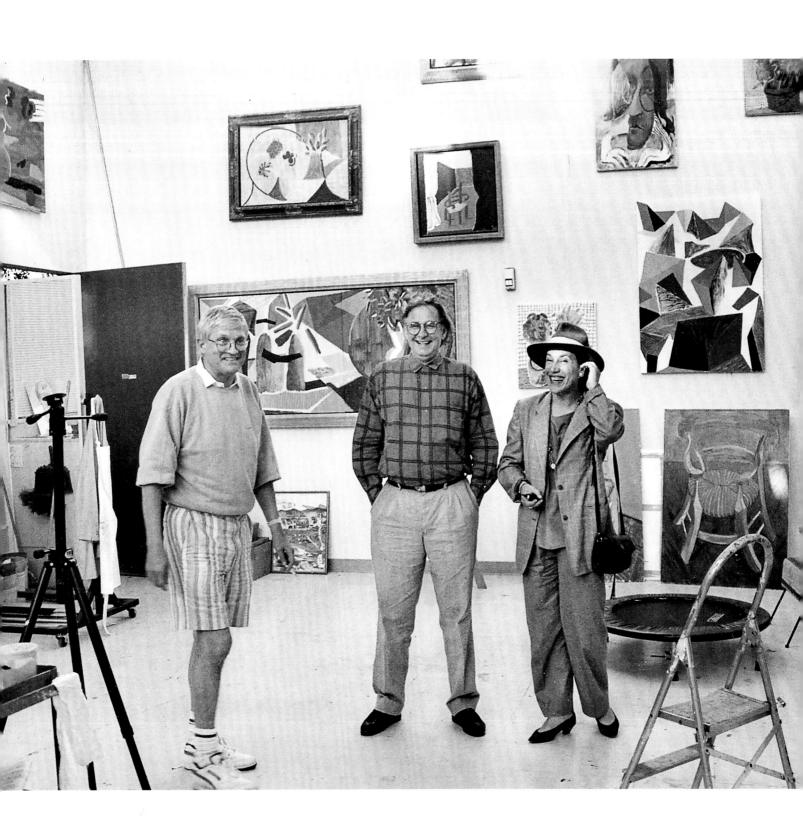

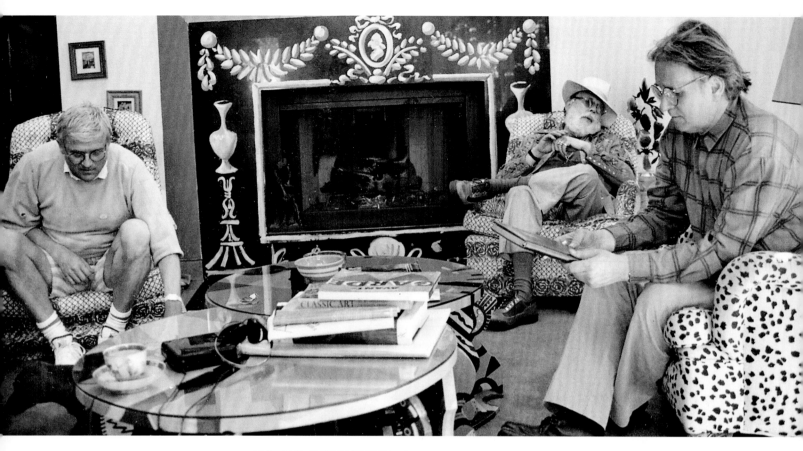

above: *left to right*, Hockney,
Geldzahler, and Earl

below: Bill Katz and
Henry Geldzahler

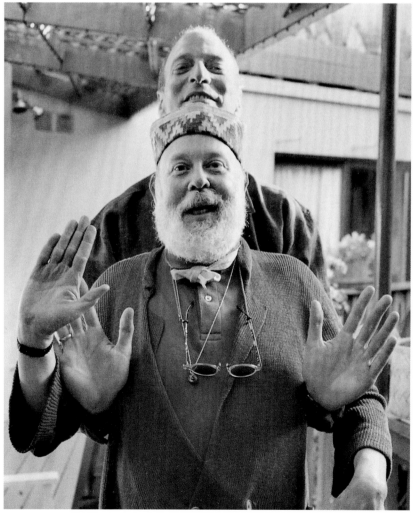

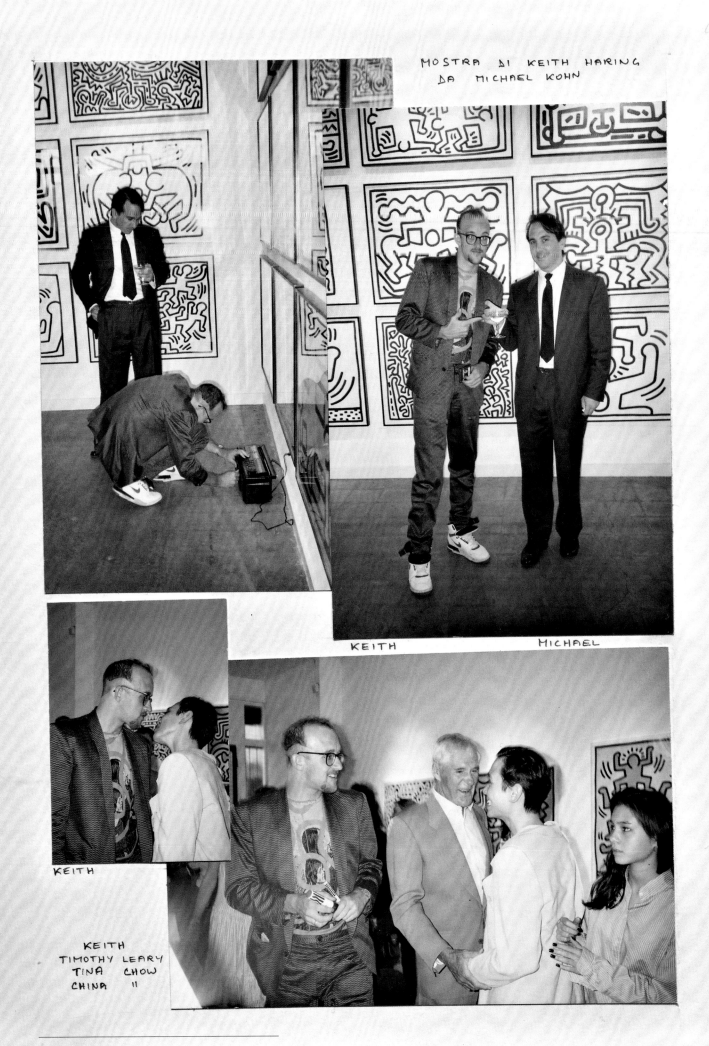

49

MOSTRA DI KEITH HARING
DA MICHAEL KOHN

KEITH MICHAEL

KEITH

KEITH
TIMOTHY LEARY
TINA CHOW
CHINA "

A Keith Haring show at Michael Kahn's Gallery

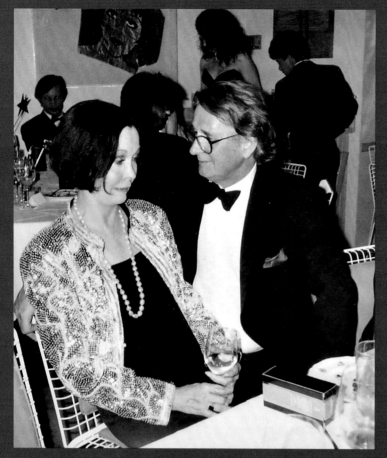

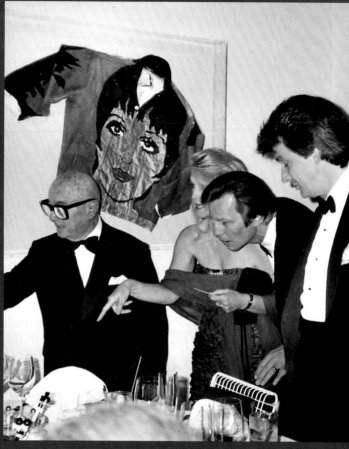

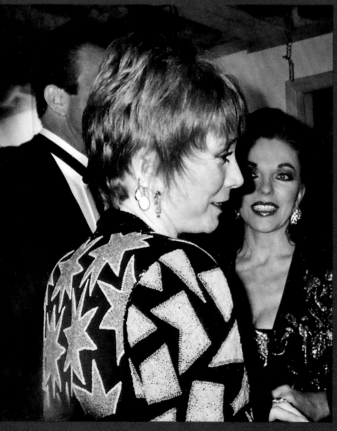

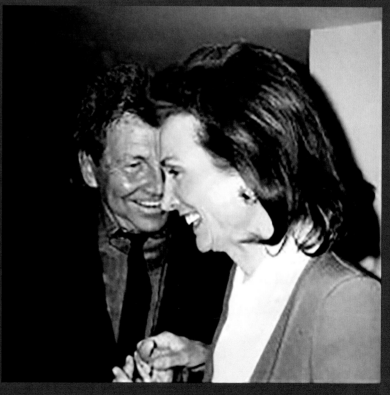

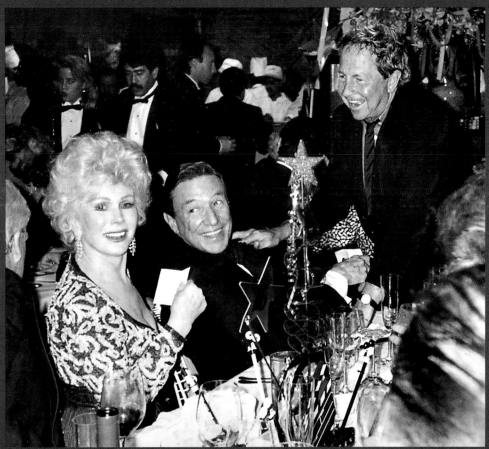

Academy Awards dinner
given by Irving and Mary Lazar
at Spago, March 29, 1989

opposite, top left: Mary Lazar
and Earl

opposite, top right: Irving Lazar,
Pat York, and Michael York

opposite, bottom left: Shirley
MacLaine and Joan Collins

opposite, bottom right: Robert
Rauschenberg and Lee Radziwill

this page, top: *left to right*,
Eva Gabor, Mike Wallace,
Robert Rauschenberg

below, left: Plácido Domingo,
Kathleen Turner, Phil Collins

below: Reinaldo Herrera
and Catherine Oxenberg

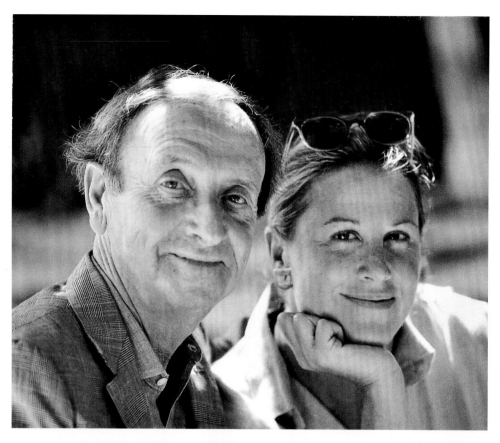

Lunch at 454 North Robertson, 1989

right: Brian Moore and Wendy Stark

below, left: Sabrina Guinness and Peter Beard

below, right: Sabrina Guinness

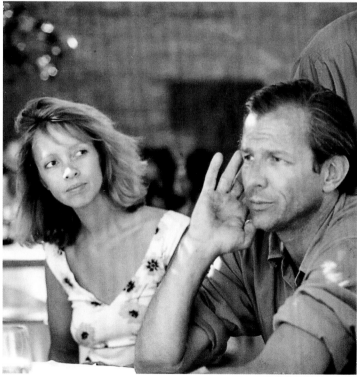

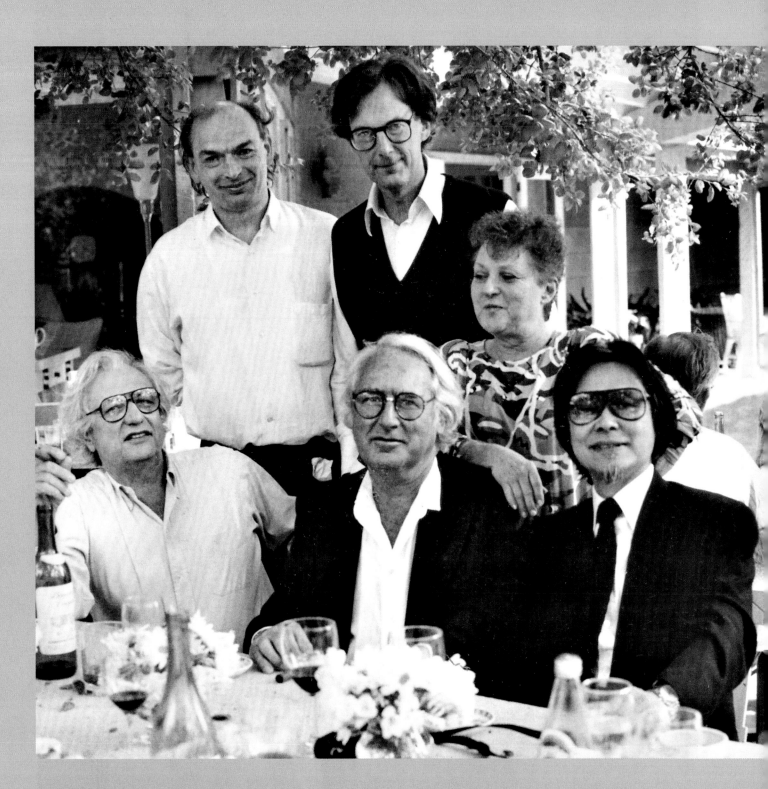

A lunch in April 1989 in honor of Kisho Kurokawa at Charles and Maggie Jencks's house during an architects' conference

standing, left to right, Jean Nouvel, Charles Jencks, Elyse Grinstein; *seated, left to right,* Frank Gehry, Richard Meier, Kisho Kurokawa

**Dinner at the house,
December 16, 1989, after
the Bill Wyman opening**

above: *left to right,* Miranda
Guinness, artist Adam McEwen,
historian Ann Lambton, and
Sabrina Guinness

bottom: *left to right,* Linda
Janklow, Bill Wyman, and
Angela Janklow

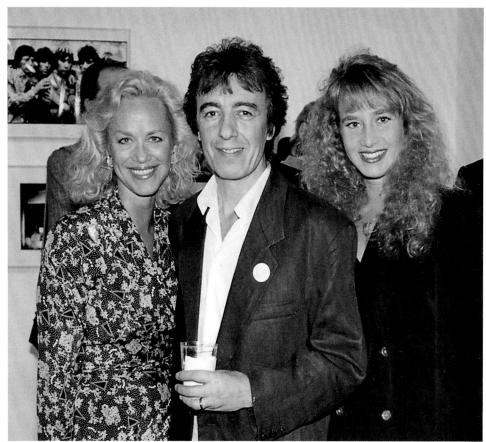

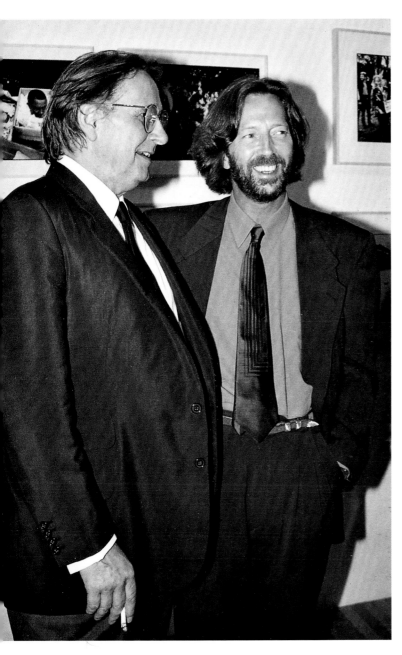

above: Eric Clapton

left: Earl and Eric Clapton

David Hockney and John
Richardson at Hockney's house
in Malibu, 1989

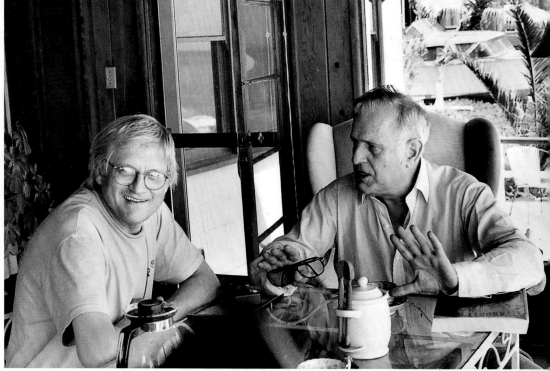

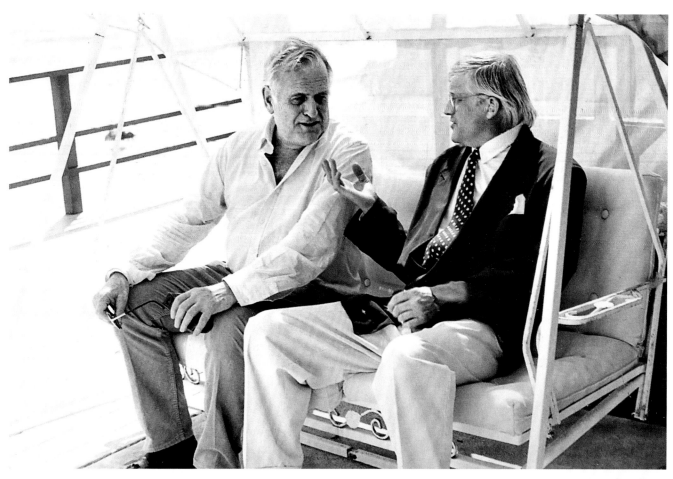

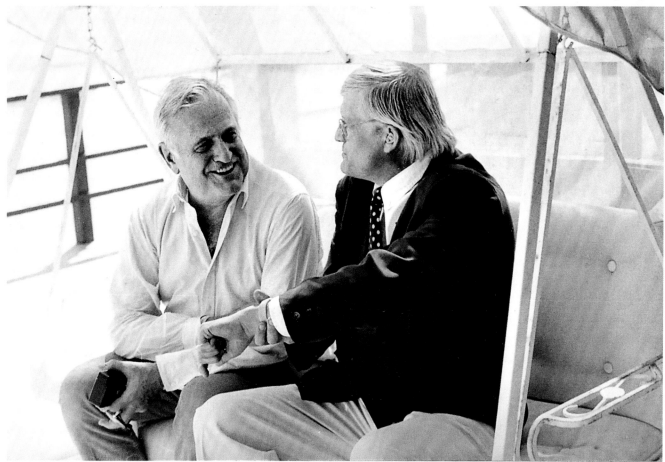

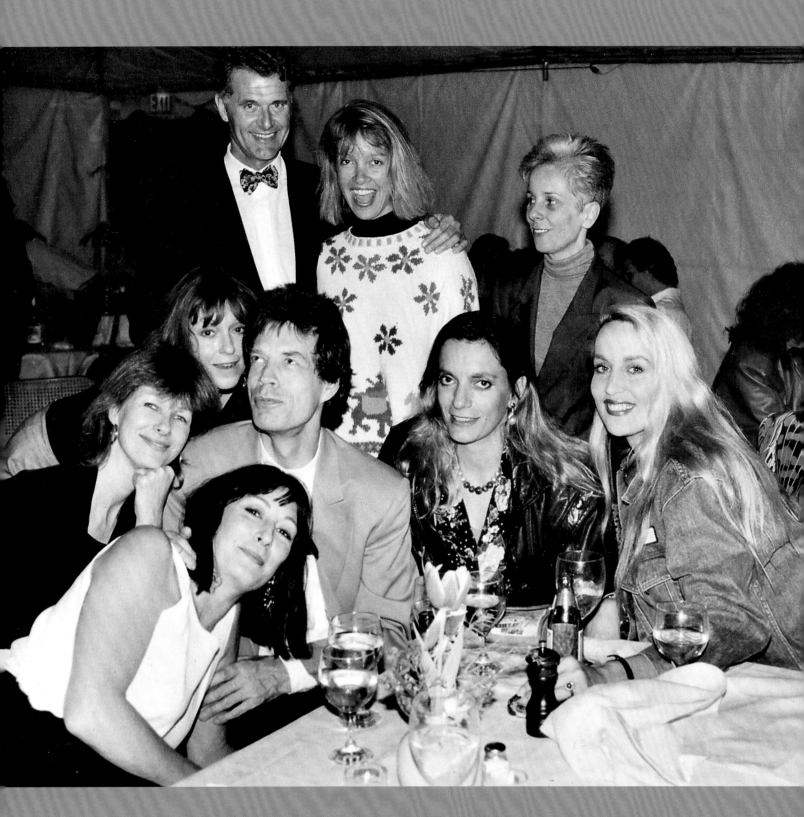

October 26, 1989, Rupert Loewenstein's party for the Rolling Stones at Morton's after their concert

standing, left to right, Manolo Blahnik, Sabrina Guinness, Gaia de Beaumont; *crouching,* Annie Marshall; *seated, left to right,* Susan Forristal, Anjelica Huston, Mick Jagger, Ann Lambton, Jerry Hall

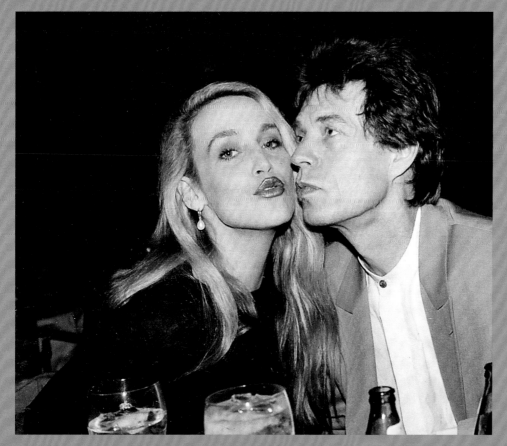

left: Mick Jagger and Jerry Hall

below, left: Director Herbert Ross and Lee Radziwill

below, right: Dora Loewenstein with her father, Rupert Loewenstein

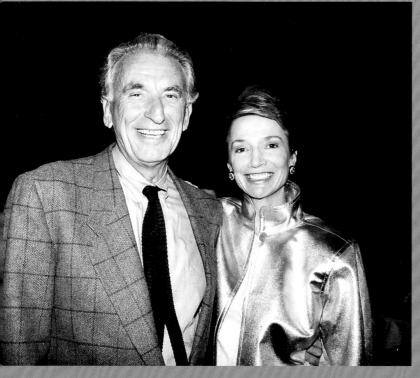

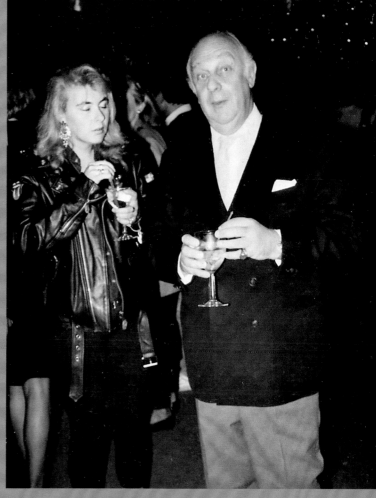

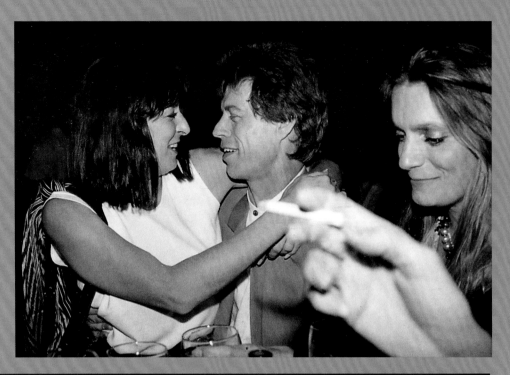

top: *left to right*, Anjelica Huston, Mick Jagger, and Ann Lambton

below: *left to right*, Michelle Phillips, Peter Asher, Wendy Asher, Astrid Wyman, Valerie Perrine

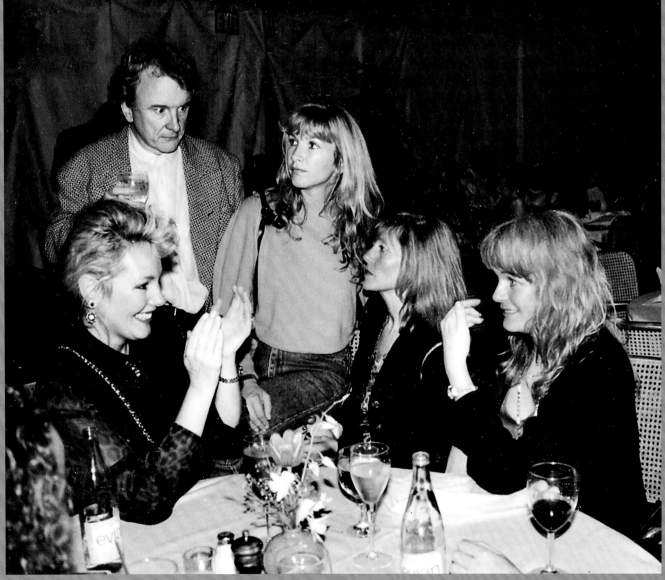

Dinner at the house for Richard
Gere and Joan Quinn, who
was the West Coast editor
of *Interview* magazine,
December 16, 1989

above, left: Lisa and Peter
Frankfurt

above, right: Bob Colacello

left: Mario d'Urso, Earl

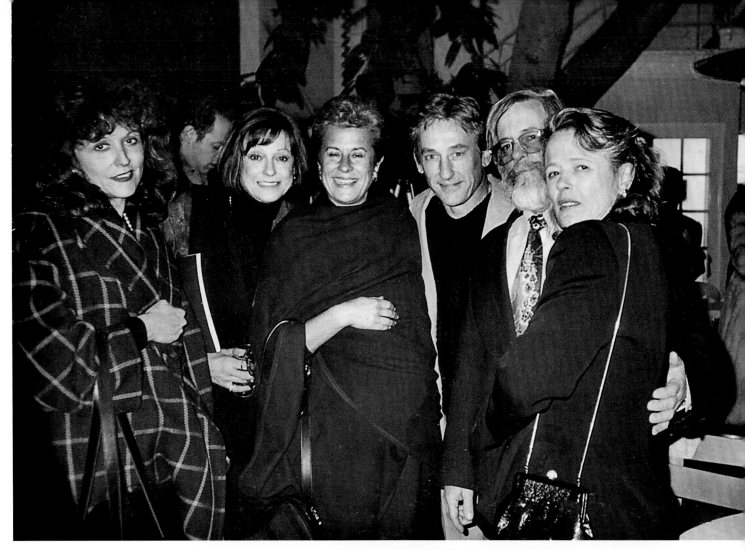

above: *left to right*, Dana
Ruscha, Annie Marshall,
Philippa Calnan, Ed Ruscha,
Ken Price, Hope Price

right: Richard Gere, Joan Quinn

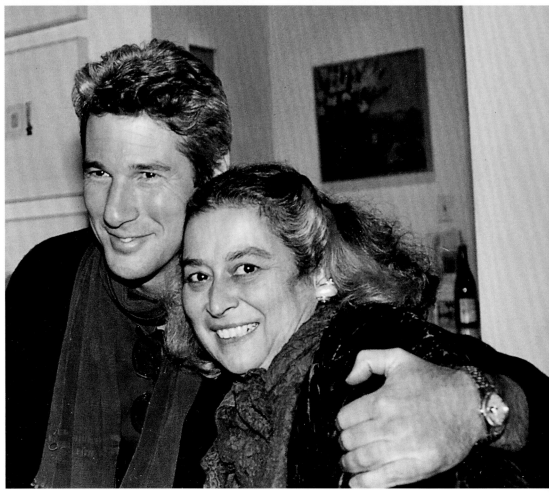

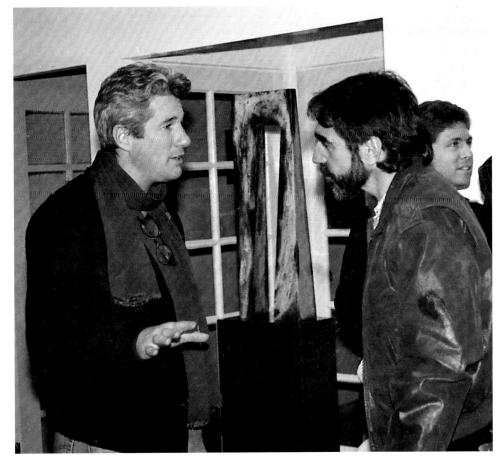

left: Richard Gere talking to cinematographer, director, and producer Peter Pilafian

below: Joan Quinn, Earl, Richard Gere, and Michael Pearl

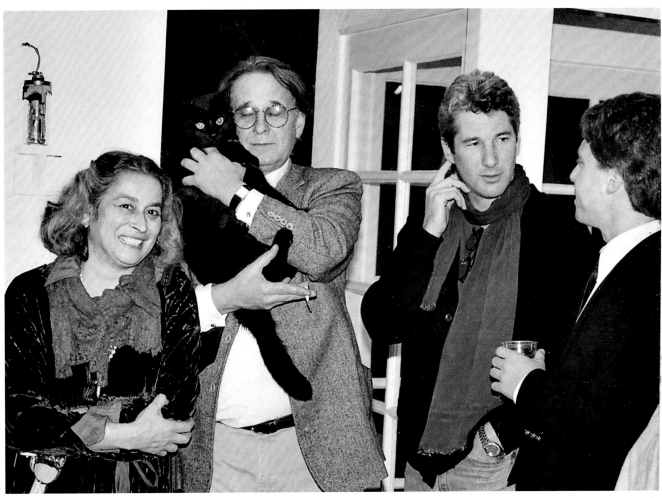

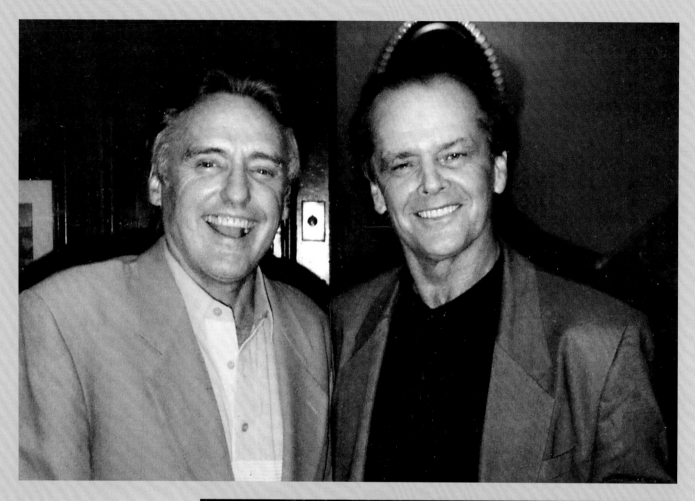

Opening of *The Two Jakes* with Jack Nicholson, 1990

above: Dennis Hopper and Jack Nicholson

right: Ed Ruscha and Sabrina Guinness

above: *left to right*, Director Michael Lindsay-Hogg, Nona Gordon Summers, and Sabrina Guinness

bottom: *left to right*, Teri Garr, Annie Marshall, and Mary Lazar

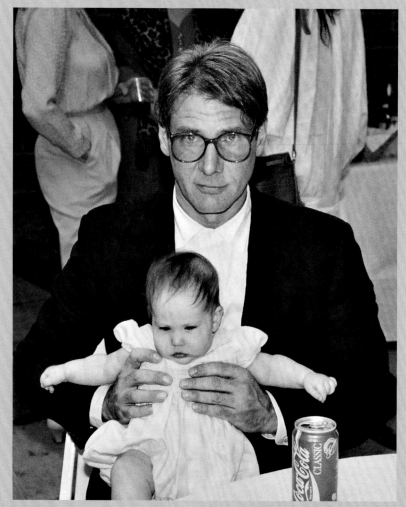

Lunch at 454 North Robertson

right: Harrison Ford with his daughter, Georgia

below: Robert Graham, Harrison Ford, Mike Medavoy

above: Anne-Marie and
Michael Crichton

left: Eric Idle

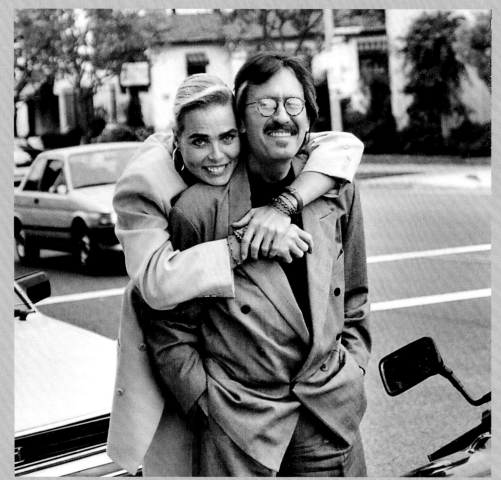

right: Margaux Hemingway and curator Maurice Tuchman

below: Sabrina Guinness, Henry Pembroke, Earl

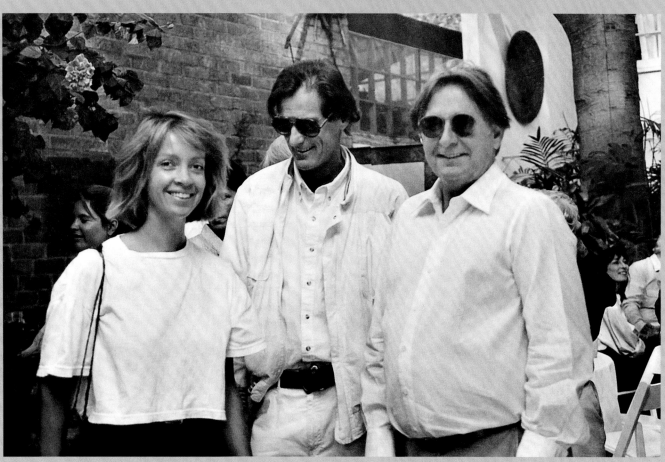

Lunch, February 24, 1991

left: Ed Moses, Katherine
and Dennis Hopper

below, left: Julian Schnabel
and Dennis Hopper

below, right: George Segal

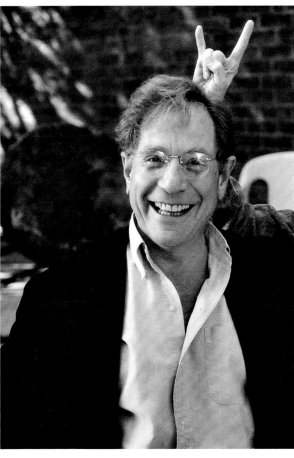

**Robert Graham and
Anjelica Huston's wedding,
Hotel Bel-Air, May 22, 1992**

top: Mick Jagger, Earl,
Robert Graham

right: Connie Wald, Ivan Moffat

left: Irving and Mary Lazar,
Lauren Bacall, writer
Lillian Ross

below: Lauren Hutton and
photographer Luca Babini

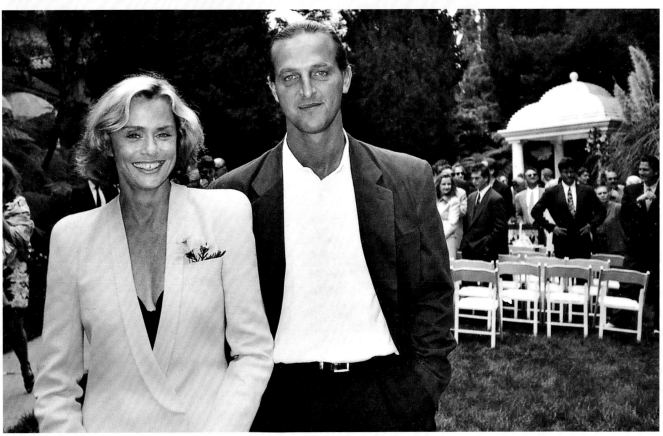

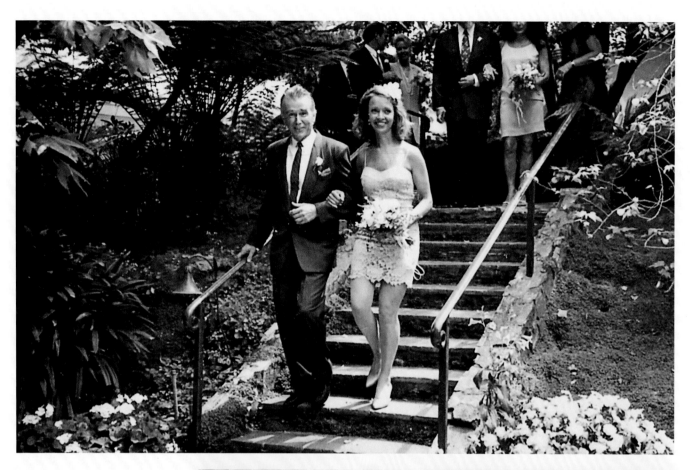

above: Billy Al Bengston
and Sabrina Guinness

right: Steven Graham
and Jerry Hall

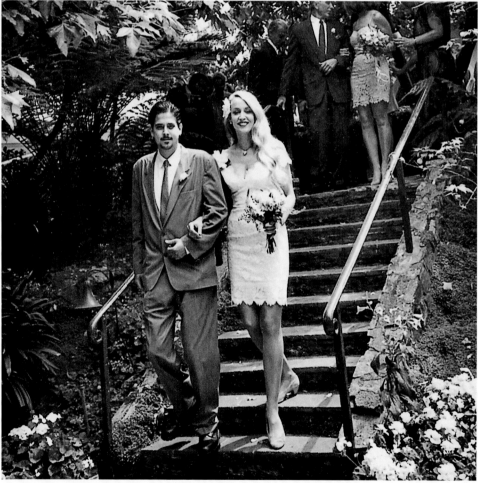

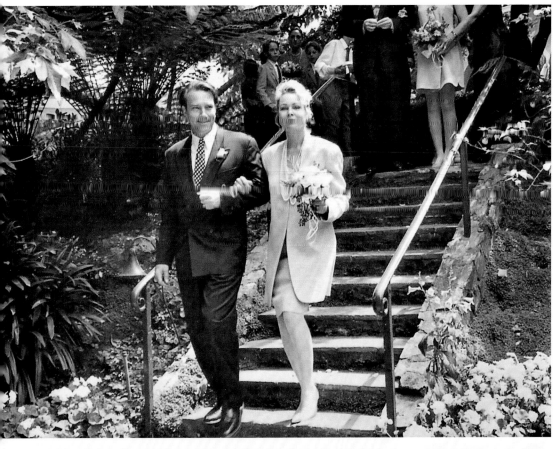

left: Jeremy Railton
and Michelle Phillips

below, left: Danny and
Allegra Huston

below, right: The maid of
honor, Joan Juliet Buck

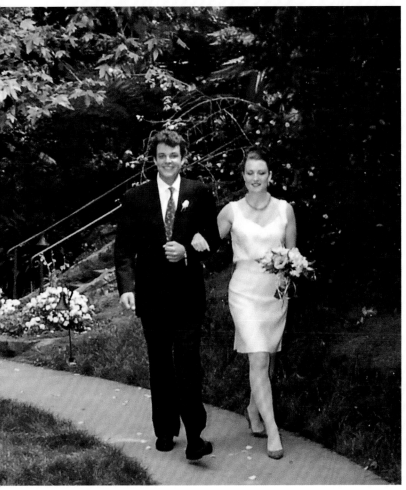

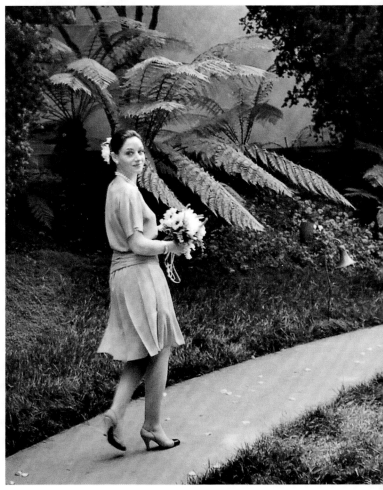

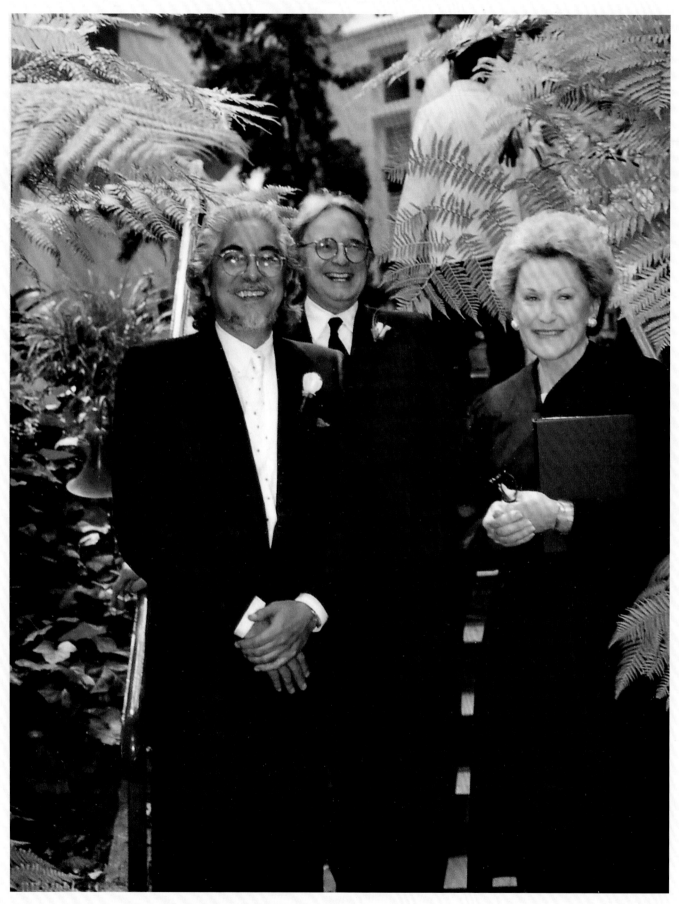

above: Robert Graham, Earl, and Judge Mariana Pfaelzer

opposite: Anjelica Huston

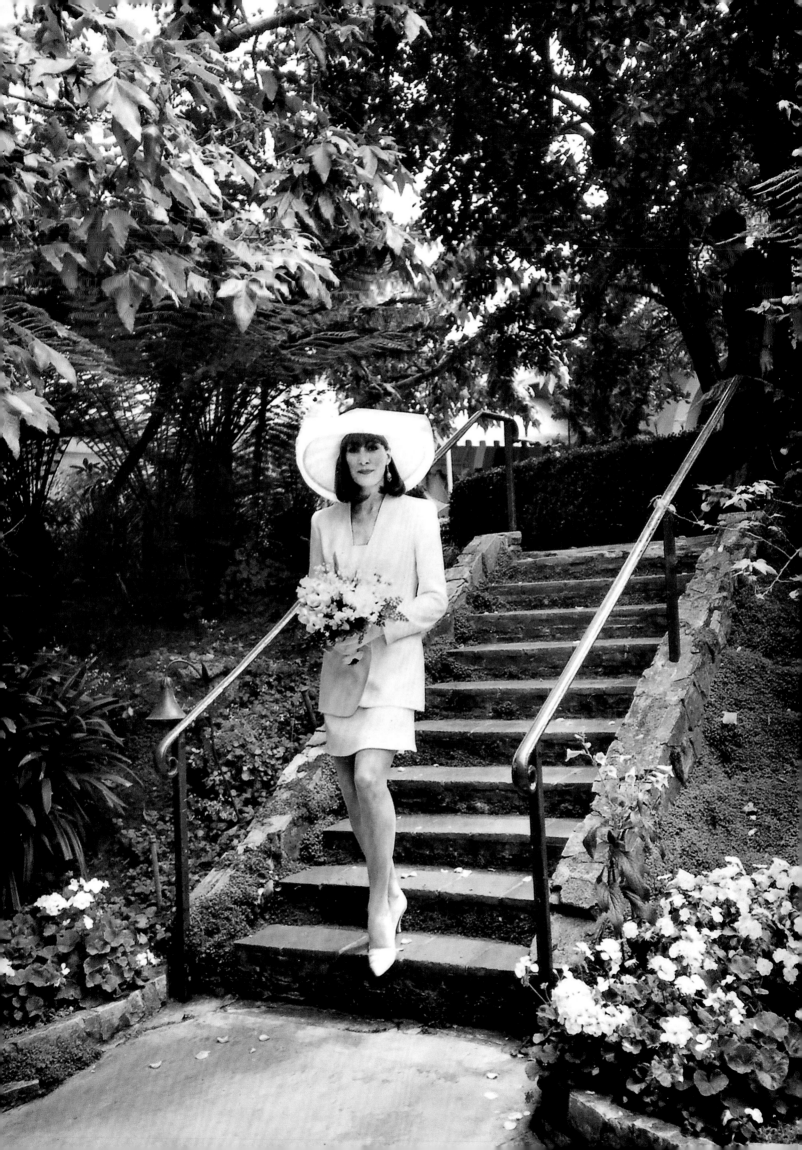

first row, *left to right,* Jack Huston, Matthew Huston, Aaron Phillips, Austin Hines; *second row, left to right,* producer Laila Nabulsi, Susan Forristal, Nona Summers, Michelle Phillips, Helena Kallianiotes, Sabrina Guinness, Jerry Hall, Allegra Huston, Laura Huston, Joan Juliet Buck, Anjelica Huston, Robert Graham, Danny Huston, Hans Neuendorf, Steven Graham, Billy Al Bengston, Roy Doumani, Jack Quinn, Ed Moses; *back row, left to right,* Jeremy Raylton, Tony Huston, Earl

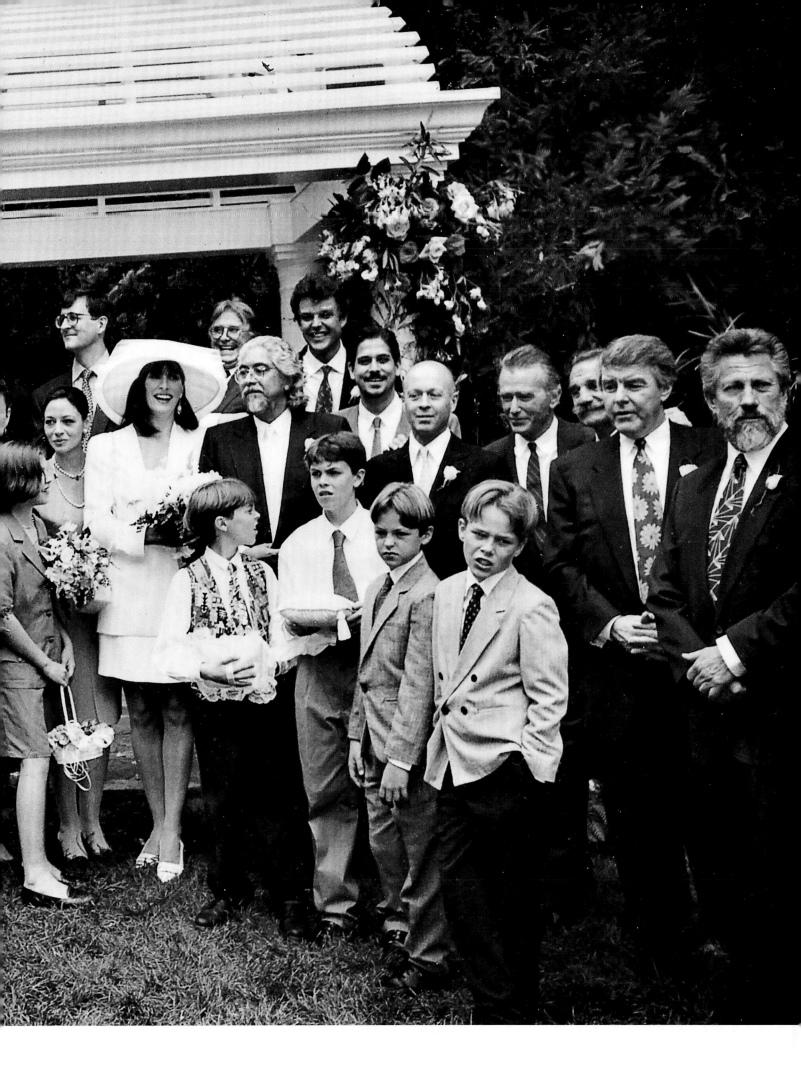

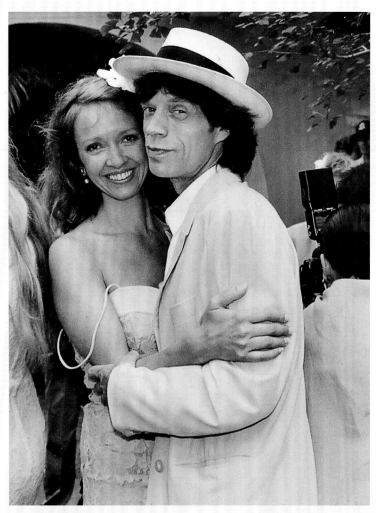

opposite, top left: Sabrina Guinness and Mick Jagger

opposite, top right: Carrie Fisher and Bryan Lourd

opposite, below left and right: Nona Summers, Susan Forristal throwing the bouquet

left: Bride and groom

below: Cutting the cake

above: *left to right,* Don Gummer, Meryl Streep, Frank Gehry; *seated,* Chuck Arnoldi, Stanley Grinstein

right: Joan Juliet Buck, Anjelica Huston, Allegra Huston

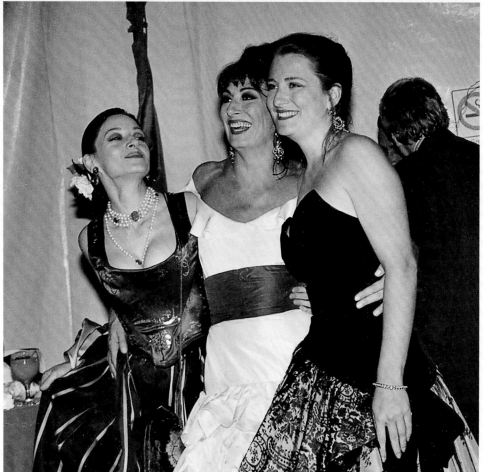

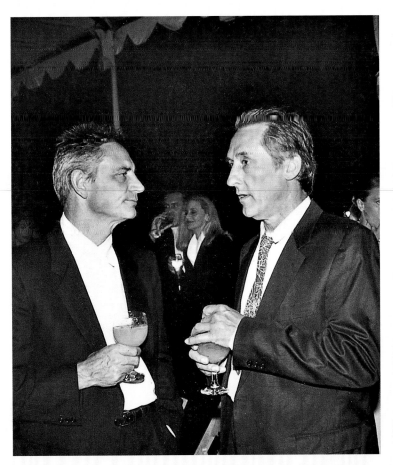

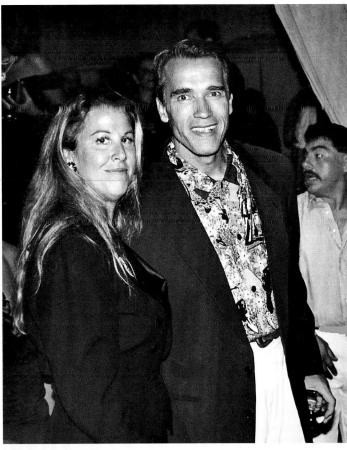

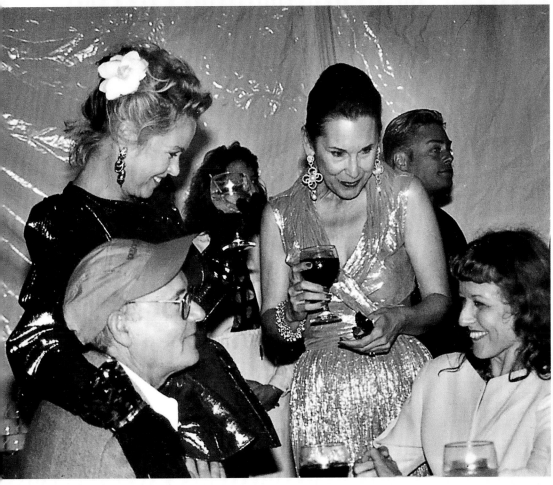

above, left: Artists Chuck
Arnoldi and Ed Ruscha

above, right: Wendy Stark
and Arnold Schwarzenegger

left: Buck Henry, Michelle
Phillips, Alana, Dana Ruscha

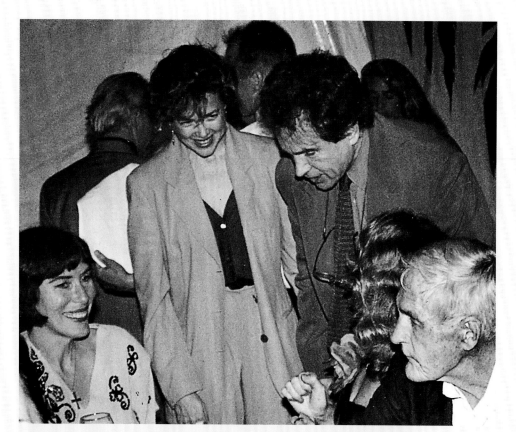

right: Mary Woronov, Annette Bening, and Warren Beatty

below: Anjelica Huston and Robert Graham

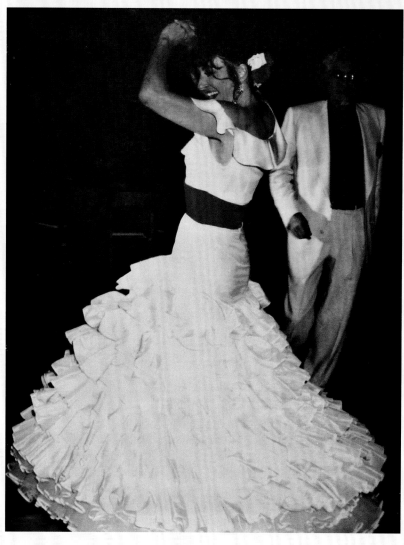

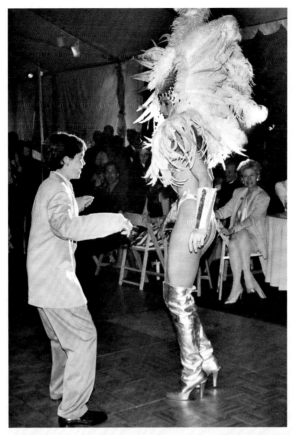

left: Jack Huston

below: Mick Jagger
and Anjelica Huston

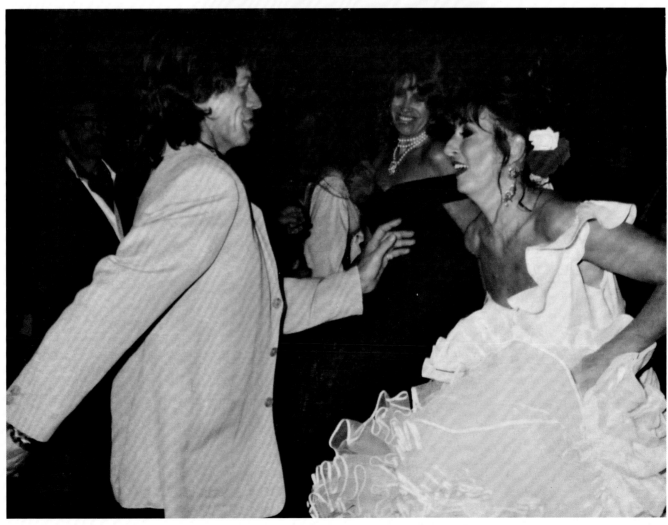

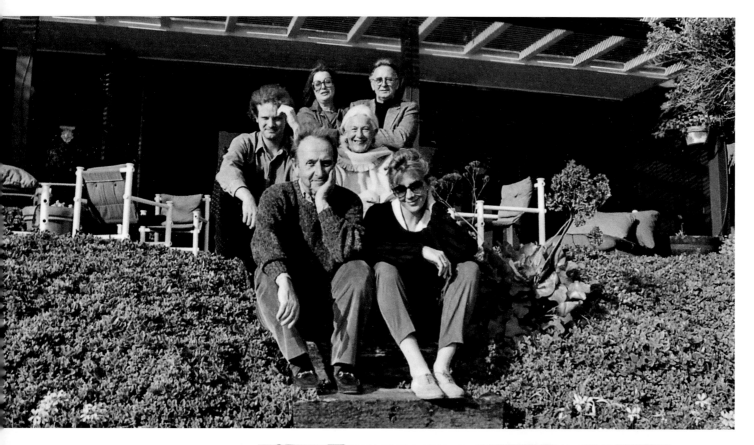

**Lunch at Brian and
Jean Moore's, 1992**

top: *back row,* Colin Firth, Jean,
Earl, Connie Wald; *in front,*
Brian, and Natasha Richardson

right: Natasha Richardson

below: Natasha Richardson
and Earl

In Robert Graham's studio,
1993

left: Earl, Giovanni Volpi,
Robert Graham

below: Robert Graham

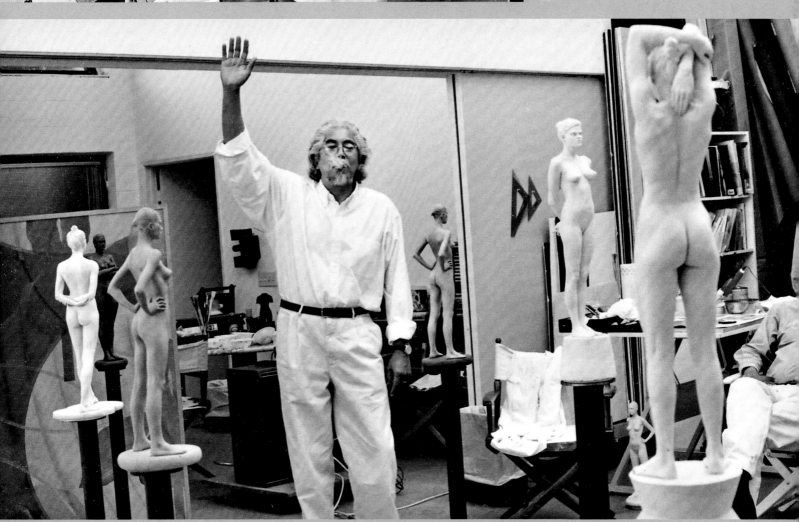

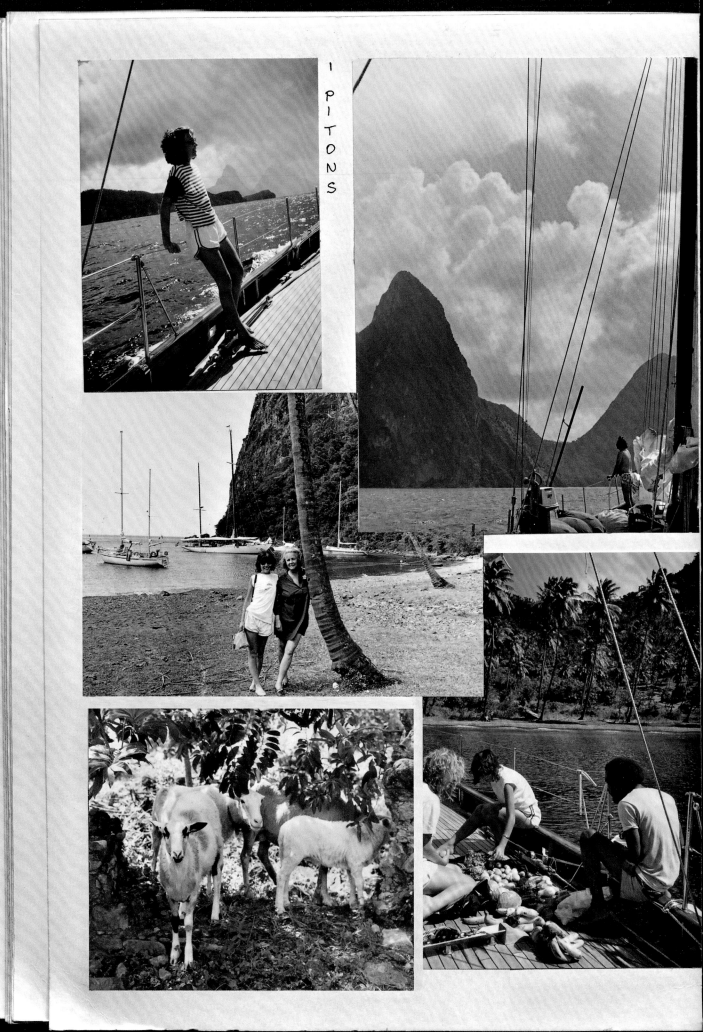

PITONS

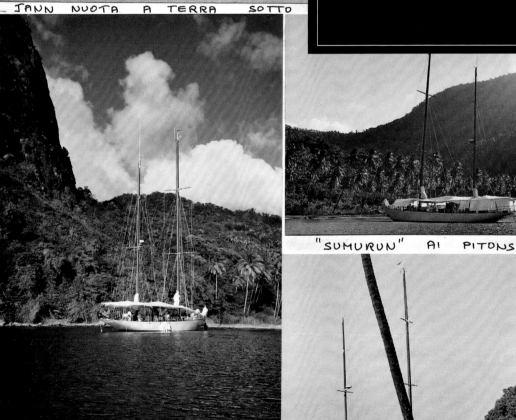

JANN NUOTA A TERRA SOTTO

Travel

"SUMURUN" AI PITONS

n 1961 Earl was working with the theater, television, and film producer Fred Coe. His résumé also cited him as "US manager of the Spoleto Festival and general assistant to Gian Carlo Menotti," 1957–61. Camilla and Earl met in 1958 but didn't marry until 1963. They were together in Trevi, but Earl might not have been on the Agnelli boat in 1971. Then, in the early 1970s, there were a number of lively trips to the Caribbean, including Mustique, Barbados, and St. Barts, some of which are shown here.

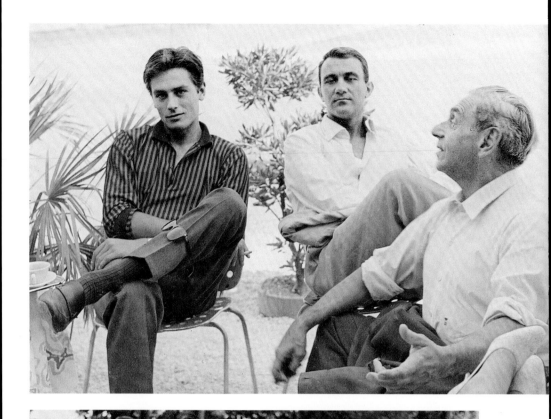

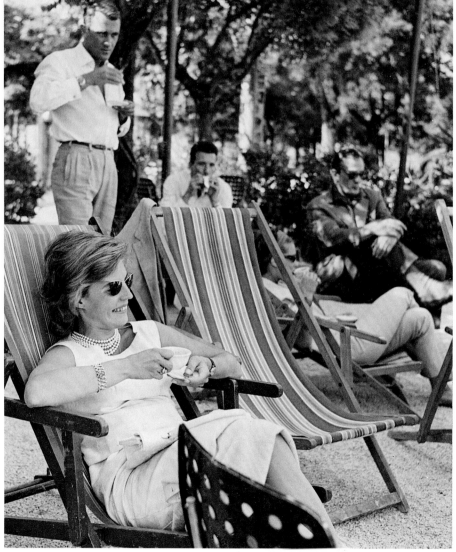

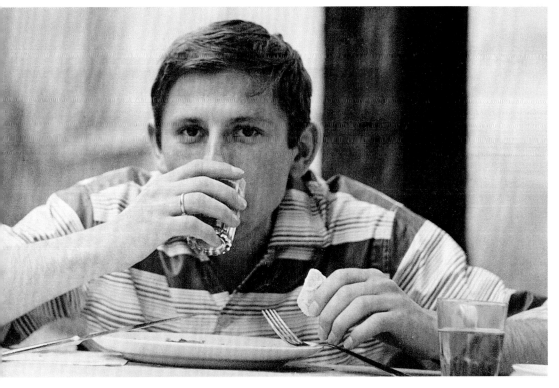

Trevi, July 10, 1960

opposite, top: *left to right,* Actors Alain Delon, Ruggero Nuvolari, and jewelry designer Fulco di Verdura

opposite, bottom: *standing,* Ruggero Nuvolari; *seated,* Domietta Hercolani, Romy Schneider, Luchino Visconti

this page, top: Roman Polanski

left: Barbara Kwiatkowska-Lass, a Polish actress who was married to Roman Polanski from 1959 to 1961

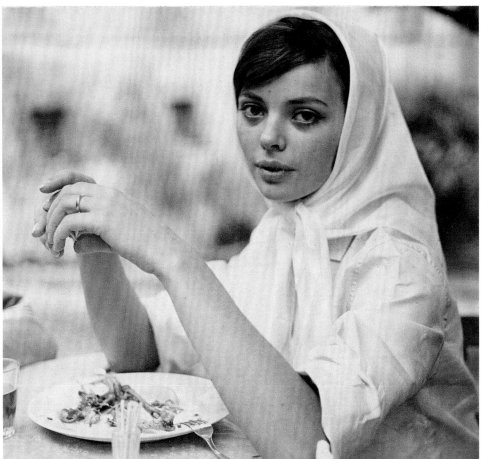

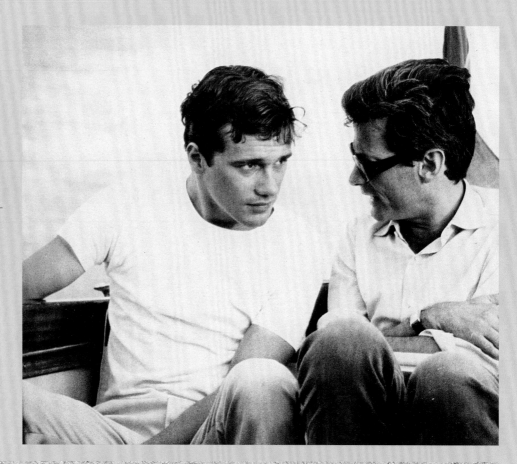

Venice, 1965

Earl and Richard Avedon

below: Gian Carlo Menotti and Richard Avedon observe the sandcastle in the making

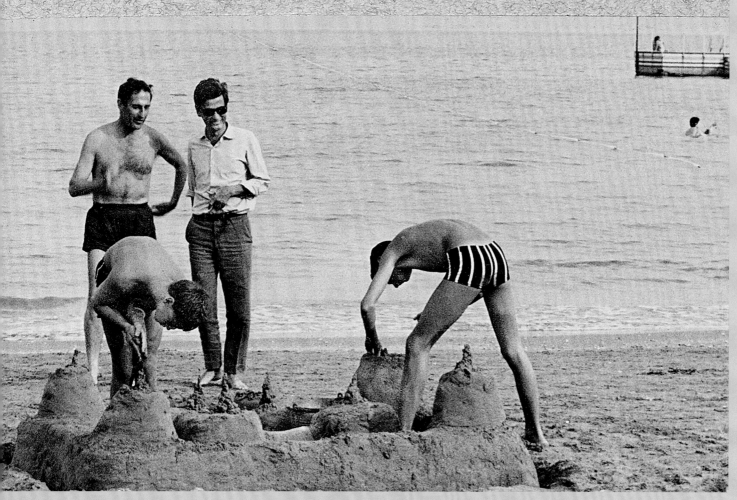

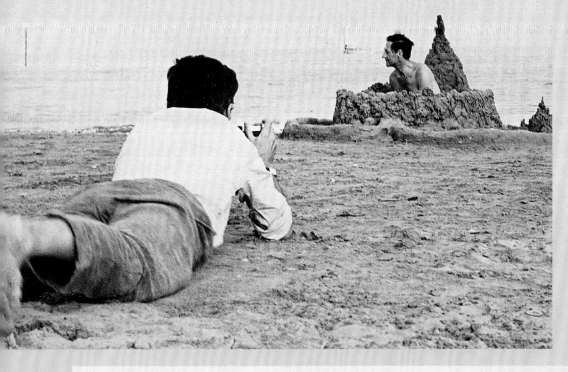

Avedon photographing
Menotti

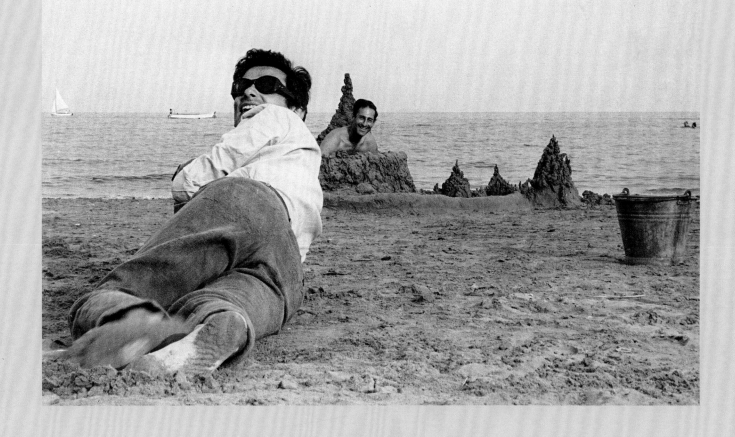

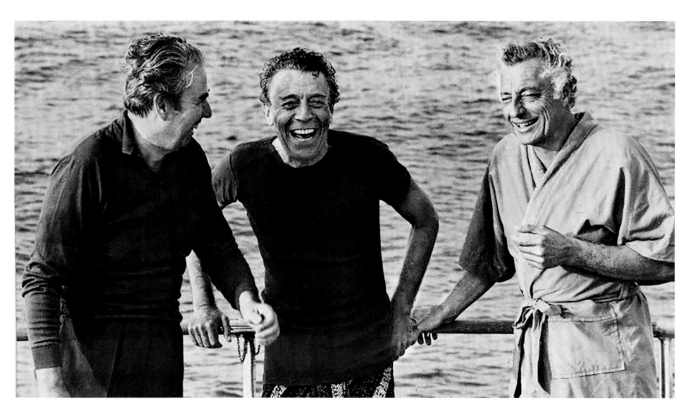

With the Agnellis on a boat off Ischia, 1971

top: *left to right,* Sandro d'Urso, Renzino Avanzo, and Gianni Agnelli. Avanzo, a cousin of director Roberto Rossellini and married to the sister of director Luchino Visconti, was an actor, producer, and screenwriter; a passionate diver, he also made underwater documentaries.

right: Marella and Gianni Agnelli

opposite, top: A view of Ischia

opposite, below: Agnelli, Avanzo, and Camilla

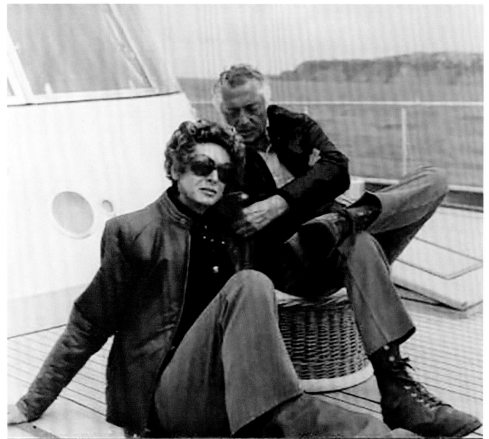

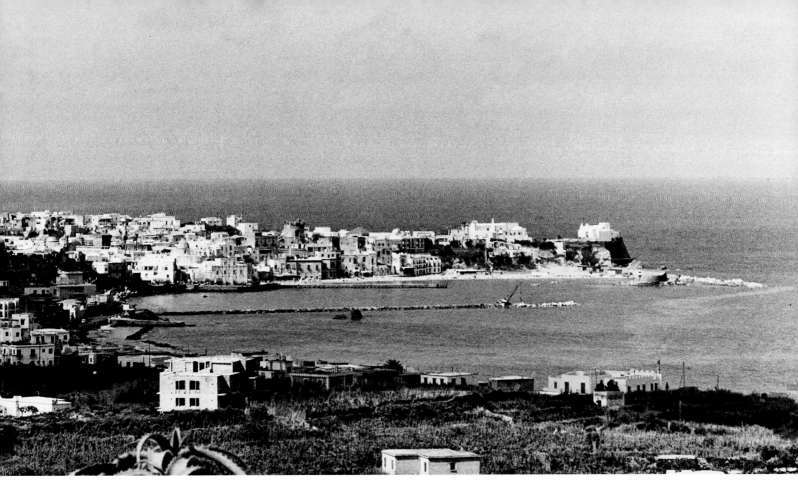

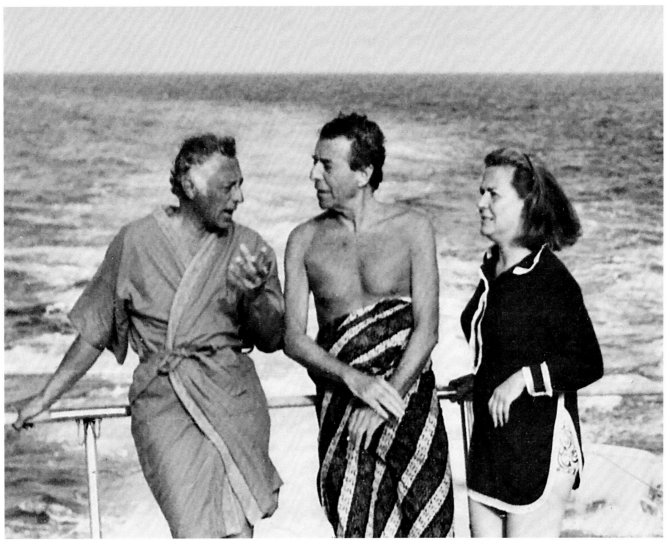

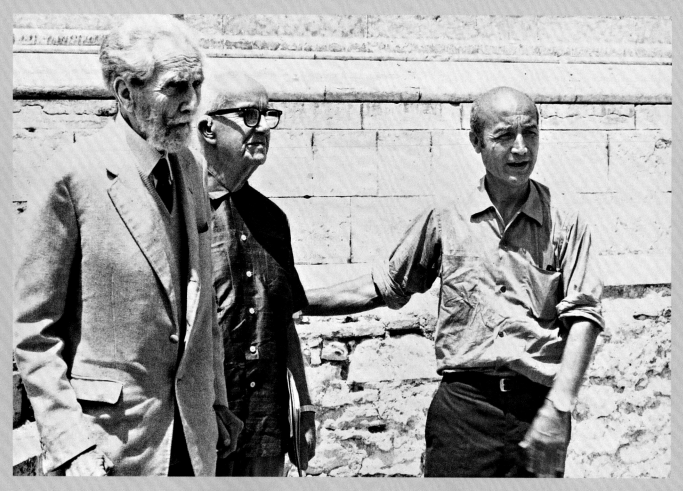

Spoleto, 1971

top: *left to right,* Ezra Pound, Buckminster Fuller, and Isamu Noguchi

below: Ezra Pound and Buckminster Fuller

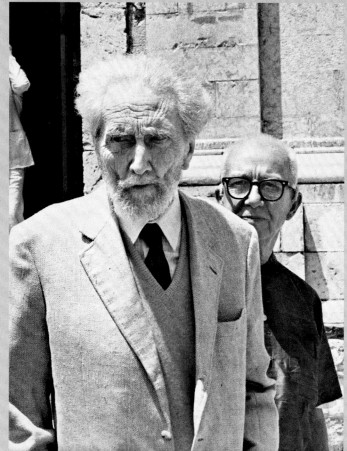

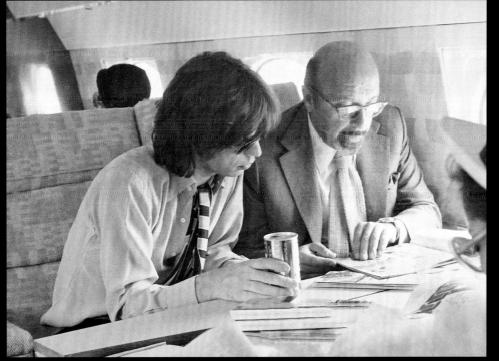

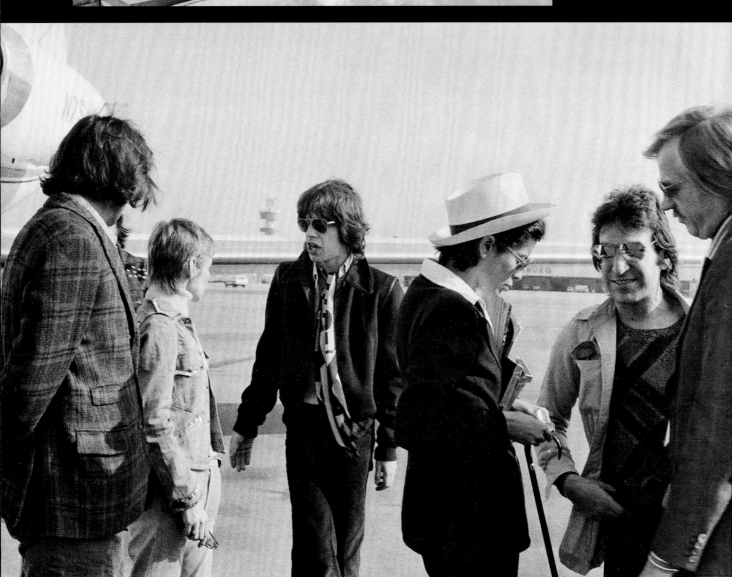

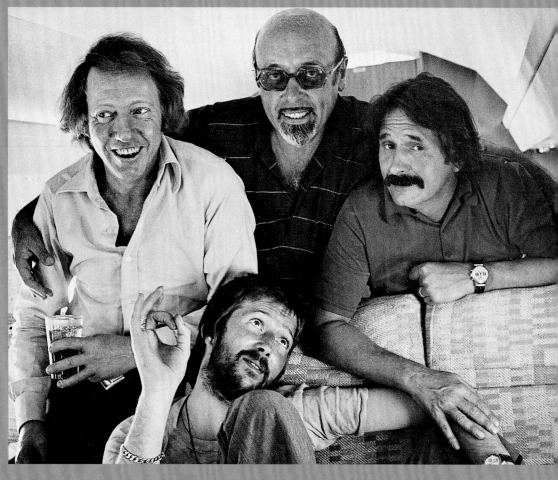

On the plane back from a trip to Barbados, April 13, 1974

top: *clockwise*, Producer Robert Stigwood, Ahmet Ertegun, Earl, Eric Clapton

below, left: Mica Ertegun

below, right: Eric Clapton

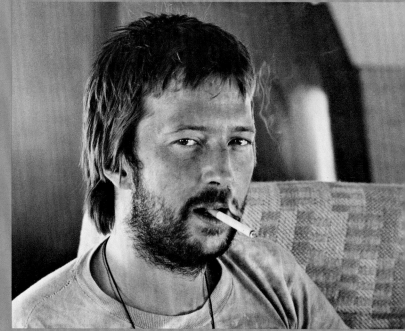

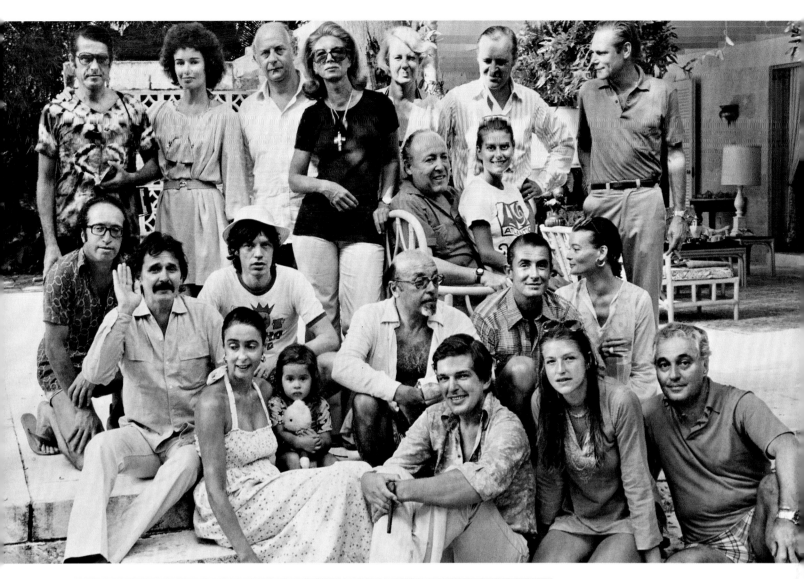

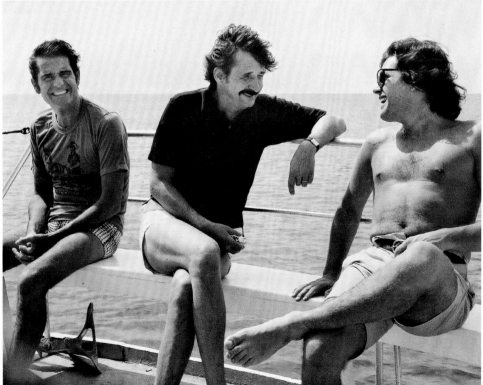

The Erteguns rented three
houses in Barbados for
Thanksgiving and invited
a group of friends,
November 24, 1974

above: *standing, left to right,*
publisher and art collector
Daniel Filipacchi, Sandra
Peterson, Rupert Loewenstein,
Marjorie Downey, Elizabeth
Byron, financier Peter Kirwan-
Taylor, Billy Rayner; *in a chair,*
Jerry Zipkin and Selma Ertegun
(Ahmet's sister); *middle row,*
Earl, Mick Jagger, Ahmet
Ertegun, Joel Schumacher,
Chessy Rayner; *front row,*
Mica Ertegun, Jade Jagger,
and Charles Byron

left: Daniel Filipacchi, a publisher
who owned *Paris-Match* and
Look, among other publications;
Earl and Jann

above, left: Jade Jagger

above right: Mick Jagger
and Jade

right: Bianca Jagger

opposite: Mick Jagger

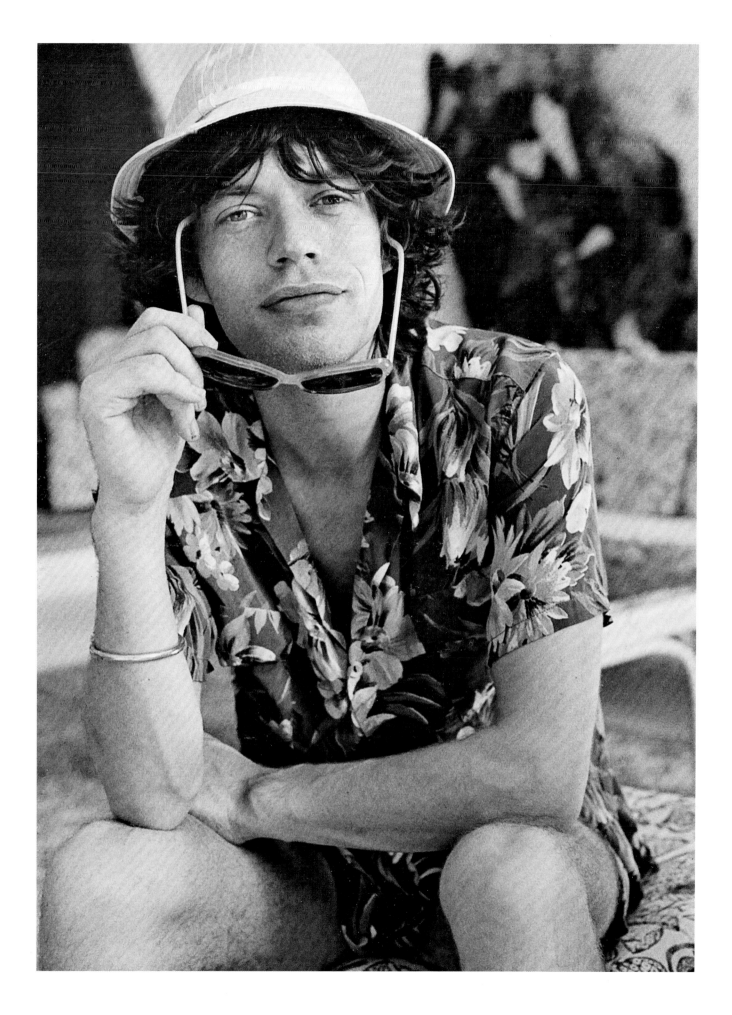

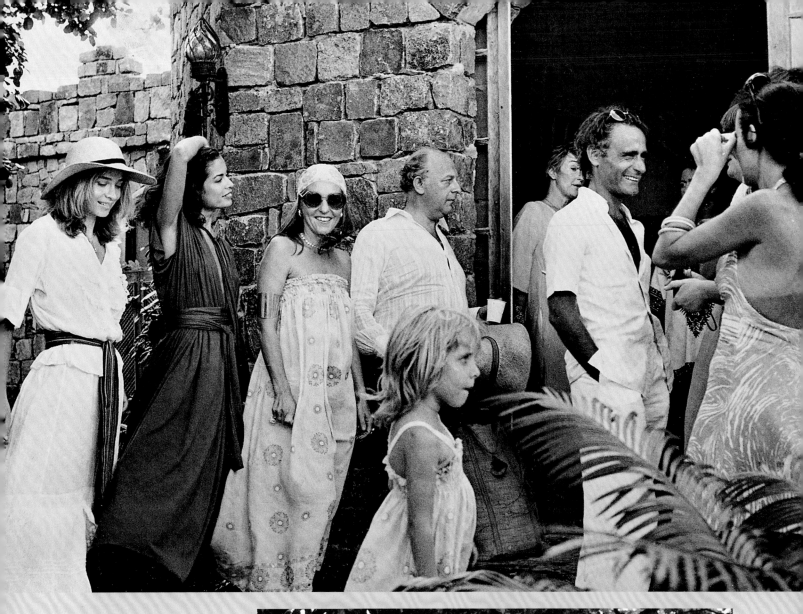

In 1976 Camilla and Earl
went to Mustique for the
fiftieth birthday party of Colin
Tennant, attended by a group of
revelers that included Princess
Margaret. Tennant had given
her a house there that year
called Les Jolies Eaux. The
guests had to dress in costume
for the gold-themed birthday
dinner.

top: *left to right*, Bianca
Jagger, Anita Linquist, Rupert
Loewenstein, John Stefanidis

right: Bianca Jagger and
Reinaldo Herrera

opposite: Colin and
Anne Tennant

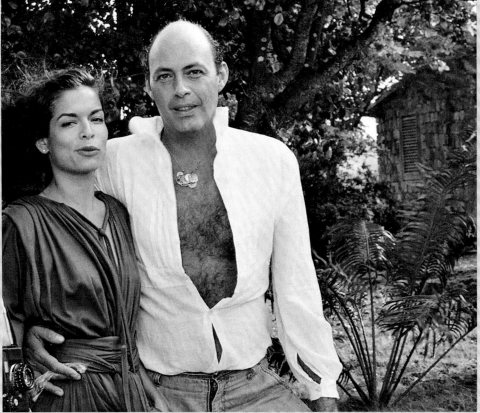

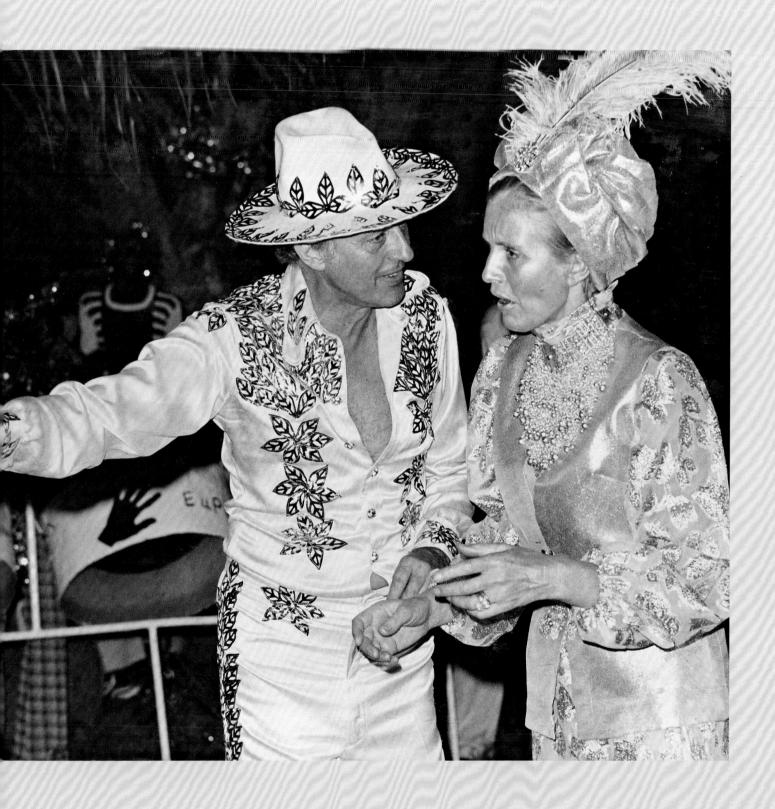

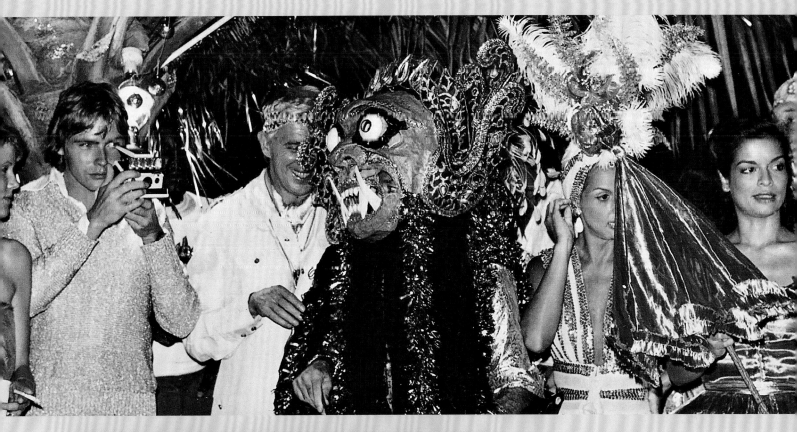

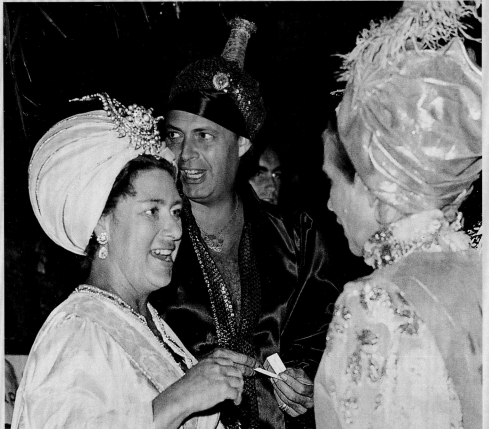

opposite, top left:
Reinaldo Herrera

opposite, top right: Jade Jagger

opposite, below left: Carolina
Herrera

opposite, below right: Oliver
Messel, artist, stage designer,
and architect and designer
of houses in Barbados and
Mustique

this page, top: Oliver Messel
in his monster mask, Carolina
Herrera, and Bianca Jagger

left: *left to right*, Princess
Margaret, Reinaldo Herrera,
and Anne Tennant

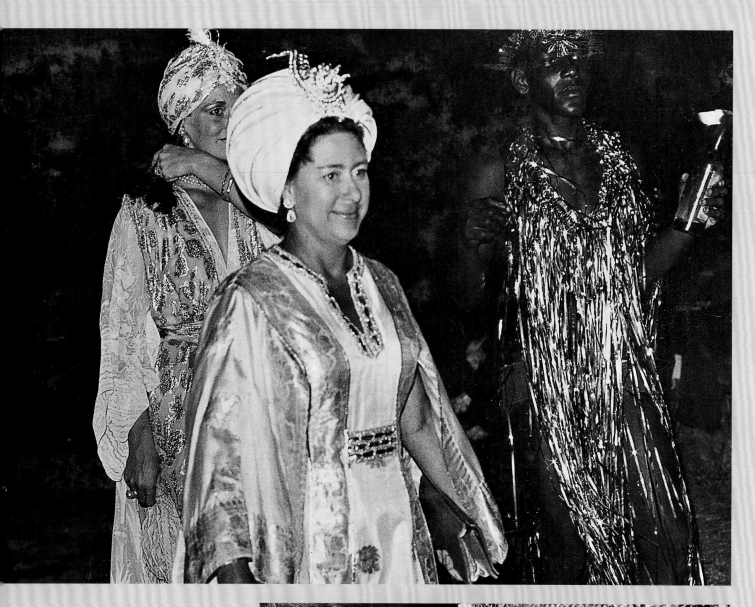

above: Princess Margaret with one of the dancers

right: Bianca and Mick Jagger

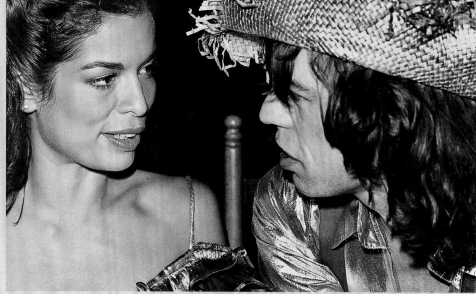

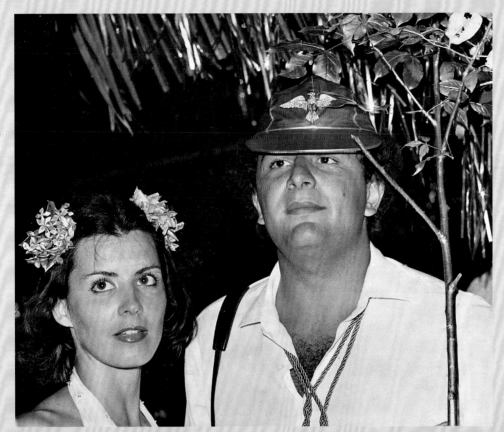

left: Chilla Henser and
Johnny Pigozzi

below: *back row, left to right,*
Camilla, Ahmet Ertegun, Isabel
Eberstadt; *front row, left to
right,* Bianca Jagger, Oliver
Messel, Princess Margaret

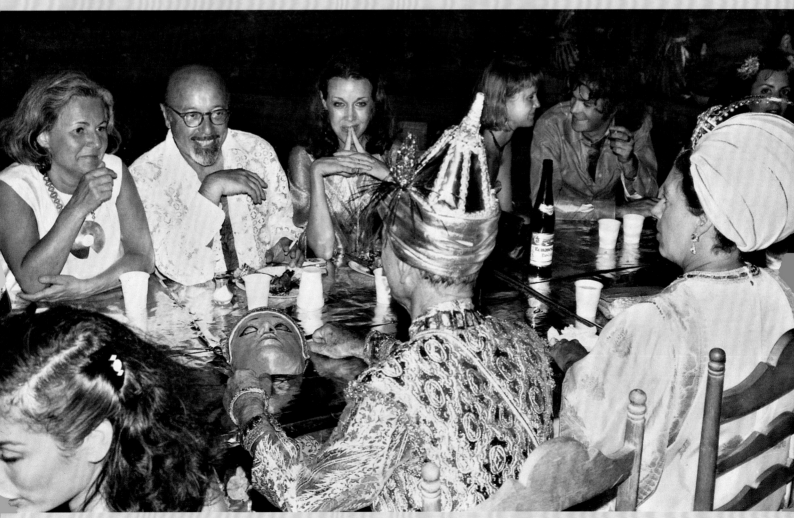

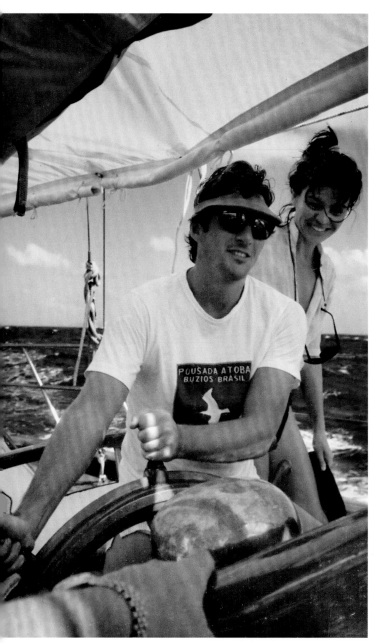

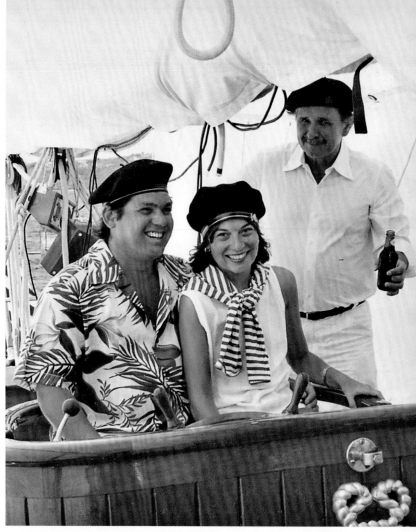

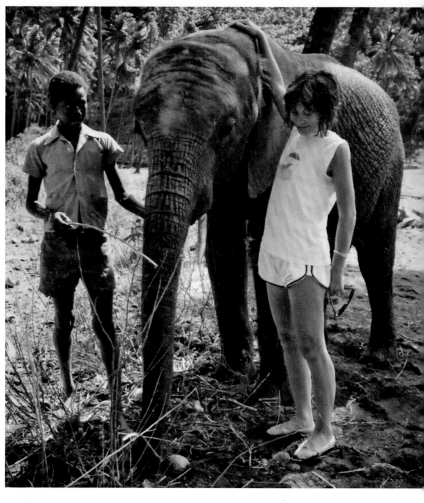

Camilla and Earl joined the Wenners for a sailing trip, starting in Martinique and going to St. Lucia, Bequia, Petit Saint Vincent, and ending up in Mustique, December 23–31, 1984

above: Richard Gere taking the wheel with Sylvia Martins

top, right: "A beret moment": the Wenners with Earl

bottom, right: Jane Wenner and a baby elephant on Saint Lucia

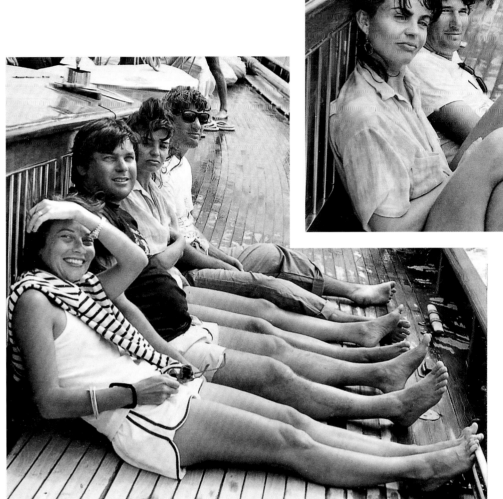

above: Artist Sylvia Martins and Richard Gere

left: Leaving Bequia for Petit Saint Vincent, Jane and Jann Wenner, Sylvia Martins, and Richard Gere

below: Jane Wenner

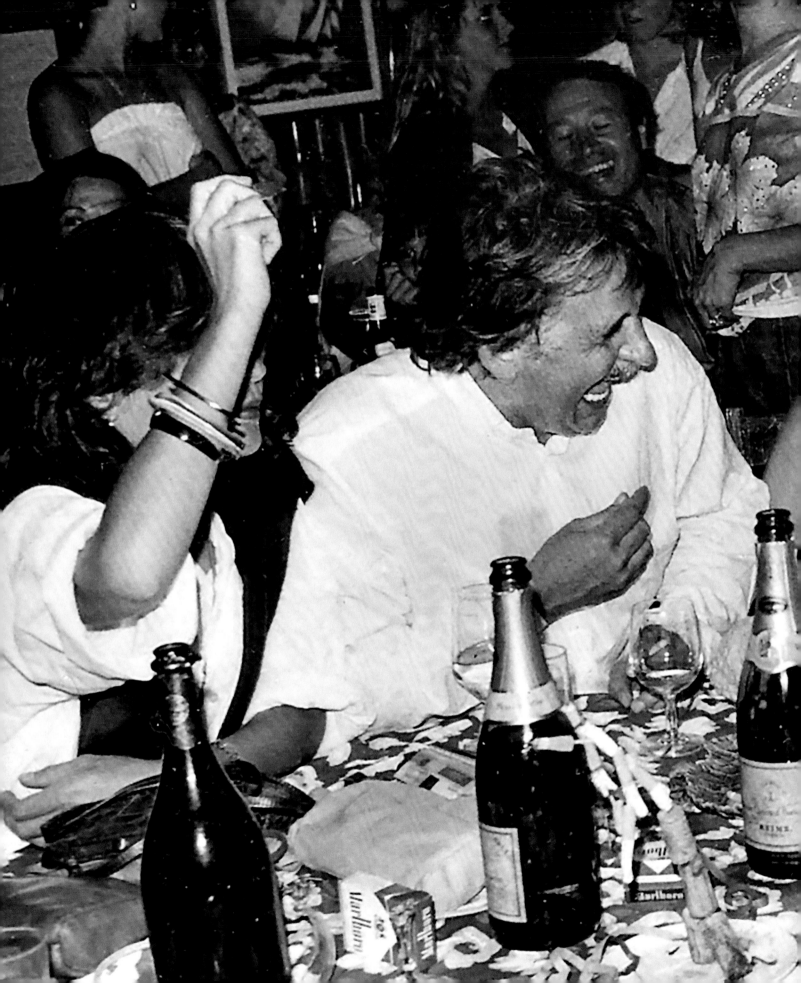

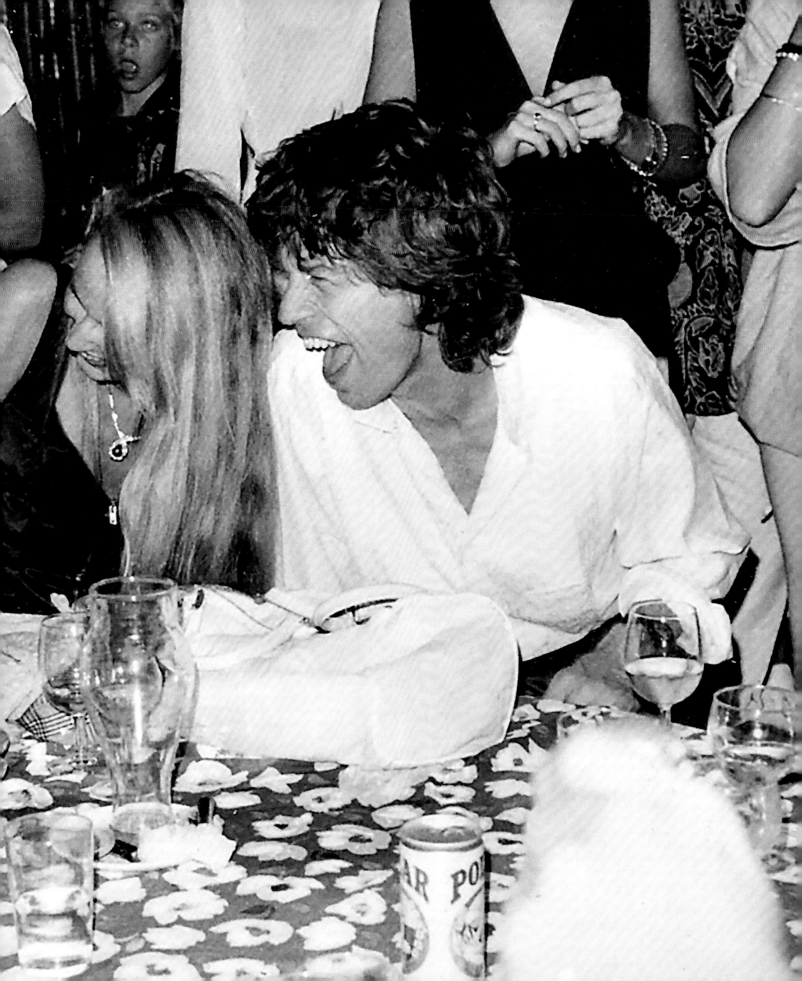

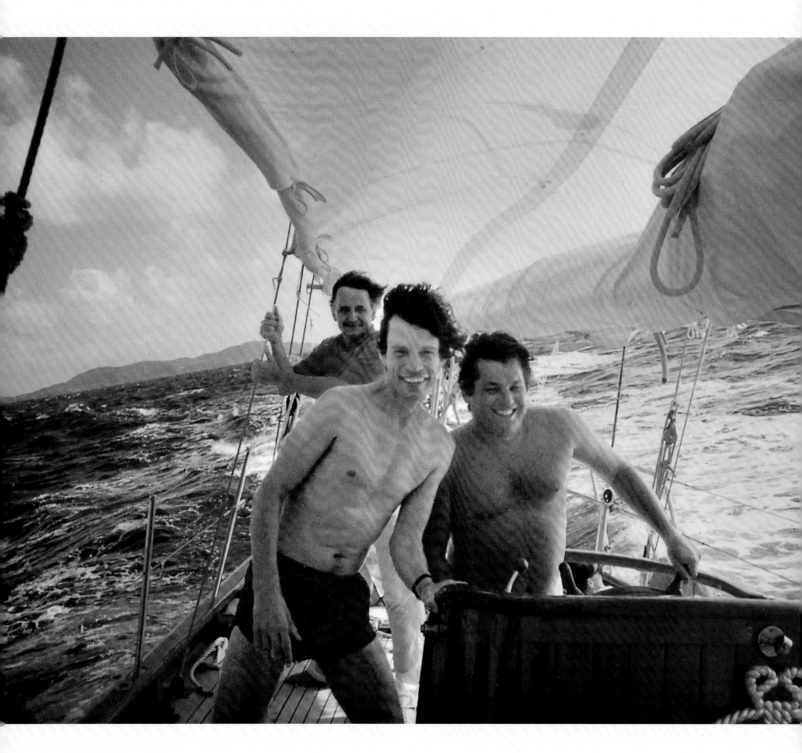

Sailing around Mustique

Earl, Mick Jagger, Jann Wenner

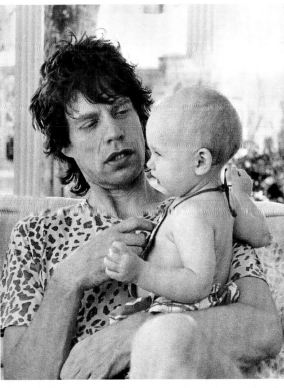

Baby Elizabeth Jagger with
her parents

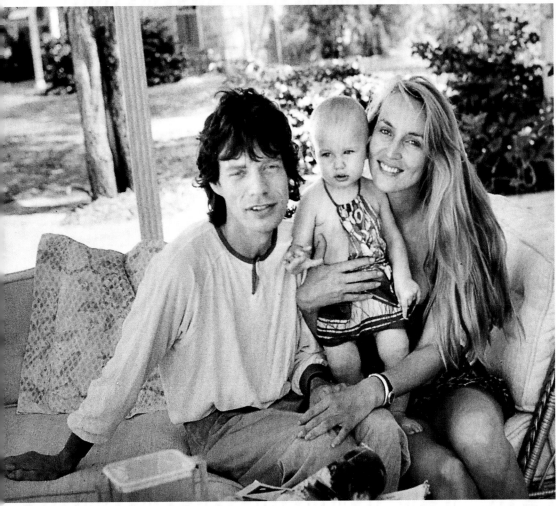

above: Jane Wenner

right: Jane and Jann Wenner
with Sylvia Martins

E arl and Camilla were great travel companions. They seemed to know everyone in the world, had some connection on every island and in every capital, and they always made whatever they were doing great fun. We had ideas and plans all the time. We started off by going with them to Barbados in 1974.

Ahmet and Mica Ertegun used to rent a villa on the beach next to the Sandy Lane Hotel. Jane and I had been down there once already, staying next door to them. The McGraths would stay with the Erteguns. There was one trip when the Erteguns had a whole houseful of guests that included Mick and Bianca Jagger. Jane and I had rented another house nearby. Annie Leibowitz was staying with us. Richard Pryor was also there but in a separate house. It was a round of lunches and dinners and going to the beach, and we were all swept up in the Erteguns' household.

On those trips, we got to know a group of people with far-flung interests that the Erteguns had known over the years, a lot of British, including the

set designer Oliver Messel, who designed many houses in Barbados and Mustique, in the Grenadines; the writer Christopher Sykes; and Prince Rupert Loewenstein, who was the manager of the Stones. In those days, people were always around Mick because he was Ahmet's star artist. Earl used to call Rupert "the Quince."

At one point, the Erteguns had rented a big motorboat. Daniel Filipacchi, who owned *Paris-Match* and French editions of several American magazines, came along. There was this plan to get me—though I wasn't very important at the time—and Daniel together because we were both magazine publishers. He was perfectly nice, but he was taciturn and didn't talk. Within two months, he asked me to take over *Look* for him to revive it. Then, through Johnny Pigozzi, I met a guy who had a boat called *Sumurun,* a 1914 classic racer. Victoria Sackville-West had it built as a present for her husband. I chartered the boat from him over Christmas 1984, and invited Earl, Camilla, and Richard Gere and his girlfriend at the time, the painter Sylvia Martins.

On all these trips, Camilla would keep things organized if we were getting out of control—not by saying anything, just by being there. Just by being there, it meant we were going to live by a certain standard of food, and manners. We weren't going to just fling some spaghetti down in the galley. Pasta would be cooked correctly and Camilla would be making a fabulous sauce. And you

could not repress Earl's laughter and his ability to entertain us and himself. We got very close to the McGraths, like many people. They took you under their wing so gracefully, in a way which you didn't even realize. Earl spotted perhaps some eccentric and bohemian thing about us that he liked and that appealed to him.

Camilla and Earl were so easy to be with, and traveling with them was kind of natural. On this boat, we sailed around the Grenadines with the idea of ending up in Mustique, where we had a lot of friends and so did the McGraths, but particularly Mick and Jerry were there. So we got there and spent two or three days staying on the boat. Mick and Jerry had a house that they had rented and there was this bar called Basil's. It was the only night life there. Mick liked sailing though he didn't know anything about it, but none of us really did. We could take a wheel but that's about it. It was a great opportunity for us all to be together and relax. When Mick is not on tour he is completely charming. On this trip you can see he's very easy about letting Camilla take pictures. On our second sailing trip, we took Rupert Everett and the beautiful Sabrina Guinness.

We went back to Mustique another year for a Thanksgiving trip and rented Colin Tennant's house (Tennant owned the whole island at one point), called the Great House, designed by Oliver Messel, and we brought along Yoko Ono and her boyfriend, the painter

Sam Havadtoy, and Sean Lennon, who was about six years old, and Michael Douglas and his wife Diandra and their son Cameron. Jane and I had our son, Alex, who was about a year old at the time, and I always remember Sean and him crawling under the bed together. The house was almost a resort unto itself, with palm trees everywhere. Every evening the staff would cut out the hearts of palm at the top of a tree so every night we would have fresh hearts of palm. The house had antique Indian screens everywhere and grand rooms. That trip was all about living well at the house, not about traveling. There wasn't much to do on the island then anyway. I remember that Mary Lawrence of Wells, Rich and Greene, who had the idea of Pucci uniforms for the stewardesses of Braniff Airlines, and her husband Harding, president of Braniff, were building a vast house on the top of a mountain. Jerry arranged for all of us to go up and tour it. It wasn't finished yet but it was like a Roman villa: lots of columns and courtyards. I can remember walking around and Yoko—she was a bit paranoid then with all the intrigue that was going on—and she was looking through the windows and saying the window is so big and all the staff could be looking at you. We were already all tiptoeing around anyway because we were trespassing. But that trip was the most family-style trip we had ever taken.

All those trips were an education for us as a young couple in the ways of the world, and it was great fun. The islands were still a playground for very few people. And with Camilla along, you could still feel the whole vibe of Marlia, her family palazzo outside Lucca. The people we spent time with—with her—were from many different worlds. They were among the most enjoyable, even possibly most innocent, times of our lives. We were so young then, so free.

—JANN WENNER

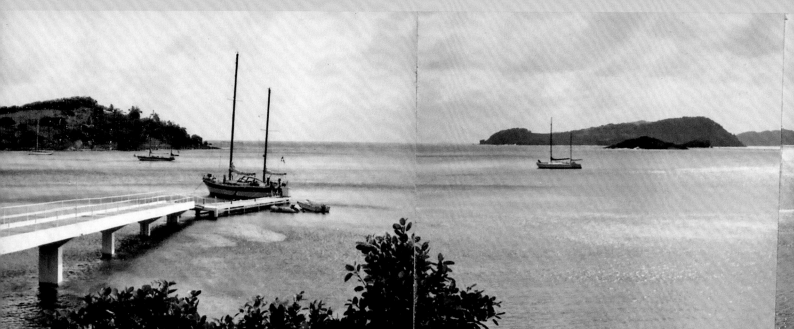

The McGraths spent Thanksgiving 1985 in Mustique and Bequia with the Wenners

opposite, top: View from the house in Mustique

above: *left to right,* Diandra Douglas, Jerry Hall, Jann Wenner, Earl, Michael Douglas, Jane in Bequia

left: Friendship Bay, Bequia

right: Alexander Wenner, Jane Wenner, Jerry Hall, James and Elizabeth Jagger

below: Michael and Cameron Douglas

opposite, top left: Jann, Jane, and Alexander Wenner

opposite, top right: Cameron Douglas and Sean Lennon

opposite, below: Yoko Ono and Sean Lennon

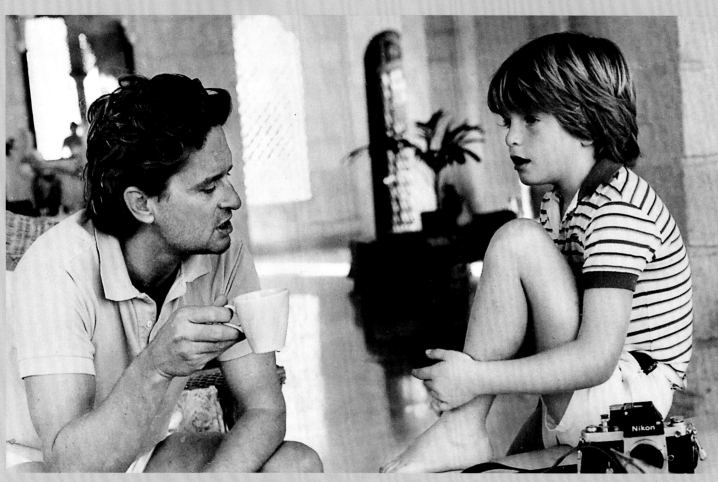

opposite, top: The house in
St. Barts

opposite, below: View from
the house

above: *left to right,* Earl, Evan
Sidel, Jane Wenner, Fran
Lebowitz, and Kelly Klein

left: Calvin Klein and Jane

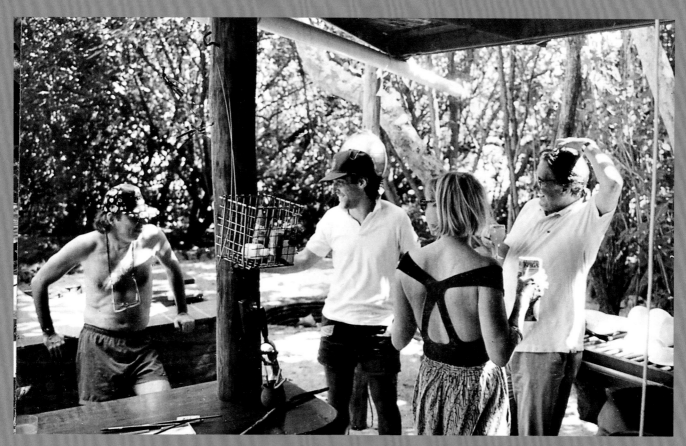

At the Mardens' house

above: *left to right*, Brice
Marden, lawyer and
entrepreneur Tommy Cohen,
Helen Marden, Earl

right: Brice Marden and Earl

Lunch at La Lafayette

left: Tarlton Pauley and
Peter Morton

below: Tony Shafrazi and Earl

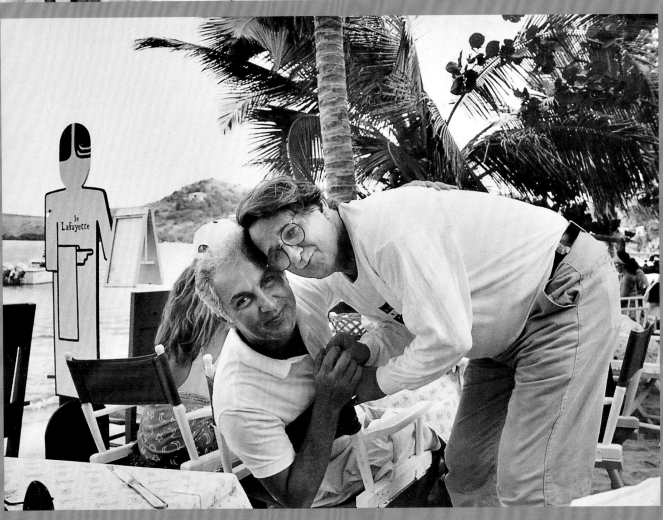

Thomas Ammann's dinner at Maya's, in St. Barts, New Year's Day evening

top: *left to right*, Gallerists Aeneas Bastian, Thomas Ammann, and Heiner Bastian

bottom: *left to right*, Bianca, Jane, Helen Marden, and Heiner Bastian

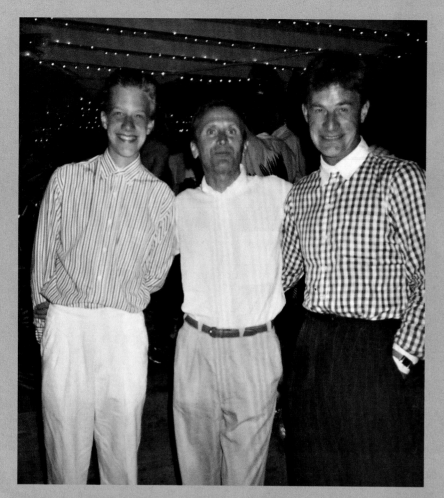

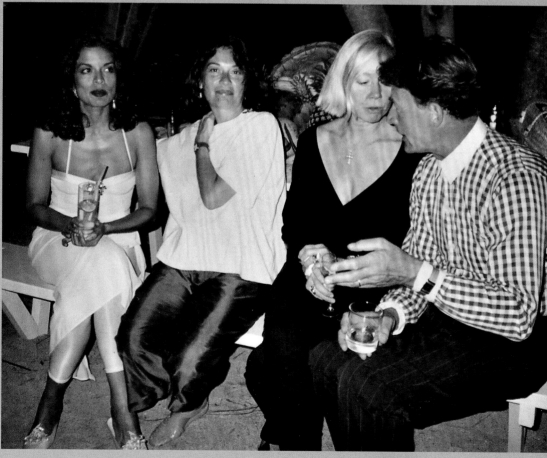

left: Calvin Klein and
Bianca Jagger

below, left: Kelly and Calvin Klein

below, right: Johnny Pigozzi
and Evan Sidel

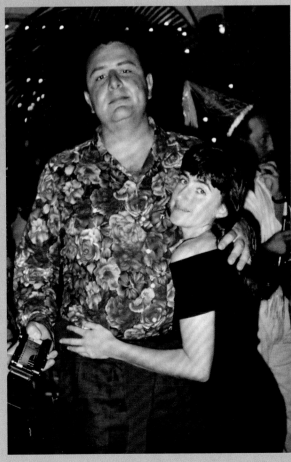

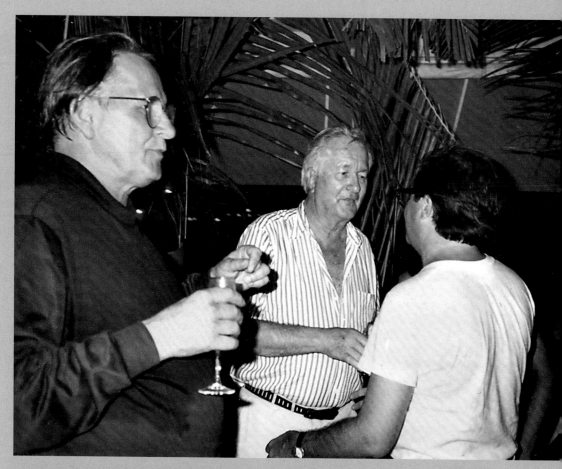

right: Earl, William Styron, and Bob Colacello

below: Brice Marden, Jean Stein, Torsten Wiesel, and Earl

opposite, top: Tommy Cohen and Susan Forristal made a spontaneous outfit switch and took to the dance floor

opposite, below: Earl, actress Carey Lowell, Griffin Dunne, Bob Colacello, and Bianca Jagger

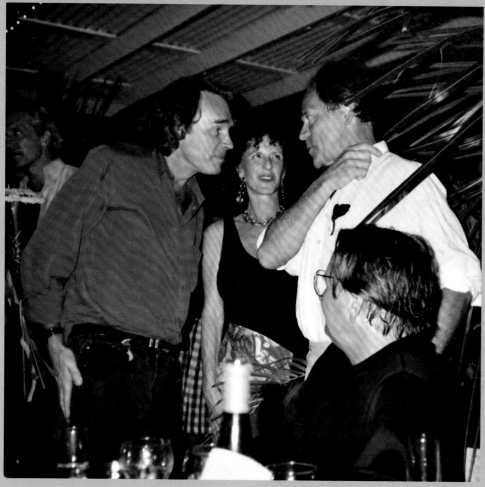

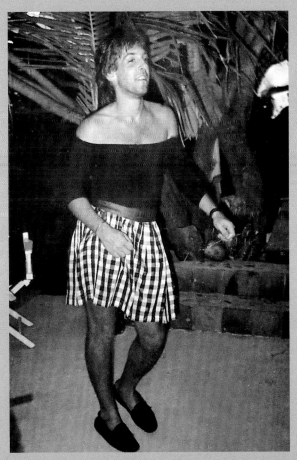

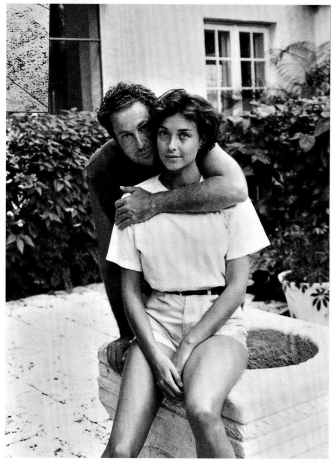

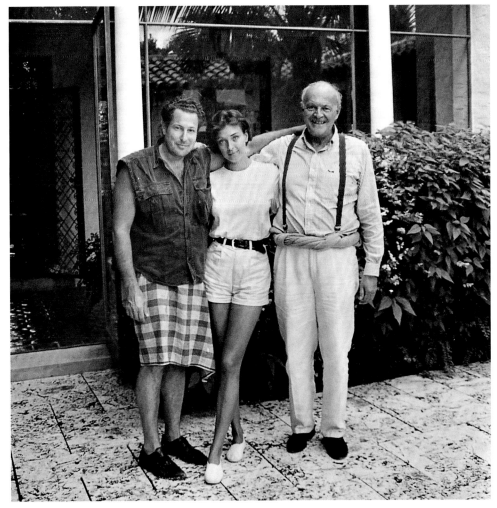

Visiting Julian Schnabel in Palm Beach with Cy Twombly, February 24, 1993

opposite, top: Schnabel's paintings laid out on the grass

opposite, below left: Schnabel

below right: Schnabel with actress Olatz López Garmendia, who was his second wife

top: Schnabel, Olatz, and Twombly

below: Camilla and Twombly looking at the paintings

DIETRO:
PHIL CARSON
SHELDON VOGEL
ANNE VOGEL
ALFREDA RUSHMORE
JOHN RICHARDSON
DAVANTI:
EARL
CAMILLO RICORDI
CINDY LEHMAN
JERRY HALL

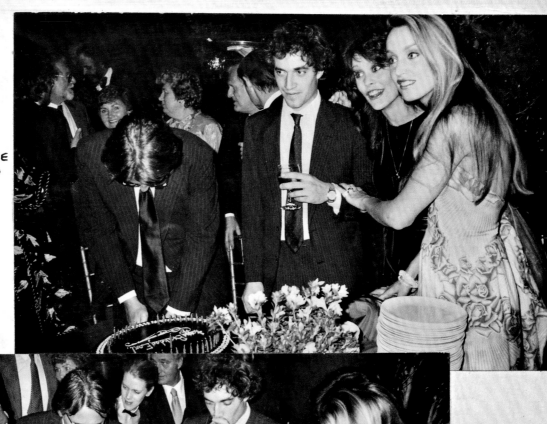

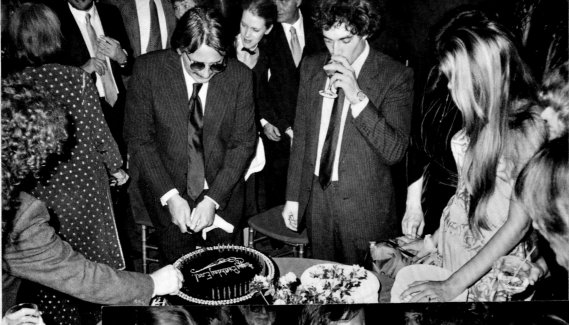

CHARLES BYRON
EARL
CAMILLO
JERRY

Acknowledgments

Writing this essay reminded me of all the wonderful times with Camilla and Earl, and I am grateful to all those who helped me. In particular I must thank Gaia de Beaumont, Camilla's niece, for her early encouragement and her very useful insights. Gaia's daughter, Sabina Bernard, was also immensely helpful in giving me access to Mimì Pecci-Blunt's photo albums—an extraordinary window into the world Camilla grew up in. And Valerie Grace Ricordi, executive director of the Camilla and Earl McGrath Foundation, collaborated enthusiastically on the project and was an invaluable asset all along.

I also benefited greatly from conversations with friends of Earl and Camilla, including Richard Baker, Pietro Cicognani, Joshua Dov Levy, Griffin Dunne, Frederick Eberstadt, Charles Evans Jr., Chayt Holzer, Beatrice Monti von Rezzori, Clarice Rivers, Gwynne Rivers, Filippo di Robilant, Nadia Stancioff, Christopher Sykes, Maria Teresa Train, Musa Train Klebnikov.

And a special thank you to Griffin Dunne, Harrison Ford, Vincent Fremont, Fran Lebowitz, and Jann Wenner, who allowed their taped conversations to become pieces.

Others who must be thanked are Eliel Ford and, at Knopf, Andy Hughes, and Romeo Enriquez, who made these photographs look their very best; Cassandra Pappas, for her beautiful design; and last but not least Kevin Bourke and Tatiana Dubin.

A NOTE ON THE TYPE

This book was set in a type called Baskerville. The face itself is a facsimile reproduction of types cast from the molds made for John Baskerville (1706–1775) from his designs. Baskerville's original face was one of the forerunners of the type style known to printers as "modern face"—a "modern" of the period circa 1800.

Prepress by North Market Street Graphics,
Lancaster, Pennsylvania

Composed and designed by Cassandra J. Pappas

Printed and bound by C&C Offset Printers, China